Colouring the Past

Colouring the Past

The Significance of Colour in Archaeological Research

Edited by
Andrew Jones and Gavin MacGregor

Oxford • New York

First published in 2002 by
Berg
Editorial offices:
150 Cowley Road, Oxford, OX4 1JJ, UK
838 Broadway, Third Floor, New York, NY 10003-4812, USA

Berg is the imprint of Oxford International Publishers Ltd.

Library of Congress Cataloging-in-Publication Data
Colouring the past : the significance of colour in archaeological
research / [compiled by] Andrew Jones and Gavin MacGregor.
 p. cm.
Includes bibliographical references and index.
 ISBN 1-85973-542-8 – ISBN 1-85973-547-9 (pbk.)
 1. Social archaeology – Research. 2. Social archaeology – Methodology.
3. Color – Social aspects – History. 4. Symbolism of colors – History.
5. Antiquities. 6. Material culture. 7. Aesthetics. I. Jones, Andrew, 1967- II.
MacGregor, Gavin, 1969-
 CC72.4 .C65 2002
 930.1–dc21

 2002003430

British Library Cataloguing-in-Publication Data
A catalogue record for this book is available from the British Library.

ISBN 1 85973 542 8 (Cloth)
 1 85973 547 9 (Paper)

Typeset by JS Typesetting, Wellingborough, Northants.
Printed in the United Kingdom by Biddles Ltd, Kings Lynn.

Contents

Contents

Preface

This volume has been a long time in gestation. Many of the chapters originated from a conference session on the subject of colour and archaeology at the European Archaeological Association (EAA) meeting held in Bournemouth, September 1999. These include the contributions by Cooney, Jones, Keates, Owoc and MacGregor. Further contributions were elicited as interest in the subject grew over the ensuing time period between the end of this conference and the date of publication. The volume has metamorphosed considerably over this time. While many of the chapters deal with European prehistory, partly a reflection of the original conference session, we are pleased to note that the final publication includes a diversity of chronological periods and a wide geographical coverage. Meanwhile the theoretical approaches brought to bear on this rich material evince an equally diverse range of approaches.

A number of people have been instrumental in providing us with contacts and encouragement during the production of this volume. We would particularly like to thank Pim Allison, Barbara Bender, Dusan Boric, Richard Bradley, John Chapman, Ludmila Koryakova, Nick Saunders, Hannah Sackett, Jill Sievewright and Chris Scarre. Our special thanks go to the McDonald Institute for Archaeological Research, Cambridge who generously provided funding for the reproduction of illustrations.

Finally, during the gestation period of this volume both editors saw new additions to their families. For this reason, we dedicate the volume to Joshua Gethin Jones Sackett and Arran Sievewright MacGregor.

List of Illustrations

List of Illustrations

Notes on Contributors

Penelope M. Allison has taught ancient history and archaeology at the University of Sydney (Australia), the Australian National University and the University of Sheffield (UK). She has held research fellowships at the University of Sydney (Australia) and in the Faculty of Classics, Cambridge (UK). She is currently an Australian Research Council Queen Elizabeth II Fellow at the Australian National University. She has recently edited *The Archaeology of Household Activities* (Routledge 1999) and co-authored *Casa della Caccia Antica*, for the series *Häuser in Pompeji* (Hirmer, Munich) and authored *Pompeian Households* (The Cotsen Institute of Archaeology at UCLA).

Dusan Boric is currently completing his doctoral research on the topic of 'Mesolithic-Neolithic time views: seasons and life cycles in the Balkans, *c.* 9000–5500 BC' in the Department of Archaeology, University of Cambridge (UK). His current research focuses on the Early Holocene archaeological sequences of the Danube Gorges of Serbia and the sites of Lepenski Vir, Padina, Vlasac and Hajducka Vodenica with an emphasis on subsistence practices, mortuary data and domestic architecture. He is interested in exploring theoretical aspects of archaeological inquiry that can contribute to the wider field of social theory. These include questions of apotropaism, temporality and the political nature of archaeological practice.

The late Anatoli Filippovich Bushmakin worked at the Institute of Mineralogy, Urals Branch of the Russian Academy of Science (Russia) in collaboration with Alexander Tairov.

Gabriel Cooney is a Professor in the Department of Archaeology, University College Dublin (Ireland). He is the author of numerous articles on the Irish Neolithic, landscape archaeology and archaeological theory. He recently published *Landscapes of Neolithic Ireland* (Routledge 2000).

John Chapman is a Reader in Archaeology in the University of Durham (UK) with research interests in archaeological theory, settlement, mortuary studies and social structure. He has worked for over 30 years with the Mesolithic, Neolithic and Copper Age of Central and Eastern Europe. He recently published a ground-breaking book *Fragmentation in archaeology* (Routledge 2000). His latest book

is *Tensions at Funerals: Micro-tradition Analysis in Later Hungarian Prehistory* (Archaeolingua, Budapest 2000). Together with his Hungarian colleagues, he is currently completing the publication of the Upper Tisza Project.

Timothy Darvill is Professor of Archaeology in the School of Conservation Sciences at Bournemouth University (UK). After taking a degree in archaeology at Southampton University and then completing a PhD on the Neolithic period in the mid-west of Britain he directed a series of research projects relating to archaeological resource management in England. Current research interests include the Neolithic of north-western Europe, and the management of archaeological resources. He is currently directing excavations at Billown in the Isle of Man and involved in collaborative research in Russia.

Andrew Jones is a Lecturer in the Department of Archaeology, University of Southampton (UK). Prior to this he held a Fellowship at the McDonald Institute for Archaeological Research, Cambridge (UK) and a lectureship in the Department of Archaeology, University College Dublin (Ireland). He has recently published *Archaeological Theory and Scientific Practice* (CUP 2002). He is currently working on a project examining issues of aesthetics and memory in relation to artefacts and mortuary practices in the Late Neolithic and Early Bronze Age of Britain. Furthermore he is also involved in collaborative field projects in Scotland and Norway investigating the relationship between prehistoric rock art, memory and landscape.

Stephen Keates recently completed his doctorate on the Italian Chalcolithic at the University of Birmingham (UK). His main research interests include the Neolithic, Copper Age and Bronze Age of Italy, rock art studies and archaeological theory.

Gavin MacGregor is a Project Officer with Glasgow University Archaeological Research Division (GUARD). His research interests include Neolithic and Bronze Age Scotland (with special reference to Aberdeenshire), Historical Archaeology and material culture studies. His theoretical interests focus on issues of materiality and historical phenomenology as well as the archaeology of the senses. He is currently involved in several landscape research projects in the Central Highlands of Scotland.

Mary Ann Owoc is an assistant professor of Anthropology/Archaeology at Mercyhurst College, Erie, PA (USA). She holds a BA in Anthropology and History from the University of Pittsburgh, and a PhD in Archaeology from the University of Sheffield. Her main research interests include funerary rituals, prehistoric cosmology and archaeological theory. She is currently engaged in fieldwork on

Bronze Age settlement and funerary practices on the Isles of Scilly, and on the historic burial customs of Erie County, Pennsylvania USA.

Nicholas J. Saunders is Lecturer in Material Culture and British Academy Institutional Fellow in the Department of Anthropology, University College London (UK). He has held teaching and research positions in the USA, Mexico, Argentina, Trinidad and Jamaica, and is currently engaged in research into the symbolism of brilliance and colour in Pre-Columbian and Native America.

Chris Scarre is currently Deputy Director of the McDonald Institute for Archaeological Research, Cambridge (UK) and editor of the *Cambridge Archaeological Journal*. He is a specialist in the prehistory of Western Europe, with a particular interest in the archaeology of the Atlantic facade (Iberia, France, Britain and Ireland). He has participated in fieldwork projects in Britain, France, Greece and India and has directed excavations at Neolithic settlement and mortuary sites in western France. His recent publications have considered the meanings which prehistoric societies may have attached to natural landscape features in Brittany, and the manner in which those meanings were given material expression through the construction of burial mounds or settings of standing stones.

Alexander Tairov is lecturer and researcher at Chelyabinsk State University (Russia). His main research interests are in the Iron Age nomads' burials of Kazakhstan and the southern Urals regions.

Introduction: Wonderful Things – Colour Studies in Archaeology from Munsell to Materiality

Andrew Jones and *Gavin MacGregor*

Preamble

What reader will not be familiar with the painted horses and bison of Upper Palaeolithic cave sites such as Lascaux, France and Altamira, Spain, the Mycenean gold 'mask of Agamemnon', the gold leaf and green glass of the Sarcophagus of Tutankhamen? Less familiar, but no less spectacular, are the horse and chariot of bronze and gold leaf from Trundholm, Denmark, the decorated Passage graves of Iberia, the painted frescos of Roman Pompeii and Minoan Knossos, the jade figurines of Neolithic and Shang period China, or the turquoise and jade of Mixtec and Aztec masks and figurines. These paintings and artefacts are the stuff of archaeological myth – 'wonderful things' as Howard Carter proclaimed to Lord Caernarvon as he entered the tomb of Tutankhamen. We argue that one of the reasons that these objects fascinate and compel is their colour. The contributors to this volume are united by the desire to take this compelling attribute of ancient artefacts, paintings and monuments seriously.

Why has it taken so long for a critical treatment of the archaeology of colour to be offered? This point is best answered by reflecting upon the changing intellectual character of the discipline of archaeology. With the shift away from the positivist scientific frameworks of the 1960s and 1970s, Anglo-American archaeology began during the 1980s to embrace approaches based on a variety of post-structuralist perspectives (see Hodder 1982). By the 1990s archaeologists had begun to explore the experiential character of material culture (see especially Gosden 1994; Karlsson 1998; Thomas 1996; Tilley 1994; 1996). An interest in the experiential nature of material culture led some to emphasize the embodied and performative character of past materialities (see especially Gilchrist 2000; Meskell 1996; Hamilakis 1998; 1999). This interest led to an increased awareness of the senses in archaeological enquiry (Hamilakis 1999; Houston and Taube 2000; Jones 2001; MacGregor 1999; Watson and Keating 1999). The discipline also observed an increase in interest in representation and visual communication (Molyneaux 1997; Moser 1998).

Our first encounter with issues of colour took place through fieldwork on two related groups of monuments in the Northeast of Scotland, the Clava Cairns of Inverness-shire (AJ) and the Recumbent Stone Circles of Aberdeenshire (GM).

It had long been acknowledged that Irish passage graves were constructed of stones of different colour and lithology (Bergh 1995; Cooney 2000: 135–8, Eogan 1986; O'Kelly 1982; Mitchell 1992). The patterned use of coloured stone, especially quartz, was imagined to have an effect on the direction of light into the darkened interior of the monument. This is especially true at Newgrange, *Brú na Bóinne*, Co. Meath where the Midwinter sunrise shines directly down the passage. During work at the Clava Cairns, similar patterned uses of stone were observed (Bradley 2000). Observations began of complex relationships between the colour, lithology and shape of stones that made up the monuments (Bradley 2000: 14–39; Trevarthen 2000). Stone colour and light are interrelated at Clava as the cairns are oriented on a SW–NE axis. At different times of year – particularly Midwinter sunset and Midsummer sunrise – different zones of the monuments, constructed of different-coloured stones, are highlighted. This suggests a close relationship between stone colour and events of wider cosmological significance (Bradley 2000: 126–8). The analysis of the significance of colour at Clava took place against the background of research on Irish passage graves and the significance of solar and lunar alignments at contemporary monuments (Ruggles 1999).

This account of fieldwork forces us to reflect on a number of problems concerning the significance of colour in the past. While the stones recorded at Clava were described in terms of specific colours such as red, white, black and yellow, their appearance in the present is altered by weathering, lichens and mosses. The objective recording of stones of different colour suggests a reconstructive goal, yet the establishment of colour patterns at the site seem to fit with our wider interpretation of these and similar monuments.

The balance taken between the objective practice of data recording and the hermeneutics of interpretation is more generally characteristic of archaeological practice (see Jones 2002). Such issues highlight concerns related to the objectivity and subjectivity of observations and the rationality and relativity accorded to our knowledge claims. These issues are not peculiar to archaeological practice, nor to colour research. However, the subject of colour does throw many of these issues into relief. Is colour a universal and homogenous phenomenon? Should we expect colour perception to be uniform spatially and temporally? If not, to what extent are colours uniformly perceived within a given historical or cultural context?

Our aim in this introductory chapter is not to discuss the survival and reconstruction of past colours, but to examine the significance of colour to past societies. As with the approaches of art history and anthropology, our aim is to move beyond a universally descriptive mode of colour investigation and consider the local context of ideas relating to colour. Our aims in delineating an 'archaeology of colour' are twofold:

1. To develop an approach to the study of the deep history of colour. The origins of art history and archaeology are interlinked through the efforts of early practitioners such as Winckelmann (see Davis 1996). While many art historical texts commence with examples of the Upper Palaeolithic art of Europe, less attention is paid to the art of later prehistory. Art history provides a detailed analysis of changing approaches to colour. We wish to expand the analysis of the historical trajectory of approaches to colour offered by art history. Archaeology is eminently suited to the examination of the transformation of ideas and perceptions over considerable time periods. It is the intention of this volume to examine those periods of time outside the traditional purview of art historical analysis.

2. We wish to sketch the outlines of 'an archaeology of colour' which moves beyond concerns with the abstract nature of colour perception and symbolism and begins to take account of considerations of materiality. Studies of the perception, use and meaning of art are important elements of an anthropology of art that routinely deals with the cultural differences enacted through and generated by artistic production. We wish to preserve this attention to cultural difference in order to examine the various modalities by which colour may be considered to have a social effect. Here it is important to generate an understanding of how the material nature of colour has an affect upon the perception and deployment of colour socially.

The Munsell chart and its outcomes – problems of universality and relativity in colour research

Archaeology is often perceived – by both some of its practitioners and the wider public – as a reconstructive enterprise, in which originary archaeological reality is constructed anew in the present. Questions regarding the objective status of archaeological data and knowledge have been subject to detailed criticism (e.g. Shanks and Tilley 1987: 46–67). The material record is not simply a representation of past realities awaiting recovery through diligent recording techniques (for a critique of this approach see Barrett 1994; 2000). Rather, the past exists for us in the present and our constructions of it are dependent upon both our present prejudices and our political standpoints.

If we are to understand the problems associated with the reconstructive paradigm, we first need to examine the debates concerning the relativity or universality of colour in contemporary psychology (see also Chapman in Chapter 2 of this volume). Systematic investigations into colour perception and naming arose out of the need to question the relativism of the Whorf hypothesis (Whorf 1956) which proposed a causative linkage between the linguistic naming of colour terms and the perception of colour. Languages were considered to divide up the colour space arbitrarily and shape the way in which their speakers perceived

coloured objects. This relativistic notion was challenged by the work of Berlin and Kay (1969) who drew on earlier opponent process theories of colour. Opponent process theories posit that colour perception can be defined by a series of elementary colours, divided into achromatics – black and white – and chromatics – red, yellow, green and blue. According to this theory, our failure to see mixtures such as red-greens or yellow-blues suggests that colour vision is divided neurophysiologically in an antagonistic system, with red opposed to green and yellow opposed to blue.

The notion of elementary units formed an important background to Berlin and Kay's colour theories since it suggested that colour perception was neurophysiologically determined and therefore universal in nature. In order to investigate claims of perceptual universality against those of linguistically determined colour perception they proposed to distinguish the basic (or elementary) colour terms from the non-basic within a cross-section of languages. Basic colour terms are defined by their *generality* and *salience*. Terms are general, since their meaning is not subsumed by other terms, and they apply to a diverse array of objects. Saliency is defined by frequency and consensus of usage within a given language.

Experimental and cognitive psychology describes colour according to three distinct terms, and these terms are related to aspects of the Munsell Colour Chart. *Chroma*, the maximum colour strength in an ordered array of Munsell chips; *value*, degrees of lightness and darkness in these chips; and *hue*, the traditional conception of colour, which increases by an ordered (if arbitrary) division. In order to test for basic colour terms the chart was covered in transparent acetate and subjects were asked to define the best example of a given colour and the region on the chart defined by that colour by tracing around colours with a pen.

The findings of the original Berlin and Kay study can be summarized by an analysis of their synchronic and diachronic features. They proposed that languages varied synchronically according to the number of their use of basic colour terms, with some languages using just two colour terms while other languages used as many as eleven. Whatever the number of terms used in a given language, the foci for colour clustered in discrete areas of the chart. The diachronic conclusions of their research were more problematic. They proposed that, if languages were ordered by the numbers of basic colour terms, then the sequence by which these are encoded should also be ordered sequentially. If a language has two basic colour terms (a Stage I language), those terms will be black and white. If a language has three basic colour terms (a Stage II language) the terms will be black, white and red, while if it has four terms (a Stage III language) then those terms will be black, white, red and either yellow or green. This scheme was interpreted as evolutionary, with a sequence from Stage I languages typified by the Dani of Papua New Guinea to Stage VII typified by Modern English. The scheme is unusual in that it is one of the instances in which linguistic development proceeds in a single direction

from simple to complex (Hardin and Maffi 1997: 5). This monolithic scheme has continued to be utilized with modifications (especially Kay and McDaniel 1978; MacLaury 1992; Kay, Berlin, Maffi and Merrifield 1997) since the early study.

The Berlin and Kay findings appear to be of enormous potential for archaeology since they posit a scheme of universal and sequential order (see Sahlins 1976). However, we wish to question this scheme. The original Berlin and Kay thesis was formulated using twenty informants in and around the San Francisco area who were native speakers of twenty different languages. Their research was supplemented by a literature review of seventy-eight other languages. The unifying instrument in these analyses was the Munsell Colour chart. The use of this device has been criticized by Lucy (1997), Saunders and van Brakel (1988), Saunders (1995) and Wierzbicka (1990).

We observe many instances of colour usage in which other phenomena are brought to bear on the description and classification of colour. Examples include wetness and dryness, as noted by Conklin in his classic study of the Hanunoo colour system (Conklin 1952), or darkness and light as with the Dani (Rosch 1972). What this means is that in effect languages are classified solely by their understanding and utilization of a single attribute of colour, and that attribute of colour is determined by the Munsell Colour Chart (see Saunders 1995). If we are to question notions of universalism and rationalism in experimental and cognitive psychology, we need to focus on this device. Here it is worthwhile considering perspectives on these topics generated in the sociology and anthropology of science.

Latour (1999: 58-60) notes how the use of the Munsell Chart in the field of pedology translates the physical attributes of the soil, in this case its colour, into a numerical figure. This figure can then be circulated widely and published in scientific reports, and comes to have a veracity of its own (see Latour 1990; Lenoir 1998). The universal circulation and use of the Munsell Chart is productive of a rationalized ordering of the colour space, and the chart is used to determine the nature and extension of that colour space (Saunders 1995). The scheme is a classic example of the temporalization of the other (see Fabian 1983). As Fabian notes (1983: 105–41) one of the ways in which Western science affects the process of temporalization is through the visualization of knowledge. The Munsell Chart is used as a device to visualize and then determine a universal system of colour usage – the colour space. This colour space is then divided up according to a scheme assumed to develop sequentially over time. While this scheme is suggestive of systems of colour classification separated in time, the practical development of this scheme utilizes supposed systems of colour classification separated in space. Although the Dani of Papua New Guinea are coeval with contemporary colour researchers, their colour classifications are equated with notions of the primitive, assuring a neat predetermined distance between 'us' and 'them'.

Are there then any aspects of the Berlin and Kay scheme that can be retained? Is the use of the Munsell Colour Chart and its association with systems of universality too problematic? The Munsell system was devised as a reference device to provide a common point of discussion for artists reflecting upon their use of colour in painting (Gage 1999; Jameson and D'Andrade 1997). The creation of such colour systems has a long and varied pedigree (Gage 1999: 21–33), and as long as we remember that notions of standardization and referentiality are embedded in the chart, then the chart remains a useful reference system. The Munsell chart is in common usage in certain fields of archaeology, such as geoarchaeology, although its use is by no means universal. The chart serves to codify the perception and recording of individual colours, and as such is a useful medium of communication. This does not mean that the chart stands as an atemporal definition of colour which can be utilized as a universal standard for colour in the past and the present.

We need to remember that the use of the Munsell Chart in the codification of colour terms in the Berlin and Kay scheme acts as a useful means of communication between colour researchers. Again, it need not mean that we need to attach cognitive, neurophysiological or evolutionary veracity to the distinctions between these terms; the chart simply serves as a 'site' allowing researchers to discuss colour according to the same terms of reference. One of the critical points established by the use of the Munsell Chart in these kinds of experimental procedure is the fact that, because of the physiological commonalities of the mechanism of the human eye used in colour vision, humans in different cultural settings perceive colour in similar ways. All individuals studied were able to perceive colours prior to defining them on the Munsell chart. Although this point is exceedingly basic, it is of signal importance to the study of archaeology since it allows of the fact that colour vision is an integral attribute of *Homo sapiens sapiens*. However, this is a far cry from stating that colour categories are fixed neurophysiologically and determined by evolutionary development.

The problem with an evolutionary approach is that it shears colour from both its lived and its social dimensions. Once these aspects are factored out of the equation, we are left with colour as an abstraction whose categorization apparently progresses from simple to complex without acknowledging the environmental or social aspects of change.

On the face of it, archaeological analyses of colour ought to be able to empirically counter linear evolutionary schemes. For example, we observe an overwhelming use of the colours black and red at the recently discovered European Palaeolithic cave-art sites of Cosquer and Chauvet, France (see Clottes 1998) dated 27,110 +/-350 bp for Cosquer, and from 30,340 to 32,410 bp for Chauvet. At the rock shelter sites of Nauwalabila I and Malakunanja II in Australia, dated to approximately 60,000 bp, pieces of red and yellow ochre along with worked pieces

of haematite have been found (Flood 1996: 10). Both of these instances suggest that an evolutionary scheme initiated by the categories 'black' and 'white' is exceedingly problematic.

However, we need to be aware that the Berlin and Kay scheme was originally devised in order to answer questions about the cross-cultural nature of linguistics. As Davidoff (1997) notes, the naming of colour and the categorization of object colours need not be cognitively related. While the colours deployed in the Australian or European Palaeolithic are of importance for an understanding of the use and significance of colour in this period, they are of little help in circumventing assumptions about the evolutionary character of linguistic colour categories.

The work of John Baines (1985) is of importance in this regard since his analysis of Ancient Egyptian colour categories – both linguistic and material – clarifies much about the relationship between the two. Baines examines the evolution of colour terms and paint colours, from the Old Kingdom (*c.* 2600 BC) to the later New Kingdom (*c.* 1540–1070 BC). Although the linguistic colour terms recorded for these periods are at Stage IIIa of Berlin and Kay's scheme, the use of paints over the time period analysed progresses from Stage V in the Old Kingdom period, through Stage VI in the Middle Kingdom to partial Stage VII in the New Kingdom. The material use of colour therefore precedes its linguistic description and categorization. As Baines (1985: 289) notes, 'colour is more easily painted than talked about'. There remains a distinct possibility that societies with few basic colour terms may have varied material-colour 'vocabularies'.

Symbolism and phenomenology: towards an understanding of colour in the lived world

The Berlin and Kay scheme overlooks what may be some of the most basic aspects of colour. These include its context and the structure and nature of colour meanings (see Sivik 1997). If we are to consider these issues we need to examine the social dimensions of colour usage. The results of the Berlin and Kay scheme were greeted with enthusiasm by those working in the field of semiotics (see Sahlins 1976), and it is to symbolic approaches that we will turn now. Probably the most important anthropological study to consider the symbolic aspects of colour is Victor Turner's analysis of colour in Ndembu initiation ritual (1967). Turner notes a tripartite division of black, white and red and proposes a cross-cultural association between these colours and bodily products. Turner's study draws on earlier archaeological research and his proposal has been adopted by archaeologists. In a contextual study of colour in Middle Neolithic passage graves in Southern Scandinavia, Tilley interprets the placement of amber beads and red ochre with human bones in tombs as a commingling of 'blood' with the 'semen-milk' of ancestral bones (Tilley 1996:

322). In the Early Neolithic of Arran, Scotland, Jones (1999) suggests that the use of coloured stones in the construction of chambered tombs relates to the symbolism of the body.

The association between ochre and blood has been made in relation to the remarkable burials from the European Upper Palaeolithic and Mesolithic. One of the burials at Sunghir, Russia (dated to *c*. 28,000 bp) was a double inhumation of two juveniles associated with, among other things, a human femur containing red ochre (McBurney 1975). The relationship between white bones, red ochre and blood appears clear in this context. At Dolni Vestonice, Czech Republic (28,000–26,000 bp), we observe a triple inhumation of two men and a woman accompanied by wolf- and fox-tooth pendants, ivory beads and shells. The heads of the two males are covered with red ochre while the groin area of the women is covered with ochre (Klima 1987). The male inhumation to the left of the female has his hand placed around the groin area of the female. The use of red ochre in this context is viewed as signifying the blood of an unsuccessful delivery (Parker-Pearson 1999: 151–2).

Red ochre in burial is even more common in the Mesolithic. At Vlasac, Serbia red ochre was placed on the heads of men and the groins of women (Handsman 1991). Red ochre is also found in graves at Dragsholm, Denmark (Brinch-Petersen 1973), Skateholm I and II, Sweden (Larsson 1989) and Teviec and Hoedic, Brittany, France (Kirk 1991). The use of this colourful substance is seen as a general signifier of blood (Bradley 1998: 24; Tilley 1996: 63) The argument for blood symbolism is forceful but partial. It does not explain the placement of ochre around the head, for instance (but see Boriç in Chapter 1 of this volume). The recognition of such symbolism is not wholly self-explanatory: symbols are polysemic, and the nature and significance of 'blood' in different societies will relate to different ontological understandings of the world.

Our ability to discuss the symbolic nature of red ochre in this manner is underpinned by the notion of colour as a stable and universal entity, a concept akin to the universalized conception of colour engendered by cognitive psychologists. Studies associated with the symbolism of colour tend to view colour as naturally constituted while the meanings associated with colours are culturally constructed (see especially Sahlins 1976). A distinction is made between sensation and representation. Ingold (2000: 157–71) notes that the assumed distinction between the acquisition of sense data by individuals and the possession of cultural knowledge by groups causes problems when we wish to discuss the intersubjective, and intergenerational, transmission of cultural understandings.

Many approaches to the anthropology of the senses emphasize the different weights or ratios of various senses in their construction of different cultural experiences and understandings (Classen 1993; Feld 1996; Howes 1991; Classen, Howes and Synnott 1994; Stoller 1997). According to these approaches, vision

comes to stand for a mode of objectifying and apprehending the world 'out there'. This supposition is underpinned by a notional division between the outside world (awaiting the experiencing subject) and the impingement of that world upon the calculating cognitive subject. This division is unsustainable not least because it presupposes a degree of stasis between person and world (Csordas 1994; Lambek and Strathern 1998: 13–19).

Our approach is to consider the embodied (or enminded – see Ingold 2000: 171; Lambek 1998) subject as a person within his or her environment. Such an approach attempts to capture the mutual relationship between the body as the existential ground of culture and the environment as formed by and through the engagement of that subject. This proposal shifts the emphasis from the body as a conduit for sensations (such as the perception of colour as light), which are then constructed culturally, towards an understanding of the body as the *subject* of perception (Merleau-Ponty 1962). The perceiving body-as-subject moves through the world, and colours 'come to light' for the subject as a component of his or her flux of experience (ibid.1962: 300). As Merleau-Ponty (1962: 305) points out, variations in light will affect the experience of the colour of an object. We cannot disengage the colour of an object from that object and contemplate it in isolation: rather, the colour of the object will change according to the conditions of experience.

This approach to the archaeology of colour is illustrated in Chapter 10 of this volume by Allison, who discusses the way in which the experience of colour alters as the subject moves in and around the Casa della Caccia Antica, Pompeii.

Time, space, colour and material culture

We need to consider not only our subjective engagement with the lived world, but how that world comes to have significance. MacGregor raises the point, in Chapter 7 of this volume, that our experience of colour is often paradoxical. At a tautological level the entire world is coloured; colour is a background and frame for lived experience. Our task lies in examining how, through experiential engagement with the environment, certain colours come to be foregrounded and imbued with significance.

If we consider material culture as it relates to the embodied subject then we must consider the temporal and spatial qualities of the material world. As the body inhabits the world, so the material world co-extends with the subject through time and space. At this point it is illuminating to consider the remarks made by Tilley (1999: 260–73) regarding material culture and metaphor. Tilley notes that material culture is both spatially and temporally constituted. With regard to temporality, he notes:

material metaphors need to be understood [temporally] in their actional and biographical contexts: how the artefact is produced, and from what sources and raw materials, the manner in which these materials may be combined in a technological process, its subsequent exchange and consumption contexts, how it may be destroyed, what is done to the thing, how it is used and in what sequence it occurs in relation to other artefacts in a series of events. (ibid.: 264)

Concerning spatiality he goes on to say that 'because material metaphors are solid and spatial the process of "reading" them is immediate' (ibid.: 264).

Colour is a temporal and spatial component of the environment. The colours of the natural world alter over the course of the day, from light to dark, and over the year as the seasons change. Equally colours are spatial since they are associated with specific geological formations and minerals, with bodies of water, with botanical and animal life. It is important to remember that our engagement with the environment is creative of this spatio-temporal experience. For example, as hunter-gatherers explore their environment they will experience different colours in different regions of the landscape over the course of the seasons (see Borič in Chapter 1 of this volume). However, experience of colour is also created through the manufacture of artefacts or the construction of architecture of different colours.

The environmental and material dimensions of colour are deeply significant to our experience and definition of colour. This point has been raised in a number of archaeological studies of monumental architecture, which point out that colour, provenance and environmental and topographic location cohere in and through their construction (Jones 1999; Owoc in Chapter 6 of this volume; Scarre in Chapter 12 of this volume; Tilley 1993). Jones (1999) discusses the way in which the use of red and white stones in the construction of Early Neolithic chambered tombs articulates a series of spatial relationships relating to the geography of the island of Arran, Scotland. Colour channels and condenses the significance of the spatiality of the inhabited world.

Cooney (Chapter 4 of this volume) argues that both temporality and spatiality are of significance in the exchange of polished stone axes during the Irish Neolithic. Particular sources of rock used in the production of stone axes are distinguished by their colour, and the process of polishing serves to highlight this relationship to specific places (see also Whittle 1995). In this instance colour is a means of foregrounding the significance of these sources and those who have access to these sources; colour, place and identity are intertwined. The cognitive coherence between spatial distance, identity and the exchange and use of exotic (and highly coloured) substances is amply documented by Helms (1988). Colour is an important means of circulating the significance of place.

The significance of spatiality and of temporality coheres with the use of colour in architecture. Boivin (2000) discusses the way in which soils of different colours are used to transform households in rural Rajasthan, India. She describes how the

two soils called *Doli mitti* and *Pili mitti* were used at different stages of the yearly cycle to redefine the household space. *Doli mitti* is used every day; *Pili mitti* is an embodiment of *Laksmi*, the Hindu goddess of wealth, and is used on auspicious occasions. The practice of re-plastering floors with soils of differing colours fuses spatial and temporal experience. The daily and seasonally regulated cycles of re-plastering frame and articulate lived human life cycles. Temporal embodied experience is cued by the use of colour.

Just as the environment may be altered by colour so, over time, the colour of the environment alters. Because of the architectural arrangement of certain monuments, the experience of colour will alter according to time of day, month, or year (Bradley 1989; Jones 1999; MacGregor in Chapter 7 of this volume). The ever-changing character of monuments can be examined by empirical method-ological procedures. The temporal cycles and their spatial expression noted by Boivin were investigated using soil micromorphology to examine plaster. Temp-oral sequences may also be examined through conventional archaeological stratigraphy. The causewayed enclosures and cursus monuments of the British Neolithic are often constructed by cutting ditches into chalk or gravel, exposing the underlying bedrock or soil, in most cases a bright white. That this act was viewed as ephemeral in nature is emphasized by the periodic re-cutting of these monuments to renew the fresh and distinct appearance of these monuments (Edmonds 1993; Richards 1990). A similar process occurred in the process of re-cutting the large chalk hill figures of lowland Britain. The most clearly dated, the White Horse at Uffington, Oxfordshire is likely to have been constructed in the Late Bronze Age (Gosden and Lock 1998). The continued process of re-cutting instantiates the continued significance of the figure. In each of these cases the experience of colour and notions of social memory elide in the act of continued renewal.

We have discussed the way in which colour is intertwined with the spatial and temporal rhythms of existence. We would argue that it is through phenomenal experience that the significance and power of colour is generated. At this point we need to reconsider the role of metaphors and metonyms in the treatment of colour. We have noted the ontological inextricability between colour and things; if we are to think of colour in this context then colour and thing are related in a metonymic relationship (see Chapman in Chapter 2 of this volume). Although metonym is arguably primary to the phenomenological understanding of colour, we also need to take into account the metaphorical power of colour (see Owoc in Chapter 6 of this volume).

In developing a theory of material culture as condensed metaphor, Tilley (1999: 265) suggests that material metaphors, unlike linguistic metaphors, signify in a non-arbitrary fashion. He notes that the use of red to symbolize blood or white to symbolize semen is non-arbitrary. Colours are an intimate component of the lived

world, it is their close association with the substances, phenomena and organisms of that world that provide colours with their significatory power (see also Wierzbicka 1990). The ascription of meaning to colours is an analogical process based on the ontological appearance of colour in the material world. In this context we may think of colour in relation to Wagner's (1986) work on symbolic obviation (see discussion by Tilley 1999: 266). Colours form the background of all lived experience – they exist in a figure-ground relationship. Each colour forms part of a referential field of colours. In terms of a figure-ground relationship the figure is given significance due to its wider relationship to the ground. The creative manipulation of colour as a component of material culture means that 'point metaphors' are expanded into 'frame metaphors' (Wagner 1986). Artefactual colour is used metaphorically as a mode for revealing unities between the properties of things (Jackson 1996: 9). A useful example would be Cooney's analysis in Chapter 4 of this volume of the significance of colour in relation to stone axes, since place-related significance is condensed in the colourful qualities of the axe.

The ontological properties of material culture need not constrain the metaphorical elaboration of colour. Saunders (1998; also Chapter 11 of this volume) discusses the way in which colour and the properties of light and brilliance imparted by colourful or shiny substances were woven into complex cosmologies in the pre-Colombian Americas. The experience of colour in the material world forms a ground, then, for the elaboration of more complex schemes of order.

Colour and difference

It is important to consider not only the colour of material objects but also the context in which these are deployed. It is here that we observe the use of colour as a subtle yet powerful means of objectifying other social and symbolic values. Colour is powerful in the construction of difference in other social and material arenas such as food consumption and architecture. For example, Miller (1985) discusses the use of red and black coloured pottery as a means of distinguishing everyday use from ritual in contemporary contexts in rural India. Materialities of colour serve as a framework out of which the identity of particular events, and those able to participate in them, are sedimented.

Colour acts as an important means of constructing difference in the form of adornments and body paints. We wish to make it clear that in considering the issue of colour and the body, the differential use of colour is not seen as so many secondary inscriptions of meaning related to such societal issues as rank and status. To complement these forms of analysis we need to understand how the body is used to actually carry meanings or how meanings are instantiated through the medium of the body. One of the ways in which we may examine these issues is through the analysis of mortuary data.

One striking example of the analysis of the lived body comes from the Pazryk burials of Iron Age Siberian Russia where we observe well-preserved subcutaneous tattoos which were executed in charcoal during early life. Largely, these tattoos are found on women. Here we observe immediate distinctions in the use of colour to materialize particular kinds of difference. Difference is inscribed in the flesh of women and is part of the process of making the bodies of specific kinds of women. In other areas of Siberia and North Kazakhstan colour is used to reiterate and emphasize difference on death. Tairov and Bushmakin (Chapter 9 in this volume) note the use of coloured pigments, stone altars for the preparation of pigments, and articles used for the application of colour in the context of the grave. The location of such equipment is significant and is suggestive of the application of colour to either corpse or mourners. What is striking in this example is the significance attached to colour in the context of mortuary rituals. Even on death the corpse is held to be an important medium for the display and enactment of difference, and this difference is reiterated through the body of the corpse and the significance attached to this act by the mourners.

The adornment of the body with metal artefacts is a particular feature of the European Bronze Age (Sørensen 1997). While there are distinctions of practice between those in Eastern and those in Western Europe, the early use of copper and bronze in prehistoric Europe was often associated with the production of items of dress, such as beads or more complex items (see Chapman in Chapter 2 of this volume and Jones in Chapter 8). While weapons were also produced – in some instances, such as the Remedello daggers of the Italian Chalcolithic discussed by Keates (Chapter 5 of this volume), these were also associated with display on the body in both life and death. Arguably, colour and its affective properties was critical to the early production and use of metal. Sørensen notes a degree of *bricolage* in the use of specific combinations or assemblages of objects, and their placement or composure on the body: working with metals serves to define both gender and age distinctions in many areas of Bronze Age Europe. For example at Lüneburg, North Germany a clear difference in the use of arm or ankle-rings and fibulae and pins distinguishes younger and older women respectively.

Colour, object and embodied experience are entangled. As with the Pazryk burials, the relationship between colour and the embodied subject is mutually constituted. But what is it about colourful objects that make them so socially significant?

Technologies of colour

What material qualities of objects compel the viewer? Gell discusses the efficaciousness of the complexity of designs inscribed on objects (1998: 73–95), but it

is also important to consider the compelling properties associated with the colour of objects. Gell (1992) considers this with regard to the polychromatic prows of Trobriand canoes. Similarly, Morphy (1989) discusses the nature of brilliance in the context of Yolungu bark painting where bichromatic objects effect ancestral and social power through their production and display in ritual contexts.

Morphy (1989) observes that the concept of brilliance, or *bir'yun* (the Yolungu word for this effect) may be considered to have greater cross-cultural significance. While there are problems with discussing cross-cultural regularities in the cognitive categorization of colour, at least we know that the human species is able to perceive colour using the same neurophysiological apparatus. Because of this, we believe that we ought to take seriously any considerations of the neurophysiological effect of colour, and there are two aspects of colour we believe to be of significance in this regard.

The first of these relates to the material qualities of the coloured object, its relative degree of sparkle, brilliance or shininess (see Darvill in Chapter 3 of this volume). These properties may relate to unaltered objects, such as Macaw feathers utilized and exchanged throughout the Americas during the pre-Columbian period (Helms 1988), or the Bird of Paradise feathers utilized in ritual contexts in regions of Highland Papua New Guinea (Strathern and Strathern 1971), or *Spondylus* shells exchanged from the Aegean across Neolithic Europe. Alternatively, objects may be manufactured in order to achieve these qualities. The production of metal objects in the Copper and Bronze Ages of Europe drew on the luminous qualities of freshly smelted copper, bronze and gold (Jones, Chapter 8 this volume; Keates, Chapter 5), as did the metalworking cultures of historic Mesoamerica (Hosler 1994).

Saunders (1998; 1999) has discussed the cross-cultural significance of the effect of brilliance during the contact period in Mesoamerica. As objects were exchanged from indigenous to colonial regimes of value, they were re-evaluated, but in both cases the qualities of brilliance and shininess were held to be important by both groups of exchange partners. The colourful properties of gold, pearls and glass affected a material agency over both groups.

The second aspect of colour relates to a central concern of Gell's: the effect of colour patterning. While the brilliance of certain bright colours is significant, their effect is increased when contrasted alongside other colours. We often observe dark and light, or dull and bright colours juxtaposed or interwoven in the manufacture of material culture. Helms (1996) notes the use of colour as a means of defining design units in a polychrome bowl from the pre-Columbian Conte period of Panama (*c.* AD 600–800). Although colour is not used to encode specific meanings, its manner of execution and its use in combination with other colours is important. For instance, while the black lines on the bowl need not encode serpents, the sinuous application of the colour is suggestive of the movement of a

snake. With the addition of brown, used to render the fur of animals, the bowl emanates brilliance, a manifestation of spiritual power.

It is the involution and juxtaposition of colour that achieves the cognitive effect of bedazzlement which makes colour efficacious. We need not distinguish between decorative complexity and distinctions of colour, since the two are cognitively and physically irreducible. While considerations of symmetry and asymmetry (Washburn and Crowe 1988) are of crucial importance here, we also need to consider that in and of themselves colours affect a striking aesthetic juxtaposition.

One of the strengths of an art historical approach to colour is the interweaving of the technological, social and ideational aspects of the phenomenon of colour. For instance Gage (1999: 76–82), in a wider work on colour and meaning, describes the method of staggering coloured *tesserae* on wall surfaces in the execution of Byzantine mosaics. Such a technique was meant to convey softness and depth to the mosaic viewed from a distance. He goes on to suggest that, while we cannot be certain that the artisans and the designers who directed them were not aware of Ptolemy's *Optics*, it does suggest a shared set of beliefs about the nature of vision and colour. This example demonstrates the intertwining of techniques used to manufacture coloured objects, visual effects associated with colour and the realm of discourse and ideas.

Hosler's (1994) examination of metallurgy in Ancient West Mexico describes a correlation between the practice of alloying copper and wider cosmological schemes related to the understanding of gold, silver and qualities of light and brilliance. It is, in part, the colour of objects which provides them with agency. Colour acts as an important conduit for the intentions of the artist; however, the particular effect coloured objects will have upon recipients will depend upon the socially embedded qualities ascribed to specific colours.

References

Baines, J. (1985), 'Color terminology and color classification: ancient Egyptian color terminology and polychromy', *American Anthropologist*, 87, 282–97.

Barrett, J.C. (1994), *Fragments from Antiquity: an Archaeology of Social Life in Britain, 2900–1200 BC*, Oxford: Blackwell.

Barrett, J.C. (2000), 'A thesis on agency', in M.-A. Dobres and J. Robb (eds), *Agency in Archaeology*, London: Routledge, 61–9.

Bergh, S. (1995), *Landscape of the monuments*, Riksantikvarieämbet Stockholm: Arkeologiska Undersöknigar.

Berlin, B. and Kay, P. (1969), *Basic Color Terms: Their Universality and Evolution*, Berkeley: University of California Press.

Boivin, N. (2000), 'Life rhythms and floor sequences: excavating time in rural Rajasthan and Neolithic Catalhoyuk', *World Archaeology*, 31(3), 367–88.

Bradley, R. (1989), 'Darkness and light in the design of megalithic tombs', *Oxford Journal of Archaeology*, 8, 251–9.

Bradley, R. (1998), *The significance of monuments*, London: Routledge.

Bradley, R. (2000), *The Good Stones: A New Investigation of the Clava Cairns*, Edinburgh: Society of Antiquaries of Scotland Monograph 17.

Brinch-Petersen, F. (1973), *Gravene ved Dragsholm*, Nationalmuseets Arbeidsmark (1973), 112–20.

Classen, C. (1993), *Worlds of Sense: Exploring the Senses in History and Across Cultures*, London: Routledge.

Classen, C., Howes, D. and Synott, A. (1994), *Aroma: the Cultural History of Smell*, London: Routledge.

Clottes, J. (1998), 'The three C's: fresh avenues towards European Palaeolithic art', in C. Chippindale and P. Taçon (eds), *The Archaeology of Rock Art*, Cambridge: Cambridge University Press, 112–29.

Conklin, H.C. (1952), 'Hanunoo color categories', *South Western Journal of Anthropology*, 11(4), 339–44.

Cooney, G. (2000), *Landscapes of Neolithic Ireland*, London: Routledge.

Csordas, T.J. (1994), 'Introduction: the body as representation and being-in-the-world', in T.J. Csordas (ed.), *Embodiment and Experience: the Existential Ground of Culture and Self*, Cambridge: Cambridge University Press, 1–27.

Davidoff, J. (1997), 'The neuropsychology of color', in C.L. Hardin, and L. Maffi (eds), *Color Categories in Thought and Language*, Cambridge: Cambridge University Press, 118–35.

Davis, W. (1996), *Replications: Archaeology, Art history, Psychoanalysis*, University Park: Penn State University Press.

Edmonds, M. (1993), 'Interpreting causewayed enclosures in the past and the present', in C. Tilley (ed.), *Interpretative Archaeology*, Oxford: Berg, 99–142.

Eogan, G. (1986), *Knowth and the Passage Tombs of Ireland*, London: Thames and Hudson.

Fabian, J. (1983), *Time and the Other: How Anthropology Makes its Object*, New York: Columbia University Press.

Feld, S. (1996), 'A poetics of place: ecological and aesthetic co-evolution in a Papua New Guinea Rainforest Community', in R. Ellen and K. Fukui (eds), *Redefining Nature: Ecology, Culture and Domestication*, Oxford: Berg, 61–89.

Flood, J. (1996), 'Culture in Early Aboriginal Australia', *Cambridge Archaeological Journal*, 6(1), 3–36.

Gage, J. (1999), *Colour and Meaning*, London: Thames and Hudson.

Gell, A. (1992), 'The technology of enchantment and the enchantment of tech-
nology', in J. Coote and A. Shelton (eds), *Anthropology, Art and Aesthetics*,
Oxford: Clarendon, 40–67.

Gell, A. (1996), 'Vogels net: traps as artworks and artworks as traps', *Journal of
Material Culture*, 1(1), 15–38.

Gell, A. (1998), *Art and Agency: an Anthropological Theory*, Oxford: Clarendon.

Gilchrist, R. (2000), 'Archaeological biographies: realizing human lifecycles, -
courses and –histories', *World Archaeology*, 31(3), 325–8.

Gosden, C. (1994), *Social Being and Time*, Oxford: Blackwell.

Gosden, C. and Lock, G. (1998), 'Prehistoric Histories', *World Archaeology*, 30,
2–12.

Hamilakis, Y. (1998), 'Eating the dead; mortuary feasting and the politics of
memory in the Aegean Bronze Age societies', in K. Branigan (ed.), *Cemetery
and Society in the Aegean Bronze Age*, Sheffield: Sheffield Academic Press,
115–32.

Hamilakis, Y. (1999), 'Food technologies/technologies of the body: the social
context of wine and oil production and consumption in Bronze Age Crete',
World Archaeology, 31(1), 38–54.

Handsman, R.G. (1991), 'Whose art was found at Lepenski Vir? Gender relations
and power in archaeology', in J.M. Gero and M.W. Conkey (eds), *Engendering
Archaeology: Women and Prehistory*, Oxford: Blackwell, 329–66.

Hardin C.L. and Maffi, L. (1997), 'Introduction', in C.L. Hardin and L. Maffi
(eds), *Color Categories in Thought and Language*, Cambridge: Cambridge
University Press, 1–21.

Helms, M. (1988), *Ulysses' Sail: An Ethnographic Odyssey of Power, Knowledge
and Geographical distance*, Princeton: Princeton University Press.

Helms, M. (1996), 'Color and creativity: interpretation of themes and design styles
in a Panamanian Conte bowl', *RES: Anthropology and Aesthetics*, 29/30,
290–303.

Hodder, I. (1982), *Symbolic and Structural Archaeology*, Cambridge: Cambridge
University Press.

Hosler, D. (1994), *The Sounds and Colors of Power: the Sacred Metallurgical
Technology of Ancient West Mexico*, Cambridge, Mass.: MIT Press.

Houston, S. and Taube, K. (2000), 'An Archaeology of the Senses: Perception and
Cultural Expression in Ancient America', *Cambridge Archaeological Journal*,
10(2), 261–94.

Howes, D. (1991), Introduction: 'To summon all the senses', in D. Howes (ed.),
The Varieties of Sensory Experience, Toronto: University of Toronto Press,
3–21.

Ingold, T. (2000), *The Perception of the Environment: Essays on Livelihood,
Dwelling and Skill*, London: Routledge.

Jackson, M. (1996), 'Introduction', in M. Jackson (ed.), *Things as They are: New Directions in Phenomenological Anthropology*, Bloomington: Indiana University Press, 1–51.

Jameson, K. and D'Andrade, R.G. (1997), 'It's not really red, green, yellow, blue: an inquiry into perceptual color space', in C.L. Hardin, and L. Maffi (eds), *Color Categories in Thought and Language*, Cambridge: Cambridge University Press, 295–320.

Jones, A. (1999), 'Local colour: megalithic architecture and colour symbolism in Neolithic Arran', *Oxford Journal of Archaeology*, 18(4): 339–50.

Jones, A. (2001), 'Drawn from Memory: the archaeology of aesthetics and the aesthetics of archaeology in Earlier Bronze Age Britain and the present', *World Archaeology*, 33(2), 334–56.

Jones, A. (2002), *Archaeological Theory and Scientific Practice*, Cambridge: Cambridge University Press.

Karlsson, H. (1998), *Re-thinking archaeology*, Gotarc series B. Gothenburg Archaeological Theses 8. Göteborg: Göteborg University Department of Archaeology.

Kay, P. and McDaniel, C.K. (1978), 'The linguistic significance of the meanings of basic color terms', *Language*, 54, 610–46.

Kay, P., Berlin, B., Maffi, L. and Merrifield, W. (1997), 'Color naming across languages', in C.L. Hardin and L. Maffi (eds), *Color Categories in Thought and Language*, Cambridge: Cambridge University Press, 21–59.

Kirk, T. (1991), 'Structure, agency and power relations "chez les derniers chasseurs-cueilleurs" of Northwest France', in R.W. Preucel (ed.), *Processual and Postprocessual Archaeologies: Multiple Ways of Knowing the Past*, Carbondale: Southern Illinois University, Center for Archaeological Investigations, 108–25.

Klima, B. (1987), 'A triple burial from the Upper Palaeolithic of Dolni Vestonice', *Journal of Human Evolution*, 16, 831–5.

Lambek, M. (1998), 'Body and mind in mind, body and mind in body: some anthropological interventions in a long conversation', in M. Lambek and A. Strathern (eds), *Bodies and Persons: Comparative Perspectives from Africa and Melanesia*, Cambridge: Cambridge University Press, 103–27.

Lambek, M. and Strathern, A. (1998), 'Introduction', in M. Lambek and A. Strathern (eds), *Bodies and Persons: Comparative Perspectives from Africa and Melanesia*, Cambridge: Cambridge University Press, 3–35.

Larsson, L. (1989), 'Late Mesolithic settlements and cemeteries at Skateholm, southern Sweden', in C. Bonsall (ed.), *The Mesolithic in Europe*, Edinburgh: John Donald, 367–78.

Latour, B. (1990), 'Drawing things together', in M. Lynch and S. Woolgar (eds), *Representation in Scientific Practice*, Cambridge, Mass.: MIT Press, 19–69.

Latour, B. (1999), *Pandora's Hope: Essays on the Reality of Science Studies*, Cambridge, Mass.: Harvard University Press.

Lenoir, T. (1998), 'Inscription practices and materialities of communication', in T. Lenoir (ed.), *Inscribing Science: Scientific Texts and the Materiality of Communication*, Stanford: Stanford University Press, 1–19.

Lucy, J.A. (1997), 'The linguistics of "color"', in C.L. Hardin, and L. Maffi (eds), *Color Categories in Thought and Language*, Cambridge: Cambridge University Press, 320–47.

McBurney, C. (1975), 'Early man in the Soviet Union: the implications of some recent discoveries', *Proceedings of the British Academy*, 61, 171–221.

MacGregor, G. (1999), 'Making sense of the past in the present: a sensory analysis of carved stone balls', *World Archaeology*, 31(2), 258–271.

MacLaury, R.E. (1992), 'From brightness to hue: an explanatory model of color-category evolution', *Current Anthropology*, 33, 137–86.

Merleau-Ponty, M. (1962), *The Phenomenology of Perception*, London: Routledge.

Meskell, L. (1996), 'The somatization of archaeology: institutions, discourses and corporeality', *Norwegian Archaeological Review*, 29(1), 1–16.

Miller, D. (1985), *Artefacts as Categories: a Study of Ceramic Variability in Central India*, Cambridge: Cambridge University Press.

Mitchell, G.F. (1992), 'Notes on some non-local cobbles at the entrances to the passage-graves at Newgrange and Knowth, County Meath', *Journal of the Royal Society of Antiquaries of Ireland*, 122: 128–45.

Molyneaux, B.L. (1997), 'Introduction', in B.L. Molyneaux (ed.), *The Cultural Life of Images: Visual Representation in Archaeology*, London: Routledge, 1–16.

Morphy, H. (1989), 'From dull to brilliant: the aesthetics of spiritual power among the Yolngu', *Man* (NS), 24(1), 21–39.

Moser, S. (1998), *Ancestral Images: the Iconography of Human Origins*, Stroud: Sutton Publishing.

O'Kelly, M. (1982), *Newgrange: Archaeology, Art and Legend*, London: Thames and Hudson.

Parker-Pearson, M. (1999), *The Archaeology of Death and Burial*, Stroud: Sutton Publishing.

Richards, J. (1990), *The Stonehenge Environs Project*, London: English Heritage.

Rosch, E. (1972), '"Focal" color areas and the development of names', *Development Psychology*, 4, 447–55.

Ruggles, C. (1999), *Astronomy in Prehistoric Britain and Ireland*, London and New Haven: Yale University Press.

Sahlins, M.D. (1976), 'Colors and cultures', *Semiotica*, 16(1), 1–22.

Saunders, B.A.C. (1995), 'Disinterring *Basic Color Terms*: a study in the mystique of cognitivism', *History of the Human Sciences*, 8(4), 19–38.

Saunders, B.A.C. and van Brakel, J. (1988), 'Re-evaluating *Basic Color Terms*', *Cultural Dynamics*, 1, 359–78.

Saunders, N.J. (1998), 'Stealers of light, traders in brilliance: Amerindian metaphysics in the mirror of conquest', *RES: Anthropology and Aesthetics*, 33 (1), 225–52.

Saunders, N.J. (1999), 'Biographies of brilliance: Pearls, transformations of matter and being, *c.* AD 1492', *World Archaeology*, 31 (2), 243–57.

Shanks, M. and Tilley, C. (1987), *Reconstructing Archaeology*, Cambridge: Cambridge University Press.

Sivik, L. (1997), 'Color systems for cognitive research', in C.L. Hardin, and L. Maffi (eds), *Color Categories in Thought and Language*, Cambridge: Cambridge University Press, 163–97.

Sofaer Derevenski, J. (2000), 'Rings of life: the role of early metalworking in mediating the gendered life course', *World Archaeology*, 31(3), 389–406.

Sørensen, M.L.S. (1997), 'Reading dress: the construction of social categories and identities in Bronze Age Europe', *Journal of European Archaeology*, 5(1), 93–114.

Stoller, P. (1997), *Sensuous scholarship*, Philadelphia: University of Pennsylvania Press.

Strathern, A. and Strathern, M. (1971), *Self Decoration in Mount Hagen*, London: Thames and Hudson.

Thomas, J. (1996), *Time, Culture and Identity*, London: Routledge.

Tilley, C. (1993), 'Art, architecture, landscape [Neolithic Sweden]', in B. Bender (ed.), *Landscape, Politics and Perspectives*, Oxford: Berg, 49–85.

Tilley, C. (1994), *A Phenomenology of Landscape*, Oxford: Berg.

Tilley, C. (1996), *An Ethnography of the Neolithic*, Cambridge: Cambridge University Press.

Tilley, C. (1999), *Metaphor and Material Culture*, Oxford: Blackwell.

Trevarthen, D. (2000), 'Illuminating the monuments', *Cambridge Archaeological Journal*, 10(2), 294–315.

Turner, V. (1967), *The Forest of Symbols: Aspects of Ndembu Ritual*, Ithaca: Cornell Univerity Press.

Wagner, R. (1986), *Symbols that Stand for Themselves*, Chicago: University of Chicago Press.

Washburn, D. and Crowe, D.W. (1988), *Symmetries of Culture: Theory and Practice of Plane Pattern Analysis*, Seattle: University of Washington Press.

Watson, A. and Keating, D. (1999), 'Architecture and sound: an acoustic analysis of megalithic monuments in prehistoric Britain', *Antiquity*, 73, 325–36.

Whittle, A. (1995), 'Gifts from the earth: Symbolic dimensions of the use and production of Neolithic flint and stone axes', *Archaeologia Polona*, 33: 247–59.

Whorf, B.L. (1956), *Language, Thought and Reality: Selected Writings of Benjamin Lee Whorf*, J.B. Carroll (ed.), Cambridge, Mass.: MIT Press.

Wierzbicka, A. (1990), 'The meaning of color terms: semantics, culture, and cognition', *Cognitive Linguistics*, 1(1), 99–150.

Apotropaism and the Temporality of Colours: Colourful Mesolithic-Neolithic Seasons in the Danube Gorges
Dusan Boric

The light was not so strong as to trouble Roberto's eyes, but strong enough to heighten the colours of the foliage and make the first flowers open. Roberto's gaze rested on two leaves that had at first seemed like the tail of a crayfish, from which white jujubes blossomed, then on another pale-green leaf where a sort of half-flower was emerging from a clump of ivory lilies. A disgusting stench drew him to a yellow ear into which a little corncob seemed to have been thrust, while near it hung festoons of porcelain shells, snowy, pink-tipped, and from another bunch hung some trumpets or upturned bells with faint odour of borage. He saw a lemon-coloured flower which, as the days passed, would reveal to him its mutability, for it would turn apricot in the afternoon and a deep red at sunset, as others, saffron in the centre, faded then to lilial white.

Umberto Eco, *The Island of the Day Before* (1998: 38–9).

Introduction

The castaway, Roberto della Griva, lurks from evenings to dawn exploring the deserted boat called *Daphne*, somewhere on the Pacific Ocean in 1643, that carried back the collected wonders of newly discovered worlds. He cannot swim, as land – the 'Island', with its palm trees along the shore – remains out of his reach. He explores the boat only after sunset as a consequence of his photophobia. Now, below the decks of *Daphne*, he discovers an indoor garden with stunning flowers and fruits from the tropic islands, together with cages of colourful birds he cannot name.

This is just the beginning of a baroque tale by Umberto Eco, venturing into the spirit of the times when Europeans were exploring remote parts of the Earth, making adventurous voyages while carrying their homeland identities with them (Figure 1.1). Their discoveries brought back to the homelands wonderful and frightening tales and memories, together with newly discovered objects, colours, smells and tastes that would forever change the sensual experiences of the

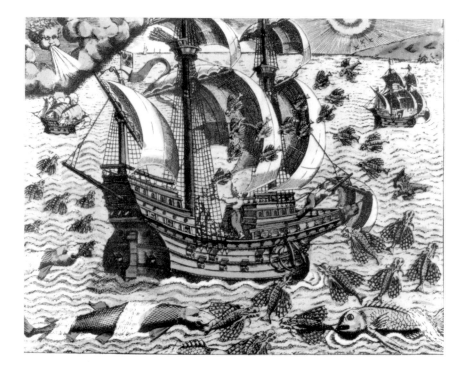

Figure 1.1 Fish flying in the Pacific (from Carton d'un Carte de l'Atlas Mercator (1595) in *Histoire universelle des explorations: La Renaissance (1415–1600)*: Pl. VI. Paris, F. Sant'Andrea.)

European world. Roberto epitomizes his time, as is likewise enchanted with the new perfumes and colours he experiences in his refuge below the decks of *Daphne*. The colours Roberto experiences in the passage quoted at the beginning cannot be distinguished from the volume, structure, touch or odour of the flowers and fruits he encounters. He cannot compare or describe the newly discovered feelings, objects or colours without making analogies to his previous life experiences, regardless of how incomparable these may be.

As we learn from Roberto, the human perception of colours is a holistic experience. It is contextual and depends on the long histories of structures of meaning and the histories of perception associated with each individual. Colours, although among the basic means of characterizing the world by an experiencing subject, are experienced or perceived in a far less conscious way, more frequently as pure bodily sensations, producing a vast spectrum of feelings from irritation to pleasure. They sediment unconscious memories, comparable to the shiver that Marcel Proust felt when sipping a cup of tea and a soaked piece of '*petite madeleine*'. This experience, at the level of unconscious bodily memory alone, evoked the pleasurable memories of his childhood (Proust 1996 [1928]; Hodder 1998: 72–3).

Colours, as vividly experienced by Roberto, change rapidly with environmental conditions. The perceived sensation of colours is not the same in England, California, or New Zealand, nor is it the same in the changing light of a passing day or passing seasons. Colours are constantly shifting as we encounter the world in its celestial cycles.

It is true that humans develop a plethora of very conscious meanings associated with particular colours each of which has complex cultural significance, as described through numerous cases presented in this volume and elsewhere. I shall argue that this is a consequence of unconscious or habitual activity articulated through various cultural practices. Also, I would point to intrinsic connections between the pronounced temporal aspects of colours and the culture-specific ways they are patterned to serve particular functions, or convey particular meanings. A colourful place for such an archaeological inquiry is the Danube Gorges of south-east Europe in the period from *c.* 9000 to 5500 BC.

Colour and the body

Victor Turner (1967: 89) pointed out the universal metaphorical significance of some basic colours in relation to the body, distinguishing three basic colours – white, red and black – that primarily relate to the basic fluids which the human body emits. He further developed an argument relating 'powerful physical experiences' to particular colours and emotions (Table 1.1).

Among archaeologists Tilley (1996: 321–2) acknowledges this scheme as useful, applying it to archaeological examples in the Neolithic of southern

Table 1.1 Turner's scheme for the universal physical experience of the three colours (1967: 89)

White	Red	Black
→ *semen* – mating between men and women → *milk* – mother-child tie	→ *maternal blood* – mother-child tie + process of group recruitment and social placement → *bloodshed* – war, feud, conflict, social discontinuities → *obtaining and preparing animal food* – male productive role → *transmission of blood from generation to generation* – an index of membership in a corporate group	→ *excreta or bodily dissolution* – transition from one social status to another viewed as mystical death → *rain clouds or fertile earth* – unity of widest recognised group sharing same life values

Scandinavia. Turner's tendency to make universal statements may be criticized in the same way as any generalization can be. However, we might rescue some aspects of his approach. The first of these relates to the proposition that the human body is the immediate source of metaphors relating to the world at large, including colours (see Jones and MacGregor's Introduction to this volume). It may be necessary to underline the point that the dichotomies constructed around the body/ mind division might serve to facilitate complex processes of categorization and substitution (Lambek 1998). The body serves as a primary source for the categoriz- ation of the self, while these categorizations are simultaneously transcended through externalized and collectivized cognitive processes (see also Jones, Chapter 8 in this volume). This perspective need not evoke the concept of social evolut- ionary stages and does not depend on issues of social complexity. Rather, it evokes a phenomenological experience or immanent field (cf. Deleuze and Guattari 1984) where the self experiences the world both while being an inextricable part of it and through the continual processes of exploring and creating differences.

By retaining some aspects of structuralism, Deleuze and Guattari (1984) and Goodchild (1996) point to the processes that translate culture into expressive signs. However, in going beyond the signification of concepts, Deleuze (1990) identifies a dimension of 'sense', as an empty space surrounding signifying structures. Sense is actualized in the body, but for Deleuze and Guattari (1984) it is 'the machinic unconcious' that is self-transformative and in the state of becoming. On the other hand, the 'regime of signs' that serve as the central mode of representation in a society enforces dominant senses and values to become inscribed onto the body (ibid.).

Another baseline of universal significance is fire. The fact that white, red and black are indeed used more frequently as basic ornamental colours across a number of ethnographic and archaeological examples can be related to the significance of fire whose colour spectrum encompasses exactly these three colours in its contact with organic and non-organic materials. The production of a black-red-white spectrum may be connected to the significance and production of meanings and metaphors that relate to fire cross-culturally. Thus white, red and black, in a way also transcend some fire associations related to a household or communal hearth space.

Colour and apotropaism

Colours have an important place in the context of geometric patterns. Of these, dynamic alterations of dark and white are the most basic way of creating geometric designs. This phenomenon has been discussed by Alfred Gell (1998). In his search for an understanding of the allure of many artworks, including geometric art, Gell

(1998: 74) emphasizes the notion of a 'technology of enchantment' (Gell 1992) as a basic component of a social technology. Although he does not place an emphasis on the salience of particular colours in relation to decorative patterns, in citing several ethnographic examples, he emphasizes the psychological aspects of decorative art and its animated qualities (1998: 76). These involve the effects of aesthetically appealing repetitive rhythms and symmetries. Decorative art, by its execution and effects, differs considerably from representational art, for the agency involved in any work of decorative art is more difficult to capture; it is fluid and animate. Gell suggests that one of the important psychological effects of this rhythmic art is the 'pleasurable frustration' of being trapped in a complex pattern (1998: 80). Complex decorative art is frequently found on personal objects such as clothes or vessels, and indeed can be very closely related to the body through the execution of tattoos (cf. Gell 1993). Why is this so? First, Gell suggests that complex decorative art serves to protect the object or bearer from harmful forces: this effect is conferred both to those that produced the art and those who wear these patterns or are in contact with them. The apotropaic efficacy of very complex designs is central to their frequent application to a wide spectrum of objects, architectural details or body art: as harmful forces are trapped when encountering a complex and non-comprehensible pattern, their malevolent intentions are neutralized.

In many ethnographic cases, the features of geometric designs are conceived as thresholds between the worlds of the living and the dead (Gell 1998: 87–95). These worlds are close yet strongly separated. Here geometric designs are salient not only for trapping the agency of harmful forces, but also in defining the threshold between the world of the living and that of the newly deceased. Furthermore they aid the safe journey of the newly deceased on the complicated and dangerous journey to the Underworld. The use of particular colours and decorative art as a means to overcome the dangerous and liminal experiences of life will be elaborated below.

Discussion of geometric designs and their significance cannot escape the point that colours are a constitutive component of the fascination instilled by decorative art. It is important to emphasize the associations that specific colours may gain by being inseparably linked to a complex geometric pattern and the apotropaic significance it may carry. It may be possible to view decorative art production as more related to women in the context of agrarian societies; and by the same token, representational art is often frequently related to men, especially in the context of high-status ritual art (Gell 1998: 71). This generalization has some relevance if we turn to the decorative arts reflected in European folk dress. In Welter's collection of papers on the subject of folk dress in Eastern Europe and Anatolia (Welters 1999), specific beliefs about protection and fertility were singled out as the main themes involved in the process of the execution of the designs. The choice

of colours in clothing and decisions about the appropriate time for wearing specific pieces of clothing were also critical. For instance, throughout Greece and Turkey painting henna on the hands of the relatives of brides and grooms conveys fertility (Welters 1999a: 8).

One of the recurrent pieces of folk dress in the region is the string skirt that may be worn at the front and the back of the pelvic area of a female. It seems these exhibit great antiquity as witnessed by their various representations on Palaeolithic and Neolithic figurines (cf. Barber 1999: Figure 2.3). By covering the genital areas of women, string skirts convey notions of both fertility and protection. Their designs are complex and colourful. A piece of clothing with similar significance is the belt that could be worn by both women and men (Welters and Kuhn-Bolsaitis 1999). A rich decorative geometric variety is found in relation to female clothing across Eastern Europe and Anatolia. This may relate to the captivation of the agency of the 'evil eye' and the neutralization of the harm that was intended upon the person wearing such a piece of clothing. The belief in the 'evil eye' is strongly rooted throughout the Mediterranean (e.g. Welters 1999b: 64; Mladenoviç 1999: 101). It was often considered to be most harmful to those in the liminal stages of life, such as newborn children, the newly married, or pregnant women. Indeed Welters (1999b: 65–6) cites an interview with a woman in Greece who says that wearing a string skirt (or *zonari*) has the effect of 'confusing' the 'evil eye' because of the unusual structure of this piece of clothing. She especially emphasized the role of colour and the irregularity of colour as of importance here.

Often things related to distinctive bodily sensations – be it smell, taste or vision – are used either on their own or, as in the case of clothing, in combination with structure and pattern. However, red is most abundantly used throughout the described regions to protect parts of bodies by keeping demonic forces at bay. In Macedonia red substances along with basil are used for their prophylactic qualities. Red is a dominant colour on pieces of clothing such as the apron, the headdress and the girdle in Macedonia; clothing which is focused on the most important parts of a woman's body (Mladenoviç 1999: 104). It was also noted that red was frequently used in folk textile production (Williams 1999: 146).

Mesolithic-Neolithic seasons in the Danube Gorges: setting and chronology

The name Danube Gorges refers to a specific landscape setting along both banks of the Danube cutting into the south-west Carpathian mountains (Figure 1.2). The geological history of the region left dramatic landscape features – such as exposed and bare cliffs – which contrast with the strong flow of the Danube (cf. Markoviç-Marjanoviç 1978; Radovanoviç 1996; Boriç 1999).

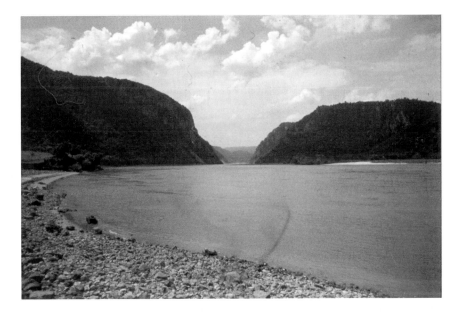

Figure 1.2 View over the entrance to the Lower gorge of the Danube in the vicinity of the site of Hajducka Vodenica (courtesy of B. Jovanoviç)

The earliest dated traces of occupation in the Danube Gorges come from the cave site of Cuina Turcului and cover a period from the twelfth to the tenth millennia BC (Paunescu 1978). A number of human burials from the open-air sites of Padina (Burleigh and Îivanoviç 1980) and Vlasac (Bonsall et al. 1997) appear to be of considerable antiquity, with several burials probably dating to the tenth millennium Cal BC. It seems that these sites remained occupied for a considerable period of time as younger deposits overlie them (cf. Boriç 1999). This does not point to an unbroken continuity of occupation. It is more probable that a number of these sites were occupied, abandoned and re-occupied on a seasonal basis and throughout longer periods in the course of the sequence. A specific Epi-Palaeo-lithic lithic industry characterizes the levels of Cuina Turcului and survives into the Mesolithic period in the region, represented at open-air sites such as Vlasac, Padina and Lepenski Vir. This is clearly established by recent AMS dating of both human burials (Bonsall et al. 1997) and occupation at these sites (Whittle et al. 2001). The dates cover a period of at least *c.* 8000–6700 Cal BC. It is difficult to specify the period during which domestic features began to be elaborated with dug-in trapezoidal spaces and floors around rectangular hearths. The earliest forms of these features can be seen at the site of Vlasac (Srejoviç and Letica 1978). However, the dating of some of the contexts at this site remains problematic at present. The neighbouring sites of Padina and Lepenski Vir, on the other hand,

have a series of consistent dates on both charcoal (Quitta 1975) and animal bones (Whittle et al. 2001) associated with the trapezoidal houses. These indicate that the occupation, elaboration and abandonment of these houses coincides with the start of the Early Neolithic in the wider region of the central Balkans, i.e. covering a time-span from *c.* 6200–5500 Cal BC.

Subsistence practices, seasons and life cycles

Specific cultural features were recognized, readjusted or reinvented over numerous generations in the Danube Gorges region during the Mesolithic-Neolithic period. Rectangular hearths made out of stone slabs with a number of alterations are a recurrent feature at these sites and their recognition, elaboration and meanings might have been defined through subsistence practices such as fishing. These became closely intertwined with practices of ritualization, emphasizing the periodicity and life cycles of domestic spaces and the life cycles of the inhabitants of these sites. For example, in the practice of placing burials over house floors, and in this way ending the life cycle, of a house that was previously used as a domestic space (e.g. House 65 at Lepenski Vir, cf. Borič 2000; 2002).

Specific landscape features, such as cascades and deep whirlpools, facilitated fishing in the Danube Gorges. Major fish species include large migratory (anadromous) *Acipenseridae* fish. Among these the largest is beluga (*Huso huso*), followed by the sturgeon. The existing ethnography of Danube Gorges fishing (Petrovič 1941) provides insights into the diversity of fishing practices and offers precious information on the vanished craft of local fishermen. An important aspect of beluga and other migratory fish species is the production of caviar (that is made out of eggs of a beluga female approximately 20 years old), in the local ethnography known as black *ajvar* (ibid.). These observations inform us of two annual runs of beluga – spring and autumn. The peak of the fishing season for beluga in the Danube Gorges is in October and November (Keckarevič et al. 1998) when the fish returns to the Black Sea, thus emphasizing a structured seasonality to fishing in the Danube Gorges.

The remains of beluga were abundant at the sites of Padina, Lepenski Vir, and Schela Cladovei in both Mesolithic and Neolithic contexts (Brinkhuizen 1986; Bartosiewicz et al. 1995; Dimitrijevič and Borič forthcoming). At the sites of Padina and Lepenski Vir, preliminary results on the ageing of mammal remains from a number of contexts tentatively indicate that the remains indicate occupation in October/November. That may represent the season for the abandonment of a number of these features and contexts (Dimitrijevič 2000; Dimitrijevič and Borič forthcoming).

These findings indicating the seasonal schedule for the acquisition of aquatic and terrestrial resources suggest that the occupation of the sites in the region spanned the period from the start of the summer (or late spring) to the autumn. It seems likely that after that the sites were seasonally abandoned. Arguably, the population or a part of the population that inhabited the Gorges during the summer months moved to the hinterland areas of the Gorges for the winter months during the Mesolithic and the Neolithic periods. The temporary abandonment of the trapezoidal houses at Padina and Lepenski Vir would thus appear seasonally structured. It remains difficult to characterize the inhabitation of the hinterland areas of the Danube Gorges. Instead I shall focus on the rich settlement record of Vlasac and Lepenski Vir where the deposition of both animal bones and human remains on house floors or dug into house floors indicates structured deposition (e.g. Bökönyi 1969; Dimitrijeviç and Boriç forthcoming; Stefanoviç and Boriç 2001).

Ochre, floors and forest: meaningfully red at Vlasac and Lepenski Vir

At the site of Vlasac a number of burials were sprinkled with red ochre over particular areas of the body (Srejoviç and Letica 1978: 53–82). The excavators note that red ochre was deposited over the groin area of several female burials (Burials 32, 47, 67, 63, 79?) as well as other different parts of the body (vertebrae, ribs, feet bones) of several male burials (Burials 6, 45, 50a, 50b). This practice has been emphasized by a number of authors in relation to Palaeolithic and Mesolithic contexts across Eurasia (e.g. Bradley 1998; also, Jones and MacGregor's Introduction to this volume). Besides adult burials, several infant burials (Burials 42, 59, 61, 62) at Vlasac were covered with red ochre too. The head of female Burial 32 was placed on red limestone and in the pelvic area, covered by red ochre, of female Burial 67 a foetus was found. Also, newborn infant burials 59, 61 and 62 were completely covered with red ochre placed in small pits next to adult Burial 60 under whose pelvic area *Cyprinidae* (fish) teeth were found. *Cyprinidae* teeth were also found, together with red ochre, covering infant Burial 42. The examples from Vlasac indicate red ochre was related to issues of reproduction in the case of women that might have died giving birth, dramatically obvious in the case of Burial 67. I interpret red ochre on the bones of feet, vertebrae and ribs of several male burials as relating to the vulnerability of and protection for particular body parts. It is plausible that issues of protection were crucial for Vlasac infant burials covered by red ochre or *Cyprinidae* teeth. More indications on the meanings of Vlasac burials can be gained by considering burials from house floors at the neighbouring site of Lepenski Vir.

Figure 1.3 Excavated houses at Lepenski Vir (after Srejoviç 1969).

The trapezoidal houses at Lepenski Vir (Figure 1.3) make an explicit reference to the trapezoidal Treskavac mountain on the opposite shore of the Danube. Their significance comes from mimicking the cosmological order of the world. The floors of houses at Lepenski Vir were furnished with limestone (cf. Ney 1971). Because of the amorphous iron oxides that impregnate the fabric of calcitic quartz sand (C. French, pers. comm.) the colour of the floors is a striking red.

The dominant group of burials connected to these house floors is that of around forty newborn infants (Stefanoviç and Boriç 2000). The newborns were found in connection to eighteen houses at Lepenski Vir and were dug next to the floor of the house or through the lime floor almost exclusively in the rear end of a house (Figure 1.4). They form a uniform age group whose burial was highly structured (Figure 1.4). On the basis of contextual observations of these burials at Lepenski Vir and also by reading other Balkan ethnographies, it seems likely that these burials are related to the expression of ideas about the protection of the deceased individuals' entering the liminal and transitional states. This is of importance with regard to newborns, which are often regarded as not having obtained a full social persona and which are therefore unable to undergo protective rites of passage. Therefore, notions of protection and apotropaic potency might have been anchored

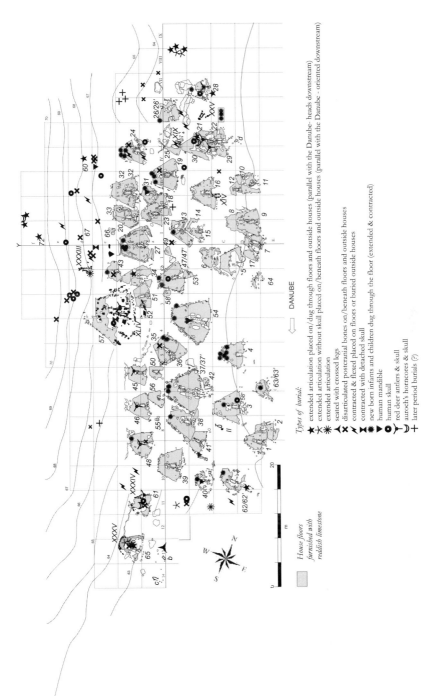

Figure 1.4 Lepenski Vir – houses and infant burials (after: Srejović 1981: 20–1; Stefanović and Borić 2000: Figure 1).

to the houses, with their concrete-like floors and domestic hearths objectifying particular lineages. This interpretation sees the deceased newborns as in dramatic need of the guidance of ancestral potencies. Such potencies are objectified by the houses and their contents, including the ancestral bones kept in houses and the sculptured and painted boulders placed around the house hearths or beneath the floors (Borič 2002; Stefanoviç and Borič 2000). At Lepenski Vir, adult Burials 7/I and 26 and an older child – Burial 63 – were also placed inside houses (Srejoviç 1969; 1972). Again these burials emphasize the need for the guidance of the deceased, as Burials 7/I and 63 were also deposited with sculptured boulders above their heads. Burial 7/I was associated with another human (ancestral?) skull placed next to the skull of the deceased man (Stefanoviç and Borič 2000; Borič 2002).

It is interesting that the colour of house floors at Lepenski Vir are *red* and that infant burials and the groin area of females, as well as some other body parts of male burials at Vlasac, were sprinkled with *red* ochre. As previously emphasized, the use of red in this context is likely to relate to its prophylactic efficacy. The relationship between redness and protection might have undergone a long history of sedimentation, with the significance of red being initiated by its relation to the human (and animal) body.

We might also consider other environmental conditions for the sedimentation of ideas related to red. From the early autumn the green deciduous oak forest covering the slopes of the gorges turns red and the colour of the landscape changes. In autumn, red comes to dominate the entire forest; only the edges of the exposed white limestone cliffs alternate with the red. This seasonal change of landscape colour coincides with the peak of the fishing season and might have been imbued with a particular importance. I have suggested (Borič 1999) that mountain tops and white limestone cliffs in the Gorges (Figure 1.2) might have been seen as eternal ancestral houses of powerful spirits whose enduring qualities were possibly mimicked through the examples of concrete-like lime floors at Lepenski Vir. We may speculate that the white colour of these cliffs also related to the white colour of the ancestral bones kept in many houses. The observed changes of colour in seasonal cycles and their relationship to ritualized practices and burials thus become elided.

At Lepenski Vir, Padina and Hajducka Vodenica (Figure 1.5 and Plate 1), ancestral agencies were abundantly present in the sculptured representational and aniconic boulders frequently found in a central location around house hearths, with extensive use of red, red-brown or dark-brown pigment over their spherical surfaces. Their colouring was achieved by a controlled exposure to fire, colouring them red and black (for Lepenski Vir see Table 1.2, from Srejoviç and Baboviç 1983). While the representational boulders have human faces, they also bear features resembling fish, perhaps indicating the totemic significance of migratory fish and their ancestral metamorphosis (Radovanoviç 1997). A number of boulders

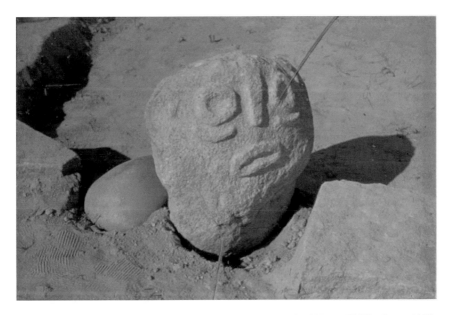

Figure 1.5 Sculptured boulder 'Danubius' *in situ* behind the hearth of House XLIV at Lepenski Vir (after Srejoviç 1967: Figure 11).

are ornamented with complex abstract curvilinear, circular and spiral designs that possibly relate to representations of the internal skeletal structure of fish. Red and occasionally black pigments covered the positive areas of relief, emphasizing the contrast of the carving. Lips, eyeholes and necks, in the case of representational boulders, were painted with a red pigment. Only in the case of boulders 'Adam' (cat. no. 1, House 28) and 'Danubius' (cat. no. 9, House XLIV) was a dark black pigment used (Figure 1.5). The top of the boulder (or its back) was exposed to fire, producing red and black zonation. The boulder named 'Vulva' (cat. no. 18, House 51) was also fired, achieving an intensive red colour (see Plate 1) over its surface that may well be associated with sprinkling red ochre on the pelvic area of females at Vlasac. The aesthetics of these boulders may be connected with the social efficacy they embodied, representing sacred heirlooms of individual houses (Boriç 2002).

Another type of object found inside houses on the floors and around the hearths are stone clubs that Srejoviç and Baboviç (1983: 185–9). Although the role of these objects as important heirlooms cannot be excluded, their function relates to fishing large species of fish. The ethnography of fishing of the migratory fish in the Danube Gorges describes that, after being trapped, fish were killed with clubs (Petroviç 1941). At Lepenski Vir, one of these clubs bears a fish engraving (Srejoviç and Baboviç 1983: 189). Both decorated and plain clubs were covered with red and brown pigment (ibid.: 185–9).

Table 1.2 Presence of colour pigments on sculptured boulders and their context at Lepenski Vir (Source: Srejoviç and Baboviç 1983)

House-sculpture name	Pigment colour(s)	Colour intensity	Coloured (body) part	Traces of fire	Context
28 – Adam	dark brown	hardly visible	neck & body	–	rear end of the house above a child burial (B. 92)
40 – Sirena	pale red	light	body & lips	–	above the head of a child (B. 63) buried in the rear end of the house
31 – Vrac	red	light	relief parts	–	rear end of the hearth
XXVIII – Hronos	red	hardly visible	relief parts	present	infill of House 23
24 – Skulptura	–	–	–	black & red on the lower part	rear end of the hearth
? – Lady of L. Vir	red	light	relief parts of the face	–	dislocated (?)
XLIV-Rodonacelnik	red	light	neck & eyeholes	–	rear end of the hearth
XLIV-Praroditeljka	red	light	relief parts	red on the back	front part of the house
XLIV – Danubius	brown-black		relief parts	–	front part of the house
XLIV – Praotac	red	light	relief parts & body	red & black on the back	front part of the house
? – Vodena vila	red	light	relief parts	–	dislocated (?)
54 – Crni obeliks I	brown-red	light	relief parts	black whole upper part	behind the hearth
54 – Crni obeliks II	pale red	patchy	relief parts	black whole upper part	behind the hearth
38 – Veliki beleg	red	light	relief parts	red strip	behind the hearth
28 – Skulptura	–	–		the top–black	rear end of the house
3 – Skulptura	–	–		black traces	left side of the house
52 – Vulva	–	–		intensive red	front side of the hearth
46 – Skulptura	brown-red	light	surface	lower part	front side of the hearth
9 – Skulptura	red	light	relief parts	2small zones	behind the hearth
6 – Stari poglavica	red	light	relief parts	–	next to the house (?)
37 – Skulptura	red	light	back part	–	in the infill of the house
43-Crvena skulptura	red	intensive	relief parts & strips extending orn.grooves	decorated part–intensive	making the front side of the hearth

House-sculpture name	Pigment colour(s)	Colour intensity	Coloured (body) part	Traces of fire	Context
71 – Crveni znak	–	–	–	across ornam. part	behind the hearth
25 – Skulptura	brown-red	light	surface	grey-black(?)	Above the head of Burial 4
21 – Skulptura	red	intensive	relief parts	red	Above the head of Burial 7/I
47 – Skulptura	–	–	–	top – black & red	left side of the house
? – umski list	red	light	relief parts	–	dislocated (?)
? – Skulptura	red	light	relief parts	top – black	dislocated (?)
? – Medaljon	red	very light	decorated fringes	–	dislocated (?)
XLIV-Skulptura	–	–	–	black (?)	beneath the floor level
54-Skultpura	–	–	–	black-gray	floor area (?)
XXXIII-Varvarin	red	intensive	the neck	red	infill of House 48
XVII-Jelen u %umi	red	light	relief parts	–	around House 19

It is not possible to draw sharp lines in the significance of red colour as it possibly related to the protection of bodies of adults, most importantly of pregnant women at Vlasac, and also to the protection of powerless infants at both Vlasac and Lepenski Vir. Red also acted as a marker of the powerful role of carved images. Importantly, red is grounded in the appearance of the seasonally changing landscape in the autumn, when most of the fishing was taking place, and was applied over the tools for taking the life of large anadromous fish. A strong analogical link between humans and large migratory fish such as beluga is likely, and it is further possible that the beluga's body and its black caviar was an important source for food. Of importance here is the link between the bodies of fish and those of people. The link between animal and human worlds was also objectified by the burial of the dead parallel to the flow of the River Danube itself, with positioning of heads pointing downstream possibly relating to the annual migration of the anadromous fish species taking the souls of the deceased downstream (Radovanović 1997). There is also a link in the artworks of represent-ational boulders. If this sort of totemic significance is accepted, the black caviar from migratory fish might have been connected to the death and the dissolution of the body. The reason that the two previously mentioned representational boulders from Lepenski Vir were painted with dark pigments may relate to the black caviar, invoking ideas of death and decay. On the other hand, the return of the fish in the spring every year might have reassured the perpetual order of the world and its never-ending life cycles.

The wider significance of colour in the Danube Gorges

During the Early Neolithic in the Danube Gorges, pottery has a wide spectrum of red colours (from pale orange to red-brown). This colour was achieved through the process of oxidation or by applying a slip over the surface of pots. The connection of this pottery with the occupation of house floors at Lepenski Vir is ambiguous (e.g. Jovanović 1969; Gimbutas 1976; Borič 1999; 2002; Radovanović 2000). I believe that the pottery found in connection with a number of trapezoidal houses relates to their use in the occupation of the houses as at the neighbouring site of Padina (Jovanović 1969; 1987; Borič 1999). The dominance of red in relation to Early Neolithic pottery indicates that we have to concentrate on a specific contextual coherence. The pottery and its colour have no obvious relation to the issues of protection or seasonal practices sketched above. Rather, the use of this kind of coloured pottery is likely to relate to the deliberate incorporation of the Early Neolithic world of the Danube Gorges with other pottery- using communities in South-east Europe.

Also, we note the use of yellow pre-Balkan platform flint as potentially indicative of the incorporation of more distant regions into the sphere of the

Danube Gorges. This flint is abundant at Early Neolithic sites across the central and northern Balkans, and northern Bulgaria is a possible source of this raw material (Voytek 1987). It is striking that this raw material, although occasional in the Mesolithic levels at Vlasac and Lepenski Vir (Kozlowski and Kozlowski 1982; 1983), dominates Early Neolithic assemblages. The colour of this raw material is in sharp contrast with the flint used in the Epi-Palaeolithic and Mesolithic (ibid.). At Lepenski Vir two hoards with cores (Hoard 4), blades and flakes (Hoard 3) consisting of yellow-spotted flint from the pre-Balkan platform were found in Early Neolithic pots with red monochrome surfaces (Srejović 1969: Figures 86 and 87; 1972: 82 and 83).

Conclusion

These last examples bring us back to the introductory comments on the role of colours in transcending distant and exotic worlds. The attributes of the newly exotic, including colour, may well be incorporated into quotidian reality, as might have been the case with the yellow-white 'Balkan' flint in the Danube Gorges. However, a strategy of retaining the exoticism of certain colours and experiences may frequently remain important in fuelling the desire for the Other (Fido 1995; cf. Lacan 1977; Thomas and Losche 1999; Thomas 1997).

The genealogies of meanings connected with colours such as red, white and black cannot be overlooked, as these indicate an experience of the self and the world with a strong reference to the body and its fluids. Nevertheless, the meaning generated by these colours remains pronouncedly polysemic and contextual. No generalization of association such as, say, 'red equals blood' can accommodate all the instances for the use of red and the complexity of expression it generates between and within different contexts.

Apotropaic issues may be seen as central to the use of colours, and are often inseparable from the significance that a decorative art carries, being layered over bodies, houses or objects, serving specific strategies to shape the course of events in the world. I suggest finally that while the meaning of colour may vary cross-culturally, this practice is something that remains universally human.

Acknowledgements

I wish to thank A. Spasojević, V. Trifković, P. Keckarević, A. Jones and G. MacGregor for valuable suggestions and comments on earlier drafts of this chapter. I am grateful to Churchill College, Cambridge and the Open Society Institute for funding my graduate research, in the course of which I compiled this material.

References

Barber, E.J.W. (1999), 'On the Antiquity of East European bridal clothing', in L. Welters (ed.), *Folk Dress in Europe and Anatolia: Beliefs about Protection and Fertility*, Oxford/New York: Berg, 13–31.

Bartosiewicz, L., Bonsall, C., Boroneant, V. and Stallibrass, S. (1995), 'Schela Cladovei: a preliminary review of the prehistoric fauna', *Mesolithic Miscellany* 16(2): 2–19.

Bökonyi, S. (1969), 'Kiãmenjaci (prethodni izvestaj)', in D. Srejoviç, *Lepenski Vir – Nova praistorijska kultura u Podunavlju*, Srpska knjiĭevna zadruga. Beograd, 224–8.

Bonsall, C., Lennon, R., McSweeney, K., Stewart, C., Harkness, D., Boroneant, V., Bartosiewicz, L., Payton, R. and Chapman, J. (1997), 'Mesolithic and early Neolithic in the Iron Gates: a palaeodietary perspective', *Journal of European Archaeology*, 5(1): 50–92.

Boriç, D. (1999), 'Places that created time in the Danube Gorges and beyond, *c.* 9000–5500 BC', *Documenta Praehistorica*, XXVI: 41–70.

Boriç, D. (2000), 'Hearths, houses and floors of Lepenski Vir: embodied action and meanings'. Paper presented at the 7th Neolithic Seminar *The Processes of Neolithization in Eurasia*, Ljubljana, 22–7 May 2000.

Boriç, D. (2002), 'Lepenski Vir conundrum: A reinterpretation of the Mesolithic and Neolithic sequence in the Danube Gorges', Antiquity, in press.

Boriç, D. (in prep.), 'Mesolithic-Neolithic Time Views: Seasons and Life Cycles in the Balkans, *c.* 9000–5500 Cal BC'. Unpublished Doctoral Dissertation, Cambridge University.

Bradley, R. (1998), *The Significance of Monuments: On the Shaping of Human Experience in Neolithic and Bronze Age Europe*, London and New York. Routledge.

Brinkhuizen, D.C. (1986), 'Features observed on the skeletons of some recent European Acipenseridae: their importance for the study of excavated remains of sturgeon', in D.C. Brinkhuizen and A.T. Clason (eds), *Fish and Archaeology. Studies in Osteometry, Taphonomy Seasonality and Fishing Methods*, BAR Int. Ser. 294, Oxford, 18–32.

Burleigh, R. and Îivanoviç, S. (1980), 'Radiocarbon dating of a Cro-Magnon population from Padina, Yugoslavia, with some general recommendations for dating human skeletons', *Zeitschrift für Morphologie und Anthropologie,* 70(3): 269–74.

Deleuze, G. (1990), *The Logic of Sense*, London: Athlone.

Deleuze, G. and Guattari, F. (1984), *Anti-Oedipus*, London: Athlone.

Dimitrijeviç, V. (2000), 'The Lepenski Vir fauna: bones in houses and between houses', *Documenta Prehistorica* XXVII: 101–17.

Dimitrijeviç, V. and Boriç, D. (forthcoming), *Animal Bone Assemblage from Padina*. Unpublished manuscript.

Fido, F. (1995), 'Dreams and Experiences of Elsewhere: Voyage Poems in Seventeenth-Century Italian Literature', in A. Scaglione and G.E. Viola (eds), *The Image of Baroque*, New York: Peter Lang.

Gell, A. (1992), 'The technology of enchantment and the enchantment of technology', in J. Coote and A. Shelton (eds), *Anthropology, Art and Aesthetics*, Oxford: Clarendon, 40–67.

Gell, A. (1993), *Wrapping in Images: Tattooing in Polynesia*, Oxford: Clarendon.

Gell, A. (1998), *Art and Agency: An Anthropological Theory*, Oxford: Clarendon.

Gimbutas, M. (1976), 'Chronology', in M. Gimbutas (ed.), *Neolithic Macedonia: as reflected by Excavation at Anza, Southeast Yugoslavia*, Los Angeles: Institute of Archaeology, University of California at Los Angeles, 29–77.

Goodchild, P. (1996), *Deleuze and Guattari: An Introduction to the Politics of Desire*, London: Sage.

Hodder, I. (1998), 'Creative thought: a long-term perspective', in S. Mithen (ed.), *Creativity in Human Evolution and Prehistory*, London and New York: Routledge, 61–77.

Jovanoviç, B. (1969), 'Chronological frames of the Iron Gate group of the Early Neolithic period', *Archaeologica Yugoslavica*, X: 23–38.

Jovanoviç, B. (1987), 'Die Architektur und Keramik der Siedlung Padina B am Eisernen Tor, Jugoslawien', *Germania*, 65(1): 1–16.

Keckareviç, P., Jankoviç, D. and Bogdanoviç, S. (1998), *The Danube Beluga Story*, Paper presented at the 18th Annual Meeting of the International Association for Impact Assessment, 19–24 April 1998, Christchurch, New Zealand.

Kozlowski, J.K. and Kozlowski, S.K. (1982), 'Lithic industries from the multi-layer Mesolithic site Vlasac in Yugoslavia', in J.K. Kozlowski (ed.), *Origin of the Chipped Stone Industries of the Early Farming Cultures in the Balkans*, Warszawa-Krakow: Panstwowe Wydawnictwo Naukowe, 11–109.

Kozlowski, J.K. and Kozlowski, S.K. (1983), 'Chipped stone industries from Lepenski Vir', *Preistoria Alpina*, 19: 259–94.

Lacan, J. (1977), *Ecrits: A Selection*, London: Tavistock.

Lambek, M. (1998), 'Body and mind in mind, body and mind in body: some anthropological interventions in a long conversation', in M. Lambek and A. Strathern (eds), *Bodies and Persons: Comparative Perspectives from Africa and Melanesia*, Cambridge: Cambridge University Press, 103–23.

Markoviç-Marjanoviç, J. (1978), 'Geologija i stratigrafija', in M. Garasanin (ed.) *Vlasac: mezolitsko naselje u Derdapu* (II), Belgrade: Srpska akademija nauka i umetnosti, 11–27.

Mladenoviç, V. (1999), 'Threads of life: red fringes in Macedonian dress', in L. Welters (ed.), *Folk Dress in Europe and Anatolia: Beliefs about Protection and Fertility*, Oxford/New York: Berg, 97–110.

Ney, P. (1971), 'Mineralogische Analyse einer fussbodenprobe von Lepenski Vir I', in H. Schwabedissen (ed.), *Die Anfänge des Neolithikums vom Orient bis Nordeuropa*, Teil 2: *Östliches Mitteleuropa*, Cologne/Vienna: Fundamenta, Monographien zur Urgeschichte, Reihe A, Band 3, 33–4.

Paunescu, A. (1978), Cercetarile archeologice de la Cuina Turcului-Dubova (Jud. Mehedinti). Tibiscus istorie. Volum Ónchinat celei de-a 60 a aniversari a Unirii, 11–56.

Petroviç, M. (1941), *Djerdapski ribolovi u proslosti i u sadasnjosti*, Belgrade: Srpska Kraljevska Akademija.

Proust, M. (1996 [1928]), *Remembrance of Things Past I: Swann's Way*, London: Vintage.

Quitta, H. (1975), 'Die Radiocarbondaten und ihre historische Interpretation', in D. Srejoviç, *Lepenski Vir: Eine vorgeschichtliche Geburtsstätte europäischer Kultur*, Berlin: Gustav Lübbe Verlag, 272–85.

Radovanoviç, I. (1996), *The Iron Gates Mesolithic*, Ann Arbor: International Monographs in Prehistory, Archaeological Series 11.

Radovanoviç, I. (1997), 'The Lepenski Vir Culture: a contribution to interpretation of its ideological aspects', in *Antidoron Dragoslavo Srejoviç completis LXV annis ab amicis, collegis, discipulis oblatum*, Belgrade: Centar za arheologika istraĬivanja, Filozofski fakultet, 85–93.

Radovanoviç, I. (2000), 'The Lepenski Vir culture and its cultural identity', Paper presented at the conference *The Iron Gates Prehistory: New Perspectives*, 31 March–2 April 2000, Edinburgh.

Smith, B. (1960), *European vision and the South Pacific, 1768-1850: A study in the history of art and ideas*. Oxford: Oxford University Press.

Srejoviç, D. (1969), *Lepenski Vir – Nova praistorijska kultura u Podunavlju*, Belgrade: Srpska knjiĬevna zadruga.

Srejoviç, D. (1972), *Europe's First Monumental Sculpture: New Discoveries at Lepenski Vir*, London: Thames and Hudson.

Srejoviç, D. and Lj. Baboviç (1983), *Umetnost Lepenskog Vira*, Belgrade: Jugoslavija.

Srejoviç, D. and Letica, Z. (1978), *Vlasac: Mezolitsko naselje u Djerdapu* (I arheologija), Belgrade: Srpska akademija nauka i umetnosti.

Stefanoviç, S. and Boriç, D. (2000), 'The new born infant burials from Lepenski Vir: in pursuit for contextual meanings', Paper presented at the conference *The Iron Gates Prehistory: New Perspectives*, 31 March–2 April, 2000, Edinburgh.

Thomas, N. (1997), *In Oceania: Visions, Artifacts, Histories*, Durham and London: Duke University Press.

Thomas, N. and Losche, D. (1999), *Double Vision: Art Histories and Colonial Histories in the Pacific*, Cambridge: Cambridge University Press.

Tilley, C. (1996), *An Ethnography of the Neolithic: Early Prehistoric Societies in Southern Scandinavia*, Cambridge: Cambridge University Press.

Turner, V. (1967), *The Forest of Symbols*: *Aspects of Ndembu Ritual*, Ithaca and London: Cornell University Press.

van Gennep, A. (1960), *The Rites of Passage*, Chicago: University of Chicago Press.

Voytek, B. (1987), 'Analysis of lithic raw material from sites in eastern Yugoslavia', in K.T. Bíro (ed.), *Papers for the First International Conference on Prehistoric Flint Mining and Lithic Raw Material Identification in the Carpathian Basin, Budapest-Sümeg, 1986*, Budapest, 287–95.

Welters, L. (1999), *Folk Dress in Europe and Anatolia: Beliefs about Protection and Fertility*, Oxford/New York: Berg.

Welters, L. (1999a), 'Introduction: Folk Dress, Supernatural Beliefs, and the Body', in L. Welters (ed.), *Folk Dress in Europe and Anatolia: Beliefs about Protection and Fertility*, Oxford/New York: Berg, 1–12.

Welters, L. (1999b), 'The Peloponnesian "Zonari": A Twentieth-century String Skirt', in L. Welters (ed.), *Folk Dress in Europe and Anatolia: Beliefs about Protection and Fertility*, Oxford/New York, Berg, 53–70.

Welters, L. and Kuhn-Bolsaitis, I. (1999), 'The Cultural Significance of Belts in Latvian Dress', in L. Welters (ed.), *Folk Dress in Europe and Anatolia: Beliefs about Protection and Fertility*, Oxford/New York: Berg, 179–98.

Whittle, A., Boriç, D., Bartosiewicz, L., Pettitt, P. and Richards, M. (2001), 'In the beginning: new radiocarbon dates for the Early Neolithic in northern Serbia and south-east Hungary', *Anthenaeus*, in press.

Williams, P. (1999), 'Protection from Harm: The Shawl and Cap in Czech and Slovak Wedding, Birthing and Funerary Rites', in Welters, L. (ed.), *Folk Dress in Europe and Anatolia: Beliefs about Protection and Fertility*, Oxford/New York: Berg, 135–54.

–2–

Colourful Prehistories: The Problem with the Berlin and Kay Colour Paradigm
John Chapman

Introduction

In 1969, Berlin and Kay published their 'Basic Color Terms' – a neo-evolutionary hypothesis explaining the existence of eleven basic colour terms whose order was invariate and whose distribution was correlated with the social complexity of the language groups under study. This study provided a falsely diachronic picture of social evolution, and the majority of research into colour – in linguistics, anthropology, psychology or neuro-physiology – has accepted these findings, providing a flawed paradigm for colour research.

In this chapter, I wish to answer four questions: (1) what is the Berlin and Kay paradigm and what are its strengths and weaknesses?; (2) what are the salient alternatives to Berlin and Kay?; (3) which factors account for changes in the appearance and use of colours?; and (4) how does the archaeological field of colour studies relate to alternatives to Berlin and Kay? In the first parts of this chapter, I rely on the published literature on colour. I then propose an alternative based upon the approach termed 'dynamic nominalism'. In the fourth section, I work through an example of stunning colour representation in the mortuary domain.

The Berlin and Kay paradigm

Since its publication in 1969, Berlin and Kay's research on basic colour terms has dominated the field. Although there have been revisions to the original scheme (Kay 1975; Kay and McDaniel 1978; Kay and Kempton 1984; Kay et al. 1991; a history of these developments in Kay et al. 1997), the core of the paradigm remains the same and can be summarized in six key results.

1. Every language has an indefinitely large number of expressions for colour but the number of basic colours is limited.

Berlin and Kay took native speakers of 20 language groups and asked them to identify on a Munsell colour chart the value most closely corresponding to the colours of greatest importance in North America, as cited in an American teachers' handbook (quoted in Brown and Lenneberg 1954). The authors found that members of each language group selected a narrow range of the same basic colours as the North Americans used from all possible colour terms. Berlin and Kay then used written documentation of 78 language groups to confirm this finding, relying on ethnographies, dictionaries and personal communications. Kay, Berlin and Merrifield claim that this differentiation between basic and non-basic colour terms (also known as primary vs secondary colour terms: e.g. Stanlaw 1997; cf. Mervis and Roth 1981) has been replicated in subsequent experiments, such as the World Color Survey (begun 1976: Kay et al. 1991).

Basic colour terms have four characteristics – they should be (a) morphologically simple, (b) not included in any other colour term, (c) widely applicable and (d) salient. It is claimed that basic colours are more abstract than non-basic colours, which in turn are more context-based. The claimed universality of the same set of basic colour terms has been interpreted by Rosch (1971) and Kay and McDaniel (1978) as proof of the neurophysiological basis of colour perception.

2. Colour categorization is not random; the foci of basic colour terms are similar in every language.

Berlin and Kay used best-fit Munsell values for the basic colours of the original 20 language groups to identify a core range of similar Munsell values for each basic colour.

3. There is a total universal inventory of 11 basic colour categories, from which 11 or fewer basic colour terms are drawn in any given language.

The key empirical finding of the original Munsell colour experiment was that only 11 basic colour terms existed – white, black, red, green, yellow, blue, brown, pink, purple, orange and grey. The data collected from a wide variety of types of society indicated that not all societies used the full range of basic colours. In the most controversial part of their work, Berlin and Kay identified simple societies as using the smallest number of colours, with complex industrial societies possessing 11 basic colours.

4. If a language encodes fewer than 11 basic colour terms, there are strict limits on which categories it may encode.

In the majority of the original sample of 98 language groups, Berlin and Kay found a regular set of combinations of basic colours: if no more than three basic colours

were used, those colours would be white, black and red. No examples were found of language groups using the colour combination 'white–grey–pink'. These findings suggested to Berlin and Kay a regular order of new basic colours adoption in societies of differing complexity.

5. The chronological ordering of colour encoding is interpreted as a sequence of six or seven evolutionary stages.

The question of why this particular ordering of colour clusters should occur was translated by Berlin and Kay into a chronological order combining two partly independent processes: a division of once composite colours into separate entities and a combination of derived colours into new fundamental entities (Kay et al. 1997). In the original scheme, the differentiation of black and white formed a basic Stage I, with the subsequent addition/differentiation of red (Stage II), green and/ or yellow (Stages III–IV), blue (Stage V), brown (Stage VI) and purple + pink + orange + grey (Stage VII). Berlin and Kay converted a set of synchronic differences into a diachronic sequence potentially extending back as far as the Palaeolithic (see also Jones and MacGregor's Introduction to this volume).

6. The sequence of elaboration of the colour lexicon is an evolutionary one, perhaps a reflection of increasing technological and cultural advancement.

The ambivalence of Berlin and Kay's explanatory comment on the significance of the evolution of basic colour perception is a fair reflection of their tentative position on the relationship between the position of any given society along the pathway of basic colour evolution and a measure of that society's social complexity.

In the Berlin and Kay paradigm there is a strong emphasis on the use of linguistic data to build a universal narrative of the evolution of colour perception. There are five areas in which the paradigm can be examined.

Epistemological

Saunders (1995) has mounted a strong attack on the Euro-centric nature of the paradigm and its dichotomy between form and content. Far from being an objective point, Berlin and Kay take widespread colour terms in the English language, as represented by a teachers' manual, as the baseline for a world system of colour naming. Therefore English terms become the episteme, in contrast to non-English terms, which become the doxa (or fallible belief) for colour naming by other groups. The Berlin and Kay scheme seeks universals, and guarantees to find them by using a procedure based upon Western categories (Lucy 1997: 30).

Theoretical issues

There are two sides to the principal theoretical problem of the Berlin and Kay scheme. Saunders (1995) objects to the assumption that basic colour terms are treated as atomistic entities linked to a universal language, entities which are innate and have a neuro-physiological base of their own. She questions whether we can accept the reductionist cause of basic colour terms as neuron clusters. She argues, with van Brakel (1988), that colour defies description and definition, being simultaneously internal and private and part of the character of the external world. Wierzbicka (1990) too is critical of the leap from neuro-physiology to semantics made by Kay and McDaniel (1978). She would distinguish between the mechanisms of colour perception (which are universal) and the question of colour conceptualization (which is different in different cultures but with some striking similarities).

Alternatively Saunders and van Brakel (1988: 359–60) suggest that theories, such as those of Berlin and Kay – which place colour in the brain and make colour subjective – can be dismissed, since the mind is socially constructed and cannot be understood independent of its embodiment in the brain and its embeddedness in the world.

Saunders and van Brakel's linguistic position is persuasive in terms of situated practice but they downplay the influence of the material world on the everyday practices that give meaning to the terms and categories which people use. It is the materiality of the world which provides intersubjective points of reference for people. As Tilley (1999) and Schiffer (1999) have both argued, the world of things is as important as the world of words.

Davidoff (1997) instead focuses on the importance of referential data about colour terms, not least the relations between the colour and the shape of objects. This approach is related to the work of Lucy (1997), whose main criticism of the Berlin and Kay scheme is that there is no assessment of the referential use of a colour term such as 'red', nor of its grammatical status in the language. Colour terms have meaning values, not just connotative colourings. Many colour words are attributive, referring to all the visual qualities of a referent except the form and the shape (e.g. surface textures, especially shininess; for an archaeological example of this viewpoint, see Hosler 1994).

Methodological critiques

Sivik (1997) has attacked the Munsell colour system as a 'monotheistic view of the colour world' (ibid. 167–71), based upon colorimetric rules rather than perceptual criteria. Saunders and van Brakel (1988) are also critical of Munsell

colour chips, which include a limited number of features of colour appearance and no contextual information. For Saunders and van Brakel, the most important aspects of context include physical composition or location of objects in the world as well as information on lightness, duration, size, location, kinds of texture, glossiness, lustre, fluctuation, shape, insistence, pronouncedness and fluorescence.

Empirical results

Alongside the positive reviews of Berlin and Kay's original research (e.g. Merrifield 1971; Collier 1976; Ratliff 1976; Sahlins 1976), a number of reviews accused the authors of major mistakes over the linguistic data (e.g. Durbin 1972). One vital development published by the core team of Kay, Berlin and Merrifield (1991) led to the claim that its acceptance concedes the debate to cultural relativists (MacLaury 1992). MacLaury is concerned that Kay et al. (1991)'s new category 'yellow–grey–blue' calls into question the very notion of colour-category universals.

Historical and geographical context

An early point of criticism here was made by Durbin (1972), who observed that no one had related the colour groupings proposed by Berlin and Kay to their geographical distribution. Durbin's analysis indicated strong spatial patterning in those societies typified by the various Berlin and Kay evolutionary stages. Durbin (1972) raised the possibility that these spatial patterns were produced not by independent development of colour naming but through wider processes of culture contact and diffusion of the basic colour terms.

McNeill (1972) also developed the central idea that the universality of Berlin and Kay's colour categories was produced by the invention and diffusion of artificial dyes in the nineteenth and twentieth centuries AD.

Alternatives to the Berlin and Kay paradigm

It is time to re-examine the relationship between colour and social practices. Sahlins (1976) formulated the key point about the social use of colour, that it both signifies objective differences in nature and communicates the significant differences of culture. Colour distinctions are naturally based but natural distinctions are culturally constituted. For Sahlins, the question was not 'What do colours mean in Munsell chips, but in culture?' The integration of cultural meaning into colour studies is an important part of the search for alternative approaches.

Let us begin with an attempt mounted by Maffi and Hardin (1997) to patch up the Berlin and Kay paradigm. This consists of a modification of the evolutionary

sequence through the inclusion of elements of object colour salience. Maffi and Hardin base their evolutionary scheme on the premise that 'Languages have two or three basic colours and secondary context-bound colour words encoding chromatic and non-chromatic information' (1997: 352). They propose three stages:

> Stage 1: chromatic information is recognized as object colour (i.e. the intrinsic property of the object), not separated from other visual or non-visual properties.
>
> Stage 2: the emergence of abstract conceptualization and the naming of colour is compared to the reduction of multiple meanings, leading to the colour meanings of contextualized colour terms.
>
> Stage 3: the emergence of named basic colour categories, usually colours which are the most salient and which take the lead in further developments as readily available cognitive reference points. Since not all context-dependent colours are subsumed under basic colours, a hierarchy of terms develops to cope with increasing complexity. At this time, the domain of colour itself gains in salience (Maffi and Hardin 1997: 352–3).

This is a general theoretical proposal, which could act as a framework for investigations into future research. However, no attempt is made to set an absolute chronology for the stages of such an evolutionary scheme. The scheme has two merits: (1) the introduction of context-dependent colours into the Berlin and Kay scheme allows (2) the elimination of the basic colour model of Berlin and Kay if it were felt necessary.

Wierzbicka (1990) has so far produced the clearest proposals for the naming of colours. Wierzbicka maintains that colour perceptions are described in terms of locally salient references, whether characteristic-looking minerals, plants or animals, but that semantics vary between cultures. Conklin (1973) also observed that because of general bias in favour of object colours, artefacts and the natural environment would have had a large but varied effect on colour vocabulary.

Wierzbicka refines Conklin's point to suggest that basic colour concepts are anchored in certain 'universals of human experience' (1990: 140). She uses ethnographic and linguistic evidence to verify the most obvious candidates (1990: 115–25). In many languages, black and white refer to the dark and light, or the darkness of the night and the lightness of daylight. Similarly, the words for 'green' in many languages are related to words for grass, herbs or vegetation in general (e.g. the Hanunoo: Conklin 1952). Words for blue have two typical referents – the sky or watery places such as the sea, lakes or rivers. The words for red are commonly related to blood, minerals such as red ochre, fire or pigments and dyes. Likewise, the words for yellow denote the characteristic of warmth, in relation to the sun. Thus certain key concepts would have acted as cognitive anchors for colour naming.

Wierzbicka's universals can be identified as:

day (white)	vegetation (green)
night (black)	the sky (blue)
fire (red)	the earth (brown)
the sun (yellow)	

Where Wierzbicka emphasizes the importance of the influence of universal colours in the natural world, others have turned to the more culturally variable world of animals and things. Murton (1980) discusses the constitution of the cultural world of the East African Mursi cattle-herders. Cattle are an environmental domain which act as a reference for all the colours they need. Cattle colours are not necessarily focal and their salience does not mean that other colours are excluded. The important point here is that the functional importance of a single species is what provides the potential for the formulation of a set of colour terms.

Bolton (1978) reinforces Murton's point and goes on to define five factors which influence the cultural salience of colour terms (Bolton 1978: 308–9):

1 The presence/ubiquity of actual colour in objects associated with the cultural domain.
2 The significance of a colour in providing useful information for decision-making or other behaviour in the cultural domain.
3 The nature of the task used to elicit colour terms within a cultural domain.
4 The affective meanings of objects and activities in the cultural domain.
5 Semantic links between important colour terms and specific significant objects.

These factors define a range of cultural and social practices in which colours may become salient. How can colour terms from the two domains – the natural and the cultural – be related?

Casson (1997: 233) proposes that a key figure of speech is metonymy – a figural relationship based upon the perceived contiguities between literal primary referents and figurative secondary referents. For colour, this means that there was always a priority of entity sense (e.g. the presence of a lemon) over colour sense (the naming of the colour 'lemon'). Casson insists on the unidirectionality of the entity sense to colour sense, which would mean that 'the entity stands for the entity's colour'. It is in this sense that ontological metonymy works, with sources of metonyms in the natural world as well as in the cultural world.

What is interesting about Casson's ideas is that they begin to approach the notion of the co-emergence of colour-and-things, without necessarily giving logical or causative priority to either. The connection is important for the development of another way of viewing the emergence of colours and their

naming. It is also important for giving equal weight to the material culture side of the evidence as to the linguistic.

Explanation for changes in colour usage

Several authors have developed hypotheses to account for the differentiation of basic colour terms. A variant on the first Berlin and Kay hypothesis concerns the idea that simpler societies have a smaller but less complex vocabulary, while the differentiation of colour terms relates to a general increase in the breadth of vocabulary in more complex groups. However, there is no attempt to explain why colours are necessarily important enough to reflect comparable changes in the general differentiation of language.

Hewes (1992) offers a technologically based hypothesis relating to the availability of colouring agents in simple and complex societies. He makes the point that many ancient and technologically simple societies lacked access to durable colouring agents and that these were a key source of new colours and therefore new colour terms.

Although concerned to explain colour differentiation in ancient Egypt, Baines's two-stage hypothesis may be applicable to a wider range of cases defined by the growth of social complexity. Baines (1985: 290–1) characterizes the differentiation of colour terms through the elaboration of mid-range abstract categories which gain in effectiveness from their narrower ranges of content. He argues that this is what was happening at the time of the proliferation of special techniques and unusual colour effects, set in new contexts of the domestic decoration of private houses and palaces. However, the increased range of contexts which were coloured led to choices of different colour sets in different places, which Baines takes to imply complex selection and manipulation of colour.

The major problem with the proposed hypotheses is the lack of real explanation for the alleged causes of changes in colour perception. It is suggested that a more sophisticated approach in which a more active role is given to both individuals and material culture is more likely to provide understanding of the changing uses of colour in the past.

The approach to social change adopted here has been termed 'dynamic nominalism' by Hacking (1995). This approach develops the idea of self-description through categorization, in which individual or group identities are formed through a continual process of refinement. Thus new forms of identity and new categories emerge through the very process of self-definition against an external Other. The aim is to reconcile structure and agency within a single mechanism through the attribution of a more active role to identity. Hacking (1995: 247–8) defines the core notion: categories of people come into existence at the

same time as kinds of people come into being to fit these categories in a two-way interaction. An example which Hacking draws from Foucault (1973) is the way that, owing to the development of new institutional forms of discipline, soldiers in the Early Modern period 'became' different kinds of people from Medieval soldiers.

An insightful way of treating artefacts is to consider their cultural biographies, in which their life-histories are part of their cultural impact. This implies that each person who makes, owns or uses an object makes some contribution to the item's biographical story (see Jones in Chapter 8 of this volume). It can then be seen that the value of an artefact is interdependent upon the value of the person connected to that object. It follows that a categorization of objects can provide many insights into the way in which people divide up their cultural world. The recursive relationship between manufacture as action and categorization as structure leads to the co-emergence of colour terms at the same time as the objects which they designate. It is clear that there is a close parallel between the self-categorization of emergent groups of people and the potential for naming the colours of newly emergent groups of things found in newly explored environments.

Colour in archaeology: an example from later Bulgarian prehistory

Settlements and cemeteries

In the fifth millennium cal. BC, tell settlement was widely distributed in much of south-east Europe. On the Black Sea coast of Romania and Bulgaria, tells were less common and those which did exist were significant places. Tells may best be viewed as ancestral homes; people lived in places which their ancestors had previously occupied (Chapman 1989; 1990; 1994; 1997; 1998). Tells emerged as some of the earliest monuments in the Balkan landscape.

The mortuary zone in south-east Europe is far less prominent. For the Neolithic and Copper Age, the majority of burials were individual contracted inhumations deposited with a minimum of grave goods in a variety of domestic contexts (Chapman 1983; 1994). The creation of distinct mortuary sites took place in a piecemeal process, beginning around 5000 CAL BC with small Neolithic cemeteries such as Botos, in north Serbia (Grbiç 1934) and larger entities such as Cernica, in southern Romania (Cantacuzino 1969).

By the fifth millennium cal. BC, the Black Sea zone had become differentiated from other Balkan Neolithic groups. The Hamangia group differed from other Neolithic groups in the Balkans through its emphasis on large cemeteries as major markers in the landscape (Berciu 1966; Todorova 1984).

The cemetery tradition in the Black Sea zone had the effect of creating a variety of social practices whose sole focus was the mortuary zone and which established

a social space for different practices from those on the ancestral tells. The Black Sea cemeteries became places for the implementation of novel values and practices. An important part of this difference was the tendency to bury complete human bodies in the cemeteries, rather than the human bone deposits more typical in tells (Chapman 2000a). Whole-body burial allowed a wider range of statements about the person and his or her social relations than could be made with deposits of human bones.

Durankulak and Varna

The two cemeteries investigated in this study are key sites for the later prehistory of the Eastern Balkans (Figure 2.1). The cemetery of Durankulak received more than a thousand burials over a period exceeding a millennium (Avramova 1991; Dimov et al. 1984; Todorova 1984). Three credible C14 dates for the cemetery range from 3845 +/- 200 bc (HV-12759) to 3275 +/- 85 bc (HV-12473); the tell dates cover a span of 3750 +/- 50 bc (Bln 2122) to 3525 +/- 50 bc (Bln 2121) – all

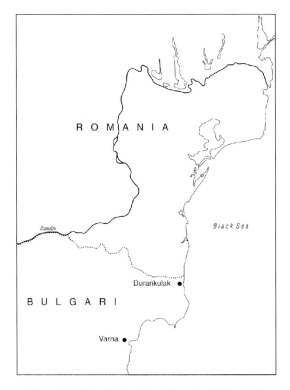

Figure 2.1 Map of sites in text (drawn by Y. Beadnell)

in the late fifth to early fourth millennia cal. BC (Boyadziev 1995: 183). Some 300 burials have been associated with the Neolithic Hamangia group, whose settlement lay 400 m North of the cemetery. In the Copper Age a tell gradually developed on a small island with occupations in the Late Copper Age. A total of some 700 Copper Age graves marked an extension to the south of the Neolithic cemetery, 150 m west of the island tell (Todorova and Vajsov 1993: Fig. 25) A far greater proportion of Copper Age graves contained grave goods, with a wider range than the Neolithic burials. The analysis draws on a representative set of colourful objects from a sample of graves (n = 42).

The Copper Age Varna cemetery (Ivanov 1991; Renfrew 1986; Chapman 1991; Fol and Lichardus 1988; Lichardus 1991) lay on the North shore of the Varna lakes (Ivanov 1978), some distance from the nearest coeval settlement. In the Late Copper Age a significant concentration of sites develops at or around the time-span of the burials (pers. comm., I. Ivanov), suggesting an expansion of settlement in the region. The cemetery is incompletely investigated, with almost 300 excavated burials. It has an extraordinary concentration of early goldworking in a small percentage of the graves (Ivanov 1991; Renfrew 1986; Chapman 1991; Fol and Lichardus 1988; Lichardus 1991).

The majority of 'rich' burials lie in a concentration towards the core of the cemetery (Figure 2.2). Two classes of graves occur, those lacking a human body ('cenotaphs') and inhumations of adult males. There are no published examples of adult females or child burials from the cemetery core – a strong case of male gender bias. Outside the core, many burials contain no grave goods; inside the core, the total of grave goods can be counted in the thousands and the weight of gold in certain graves exceeds 1.5 kg. There are four specific traits defining the group of 12 richest graves at Varna I: deposition in the grave fill, bone figurines, *Dentalium* sets and long superblades. The grey and yellow lithics deposited in the cemetery derived mostly from pre-Balkan platform sources, while the black and dark grey Varna lake-settlement lithics were imported from the Prut-Dniester zone (Margos 1978).

On the basis of specific parallels with objects found at other Bulgarian Copper Age sites I have proposed that Varna was the mortuary zone for leading members of an inter-regional elite controlling extensive exchange networks (Chapman 1991) and basing their control upon the social practice of set accumulation (Chapman 2000a).

Environmentally salient colours

It has been suggested that the two principal sources of colour in the past were the natural environment and the world of objects. The site of Varna was on the shore

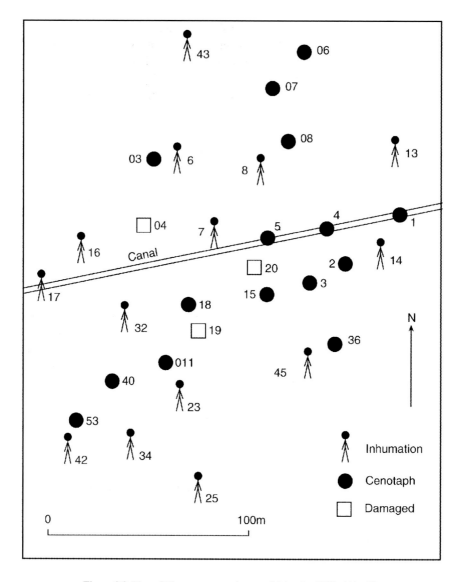

Figure 2.2 Plan of Varna cemetery (source: Lichardus 1988, Abb. 51)

during the Eneolithic (Ivanov 1978). Similarly, the tell at Durankulak was located in a brackish lagoon in an area dominated by alluvial sediments (Bulgarska Akademija na Naukite 1984: map, p. 11). Changes in the status of these areas would have affected the composition of the fish, birds and animals associated with their zones – changes which offered different metonymic and metaphorical possibilities.

A pollen diagram for the Durankulak lagoon indicates increasing levels of arboreal pollen in the Eneolithic period, with stands of oak, elm and beech near open cereal fields (Bozhilova and Tonkov 1983). By contrast, studies of the sediments from Varna indicate that vegetation contemporary with the cemetery was composed of forests of alder, with stands of oak, hornbeam, beech and hazel adjacent to grassland areas, with pine and spruce forests at a greater distance (Bozhilova and Filipova 1975). Maps indicate that chernozoems (blackearths) were the dominant soil type in both the Durankulak and Varna areas (Bulgarska Akademija na Naukite 1984: map, p. 14).

One might expect colour contrasts to have been based upon the sky (yellow or gold sun and blue sky), the sea (blue), the earth and the night (black) and the broad-leaved forests and grassy areas (greens and browns). In addition, fire and/or blood (red) and bone (white) are likely to have been significant.

Salient object colours

Part of the environment consists of the materials which communities use in a raw or transformed state. The source area of each material will have symbolic associations, along with the material itself and the persons who collected it, as part of a place-based biography. It is therefore important to define the source zones for materials found at the two cemeteries (Table 2.1). The colour terms used in the recording of these materials are also presented at this juncture, together with a summary of the number of colours used in each cemetery by phase (Table 2.2). The total number of object-related colours depends upon the range of materials brought to the cemeteries. Before the selection of materials for mortuary deposition occurs there is a primary selection of materials to be obtained by direct procurement or through exchange networks. Colour perception, usage and naming depend upon the broader processes of the inalienable economy – reproduction, enchainment and consumption (Chapman 1996; 2000a).

There is a trend toward an increase in the range of available objects and hence object-colours in time at the Durankulak cemetery and synchronically between Durankulak and Varna. Few of the materials are locally available, so the differences in available objects may indicate variations in the extent, intensity and success of regional and interregional exchange networks. This means that the introduction of novel materials involved the creation of new possibilities for colour perception and naming, part of a wider pattern of the translation of the meanings of exotic materials into a local cultural and social vocabulary (Chapman 2001).

The main growth point for different materials is the surface/outcrops zone, where the number of object-colours rises from six in the Hamangia graves at Durankulak to fourteen at Varna. Several of the surface/outcrop sources are truly

Table 2.1 Source zones and colours of materials used in the Durankulak and Varna cemeteries

Source zone	Colour	Durankulak Hamangia	Durankulak Eneolithic	Varna
Mines				
Balkan flint	grey	x	x	x
? gold	gold	–	x	x
haematite	red	x	x	x
copper	brown	x	x	x
malachite	green	x	x	x
azurite	blue	–	x	x
Sub-total		4	6	6
Surface outcrops				
marble	white	x	x	x
kaolin	white	–	–	x
calcite	white	x	–	x
Balkan flint	grey	x	x	x
talcite	grey	–	x	–
? gold	gold	–	x	x
carnelian	red	–	x	x
haematite	red	x	x	x
quartz	red	–	–	x
chalcedony	red	–	x	x
schist	green	–	x	–
Prut flint	black	x	–	x
mineral	black	–	–	x
graphite	black	–	–	x
obsidian	black	–	–	x
diorite	black	–	x	–
lignite	black	–	x	–
fired clay	various	x	x	x
Sub-total		6	11	14
Animals				
bone	white	x	x	x
teeth	white	x	–	x
antler	buff	x	x	x
Sub-total		3	2	3
Water				
Dentalium	white	x	x	x
snails	white	–	–	x
Spondylus	white/	x	x	x
	white + red	x	x	x
river pebble	various	–	x	x
Sub-total		3	4	5
TOTALS		16	23	28

Table 2.2 Summary of colours of materials used in the Durankulak and Varna cemeteries in order of frequency

Colour	Durankulak Hamangia	Durankulak Eneolithic	Varna
white	6	4	8
black	1	2	4
red	1	3	4
white + red	1	1	1
buff	1	1	1
gold	–	1	1
brown	1	1	1
grey	1	2	1
green	1	2	1
blue	–	1	1
various	1	2	2
TOTAL	14	20	25

exotic (e.g. Hungarian obsidian, Prut-Dniester flint, *Spondylus* shells from the Aegean, much of the copper (Gale and Stos-Gale, unpublished) and possibly the gold. By the time these materials and objects reached the two cemeteries, their biographies would have been extensive. The opportunities for the display of colourful things were considerable, whether in the hands of long-distance specialists who travelled to procure such exotics, or for those 'translators' who ensured the successful incorporation of a material into a local context of significance (see Helms 1988; Chapman 2000a; 2001).

In addition to factors such as the quality of the material, the size of tools produced and the predictability and regularity of supply, the colour of materials should also be taken into account as a factor in material selection. Colour could be drawn upon to access cosmological aspects of the community's life. This metaphorical access may depend upon the associations which the material brings from its source area. If initial associations are not negative, the exotic material may open up a fissure in the community's ideologies into which it may work its way, in time leading to a place of significance, which makes constant supply of this material an important social goal.

At this juncture, the object-colour will be given a 'formal' name – inextricably linked to the material itself. The restriction of the new material to certain members of the community may bestow on the material another kind of value, which could act as the basis for social competition or exclusion. This scenario would lead to changes in the structure of the community's colour spectrum, since the introduction of a new colour would impact upon the totality of the group's colour categorizations. There is a recursive relationship between the emergence and first

sight of a material and the importance it may subsequently assume for a given community. It is during this process that judgements over value are made and things are named.

Returning to Durankulak and Varna, it is noteworthy that many of the object-colours of the grave goods are visually homogenous and appear to be socially desirable. One of the most striking characteristics of most other colours is their distinctiveness. This is true of gold, since it does not tarnish, and of polished stones such as carnelian, chalcedony, marble, diorite and schist. Copper and its ores change colour on exposure to oxidizing elements. Taking the range of different sources into question, one could predict that the colours of the flaked stones would show considerable variation, but this is in fact not the case. The fact that the majority of pre-Balkan platform flint blades and superblades are shades of grey or yellow-grey, while all of the Prut-Dniester flint is black, is indicative of selection for colour. Animal and marine materials have homogenous colours, but the case of the Aegean marine shell *Spondylus gaederopus* is different. The inner structure of one of the sub-species of the shell, *Glymnaea*, forms a natural reddish or pinkish colour. The cutting of the shell in a particular way reveals this colour. To judge from its frequency among shell bracelets from the two cemeteries, it was appreciated for its distinctive colour.

The choice of the colours embodied in the grave goods at Durankulak and Varna is not random. Nine colours are represented in the range of grave goods, seven in the Hamangia graves at Durankulak (lacking gold and azurite), with the full range of nine in the Eneolithic graves there and at Varna. Five colours are represented in different ways by different things (Table 2.2). The representation of white is most diverse, displayed in eight different kinds of object at Varna and in four at Durankulak. This raises the question of whether people at Durankulak or Varna perceived these eight kinds of white as a single colour, in view of obvious differences of luminosity (quartz vs animal bone) and texture (*Spondylus* shell vs marble).

The sources of the variations on the colour white vary by site and period. The majority of white objects in all three contexts were derived from marine or animal sources. If the staining of human bones with red ochre implies the burial of de-fleshed skeletons, the colour white would have been a dominant theme in the mortuary zone. The other colour with multiple representations is black – much more frequent at Varna (4 types) than at either phase at Durankulak (one in Hamangia graves, 2 in Eneolithic graves). All the black objects in each cemetery are derived from surface/outcrop sources. Another colour which is represented by more than one object category is red, of which four variants are found at Varna and three in Eneolithic Durankulak. The sources of this colour are either mines or surface/outcrop deposits. Two variants on green are revealed by malachite and schist – again different in luminosity and texture – the former from the mining

source, the latter from surface/outcrop sources. Finally, the soft, easily scratched and very rare talcite differs from the grey pre-Balkan platform superblade flints in size, usage, luminosity and texture and may have been represented by more than one colour term.

The question of sources leads to another observation – each of the source zones has one or more colours with which it is uniquely associated. For mines, the colours are brown and blue, for surface/outcrop sources, it is black, while buff derives from animal sources and the white/red combination of the *Spondylus* is unique to the marine source. Only the association of the colour black with the surface (i.e. the soil), as well as outcrops on the surface, is correlated with the environmental colour sources proposed above. Here, Wierzbicka's association of white with bone is tautologous. Greens and browns, associated with forests and grasslands, are derived from mines or surface/outcrop sources. The biggest opposition would appear to stem from the environmental source of yellow and gold from the sun and therefore the sky, whereas the object-colours derive from mines and surface/outcrop sources. The source of azurite from copper mines is diametrically opposed to its environmental sources of sky and water. The wide range of sources for the object-colour red – mines, surface/outcrop sources and water bodies – vitiates any correlation with the sources of fire and blood.

The Hamangia graves at Durankulak

The Hamangia colour spectrum for non-ceramic materials at Durankulak is based upon the use of seven colours in seven different combinations (Figure 2.3). In several graves, more than one variant on the colour white is found – up to four in

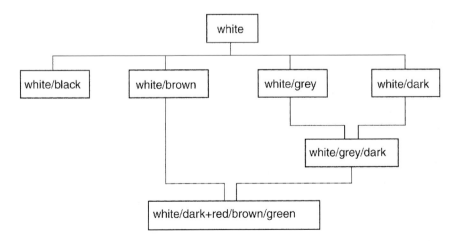

Figure 2.3 Colour pathway for Hamangia graves, Durankulak (drawn by Y. Beadnell)

grave 609. This is a tightly focused group of colour combinations, which lacks structure in two respects: (i) the restriction of single-colour grave groups to white only, and (ii) the abrupt increase in combined colours from three colours to five (one case), with an absence of an intermediate four-colour stage. The Hamangia grave groups show an emphasis on white/dark contrasts over other combinations.

A more specific analysis examines the colours of objects combined together as sets. The only sets comprising a single colour are white objects; one other set is a two-colour set (white/brown), while the most complex set is a necklace of red, green and brown beads (Figure 2.3). In the Hamangia period limited use was made of a larger colour spectrum.

A third analysis examines ceramic colouring. Often, a variegated surface in which several colours are present, frequently in coarse wares, is indicative of poor firing control. By contrast, a high degree of firing control is required to produce vessels such as the red polished fine ware bowls from Drama (Fol et al. 1988: Abb. 96).

In the Durankulak and Varna analyses, the pottery was coded for (type 1) single colour, (2) variegated colours, (3) colour contrast, and (4) colour contrast combined with variegated colours. In the case of the Varna cemetery pottery, the common application of a white slip on the vessel after the initial firing led to a more complex coding procedure.

The small Hamangia assemblage from the Durankulak cemetery showed consistency in firing to a single colour, with a clear preference for dark fine wares (dark brown, grey-brown, grey, dark grey and black) (Figure 2.4). Coarse-ware fabrics were less varied, with deposition of both red and grey wares. Overall, the Hamangia community were restrained in the way in which they made use of a wide colour spectrum. The most basic contrast – light/dark – was common in non-ceramic grave groups and costume sets. Little colour contrast was utilized in mortuary ceramics.

FREQUENCY OF TYPES OF POTTERY COLOURS (ALL WARES)

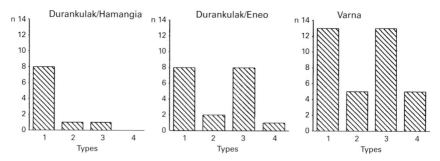

Figure 2.4 Frequency of types of pottery fabrics, Durankulak and Varna cemeteries (drawn by Y. Beadnell)

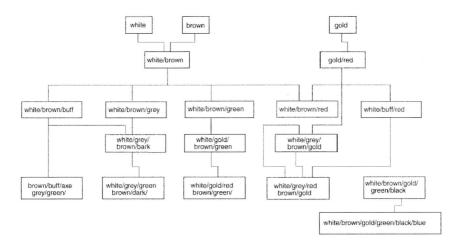

Figure 2.5 Colour pathway for Eneolithic graves, Durankulak (drawn by Y. Beadnell)

The Eneolithic graves at Durankulak

The extension of the colour spectrum for Eneolithic objects by two colours – gold and azurite – seems a minor change in the potential for material expression. However, there is a dramatic expansion in the salience of colour in this period.

The non-ceramic colour pathway of the grave groups at Eneolithic Durankulak presents a remarkable contrast to that of the Hamangia period (contrast Figures 2.3 and 2.5). In addition to three one-colour grave groups, there are sixteen combinations of colours, with one two-colour group, six three-colour groups, four four-colour groups, four five-colour groups and a single six-colour group. The basic module is the white/brown combination, accounting for the only two-colour group and contributing to four of the three-colour groups and eight out of nine of the higher-level groupings. Almost all of the higher-level groupings have grown incrementally by the addition of one colour at a time; the sole exception is the 'brown/grey/buff/green/axe' grouping, which has three new colours in comparison with all four-colour combinations. This structured hierarchy of colour additions contrasts with the weakly structured Hamangia colour pathway.

The structure is also found in the colour combinations used mostly to create costume sets in Eneolithic Durankulak (see Avramova 1991). The set pathway is more varied than in the Hamangia period, using multi-colour combinations to create bright and colourful necklaces. The structure includes seven two-colour ornaments, three three-colour ornaments and two four-colour ornaments. The incremental pattern of single-colour additions is dominant. One point of interest emerges from the sets: the two examples of necklaces in graves 223 and 447,

which use both sources of green – malachite and schist – for contrast in the luminosity and texture of beads.

The same expansion of colour contrasts is found in the mortuary ceramics at Eneolithic Durankulak. The number of categories of single-colour fabrics is exceeded by the number of fabrics with colour contrasts (Figure 2.4). The Eneolithic Sava and Varna group vessels are dark burnished wares, with occasional red slipped and burnished ware fabrics (Figure 2.4). The low frequency of variegated vessels indicates the high level of firing control exercised. The colour contrasts comprise four kinds: white-encrusted incised lines dividing dark burnished zones; zones of red paint crusted on after primary firing; bands of red and/or white or black paint applied before firing; and adjacent zones of different colours. Over half of the ceramic colour contrasts have close matches in the non-ceramic colour domain.

In summary, colour salience is emphasized to a much greater extent in the Eneolithic period at Durankulak than in the Hamangia phase. The number of object-colours was slightly higher but the use of colours was dramatically different, suggesting a heightened importance of the attributes of individual things. The new object-colours were metals, adding to the diversity of 'pure' copper and its oxide malachite. Azurite remained a rare substance, perhaps related to the sky, the lagoon and/or the sea. Perhaps symbolizing the sun and the day, gold became more common and increased in value, especially in the cenotaph graves at Durankulak (Avramova 1991).

The Varna cemetery

At Varna, colour variability is closely related to variations in both costume and raw material combinations. The total number of object colours placed in the grave and the grave fill amounts to nine different colours. Nineteen combinations of nine colours are recorded – an indication of strongly structured colour selection. The pathways for colour combinations are based upon two starting points – 'grey only' (denoting pre-Balkan platform flint) and 'gold only' (Figure 2.6). The 'grey' pathways continue without gold until the third level and are confined to inhumations. The 'gold' pathways incorporate grey at the second level and grow in complexity. Combinations of six and seven colours are restricted to cenotaphs, but both burial modes are found up to the fifth level. In concordance with the variability of the Varna data set, most colour combinations are found in only one grave. It is interesting to note that six cenotaphs use the one and only six-level combination (gold + brown + grey + black + white + red), suggesting the existence of a standard colour code for graves with elaborate offerings.

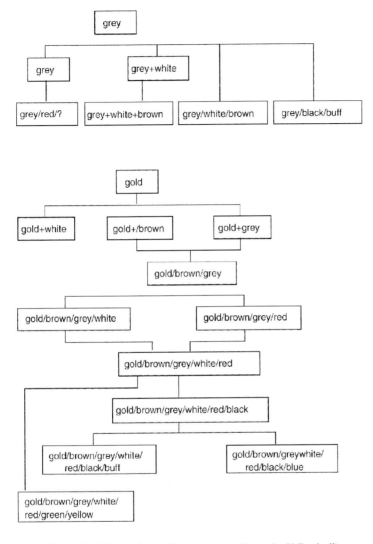

Figure 2.6 Colour pathways, Varna cemetery (drawn by Y. Beadnell)

The analysis of sets in the Varna core graves reveals a different organizing principle from Eneolithic Durankulak. This is set accumulation, by which vast quantities of classes of the same material and/or object were deposited in graves (Chapman 2000a). Three material types were most commonly accumulated in vast numbers: gold (up to 992 objects in grave 43); polished stone beads (up to 523 in grave 1); and *Dentalium* shells (up to 4,542 in grave 41). This meant that the idea of multiple colour combinations in costume sets was not as strongly exploited as in Durankulak. At Varna, six categories of single-colour sets are found, together

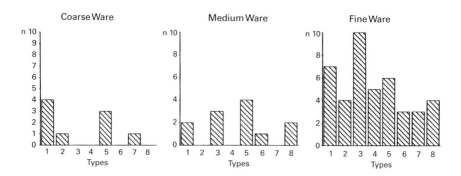

Figure 2.7 Frequency of pottery fabrics by ware, Varna cemetery (drawn by Y. Beadnell)

with one type of two-colour set, two types of three-colour set and a single four-colour set. None of the colour combinations was the same at the two sites.

The size of the pottery sample (n = 95) enables a preliminary division into coarse wares, medium wares and fine wares, of which the vast majority were fine wares. Most coarse wares were light-single-colour fabrics, with a single colour contrast (Figure 2.7). Medium wares were dominated by light fabrics but more colour contrasts were found: white-encrusted lines separating zones of darker colours; red-painted zones adjacent to darker-coloured zones; and rarely contrasts between two zones fired to different colours (Figure 2.7). It was with the fine wares that colour contrasts characterize more than 50 per cent of all vessels (Figure 2.7). Eight different methods of colour contrast are used:

1 white-encrusted lines between zones of darker colour
2 red-painted zones crusted on the surface after primary firing
3 black paint on lighter surface before primary firing
4 graphite-painted ware
5 gold paint crusted on after primary firing (Plate 2)
6 contrasts between two zones fired to two different colours
7 contrasts between two zones fired to three different colours
8 contrasts between two zones fired to two different colours, supplemented by white-encrusted lines

The ceramic colour contrasts do not form a close match with non-ceramic contrasts. The Varna colour structure differs from that in Eneolithic Durankulak, where ceramic and non-ceramic colour contrasts are much more closely aligned.

There is wide-ranging and spectacular use of colour in the non-ceramic grave goods from the Varna cemetery, dominated by the goldwork and grey superblades and supplemented by seven other colours. The structure of the colour pathways

derived from both gold and grey relies on incremental growth, with few combinations more than one colour different from an adjacent grouping. The importance of colour in signifying difference is shown in the ceramic colour spectrum. Comparison of the frequency of styles of pottery fabric colour for the two periods of burial at Durankulak and at Varna (Figure 2.4) indicates the contrast between the paucity of colour contrasts in the Neolithic burials at Durankulak and the strong emphasis on colour variability at both Eneolithic cemeteries.

Conclusion

The Hamangia community's use of colour at Durankulak can be summarized as being the combination and re-combination of a wide range of available colours. We seem to have a well-integrated colour pathway displaying few vertical developments towards greater complexity. If colouring objects is a way of categorizing the world as well as the objects themselves (Miller 1985; Chapman 1996; 2000a), this conclusion may well be read as a statement about the Neolithic Hamangia community and its social organization. The identities which would have been emerging at the same time as the consolidation of the colour vocabulary were still tentatively expressed and had probably not fully crystallized.

The complexity of the colour pathways at both Eneolithic cemeteries is striking. One of the primary purposes of such colourful grave goods was display, whether to impress and amaze or to facilitate non-verbal communication. The transmission of messages was carefully structured through the selection of specific colour combinations. Not only were two further object-colours added to the Neolithic repertoire but all known colours were used in combinations to increase the range of messages sent. The colour terminology which was co-emerging with the object-colours themselves had become well established as a focal conceptual scheme within Eneolithic mortuary ideology. Such a key node of practice required the continued procurement of appropriate object-colours and an expanded exchange network.

The relationship of the categorization of colours and the categorization of people requires elaboration. At Eneolithic Durankulak and Varna, the artefactual embodiment of variability may be read as a commentary on a diverse society with overlapping identities and combinations of relations characterizing complex social personae. When objects changed hands in fragment or complete-object enchainment, biographies were enriched and a new layer of colourful meaning was added to the exchange chain. The density of enchained meanings in such networks was one of the primary constituents of these prehistoric communities, whose colour pathways were important enough to stimulate demand for a regular supply of colourful exotic objects.

Acknowledgements

Acknowledgements and grateful thanks to the University of Durham for granting me research leave in 1996–1997, the period when I started on colour research; to the UCL Department of Anthropology and especially the Head of Department, Mike Rowlands, for hospitality and many helpful discussions. To my Durham colleagues in archaeology for discussions, colour references and general support; to Bob Layton for discussions and references; to Jim Good for interdisciplinary feedback; to Stuart Jones for help with mineralogy. To Penelope Rogers for discussions, suggestions about dye literature and comments on an earlier draft; to Carole Gillis and Amanda Chadburn and others at the EAA-1998 at Gothenburg for stimulating discussions. To Henrieta Todorova for illuminating discussions; to Maya Avramova for showing me some of her material from Durankulak; to Todor Dimov for showing me the site of Durankulak and much material and for answering questions about the colour of objects; to Sonja Dimitrova for translation and good company. To the late Ivan Ivanov for long discussions and for showing me much material; to Alexander Mintchev for offering study facilities in his museum. To Bisserka Gaydarska for finding references not available in Britain.

References

Avramova, M. (1991), 'Gold and copper jewelry from the chalcolithic cemeteries near the village of Durankulak, Varna district', in J-P. Mohen and C. Eluère (eds), *Découverte du métal*, Paris: Picard, 43–8.

Baines, J. (1985), 'Color terminology and color classification: ancient Egyptian color terminology and polychromy', *American Anthropologist*, 87, 282–97.

Barber, E.J.W. (1999), 'Colour in early cloth and clothing', *Cambridge Archaeological Journal*, 9(1), 117–20.

Berciu, D. (1966), *Cultura Hamangia: Noi contributii*, Bucharest: Institutul de Arheologia al Academiei RPR.

Berlin, B. and Kay, P. (1969), *Basic Color Terms: Their Universality and Evolution*, Berkeley: University of California Press.

Binford, S.R. and Binford, L.R. (1968), *New Perspectives in Archaeology*, Chicago: Aldine.

Bolton, R. (1978), 'Black, white, and red all over: the riddle of color term salience', *Ethnology*, 17(3), 287–311.

Boyadziev, Y. (1995), 'Chronology of prehistoric cultures in Bulgaria', in D.W. Bailey and I. Panayotov (eds), *Prehistoric Bulgaria*, Monographs in World Archaeology 22, Madison, WI: Prehistory Press, 149–91.

Bozhilova, E. and Filipova, M. (1975), 'Polenov anliz na kulturi plastove ot Varnenskoto Ezero', *Izvestia na Narodiya Muzej v Varna*, 11(26), 19–25.

Bozhilova, E. and Tonkov, S. (1983), 'Palaeoecological studies in lake Duran-kulak', *Annuaire de l'Université de Sofia*, Faculté de Biologie, 76: 25–31.

Brown, R. and Lenneberg, E. (1954), 'A study in language and cognition', *Journal of Abnormal and Social Psychology,* 49, 454–62.

Bulgarska Akademiya na Naukite (1984), *Istorija na Dobrudzha*, Volume 1, Sofia: Bulgarska Akademiya na Naukite.

Cantacuzino, Gh. (1969), 'The prehistoric necropolis of Cernica and its place in the Neolithic cultures of Romania and Europe in the light of recent discoveries', *Dacia* N.S., XIII, 45–59.

Casson, R.W. (1997), 'Color shift: evolution of English color terms from bright-ness to hue', in C.L. Hardin and L. Maffi (eds), *Color Categories in Thought and Language*, Cambridge: Cambridge University Press, 224–39.

Chapman, J. (1983), 'Meaning and illusion in the study of burial in Balkan prehistory', in A. Poulter (ed.), *Ancient Bulgaria*, Volume 1, Nottingham: University of Nottingham Press, 1–45.

Chapman, J. (1989) 'The early Balkan village', *Varia Archaeologica Hungarica*, 2, 33–53.

Chapman, J. (1990), 'Social inequality on Bulgarian tells and the Varna problem', in R. Samson (ed.), *The Social Archaeology of Houses*, Edinburgh: Edinburgh University Press, 49–92.

Chapman, J. (1991), 'The creation of social arenas in the Neolithic and Copper Age of South East Europe: the case of Varna', in P. Garwood, P. Jennings, R. Skeates and J. Toms (eds), *Sacred and Profane*, Oxford Committee for Archaeology Monograph No. 32, Oxford: Oxbow, 152–71.

Chapman, J. (1994), 'The living, the dead, and the ancestors: time, life cycles and the mortuary domain in later European prehistory', in J. Davies (ed.) *Ritual and Remembrance: Responses to Death in Human Societies*, Sheffield: Sheffield Academic Press, 40–85.

Chapman, J. (1996), 'Enchainment, commodification and gender in the Balkan Neolithic and Copper Age', *Journal of European Archaeology*, 4, 203–42.

Chapman, J. (1997), 'The origins of tells in eastern Hungary', in P. Topping (ed.), *Neolithic Landscapes*, Oxford: Oxbow, 139–64.

Chapman, J. (1998), 'Objects and places: their value in the past', in D.W. Bailey (ed.), *The Archaeology of Value. Essays on Prestige and the Processes of Valuation*, International Series I-730, Oxford: British Archaeological Reports, 106–30.

Chapman, J. (2000), *Tensions at Funerals: Micro-Tradition Analysis in the Later Prehistory of Hungary*, Budapest: Archaeolingua.

Chapman, J. (2000a), *Fragmentation in Archaeology: People, Places and Broken Objects in the Prehistory of South Eastern Europe*, London: Routledge.

Chapman, J. (2001), 'Domesticating the exotic: reflections on Cucuteni-Tripolye exchange with steppe and forest-steppe communities', in C. Renfrew (ed.), *The Cambridge Eurasian Steppe Conference*, Cambridge: MacDonald Institute for Archaeological Research.

Collier, G.A. (1976), 'Further evidence for universal color categories', *Language*, 52(4), 884–90.

Conklin, H.C. (1952), 'Hanunoo color categories', *South Western Journal of Anthropology*, 11(4), 339–44.

Conklin, H.C. (1973), 'Color categorization. Review of Berlin and Kay 1969', *American Anthropology*, 75(4), 931–42.

Davidoff, J. (1997), 'The neurophysiology of color', in C.L. Hardin and L. Maffi (eds), *Color Categories in Thought and Language*, Cambridge: Cambridge University Press, 118–34.

Dimov, T., Boyadziev, Y. and Todorova, H. (1984), 'Praistoricheskiyat nekropol krai selo Durankulak, Tolbukhinski okrug', *Dobrudzha*, 1, 74–88.

Durbin, M. (1972), 'Basic terms – off-color ?', *Semiotica*, 6(3), 257–78.

Fol, A. and Lichardus, J. (1988), *Macht, Herrschaft und Gold*, Saarbrücken: Moderne Galerie des Saarlands-Museum.

Fol, A., Katincharov, R. and Lichardus, L. (1988), 'Die bulgarisch-deutschen Ausgrabingen in Drama', in A. Fol and J. Lichardus (eds), *Macht, Herrschaft und Gold*, Saarbrücken: Moderne Galerie des Saarlands-Museum, 151–80.

Foucault, M. (1973), *Madness and Civilisation: a History of Insanity in the Age of Reason*, New York: Random House.

Gale, N. and Stos-Gale, Z. (unpublished), 'Early metallurgy in Bulgaria', Paper presented to conference 'From Rocks to Roubles: trade and exchange in the prehistory of Central and Eastern Europe', Durham, 20/III/1999.

Georgiev, G.I. (1988), 'Die Kupferzeit (Karanovo V und Karanovo VI) in Bulgarien', in A. Fol and J. Lichardus (eds), *Macht, Herrschaft und Gold*, Saarbrücken: Moderne Galerie des Saarlands Museums, 27–48.

Grbiç, M. (1934), 'Neolitsko groblje u Botosu kod Velikog Beckereka', *Starinar*, 3rd Series, VIII-IX, 40–58.

Hacking, I. (1995), 'Three parables', in R.B. Goodman (ed.), *Pragmatism: a Contemporary Reader*, London: Routledge, 237–49.

Helms, M.W. (1988), *Ulysses' Sail: An Ethnographic Odyssey of Power, Knowledge and Geographical Distance*, Princeton: Princeton University Press.

Hewes, G.W. (1992), 'Comment on MacLaury', *Current Anthropology*, 33(2), 163.

Hosler, D. (1994), *The Sounds and Colors of Power*, Cambridge, Mass: MIT Press.

Ivanov, I. S. (1978), 'Les fouilles archéologiques de la nécropole chalcolithique à Varna (1972–1975)', *Studia Praehistorica*,1–2, 13–26.

Ivanov, I. (1991), 'Der Bestattungsritus in der chalkolitischen Nekropole von Varna (mit einem Katalog des wichtigsten Graber)', in J. Lichardus, J. (ed.), *Die Kupferzeit als historische Epoche*, Saarbrücker Beitrage zur Altertumskunde 55, Saarbrücken: Saarland Museum, 125–50.

Kay, P. (1975), 'Synchronic variability and diachronic change in basic color terms', *Language in Society*, 4, 257–70.

Kay, P. and Kempton, W. (1984), 'What is the Sapir-Whorf hypothesis?', *American Anthropologist*, 86, 65–79.

Kay, P. & McDaniel, C.K. (1978), 'The linguistic significance of the meanings of basic color terms', *Language*, 54, 610–46.

Kay, P., Berlin, B. and Merrifield, W. (1991), 'Biocultural implications of color naming', *Linguistic Anthropology*, 1, 12–25.

Kay, P., Berlin, B. and Merrifield, W. (1997), 'Color naming across languages', in C.L. Hardin and L. Maffi (eds), *Color Categories in Thought and Language*, Cambridge: Cambridge University Press, 21–56.

Lichardus, J. (1988), 'Der westpontische Raum und die Anfange der kupferzeitlichen Zivilisation', in A. Fol and J. Lichardus (eds), *Macht, Herrschaft und Gold*, Saarbrücken: Moderne Galerie des Saarlands Museums, 79–130.

Lichardus, J. (1991), *Die Kupferzeit als historische Epoche*, Saarbrucker Beitrage zur Altertumskunde 55, Saarbrücken: Saarland Museum.

Lucy, J. A. (1997), 'The linguistics of color', in C.L. Hardin and L. Maffi (eds), *Color Categories in Thought and Language*, Cambridge: Cambridge University Press, 320–46.

MacLaury, R.E. (1992), 'From brightness to hue: an explanatory model of color-category evolution', *Current Anthropology*, 33(2), 137–86.

McNeill, N.B. (1972), 'Colour and colour terminology', *Journal of Linguistics*, 8, 21–33.

Maffi, L. and Hardin, C.L. (1997), 'Closing thoughts', in C.L. Hardin and L. Maffi (eds), *Color Categories in Thought and Language*, Cambridge: Cambridge University Press, 347–72.

Margos, A. (1978), 'Les sites lacustres dans les lacs de Varna et la nécropole de Varna', *Studia Praehistorica*, 1–2, 146–8.

Merrifield, W.R. (1971), 'Review of Berlin and Kay 1969', *Journal of Linguistics*, 7(2), 259–68.

Mervis, C.B. and Roth, E.M. (1981), 'The internal structure of basic and non-basic color categories', *Language*, 57(2), 384–405.

Milisauskas, S. (1983), 'Bandkeramische Obsidianartefakte aus Olszanica', *Archäologisches Korrespondenzblatt*, 13(2), 171–5.

Miller, D. (1985), *Artefacts as Categories: A Study of Ceramic Variation in Central India*, Cambridge: Cambridge University Press.

Murton, D. (1980), 'There's no such beast: cattle and colour naming among the Mursi', *Man*, N.S., 15, 320–38.

Ratliff, F. (1976), 'On the psychophysiological bases of universal color terms', *Proceedings of the American Philosophical Society*, 120(5), 311–30.

Renfrew, C. (1986), 'Varna and the emergence of wealth', in A. Appadurai (ed.), *The Social Life of Things*, Cambridge: Cambridge University Press, 141–68.

Rosch, E. (1971), '"Focal" color areas and the development of names', *Development Psychology*, 4, 447–55.

Sahlins, M.D. (1976), 'Colors and cultures', *Semiotica*, 16(1), 1–22.

Saunders, B.A.C. (1995), 'Disinterring *Basic Color Terms*: a study in the mystique of cognitivism', *History of the Human Sciences*, 8(4), 19–38.

Saunders, B.A.C. and van Brakel, J. (1988), 'Re-evaluating *Basic Color Terms*', *Cultural Dynamics*, 1, 359–78.

Schiffer, M.B. (1999), *The Material Life of Human Beings*, London: Routledge.

Sivik, L. (1997), 'Color systems for cognitive research', in C.L. Hardin and L. Maffi (eds), *Color Categories in Thought and Language*, Cambridge: Cambridge University Press, 163–93.

Stanlaw, J. (1997), 'Two observations on culture contact and the Japanese colour nomenclature system', in C.L. Hardin and L. Maffi (eds), *Color Categories in Thought and Language*, Cambridge: Cambridge University Press, 240–60.

Taçon, P.S.C. (1991), 'The power of stone: symbolic aspects of stone use and tool development in western Arnhem Land, Australia', *Antiquity*, 65, 192–207.

Tilley, C. (1999), *Metaphor and Material Culture*, Oxford: Blackwell.

Todorova, H. (1984), 'Dobrudzha prez praistoricheskata epoha', in Bulgarska Akademiya na Naukite (ed.), *Istorija na Dobrudzha*, Volume 1, Sofia: Bulgarska Akademiya na Naukite, 23–71.

Todorova, H. and Vajsov, I. (1993), *Novo-kamennata epoha v Bulgariya*, Sofia: Nauka i Izkustvo.

Wierzbicka, A. (1990), 'The meaning of color terms: semantics, culture, and cognition', *Cognitive Linguistics*, 1(1), 99–150.

White on Blonde: Quartz Pebbles and the Use of Quartz at Neolithic Monuments in the Isle of Man and Beyond

Timothy Darvill

Another form of personal ornament, or, more probably, amulet or charm, consisted of pebbles, usually selected for their beauty or some singularity of appearance . . . The symbolism of the white pebble as representing happiness or a happy day, was widely known. The *calculi candore laudatus dies* was not confined to the Romans (Evans 1897: 468)

Introduction

In the Neolithic of the British Isles, white materials seem to have been preferentially selected. This is most marked in the surface treatment of earthworks made from chalk, limestone, and other light-coloured bedrock. The importance of such treatment may be seen at the Thornborough Circles, North Yorkshire, where the henges were covered in gypsum perhaps to imitate the great white southern henges such as Avebury or Knowlton (Thomas 1955: 436). Commentators have remarked on the impact that these white monuments would have had in the landscape when first built, but only recently has this been followed through to explore wider symbolic implications (Lynch 1998). White stone was also used in the construction of chambered tombs (Jones 1999; Bradley 2000). Most notable is the presence of white stones in burials and ceremonial contexts, the selection of which, as Evans suggests in the passage above, presumably had a special symbolic meaning. The role of white stone as a deliberately selected natural material, deposited and used in formal and structured ways, suggests that it was imbued with symbolic meaning.

In the north and west of the British Isles the most common white rock is quartz. This chapter seeks to explore the archaeological associations and context of quartz, in particular white quartz pebbles. Quartz, it is argued, was used by Neolithic communities as a substance in which colour and material combined to give expression to symbolically constructed meanings.

Whiteness, colour, and quartz

White as a colour term, and by extension those objects, structures, and things defined as being white, is replete with shades of meaning and symbolic imagery. Peace, innocence, purity, cleanliness, virginity, goodness, life, happiness, newness, and coolness are among the many interlinked symbolic associations current in the western Christianized world. Following Berlin and Kay's analysis of colour terms (1969) it seems that words for white can be found in every spoken and written language, usually in binary opposition to a term for black.

The assumed universality of colour terms for white and black, and their widespread integration into the symbolic structures of particular communities, may be based on the very ubiquity of white materials in association with the human body and with common elements of the natural world. At the simplistic level it is the act of naming and classifying things that underpins the creation of a system of meanings and allows symbolic relationships to form between colours and particular understandings of the world. For Durkheim and Mauss, primitive classification was culturally specific even though the principle of 'hierarchized notions' ran through all such that 'their object is not to facilitate action, but to advance understanding, to make intelligible the relations which exist between things' (Durkheim and Mauss 1969: 81). Lévi-Strauss (1963: 92) went further in proposing formal linkages between language and symbolism, noting in passing the way in which the human brain appears to link sound and colour in the way that words, connections and associations are made. In a sense, the symbolism that is widely associated with the colour-term white is 'natural symbolism' because it relates most often to aspects of the human body and immediately experienced environment (cf. Douglas 1973).

The way in which a few key colours are deeply embedded in the symbolic systems and cosmological schemes of different societies has been discussed by Turner (1967: 59–72). He notes for the Ndembu of north-western Zambia a belief in three rivers: a red one, a black one and a white one. These provide the basis for a colour triad. Likewise, among the Mandari of the southern Sudan studied by Buxton (1973), symbolic statements involve the use of the same three colours: red, black and white. In particular they use colour abstractions to express fundamental moral and affective states and oppositions. They also use colour to change physical conditions, to reverse a given order. These and other anthropological studies take the question of colour classification out of the modern Western world and into the domain of many other societies in time and space, and in so doing allows the cautious analysis of colour symbolism in archaeologically documented societies.

Within the British Isles, quartz[1] occurs in the landscape as: surface outcrops of living rock, mainly as veins; as boulders detached and moved from source outcrops by glacial or fluvial action; as water-worn pebbles in the beds of rivers

or along the coast on beaches; and, finely crushed or heavily abraded, as constituent particles in gravels, sands, and coarse clays. These sources have been recognized as blocks used in the construction of ceremonial and ritual monuments such as stone circles and standing stones (Burl 2000), raw material for the manufacture of artefacts and tools (Bradley 1995), a tempering agent in later Neolithic pottery (Gibson 1995: 24) and, as pebbles, some kind of talisman or token to be deposited at burial places and other similar sites (Lebour 1914). Quartz attracts attention not only because of its colour but also because of its natural sparkle and luminescence.

Quartz at Billown and beyond

At the focus of the Billown Neolithic Landscape Project, Isle of Man is the excavation of the Billown Quarry Site in the middle of the southern plain (Figure 3.1), between the Silver Burn and the Dumb River (see Darvill 1996a; 1997; 1998; 1999; 2000). Fieldwork has revealed a series of enclosures closely associated with a group of pits, shafts, scoops, earthfast jars, a mini-henge, and a pit-circle. Collectively the activities relating to the construction and use of these features span the period from the early fifth millennium BC through to the early second millennium BC.

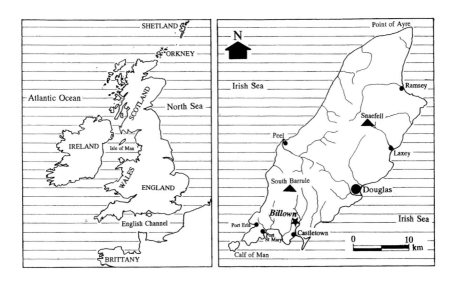

Figure 3.1 Location map showing the Isle of Man in relation to the British Isles and the western seaways (left) and the position of Billown in relation to modern settlement and the principle mountains in the Island (right).

One of the most numerous categories of finds were white quartz pebbles. These water-worn pebbles fit comfortably in the hand and could conveniently be carried in a pocket or small bag. The pebbles average about 90g in weight but have a median of about 55g. Some 600 quartz pebbles were recovered from archaeological contexts (Evans in Darvill 1996a: 37; Smith in Darvill 1998: 19–23). Red pebbles, black pebbles, and speckled pebbles of rock from the offshore island of Ailsa Craig have also been recovered in smaller numbers. This suggests that at Billown white pebbles were dominant. All the pebbles are of a shape, size, and character paralleled by assemblages on present-day beaches around the southern shores of the Island. Accordingly, it is contended that the pebbles were all brought to Billown from the coast which at its nearest is about 3km distant.[2]

Quartz pebbles in the Billown sequence

White quartz pebbles have been found in all parts of the areas excavated to date, but they concentrate in and around the Neolithic enclosure boundaries, in pits, hollows and shafts, and in the cuts forming the key components of other structures (Figure 3.2).

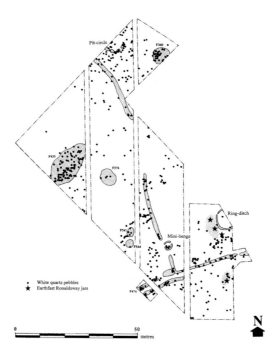

Figure 3.2 Billown Quarry Site: distribution of white quartz pebbles recorded during the 1996–1998 excavations in relation to key features mentioned in the text.

Approximately 140m of enclosure ditch has now been examined, mainly part of the northern boundary of a D-shaped enclosure but including a more ephemeral boundary that might define a small northern annexe or represent formal land division outside the enclosure. Two main phases are represented, the first being a continuous ditch with a staggered entrance created by overlapping ditch terminals. The second includes causewayed ditches and a more elaborate entrance with post-settings on either side and a cobbled surface in the entrance. All the ditches show signs of recutting. Quartz pebbles were deposited in all the ditch cuttings examined, but the most impressive are in the second-phase ditches which may tentatively be dated to the later fourth or early third millennium BC. Figure 3.3 shows the floor of one section through the terminal area of F474 excavated in 1997. The white quartz on the base of the ditch is clearly visible. Since the colour of the natural glacial till hereabouts is a pale buff, when dry this could be described as white on blonde. The first appearance of the pebbles was reminiscent of the way that the rounded tops of human crania first appear during excavation. No bone is preserved in the prehistoric deposits at Billown, but the position of the quartz pebbles invites comparison with the deliberate placement of human crania on the ditch floor of the main enclosure at Hambledon Hill, Dorset (Mercer 1980: 30).

Pits, shafts, and scoops lie outside the northern boundary of the main enclosure at Billown, perhaps in specially dedicated space. Radiocarbon dates suggest a

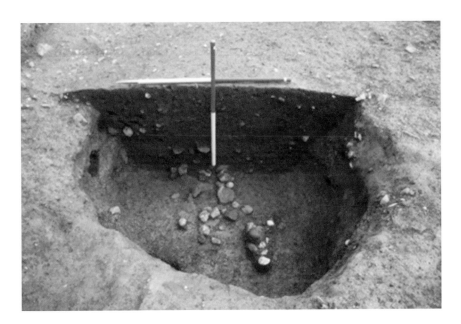

Figure 3.3 White quartz pebbles on the floor of early Neolithic ditch F474 in Site M at the Billown Quarry Site. (Photograph by Timothy Darvill. Copyright reserved)

continuous sequence of pit-digging from the early fifth millennium through to the mid-second millennium BC. It is the larger pits of third millennium BC date that contain the most quartz pebbles. Like many smaller examples on the site, these pits contain hearths and scatters of debris such as broken pottery, plant remains, flintwork, and more than 50 quartz pebbles. One of the lower hearths in F431 has a radiocarbon date of 2886–2586 BC (4170±90 BP: Beta-129019). A slightly earlier pit, F360, contained 14 quartz pebbles and had a radiocarbon date of 3630–3190 BC (4650±150 BP: Beta-129973) from a hearth low down in the fill. The examination of charred plant remains from the fills of the Neolithic pits and ditches (Fairbairn in Darvill 1999: 14–22) has revealed cereal grains and a range of autumn fruits including apple, blackberry, rosehips, haws, and hazelnuts. In some cases the pits show signs of repeated use over a period of time and it is suggested that their content and fill patterns may best be interpreted as evidence of periodic visits.

Periodic visits structure the activities involving the earthfast jars of Ronaldsway style that also date to the third millennium BC (Burrow and Darvill 1997). Four of these have been found at Billown to date, all in a discrete area. When first deposited they comprized complete vessels buried in the ground with their rims at sub-soil level, with a flat stone slab covering the open mouth. The slab could potentially have been removed at any time to allow access to the interior of the vessel. Detailed studies suggest that these were either empty or filled with undetectable substances such as water. It has been suggested that they:

> may have served to contain offerings to the dead; being so near to the surface they could even have been used for seasonal offerings . . . covered again by the slab each time after they had been used for this purpose. Bersu (1947: 169)

Another possibility, based on suggestions for the use of pits and shafts in later prehistoric times (Ross 1967: 24–33; 1968: 277) is that these vessels were conduits through which people could communicate with the spirits of the underworld. No quartz pebbles have been found inside the earthfast jars at Billown, but they are found scattered densely in the vicinity.

The mini-henge comprised two ditch segments with opposed entrances defining an internal area 1.8m across. In the central area was a series of 12 small intercutting pits and scoops. Most contained one or more quartz pebbles although a larger scoop contained burnt bone, charcoal, and quartz pebbles.

Quartz pebbles were also well-represented in and around part of a pit-circle outside the main enclosure north of the area dominated by pits and shafts. Four oval pits, representing about half of this putatively horseshoe-shaped pit circle, was excavated in 1999 (Darvill 2000: 10). White quartz pebbles were found in the lower fill and across the floor of the pits.

Quartz boulders in related monuments

Closely associated with the structures revealed in the Billown Quarry Site are three standing monuments that utilize blocks of quartz in their construction. About 100m west of the main Billown enclosure is the Booilevane Stone, a large standing stone made by raising a large block of quartz. About 1km to the south-east on the next hill is the Skibrick Hill Stone which comprises a large quartz boulder projecting 1.2m out of the ground (Figure 3.4). In reasonable sunlight the Booilevane Stone can be seen up to 7km away, for example from the passage grave on Mull Hill. The third monument in the group is the Billown Stone circle (Cubbon 1945) now embedded in the garden of a private house (Plate 3). Fourteen pillars of the original circle can still be traced, all of them quartz boulders (Darvill 1996a: 44–7).

Quartz on the mountain

The source of these quartz boulders is not precisely known. It is likely to have been one of the natural quartz veins outcropping on South Barrule, the second highest mountain on the island, capped by a later Bronze Age enclosure, a potentially

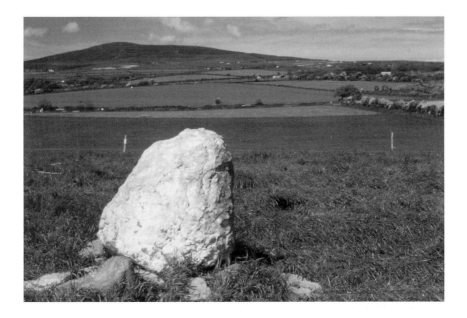

Figure 3.4 The Skibrick Hill Stone, Malew, Isle of Man, a large standing stone created using a natural quartz boulder. The Booilevane Stone can be seen in the background. (Photograph Timothy Darvill. Copyright reserved)

earlier inner enclosure, and a large cairn (Fulton in Darvill 1997: 47–52). It is reasonable to suppose that South Barrule was recognized as a significant source of quartz, a view supported by two strands of evidence. First, on the north side of the mountain there are numerous quartz mounds that seem to be the result of people shaping quartz boulders. Some are early prehistoric in date (Pitts 1999). Second, the realignment of the entrance through the northern enclosure boundary at Billown provides a direct view of South Barrule. For anyone walking north-wards out of the main enclosure toward the area dominated by pits and shafts, South Barrule provides a dramatic presence (cf. Darvill 1996b: 235). The realignment of the entrance probably took place during the third millennium BC, when interest in the deposition of quartz pebbles was strongest and structures such as standing stones and stone circles were being built.

Quartz at other Neolithic sites in the Isle of Man

White quartz is a feature of many other Neolithic sites on the island. At the Mull Hill tomb, white quartz pebbles were found in all six of the chambers (Piggott 1932: 148). The possible passage grave at Corvalley incorporates quartz boulders in the construction of the chamber (Megaw 1938: 238; Daniel 1950: 180), while excavations in the chamber of the passage grave at Ballaterson revealed quartz pebbles scattered through the fill (Harrison 1915: 470). The most thoroughly investigated long barrow is Cashtal yn Ard (Fleure and Neely 1936; Darvill and Chartrand in Darvill 2000: 34–44). Here, a standing stone at the south-east end of the monument, possibly predating the construction of the long barrow, was found to have a group of white quartz pebbles on its north side. No fewer than 125 were found in this group and scattered around the eastern end of the barrow. Although quartz is not used in the construction of the chambers or the barrow mound, one of the portal stones giving access to the chambers from the back forecourt in the west end of the barrow has a vein of quartz running through it.

Of the later Neolithic sites on the island, the stone circle at Arregon Moar has six quartz boulders as pillars and is rather reminiscent of the Billown Stone circle. At Ballaquayle two earthfast jars were associated with a spread of charcoal-rich soil and a scatter of white quartz pebbles (Cubbon 1933: 126).

Quartz at Neolithic sites in northern and western Britain

The incidence of white quartz in the Clyde tradition long barrows in south-west Scotland is discussed by Henshall (1972: 97), who records the presence of quartz blocks and boulders used in the construction of two barrows. At Beacharra and Clach no Tiompan quartz was used in the blocking, and at Cairnholy I white quartz

was found scattered along the front of the revetment. At Walton Farm, Nether Largie, Kilchoan, and Glecknabae numerous white quartz pebbles were found in the chambers. On Arran, white stones were used in the construction of chambered tombs, but here it was local granites and schists with quartz being found scattered in the forecourt of some tombs. Jones (1999) notes that three colours are prevalent in the Arran tombs – white, black, and red – and these he links to a series of structured aesthetics which allow those using them to make sense of the world.

Among Cotswold-Severn long barrows, quartz pebbles have been noted at Nympsfield, Gloucestershire, in the blocking deposits at both ends of the mound (Clifford 1938: 204), and at Notgrove and Rodmarton, Gloucestershire (Clifford 1950: 30). In north Wales, Capel Garmon, Pant y Saer, and Ty Newydd are recorded as having contained quartz pebbles (Lynch 1969: 150). Across the Irish Sea, Corcoran (1960: 107) notes the widespread incidence of white quartz pebbles in long barrows of the Carlingford tradition in northern and central Ireland. In southwest Ireland O'Brien (1999: 215–16) notes quartz deposition at Toormore and Altar Wedge Tombs.

The passage graves of the Irish Sea region show the most abundant use of quartz. Among the simple passage graves, Henshall (1972: 150–1) notes quartz at Rudh' an Dunain in the fill of the chamber, in the forecourt and in the cairn. Chips of quartz were also noted at Unival, but at Achnacree, Argyll, the rather special role of white quartz pebbles can be best glimpsed. The excavator of the site noted of the quartz pebbles that 'when we looked into the dark chamber from the outside they shone as if illuminated' (Smith 1872: 412). Quartz pebbles are recorded at Kilcoy South and Ardvreck in the Orkney-Cromerty tombs, the latter associated with blocking deposits (Henshall 1963: 103).

Quartz has long been recognized as a component of the Clava cairns in eastern Scotland (Henshall 1963: 31; 1972: 273). Fairly recently the range of colours integrated into the architecture of these structures has been expanded to include the now familiar triad of red, black, and white (Bradley 2000). At the Balnuaran of Clava ring-cairn the monoliths containing quartz were set around the north-east sector of the circle, suggesting an association with the rising sun (Bradley 2000: 127; Trevarthen 2000).

All three passage graves on Anglesey contained quartz pebbles (Lynch 1969: 150), the most impressive of which is Bryn Celli Ddu where deposits were found in the fill of the passage leading to the central chamber. Access to the inner passage was by a row of quartz boulders, and outside the chamber on the right of the entrance was a small platform of white quartz pebbles and hearths that had built up against the kerb of the mound (Hemp 1930: 193–4 and 209).

Quartz is well represented in all the excavated passage graves in the Carrowmore cemetery, Sligo (Bergh 1995: 153; Burenhult 1984), with Bergh (1995: 153) suggesting that:

as a source of power, the quartz can have been seen as giving the dead the power to undertake the journey to the other-world. Quartz as 'the stone of light', can also have symbolized life, an assurance of re-birth.

It is among the passage graves of the Boyne Valley in eastern Ireland that the use of quartz is most marked. At Newgrange the exterior wall of the massive cairn has been reconstructed with a near-vertical facing of white quartz and grey granite based on interpretations of the collapsed material around the cairn (O'Kelly 1982: 85–92). It is questionable whether the quartz blocks were used to form a wall rather than as a covering for the cairn material as Macalister suggested (1939). Either way they would have looked impressive, but there is also the possibility that much of the quartz was brought to the site in connection with the use of the stone circle that surrounds the passage grave. A pair of quartz blocks was also used to provide a movable cover to the front end of the roof-box immediately above the entrance. At times when the sunlight was allowed to shine through the roof-box into the central chamber (the mid-winter rising sun) these cover-stones would have been slid aside (O'Kelly 1982: 96). The use of quartz may betoken a connection between quartz and the sun itself. Nearby, at Knowth, white quartz and dark granodiorite was also used in the construction of the mound with spreads of quartz in front of the eastern passage (Eogan 1986: 47; Mitchell 1992). These and other uses of coloured stones in the Irish passage graves have led Sheridan (1986) to suggest that zones of astronomical or orientational significance may have been emphasized through symbolic associations with the stones. The importance of quartz blocks in the construction or use of the monument is underlined by the fact that they were brought to the Boyne Valley from the Wicklow Mountains over 50km to the south (Mitchell 1992: 128–9).

Aside from chambered tombs there are many other classes of monument at which quartz was widely used and white quartz pebbles regularly deposited. Burl (2000) illustrates the extremely widespread use of quartz in the construction of stone circles and how frequently quartz pebbles or broken boulders were scattered within the circle. Burl argues that the Recumbent Stone Circles of eastern Scotland were constructed in relation to lunar events so that, he speculates,

the steady procession of the moon above the recumbent that was wanted . . . minutes of moonlight when quartz glowed luminescently and when nocturnal ceremonies were performed. (2000: 226)

The inescapable conclusion from these numerous strands of evidence is that white quartz became sufficiently significant in the lives of people during the early Neolithic that they selectively used it in monument building and as part of the portable material culture associated with the actions and events enacted at these

places.[3] This was a tradition that carried through into the later Neolithic when interest in quartz in all its main manifestations (outcrop, boulder, and pebble) intensified.

Whiteness, quartz, and Neolithic symbolism

Although it is widely accepted that certain colour-terms are almost universal, and that colour-categories relate closely to widely recognizable symbolic associations, it remains the case that the link between particular colour-terms and specific colour-categories is far from simple. At one extreme is the position that all colour symbolism and aesthetic appreciation of colour schemes are not only socially determined but also highly specific to individual communities and the contexts of specific actions and events. At the other extreme is the notion that there exist universal categories.

In exploring colour symbolism in the Neolithic of Scandinavia, Tilley (1996: 321) resorts to universals by accepting Turner's (1967) view that the earliest symbols produced are the three colours representing products of the human body. This provides one route into the possible significance of colours. But in many cases detail is lacking because knowledge about wider cosmological schemes is absent. For western parts of the British Isles, however, such a lacuna can perhaps be partly overcome through resort to a quasi-ethnography represented through folklore studies and the recorded continuation of certain potentially ancient traditions down into early historic times.[4] The use of white quartz is one such long-lived tradition that can be approached in this way.

Quartz – a continuing relationship?

The post-Neolithic use of quartz has been well documented. Lebour (1914) made an extensive inventory of Bronze burial monuments associated with white quartz pebbles, including Mid Torrs, Glenluce, Wigtownshire; Dunragit, Wigtownshire; and Burgie, Forres, Grampian, and drew attention to Mitchell's earlier inventory (Mitchell 1884). Many others could now be added from late twentieth-century work including Staarvey Farm, Kirk German (Woodcock 1999: 90) and Killeaba, Ramsey (Cubbon 1978) in the Isle of Man. For the Iron Age there are far fewer relevant contexts for the deposition of white quartz, but Garrad (1991) notes associations with the use of wells and springs at this time (Moore 1894: 218–19). Associations of white pebbles with sacred wells is attested in north Wales (Rees 1937: 88; Jones 1954: 96; Crowe 1982: 414). The use of white quartz stones became common again in the early Christian period, although this may be as much to do with the availability of deposits in which they are preserved as with their

actual use in the past. Crowe (1982) and Garrad (1991) provide ample document-ation on the incidence of white quartz pebbles in and on graves from the earliest Christian burials in the Isle of Man and Irish Sea area, dating from the sixth or seventh century AD through to modern times. They also discuss the common occur-rence of white quartz pebbles within and around early chapels and churches (keeills).

Multi-phase sites spanning the prehistoric and early Christian periods serve to reinforce the long duration of the tradition. For example, at the tumulus reused as the site of a keeil at Cronk yn How, Ramsey, Isle of Man, white stones were placed with both pagan and Christian burials, and 160 stones were found in the body of the mound (Bruce and Cubbon 1931: 290).

At the heart of the question is how the stones were used and what they represented. As noted earlier, the range of coloured pebbles found at Billown includes red, black, white, and speckled. White quartz pebbles are in the majority at the site, but must be seen as simply one part of a wider colour scheme.[5] At Billown the pebbles were mainly scattered around what might be regarded as ceremonial contexts (shafts, enclosure boundaries, mini-henge, etc.), some of which may have involved graves and burials. The context of white quartz pebbles in early Christian times seems to be similar. Some are found in graves, suggesting deposition by the mourners or those involved in the act of burial itself, but most are found scattered above and around graves and at associated chapels, keeils, and sacred places (including wells).

White stones are obviously pieces of the natural world taken into a social domain, and in this sense may have been seen as having a spirit or character. The close physical association with water, their place of origin in the sea or in river-beds, and in particular wells and springs, suggests that here there may be a symbolic link to one of the elements. The moon is widely regarded as significant in the operation of later Neolithic and early Bronze Age sites that used copious amounts of quartz. Indeed, Burl speculates that the white pebbles within some stone circles were soul-stones, symbolizing the moon to which the spirits of the dead had gone (Burl 1981: 93). Quartz is also widely found in the passage graves of Ireland with their strong links to spiral decoration (Twohig 1981: 114). The presence of quartz in structures such as Newgrange and the Clava Cairns which appear to be cosmically referenced to solar events (especially wintertime sunrise) may be reconsidered in terms of oppositions between the sun and the moon.

Conclusions

Understanding the full symbolism of white quartz in the Neolithic is impossible without a knowledge of cosmology. That the colour white was important may reasonably be inferred on the basis of its widespread presence in the archaeological

record, cross-cultural comparison, and the apparently universal use of white within the colour lexicons of human communities. Neolithic communities along the Atlantic fringe of north-west Europe regularly selected white stone pebbles for deposition in particular contexts, especially during the third and early second millennium BC at passage graves and what are generally categorized as ceremonial sites. Aubrey Burl's observation that 'fire, quartz, soil and animal bones recur time and again in the British stone circles' (Burl 1981: 112) applies also to a range of contexts.

That white quartz blocks and pebbles continued to be used after the Neolithic is equally clear, especially in the later first and early second millennia AD. Whether over this period of time the meanings and use of these stones remained the same is less certain, but it is notable that the context of deposition in accumulative clusters at ceremonial centres seems to be the same through the centuries. Here it is argued that in north-west Europe the early Church consciously adopted the far earlier symbolism of white pebbles as a means of bridging the ideological gap between the Christian faith and existing belief systems.

Given that colour has great potency in the negotiation of human agency and the structuration of social action, and accepting the argument that echoes of earlier symbolism can be heard through more recent documented associations of white quartz, some provisional statements may be made in relation to the use and meaning of quartz at Billown.

The selective, and deliberate, placement of white quartz pebbles on the floors of ditches, pits, shafts, around earthfast jars, and in the interior of small ditched enclosures may be taken at a general level as symbolizing the presence or soul of a person. In death that symbolic meaning may relate to the idea of a 'passport' to another world, the means of crossing over; for the living the white stone may represent the gateway to other dimensions through which they negotiate with the spirit world. All of these involve the selection of the stone, its movement through space and time by being carried to the site, and its structured deposition. Although it would be inappropriate to call this an act of pilgrimage in the prehistoric context, the social actions represented here are perhaps better called fairs or festivals. Water may be important as an element symbolically linked to the whiteness of the stone; the moon may be the celestial equivalent. Again there are connections between the moon, stones, and water. Colour may also relate to time, white being related very closely with the period around harvest-time, between August and November in the modern calendar. Festivals both large and small in this period shows close connections with white materials, and in both north and south Wales there are nineteenth-century accounts of festivals bracketing the autumn period explicitly involving the collection and use of white pebbles.

In a strictly archaeological context it is also notable that in the relationship between divisions of the year and the arrangement of different coloured stones

around the monuments at Balnuaran of Clava, Trevarthen (2000) found a regular incidence between white stones, autumn-time, and the rising and setting of the sun as viewed from the centre of the monuments.[6]

Space may also be related to colour. At Billown the presence of quartz boulders in the landscape was one of the factors signifying place, while the northern entrance into the main enclosure opens directly towards the highest hill in the southern part of the island. In these matters the colour white and the white quartz rock were perhaps instrumental in conceptually subdividing space and time to establish the sacred geography of the mythical world for these Neolithic communities.

This investigation into the colour symbolism at the Billown Neolithic enclosure perhaps allows the refinement of one established model of interpretation: that of the communal meeting place. It was Isobel Smith who first set out in detail the idea that Windmill Hill, Wiltshire, and other causewayed enclosures like it, were rallying-points for dispersed populations (Smith 1965: 19). Billown fits the general pattern of what might be called 'meeting place enclosures'. In the light of the arguments set out here, the colour symbolism present allows it to be considered as an autumn festival site at which people were able to connect with the spirit world in the earth and the sky.

Notes

1 Chemically speaking quartz is silica (SiO_2). When quite clear and colourless it is usually called rock-crystal. Mainly it is white or slightly pink, yellow-brown, or smoky in colour. Quartzite is a rock made up of fragments of quartz which by metamorphism have become welded or bound together so that the boundaries of the individual pieces are no longer visible unless examined in thin-section under polarized light (Cox et al. 1974).

2 Billown lies on glacial till/boulder clay and thus there is the possibility that these pebbles could have been clasts within the till matrix. Two cubic metres of natural till was hand-sorted to test this possibility. It was found that the abundance of quartz pebbles in the till was very low (<3 per cubic metre) and that, in general, the quartz from the till was more angular than the pebbles recovered from the excavations.

3 There is no evidence that quartz pebbles occur in significant numbers on Mesolithic sites, although Woodman (1987: 5–6) notes the presence of abundant burnt quartz fragments in the fill of the possible sunken house at Cass ny Hawin.

4 Within the British Isles there is little by way of ethnographies of indigenous societies outside the archaeological/historical traditions. However, folklore studies have a long history and provide a parallel strand of documentation, although that needs to be treated with caution (see Gazin-Schwartz and Holtorf

1999) but nevertheless holds some potentially interesting insights. Colour symbolism is in fact an issue that seems to have interested scholars of folklore for some time (e.g. Mackenzie 1922; Temple 1923).

5 One thinks here of the decorated pebbles from the mid-third millennium BC Ronaldsway House (Bruce et al. 1947).

6 At the south-west cairn (Trevarthen 2000: figure 6) the summer quarterdays (in August and May) show the sun rising over white stones in the kerb around the cairn and setting over a red/pink stone. The reverse is represented at the north-east cairn (Trevarthen 2000: figure 8) where sunrise on the same days is over a red stone and sunset is over a white stone. At the ring-cairn that sits between the two previously mentioned cairns (both passage graves) the sun rises and sets over a white or white/pink stone (Trevarthen 2000: figure 8).

Acknowledgements

A number of individuals have assisted in the preparation of material for this chapter and the research behind it by kindly assembling or providing information. Among them, special thanks to Adnan Baysal, Jeff Chartrand, Marshall Cubbon, Peter Davey, Roger Doonan, Damian Evans, Andrew Foxon, Larch Garrad, Peter Harbison, Ian Hodder, Wendy Horn, Andrew Johnson, Astrid Mick, Louise Pearson, Clive Ruggles, Miles Russell, and Eileen Wilkes. Brian Beattie of Ramsey in the Isle of Man kindly led several expeditions into the upland areas of the Island to see distributions of quartz boulders and outcrops.

References

Bergh, S. (1995), *Landscape of the Monuments. A Study of the Passage Tombs in the Cúil Irra Region, Co. Sligo, Ireland*, Arkeologiska undersökningar Skrifter nr 6. Stockholm: Riksantikvarieämbetet.

Berlin, B. and Kay, P. (1969), *Basic Color Terms: Their Universality and Evolution*, Berkeley: University of California Press (reprinted 1999 by CSLI Publications, Stanford).

Bersu, G. (1947), 'A cemetery of the Ronaldsway Culture at Ballateare, Jurby, Isle of Man', *Proceedings of the Prehistoric Society*, 13, 161–9

Bradley, R. (1995), 'Fieldwalking without flints: worked quartz as a clue to the character of prehistoric settlement', *Oxford Journal of Archaeology*, 14(1), 13–22

Bradley, R. (2000), *The Good Stones: A New Investigation of the Clava Cairns*, Edinburgh: Society of Antiquaries of Scotland Monograph 17.

Bruce, J. R. and Cubbon, W. (1931), 'Cronk yn How: an early Christian and Viking site at Lezayre', *Proceedings of the Isle of Man Natural History and Antiquarian Society*, 3(4), (1928–1930), 282–97

Bruce, J.R., Megaw, V.S. and Megaw, B.R.S. (1947), 'A Neolithic site at Ronaldsway, Isle of Man', *Proceedings of the Prehistoric Society*, 13, 139–60

Burenhult, G. (1984), *The Archaeology of Carrowmore*, Thesis and Papers in North-European Archaeology 14, Stockholm: Institute of Archaeology, University of Stockholm.

Burl, A. (1981), *Rites of the Gods*, London: Dent.

Burl, A. (2000), *The Stone Circles of Britain, Ireland and Brittany*, New Haven and London: Yale University Press.

Burrow, S. and Darvill, T. (1997), 'AMS dating of the Ronaldsway Culture of the Isle of Man', *Antiquity*, 71, 412–19

Buxton, J. (1973), *Religion and Healing in Mandari*, Oxford: Oxford University Press.

Clifford, E.M. (1938), 'The excavation of Nympsfield long barrow, Gloucestershire', *Proceedings of the Prehistoric Society*, 4, 188–213

Clifford, E.M. (1950), 'The Cotswold megalithic culture: the grave goods and their background', in C. Fox and B. Dickens (eds), *The Early Cultures of North-west Europe: H.M. Chadwick Memorial Studies*, Cambridge: Cambridge University Press, 21–40.

Corcoran, J.X.W.P. (1960), 'The Carlingford Culture', *Proceedings of the Prehistoric Society*, 26, 98–148

Cox, K.G., Price, N.B. and Harte, B. (1974), *An Introduction to the Practical Study of Crystals, Minerals and Rocks* (rev. edn), London: McGraw Hill.

Crowe, C.J. (1982), 'A note on white quartz pebbles found in early Christian contexts on the Isle of Man', *Proceedings of the Isle of Man Natural History and Antiquarian Society*, 8(4) (1978–1980), 413–15.

Cubbon, A.M. (1978), 'Excavation at Killeaba, Ramsey, Isle of Man', *Proceedings of the Prehistoric Society*, 44, 69–96

Cubbon, W.C. (1933), 'Cinerary urn found at Ballaquayle, Douglas', *Journal of the Manx Museum*, 2(36), 126.

Cubbon, W.C. (1938), 'Excavations at Ronaldsway, 1935', *Proceedings of the Isle of Man Natural History and Antiquarian Society*, 4(2) (1935–1937), 145–60.

Cubbon, W.C. (1945), 'The stone circle at Billown', *Proceedings of the Isle of Man Natural History and Antiquarian Society*, 4(4) (1940–1942), 506–16.

Daniel, G.E. (1950), *The Prehistoric Chamber Tombs of England and Wales*, Cambridge: Cambridge University Press.

Darvill, T. (1996a), *Billown Neolithic Landscape Project, Isle of Man, 1995*, School of Conservation Sciences Research Report 1, Bournemouth and Douglas: Bournemouth University and Manx National Heritage.

Darvill, T. (1996b), 'Billown, Isle of Man', *Current Archaeology*, 13(6) (Number 150), 232–7.

Darvill, T. (1997), *Billown Neolithic Landscape Project, Isle of Man, 1996*, School of Conservation Sciences Research Report 3, Bournemouth and Douglas: Bournemouth University and Manx National Heritage.

Darvill, T. (1998), *Billown Neolithic Landscape Project, Isle of Man, Third Report: 1997*, School of Conservation Science, Research Report 4, Bournemouth and Douglas: Bournemouth University and Manx National Heritage.

Darvill, T. (1999), *Billown Neolithic Landscape Project, Isle of Man, Fourth Report: 1998*, School of Conservation Science, Research Report 5, Bournemouth and Douglas: Bournemouth University and Manx National Heritage.

Darvill, T. (2000), *Billown Neolithic Landscape Project, Isle of Man, Fifth Report: 1999*, School of Conservation Science, Research Report 7, Bournemouth and Douglas: Bournemouth University and Manx National Heritage.

Douglas, M. (1973), *Natural Symbols: Explorations in Cosmology*, Harmondsworth: Penguin.

Durkheim, E. and Mauss, M. (trans. R. Needham) (1969), *Primitive Classification* (2nd edn), London: Cohen and West.

Eogan, G. (1986), *Knowth and the Passage Tombs of Ireland*, London: Thames and Hudson.

Evans, J. (1897), *The Ancient Stone Implements, Weapons and Ornaments of Great Britain* (2nd rev. edn), London: Longmans, Green and Co.

Fleure, H.J. and Neely, G.J.H. (1936), 'Cashtal yn Ard, Maughold, Isle of Man', *Antiquaries Journal*, 16, 373–95

Garrad, L.S. (1991), 'The archaeology and tradition of some prehistoric and early Christian religious practices in the Isle of Man', *Proceedings of the Isle of Man Natural History and Antiquarian Society*, 10(1) (1989–1991), 79–104.

Gazin-Schwartz, A. and Holtorf, C.J. (1999), *Archaeology and Folklore*, London: Routledge.

Gibson, A. (1995), 'First impressions: a review of Peterborough Ware in Wales', in I. Kinnes and G. Varndell (eds), *'Unbaked Urns of Rudely Shape', Essays on British and Irish Pottery*, Oxbow Monograph 55, Oxford: Oxbow, 23–40.

Harrison, S.N. (1915), 'Excavation of a round barrow on Ballaterson Cronk, Maughold', *Proceedings of the Isle of Man Natural History and Antiquarian Society*, 1, 469–70.

Hemp, W.J. (1930), 'The chambered cairn of Bryn Celli Ddu', *Archaeologia*, 80, 179–214.

Henshall, A.S. (1963), *The Chambered Tombs of Scotland, Vol. 1*, Edinburgh: Edinburgh University Press.

Henshall, A.S. (1972), *The Chambered Tombs of Scotland, Vol. 2*, Edinburgh: Edinburgh University Press.

Jones, A. (1999), 'Local colour: megalithic architecture and colour symbolism in Neolithic Arran', *Oxford Journal of Archaeology*, 18(4), 339–50.

Jones, A, and Bradley, R. (1999), 'The significance of colour in European archaeology', *Cambridge Journal of Archaeology*, 9(1), 112–14.

Jones, F. (1954), *The Holy Wells of Wales*, Cardiff: University of Wales Press.

Lebour, N. (1914), 'White quartz pebbles and their archaeological significance', *Transactions and Journal of Proceedings of the Dumfriesshire and Galloway Natural History and Antiquarian Society* (Series 3), 2, 121–34.

Lévi-Strauss, C. (trans. C. Jacobson and B.G. Schoepf) (1963), *Structural Anthropology*, London: Harmondsworth.

Lynch, F. (1969), 'The contents of excavated tombs in North Wales', in T.G.E. Powell, J.X.W.P. Corcoran, F. Lynch and J.G. Scott, *Megalithic Enquiries in the West of Britain*, Liverpool: Liverpool University Press, 149–74.

Lynch, F. (1998), 'Colour in prehistoric architecture', in A. Gibson and D.D.A. Simpson (eds), *Prehistoric Ritual and Religion: Essays in Honour of Aubrey Burl*, Stroud: Sutton, 62–7.

Macalister, R.A.S. (1939), *Newgrange, Co. Meath*, Dublin.

Mackenzie, D.A. (1922), 'Colour symbolism', *Folklore*, 33(2), 136–69.

MacNeill, M. (1962), *The Festival of Lughnassa*, Oxford: Oxford University Press.

Megaw, B.R.S. (1938), 'Manx megaliths and their ancestry', *Proceedings of the Isle of Man Natural History and Antiquarian Society*, 4(2) (1935–1937), 219–39.

Mercer, R.J. (1980), *Hambledon Hill: A Neolithic Landscape*, Edinburgh: Edinburgh University Press.

Mitchell, A. (1884), 'On the occurrence of white pebbles in graves of the Stone and Bronze Age', *Proceedings of the Society of Antiquaries of Scotland*, 18 (1883–1884), 286–91.

Mitchell, F. (1992), 'Notes on some non-local cobbles at the entrances to the passage graves at Newgrange and Knowth, Co. Meath', *Journal of the Royal Society of Antiquaries of Ireland*, 122, 128–45.

Moore, A.W. (1894), 'Water and well worship in Man', *Folklore*, 5(1), 212–29

Neely, G.H. (1940), 'Excavations at Ronaldsway, Isle of Man', *Antiquaries Journal*, 20, 272–86.

O'Brien, W. (1999), *Sacred Ground: Megalithic Tombs in Coastal Southwest Ireland*, Bronze Age Studies 4, Department of Archaeology, National University of Ireland, Galway: University of Galway Press.

O'Kelly, M. (1982), *Newgrange: Archaeology, Art, and Legend*, London: Thames and Hudson.

Piggott, S. (1932), 'The Mull Hill Circle, Isle of Man, and its pottery', *Antiquaries Journal*, 12, 146–57.

Pitts, M.B. (1999), 'Quartz mounds: a preliminary assessment', in P.J. Davey (ed.), *Recent Archaeological Research on the Isle of Man*, British Archaeological Reports British Series 278, Oxford: Archaeopress, 63–74.

Rees, A.D. (1937), 'Notes on the significance of white stones in celtic archaeology and folk-lore with reference to recent excavations at ffynnon Degla, Denbighshire', *Bulletin of the Board of Celtic Studies*, 8 (1935–37), 87–90.

Ross, A. (1967), *Pagan Celtic Britain*, Routledge. London.

Ross, A. (1968), 'Shafts, pits and wells – sanctuaries of the Belgic Britons?' in J. Coles and D.D.A. Simpson (eds), *Studies in Ancient Europe*, Leicester: Leicester University Press, 255–86.

Sheridan, A. (1986), 'Megaliths and megalomania; an account, and interpretation, of the development of passage tombs in Ireland', *Journal of Irish Archaeology*, 3 (1985/6), 17–30.

Smith, I.F. (1965), *Windmill Hill and Avebury. Excavations by Alexander Keiller 1925–1939*, Oxford: Clarendon.

Smith, R.A. (1872), 'Descriptive list of antiquities near Loch Etive', *Proceedings of the Society of Antiquaries of Scotland*, 9, 396–418.

Temple, R.C. (1923), 'Colour symbolism (as a subject for Indian research)', *Indian Antiquary*, 52, 61–5

Thomas, N. (1955), 'The Thornborough Circles, near Ripon, North Riding', *Yorkshire Archaeological Journal*, 152, 425–45.

Tilley, C. (1996), *An Ethnography of the Neolithic: Early Prehistoric Societies in Southern Scandinavia*, Cambridge: Cambridge University Press.

Trevarthen, D. (2000), 'Illuminating the monuments: observation and speculation on the structure and function of the cairns at Balnuaran of Clava', *Cambridge Archaeological Journal*, 10(2), 295–315.

Turner, V. (1967), *The Forest of Symbols: Aspects of Ndembu Ritual*, Ithaca: Cornell University Press.

Twohig, E. (1981), *The Megalithic Art of Western Europe*, Oxford: Clarendon.

Varley, H. (1980), *Colour*, London: Mitchell Beazley.

Woodcock, J. J. (1999), 'A report on the excavation carried out by B.R.S. Megaw at Staarvey Farm, Kirk German', in P.J. Davey (ed.), *Recent Archaeological Research on the Isle of Man*, British Archaeological Reports British Series 278, Oxford: Archeopress, 89–98.

Woodman, J. (1987), 'Excavations at Cass ny Hawin, a Manx Mesolithic site, and the position of the Manx microlithic industries', *Proceedings of the Prehistoric Society*, 53, 1–22.

So Many Shades of Rock: Colour Symbolism and Irish Stone Axeheads

Gabriel Cooney

Introduction: Colour in the land

It has become widely recognized that archaeologists need to consider colour as an important symbolic device. While the meaning of colour is culturally specific, Berlin and Kay's (1969) cross-cultural scheme for basic colour terms indicates that the most widely occurring terms are first black and white, then red, and then yellow, blue or green, followed by other colours. In a series of articles on the meaning of colour in early societies (Gage et al. 1999), a number of authors pointed out the prominence of colour in human experience. There are difficulties in reaching an understanding of the significance of colour in prehistoric societies, but Gage et al. (1999: 109) suggest we can gain insights into colour symbolism by consideration of context or by cautious appeal to common human experience.

There is a long tradition in Ireland of symbolic meanings being attributed to different colours. Estyn Evans (1996) pointed out the very strong association of yellow (*buí*) and white (*bán*) flowers – such as whitethorn and gorse – with the marking of the beginning of summer. This is linked with the concept of fertility, a colour association also physically expressed in the colour of dairy products such as milk and butter (ibid.: 68). Similarly, O'Sullivan (1990) discussed the variety of colours in different species of wood and its symbolism. In Irish myth and folklore the colour red (*dearg*) is charged with meaning associating with blood and death, as with the female seer in the Ulster cycle of heroic tales who foretold battles by shouting 'I see crimson, I see red' (see Kinsella 1969). The elemental nature of dark colours versus white is captured in the contrasting colour of the two bulls in the central story of the Ulster cycle, the *Táin Bó Cuailnge* (or Cattle Raid of Cooley). This concern with colour is also reflected in place names that refer to colour (see Joyce 1913).

With respect to the point made by Gage et al. (1999) concerning the importance of looking at colour in context, much of the colour symbolism referred to above would be difficult to tie down to specific cultural contexts in the absence of oral or textual histories. In contrast, we wish to understand the symbolism of colour

for particular prehistoric groups or societies in the past. A medium that offers this opportunity is the material culture characteristic of particular periods. One of the most durable aspects of the lives of people who lived in prehistoric Ireland is the varied ways in which they used stone.

Attention has been drawn to the deliberate use of stones of different colour in megalithic monuments (e.g. O'Sullivan 1996; Lynch 1998; Jones 1999; Bradley 2000a: 216–17). It has also been recognized that the choice of colour was purposeful in the case of objects such as wristguard bracers (Harbison 1976) and maceheads (Simpson 1988; 1989).

An artefact type that has potential for the study of the significance of colour is the stone axehead. In Ireland the Irish Stone Axe Project has recorded over 20,000 stone axeheads (Cooney and Mandal 1998; 2000). The bulk of these date to the Neolithic period (4000–2500 BC) but they were first produced during the Meso-lithic and continued to be used well into the Bronze Age. The axeheads were produced from a variety of lithological sources (Figure 4.1). It is widely recognized

Range of lithologies used to make stone axeheads in Ireland

Igneous

Gabbro	426
Dolerite	421
Porphyry	241
Basalt	239
Andesite	107
Ryolite	54
Tuff	38
Tuff (Irish Group VI)	174

Sedimentary

Sandstone	691
Mudstone	299
Shale	3229
Limestone	67
Nodular Weathered Sediment	183
Flint	591

Metamophic

Porcellanite	9822
Schist	648
Slate	66
Others	54
Total	**17350**

Figure 4.1 Table of range of lithological sources used to make stone axeheads in Ireland.

that stone axeheads had a range of functional and symbolic values (Patton 1991a; Whittle 1995; Cooney et al. 1995; Cooney 2000). We observe obvious variation when looking at Irish axeheads made from different sources in relation to colour (Cooney and Mandal 1998: plates 3–8, 11–18). There is considerable potential for exploring whether colour was an important factor in the categorization of axeheads. Developing a point made by Whittle (1995: 254), we should recognize that colour is an aspect of stone axeheads which is indivisible from the material qualities of rock, and as such it may be integral to the symbolic meanings of these objects that are 'gifts from the earth'. Stone axeheads are particularly suitable for study, since their colour variation can be placed in broader perspective by comparing and contrasting colour with other characteristics of the objects themselves and the contexts in which they occur during their life cycle.

The colour of the rock

Rock outcrops and secondary sources such as boulders and cobbles would have provided a wide range of materials of different colours as raw material for stone axeheads. How do we begin to understand how different-coloured raw materials were selected for axe production? We might answer this question by reiterating the particular symbolism of rock itself, with its links to the power of the earth and land and the potency and danger that would have flowed from that association. Potentially there could have been danger in working, and disturbing, rock surfaces in both a physical and a metaphysical sense (Taçon 1991: 203–4). While the residues of axe quarrying at axe production sites may seem mundane as well as multitudinous, production activities were likely to have been surrounded by ritual, with activities taking place in prescribed ways and traditions. After all, they were transforming powerful materials (Burton 1994; Cooney 1998).

In some cases that transformation involved a definite change in the colour of the rock. The effect of grinding and polishing served to highlight the colour difference between raw rock and 'cultural' product. Here we are also made aware of the connections between colour and other properties such as surface texture and moistness, which become evident. In the process of grinding, the surface of the rough-out or pre-form not only changes colour, but is also progressively smoothened. The contrast between the emerging colour of the axe being ground and its source may have been highlighted if the material was repeatedly moving between a wet and dry state as would have been the case if water was used as a lubricant to aid the grinding process.

One continuing area of debate in stone axe studies is the reliability of analytical sourcing of axeheads. What has not been emphasized in the case of the known axe-production sites in Ireland and Britain is that the axeheads from these sources are

easiest to visually identify in the hand. A case in point is porcellanite, the major source for stone axeheads in Ireland (see Figure 4.1). There are two known porcellanite sources, at Tievebulliagh and Brockley, Rathlin Island, over 25km apart in the north-east of Ireland (Jope 1952; Sheridan 1986; Mallory 1990; Meighan et al. 1993; Mandal et al. 1997, Cooney 2000: 191–4). The variation of porcellanite most commonly recognized in the hand can be described in petro-graphic terms as:

> 0–30% yellow nodular corundum/mullite streaks which may be foliated, set in a fine-grained blue/gray mullite/haematite groundmass (Cooney and Mandal 1998: 59).

A terminology more akin to the way that Neolithic people might have described porcellanite is the term 'bluestone' which is used in the vicinity of the production sites (Knowles 1906). The name comes from the sharp colour contrast between the porcellanite *débitage* and the dark dolerite which is the dominant local lithology.

The most numerous axe group (Group VI) in Britain is the tuff axes from the Great Langdale and Scafell areas in Cumbria. They have a distinct green surface colouration and banding which makes them easy to identify (Fell and Davis 1988; Woolley 1989). The Type A dolerite axes from the most important axe production site in north-west France at Plussulien in Brittany are also visually distinctive (Le Roux 1979; 1998; Patton 1993: 22–9). These examples suggest a concern with colour; indeed, colour may have been a way of distinguishing axes from different sources. That the visual appearance of the axe may have been important, is evinced by the fact that these major sources are not in a functional sense (as measured by tensile strength) the best materials that were available (see Bradley et al. 1992; Patton 1993). Axeheads from these sources also frequently have a morphological signature, with faceted sides in the case of Group VI axes and oblique butts in the case of porcellanite axes. This indicates that we have to consider colour as part of a suite of characteristics that defined what the visual appearance of an axehead signified. Another important example of this is the jadeite axes which are exchanged from even further afield (e.g. Pétrequin et al. 1998).

One useful way of exploring that meaning is to think in terms of Jones and Bradley's (1999) view of colour as metaphor, as a means of condensing or packing meaning into an artefact. In the case of axes from particular sources we can suggest that the colour of the axe would have connected the axe to its place of origin in the landscape. Axe sources are sometimes in spectacular locations (Patton 1991b; 1993; Cooney 1998; 2000; Bradley 2000b). As the objects were exchanged they would have accrued meanings, and their genealogy may have included stories of their origin. Their colour and appearance made them different from locally available axes. Appealing to experience elsewhere, Ballard (1994) has pointed out

that in Papua New Guinea people to the west of the main axe quarries at Mount Hagen had no knowledge of the location of the sources. However, they distinguished them on the basis of the direction they came from, their colour and their size.

Colour in context

In the case of the specific lithologies discussed above, it has been suggested that colour, along with other visual properties, was meaningful. The sources discussed were exploited on a large scale and some of their products ended up hundreds of kilometres away from the place of production. One could suggest that colour was important since it enabled axeheads to be compared and contrasted to establish their sources.

The lithologies used to make stone axeheads in Ireland exhibit a range of colours: the blue of porcellanite, the speckled black and white appearance of gabbros, the green/gray of dolerite and tuff, the black of some igneous rocks, shales and mudstones and the pale colour of flint axeheads.

In attempting to understand the nature and extent of the symbolic overtones of these colours it might be useful to remind ourselves that they could be described as the most commonly occurring basic colour terms defined by Berlin and Kay (1969) – black and white, then red, then yellow, blue or green. The only colour that is not represented is red. If we return to the most basic of these terms – white and black – the initial reaction might be to argue that, in terms of readily available raw material, flint is closest in colour to the category 'white'. However there are a limited number of flint axes in Ireland, particularly those with an overall polish (see discussion in Woodman 1992; Sheridan et al. 1992). Nevertheless, it is clear that white had symbolic value in the Irish Neolithic, as witnessed by the various uses of white quartz/quartzite (see relevant discussion in Koeberl 1997; Smith 1998). Quartz and quartzite were utilized as decorative stone at monuments such as Newgrange, as a raw material for lithics and as a tempering agent in pottery (Mitchell 1992; Woodman and Scannell 1993; Bergh 1995; Cooney 2000: 176–7). What this example also indicates is that we have to think of the symbolism of colour operating in different media, contexts and scales. In many different societies white and bright shining objects, such as quartz, are metaphors for light, mind, knowledge and/or the most important spirit being (Hamell 1983; Taçon 1991; 1999; see also Saunders in Chapter 11 of this volume). Writing about the North-eastern Woodland cultural tradition in North America, Hamell (1983: 14) relates the identification of quartz with concepts of 'seeing' and 'knowing'. He suggests this indicates a psychobiological expression of the importance of lightness, brightness, transparency, visibility and whiteness in human perception and cognition. In Hamell's terms, 'Light, bright and white things are good to think with. They are reflective substances, literally and figuratively' (ibid.).

Jones and Bradley (1999: 114) have drawn attention to the fact that, when considering the visual perception of colour, we tend to think of colours in terms of contrast. The use of different colours therefore provides an impression of contrast and depth. Symbolically and metaphorically colours also have contrasting and complementary meanings (e.g. Hamell 1983: 7). This effect can be seen to be strikingly achieved in the arrangement of structural stones in megalithic monuments (Jones 1999) or in the stone settings outside megalithic tombs, as at Newgrange and Knowth (Eogan 1986).

With this in mind it is useful to return to the question of colour in axeheads. What becomes apparent is the extent to which the occurrence of streaks, speckles or spots of white/yellow in a darker matrix are a common feature. Furthermore, this is a feature highlighted by the grinding and polishing process.

The description of porcellanite as 'bluestone' disguises the fact that many porcellanite axes have distinct white/yellow speckles or streaks. These are the 'yellow nodular corundum/mullite streaks' mentioned above in the petrographic definition. This description can be extended to the speckled black and white of some gabbros, the white speckles that occurs in green/grey porphyritic dolerite (hence the term 'spotted dolerite'), and the white to light green speckles in a darker green or red groundmass characteristic of porphyritic andesite. In these cases the white/yellow speckles or streaks are formed by feldspar phenocrysts (Cooney and Mandal 1998: 67–8; Mandal 1997). In the case of porphyry, while the feldspars may actually be green, the important point is that by visual contrast with the darker groundmass they appear whiter and brighter.

It is widely accepted that quartz illustrates the importance of white, bright stone in the Neolithic. People were translating the power of quartz from the land into a range of scales and settings (see also Darvill in Chapter 3 of this volume). Could the white/yellow in axes similarly relate to the ancestral powers immanent in the land? The symbolic potency of these axes may have relied on the contrasting and complementary colours of the groundmass (dark) and the streaks, spots or speckles (white/yellow). With the exception of porcellanite (a metamorphic rock), all the other sources mentioned here are igneous rocks. Quartz veins would commonly occur in outcrops of these rocks. Is it plausible to consider a connection being made between this powerful rock and the appearance of speckles on the surface of stone axeheads? Perhaps what was important about these objects was that they were portable: they may have carried the power of the land with them (Burl 1976: 82).

Lambay island

Other qualities alongside colour were used to characterize and categorize axe-heads. When considering the activity of axe production, and the source being

utilized, stones of different colour, weight and texture could have been used in quarrying, in the primary production processes of chipping, hammering and pecking and in the subsequent grinding and/or polishing. One way of trying to grasp the web of meanings associated with production is to examine a site where axeheads were produced in a landscape context where the limits of the immediate social world were known, such as an island.

For the last several years we have been working on the island of Lambay, which is about 1000 acres (400 ha) in extent and situated off the east coast of Ireland, just north of Dublin itself (see Cooney 1993; 1998; 2000). Much of the island is volcanic in origin and one of the suite of volcanic rocks that occurs is porphyritic andesite or porphyry, a fine- to medium-grained igneous rock formed as lateral flows late in the volcanic sequence. In at least one location close to the centre of the island, known as the 'Eagle's Nest', porphyry on Lambay was quarried for stone axehead production during the Neolithic period (Plate 4). The cultural material and the limited number of radiocarbon dates available to date indicate activity spanning the period 3600–3000 BC. The porphyry was primarily worked by pecking and hammering rather than by flaking. All other known axe-production sites in Ireland and Britain are ones where flaking was the primary production process, producing a recognizable sequence of *débitage* (Bradley and Edmonds 1993). What also sets Lambay apart from other production sites is that axes were ground and polished at the site and deposited there.

Working with colour

In the working of the porphyry outcrops at the 'Eagle's Nest' site and the activities that took place there, we can observe a complex colour symbolism which has strong links with context, material and landscape. The site consists of two small valleys running north-west to south-east which form part of a distinct topographical unit. This unit lies between two major east–west trending valleys and is bounded by rising ground to the east, with steep rock outcrop to the north and west and a lesser sloping incline on the southern side. There is a wide view from the site to the west over the lower part of the island and the adjacent Irish coastline. The site shows evidence for two related activities. First, on the valley sides there is the working of the porphyritic andesite outcrops for stone axe production. Secondly, on the floor of the eastern valley there are a further number of related features.

While volcanic rocks dominate Lambay, sedimentary rocks also occur, notably red sandstone and conglomerate beds in the north-west of the island. Visually and aurally when working on the island one is always aware of the surrounding sea and its changing patterns due to tide and wind conditions. In terms of colour, the

most spectacular part of island through the year is the coastal zone, notably the beaches. Here there are pebbles of the local rocks, including porphyry. But there is also a range of non-local stones brought by wave action onto the shores of the island. These include flint nodules of Irish Sea and north-east Antrim coastal origin and granite from the Dublin coast further to the south. Walking on the beaches the observer is struck by the spectacular appearance of porphyry cobbles and pebbles which have been rolled and ground by a combination of wave action and abrasion. There is a striking contrast in the colour of stones in their wet and dry state, a contrast that shifts position depending on the state of the tide. In terms of condensed meaning it could be argued that this contrast raises and reflects the issue of the shore as a liminal place between dry land and the sea (e.g. Pollard 1996). The colour and brightness contrast between the wet and dry states of stone on the beach also brings to mind the alternating dry/wet state of axe pre-forms or rough-outs as they are transformed through grinding and polishing. Moreover, when axeheads are wet they appear more highly polished.

At the 'Eagle's Nest' site, the process of working the rock appears to have involved shallow quarrying along the face of outcrops. The build-up of the *débitage* layers suggests that working started toward the base and moved up the outcrop face. There are indications that exploitation may have been episodic with intervals between working phases. In the *débitage* layers there is a range of material culture, including hammerstones, grinding stones and rough-outs. The hammerstones are made from a variety of stone sources, including quartzite, con-glomerate and granite. The grinding stones are mainly of sandstone and porphyry.

On the floor of the larger valley there are a number of features. The most significant of these are structured deposits of stone and other material, in some cases placed in pits, in others over shallow scoops in the ground surface. It is clear that the intended effect was to create mini-cairns, an action paralleled at Goodland, Co. Antrim where flint nodules were extracted from the surface of chalk (Case 1973). At the southern end of this zone (spreading over an area 10m × 6m) individual pit and cairn features were incorporated into a larger build-up of stone and sediment. Deposition of material within this larger cairn seems to have focused in those areas where there had been pre-existing features of a discrete nature.

Colour coding

Colour played an important role in the process of quarrying, stone-working and depositional activities. I referred above to the effect of grinding in emphasizing the feldspars in the rock, increasing its whiteness and brightness. This process also produces axeheads that appear similar to the shiny porphyry pebbles on the beach. Another physical connection can be made between axeheads and naturally

smoothened forms of porphyry. We have observed that quarrying appears to have been concentrated in a horizontal zone where the rock surface was glacially striated. Superficially these pieces of striated rock look like (and were initially taken to be) material that had been deliberately ground, but the striae are consistently unidirectional. It is tempting to suggest that people coming into these valleys during the Neolithic saw the striated surface and took the already smoothened surface as a guide to the potential of the surface underneath.

The cultural transformation was achieved through the use of grinding stones of various sizes, some of red sandstone, and the lubricating action of water. Can we argue for a symbolic connection here? The combination of red or brown stone, with its widely recognized cross-cultural connotations of vividness and blood, the emotive and animate aspects of life (e.g. Hamell 1983), used to increase the whiteness of the porphyry, vitalizing the ancestral power in the rock? It could also be suggested that the action of the water as a lubricant during grinding might have been analogous to the effect of the sea on shaping stones on the beach. In both cases, what was produced were objects that were good to hold and think with. This view of porphyry axes defies any easy categorization of processes as either cultural or natural. Instead, at the 'Eagle's Nest' site we observe a combination of knowledge about the way the world worked and a wish to use this powerful rock. I have argued above that this power may have been seen to reside in the whiteness of the feldspar crystals. That white/brightness was an important feature associated with quarrying is suggested by two individual actions that took place in the larger valley. After some quarrying *débitage* had built up in the Neolithic, someone came to a quarried rock face and knapped and deposited crystalline quartz. In the same location at some later date, but perhaps soon after the first event, a deliberate knapping cluster of flint was deposited.

This emphasis on colour and the combination of different lithologies is also seen in the depositional activity on the floor of the larger of the two valleys. What is striking here is the association of different-coloured stones with different activities. In turn the association of these stones with different zones of the island landscape may reflect and condense a series of symbolic meanings. To illustrate this point I want to focus on the low cairn incorporating a number of foci of depositional activity (Figure 4.2). The main constituents of the cairn are pieces of quarried porphyry, varying in size from large blocks to small chips. Alongside the porphyry a range of stones of different sources, shapes and colour appear to have been deliberately employed. A number of different zones can be recognized in the cairn. In the north-west on the surface there was a distinct zone of brightly coloured beach pebbles of a broadly similar size. Below this there was another deposit of beach pebbles incorporating a dense deposit of flint, red jasper pebbles and some hammerstones. There were other depositional activities here and the initial focus seems to be a polygonal setting of porphyry slabs.

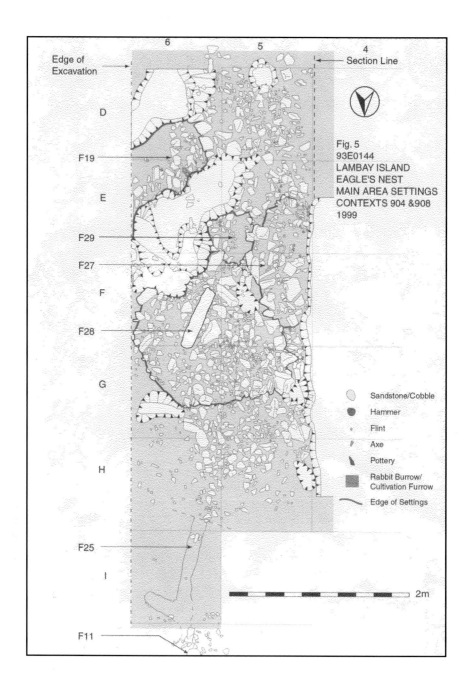

Figure 4.2 Plan of the surface of the 'cairn' at the Eagle's Nest site, Lambay.

South of a zone of large blocks, depositional activity included the use of fine beach gravel both to level up the surface and as context for the deposition of flint and jasper. There was a focus on the placement of jasper in this area. This red, chert-like rock occurs in the form of angular, unworked pieces, pebbles that had been partially worked and complete and broken jasper pendants of the type that characteristically occur in passage tomb deposits (see Herity 1974). Strengthening the passage tomb connection is the occurrence of 'Carrowkeel'-and 'Goodland'-style globular bowls in the cairn build-up (see Sheridan 1995). Further testimony to these links are two or three stone settings that occur at the north-east side of the cairn. The most striking of these consists of roughly concentric settings of stone which seem to focus on a thin gable-shaped slab of grey/green andesite. There are concentrations of material on the surface here; beach pebbles, struck flint and pottery. The stones forming the northern edge of this area overlie a series of pits.

Arguably a major characteristic that influenced how stone was used and placed was its colour. The striking appearance of the stone arrangements can only be appreciated when the surface is wet. The fact that porphyry is so functionally inadequate highlights this concern with colour and brightness. When ground and polished porphyry has a spectacular appearance and this, with the symbolic associations of brightness and whiteness, must have been a major factor in its use and significance. This concern with colour has been highlighted in other unexpected ways, as with the redness of some of the grinding stones and much more strikingly the red of jasper. Are we seeing two different expressions of the life-giving power commonly associated with redness, with the grinding stones bringing the axe rough-outs to life and the jasper specifically exploited to make objects, pendants and beads, that would be worn by and associated with the lives of particular individuals?

Making island worlds

Colour seems to have been of major importance in the choice of the Lambay porphyry for axe production and in the activities involved in its production, use and deposition. We have to see colour in association with other properties of material culture to appreciate its rich and varied symbolic meaning. Arguably, what we see at the 'Eagle's Nest' site is a deliberate representation and microcosm of the island landscape and the cycle of life and death. As a place of production the site can be seen as a metaphor for the beginning of life; but it is not only a production site but also a place of deposition. There are links here between the idea of the death of objects through breakage and deposition in the ground and the death of people as suggested by the passage tomb connotations of much of the material incorporated in the deposits.

Regarding the concept of the site as a representation of the island world, we can point to the deliberate replication on the site of elements from the beach; a variety of stones with smooth and often rounded surfaces caused by contact with water. The focus of deposition around existing or deliberately placed stones could be seen as a condensed version of the broader relationship of human activity in and on the (is)land. What we also witness at the site is the replication of ideas about water as a life-giving force, reflected in the change it brings about in porphyry and the colour enhancement it also gives to other stones.

Tilley (1999: 205) argues that ritual performance at key locations serves to create, in a physical form, the myths that provide an explanation of the world. This helps to explain places and topographical features in terms of origins and ancestral events. In this way people come to more fully understand the landscape in which they live.

Acknowledgements

My thanks to Stephen Mandal and Emmet Byrnes, my colleagues on the Irish Stone Axe Project. To them and Conor Brady, Finola O'Carroll, Beatrice Kelly, Linda Fibiger and Sarah Halpin my thanks for their work on Lambay and our discussions about what it all means. I am grateful to Aidan O'Sullivan for his comments and suggestions on the paper and to Andy Jones for his patience and perseverance!

References

Ballard, L. (1994), 'The centre cannot hold: trade networks and sacred geography in the Papua New Guinea Highlands', *Archaeology in Oceania*, 29(3), 130–48.

Bergh, S. (1995), *Landscape of the Monuments*, Stockholm: Riksantikvarieämbet Arkeologiska Undersöknigar.

Berlin, B. and Kay, P. (1969), *Basic Color Terms: Their Universality and Evolution*, Berkeley: University of California Press.

Bradley, R. (2000a), *The Good Stones: A New Investigation of the Clava Cairns*, Edinburgh: Society of Antiquaries of Scotland Monograph 17.

Bradley, R. (2000b), *An Archaeology of Natural Places*, London: Routledge.

Bradley, R. and Edmonds, M. (1993), *Interpreting the Axe Trade: Production and Exchange in Neolithic Britain*, Cambridge: Cambridge University Press.

Bradley, R., Meredith, P., Smith, J. and Edmonds, M. (1992), 'Rock physics and the Neolithic axe trade in Great Britain', *Archaeometry*, 34(2), 223–33.

Burl, H.A.W. (1976), *The Stone Circles of the British Isles*, London: Yale University Press.

Burton, J. (1984), 'Quarrying in a tribal society', *World Archaeology*, 16, 234–47.

Case, H.J. (1973), 'A ritual site in Ireland', in G. Daniel and P. Kjaerum (eds), *Megalithic Graves and Ritual*, Moesgard, Denmark: Jutland Archaeological Society, 173–96.

Cooney, G. (1993), 'Lambay: an island on the horizon', *Archaeology Ireland*, 26, 24–8.

Cooney, G. (1998), 'Breaking stones, making places: The social landscape of axe production sites', in A. Gibson and D.D.A. Simpson (eds), *Prehistoric Ritual and Religion*, Stroud: Sutton, 108–18.

Cooney, G. (2000), *Landscapes of Neolithic Ireland*, London: Routledge.

Cooney, G. and Mandal, S. (1995), 'Getting to the core of the problem: petrological results from the Irish Stone Axe Project', *Antiquity*, 69, 969–80.

Cooney, G. and Mandal, S. (1998), *Irish Stone Axe Project Monograph I*, Dublin: Wordwell.

Cooney, G. and Mandal, S. (2000), 'The Irish Stone Axe Project: sources for stone axes in Ireland', in *Contributions to the Geology and Petrology of Crystalline Complexes*, Brno: Moravian Museum Publications.

Cooney, G., Mandal, S. and O'Carroll, F. (1995), 'Stone axes as icons: approaches to the study of stone axes in Ireland', in E. Grogan and C. Mount (eds), *Annus Archaeologiae*, Dublin: Office of Public Works and Organisation of Irish Archaeologists, 23–36.

Eogan, G. (1986), *Knowth and the Passage Tombs of Ireland*, London: Thames and Hudson.

Evans, E.E. (1996), *Ireland and the Atlantic Heritage, Selected Writings*, Dublin: Lilliput Press.

Fell, C.I. and Davis, R.G. (1988), 'The petrological identification of stone implements from Cumbria', in T.H. Clough and W.A. Cummins (eds), *Stone Axe Studies, Volume II*, London: Council for British Archaeology Research Report 28, 71–7.

Gage, J., Jones, A., Bradley, R., Spence, K., Barber, E.J.W. and Taçon, P.S.C. (1999), 'What meaning had colour in early societies?', *Cambridge Archaeological Journal*, 9(1), 109–26.

Hamell, G.R. (1983), 'Trading in metaphors: The magic of metaphors', in C.F. Hayes (ed.), *Proceedings of the 1982 Glass Trade Bead Conference*, Rochester, NY: Rochester Museum and Science Center, 5–28.

Harbison, P. (1976), *Bracers and V-perforated Buttons in the Beaker and Food Vessel Cultures of Ireland*, Bad Bramstedt: Archaeologica Atlantica Research Report 1.

Herity, M. (1974), *Irish Passage Graves*, Dublin: Irish University Press.

Jones, A. (1999), 'Local colour: megalithic architecture and colour symbolism in Neolithic Arran', *Oxford Journal of Archaeology*, 18(4), 339–50.

Jones, A. and Bradley, R. (1999), 'The Significance of Colour in European Archaeology', *Cambridge Archaeological Journal*, 9(1), 112–14.

Jope, E.M. (1952), 'Porcellanite axes from factories in Ireland: Tievebulliagh and Rathlin', *Ulster Journal of Archaeology*, 15, 31–55.

Joyce, P.W. (1913), *Irish Names of Places, Volumes I–III*, Dublin: Phoenix Publishing.

Kinsella, T. (1969), *The Tain*, Oxford and Dublin: Oxford University Press and The Dolmen Press.

Knowles, W.J. (1906), 'Stone axe factories near Cushendall', *Journal of the Royal Society of Antiquaries of Ireland*, 36, 383–94.

Koeberl, N. (1997), 'Quartz: some of its uses in Irish prehistory', *Trowel*, 8, 7–11.

Le Roux, C.-T. (1979), 'Stone axes of Brittany and the Marches', in T.H.McK. Clough and W.A. Cummins (eds), *Stone Axe Studies*, London: Council for British Archaeology, Research Report 23, 49–56.

Le Roux, C.-T. (1998), 'Specialised Neolithic production, diffusion and exchange in western France', in M. Edmonds and C. Richards (eds), *Understanding the Neolithic of Northwestern Europe*, Glasgow: Cruithne Press, 370–84.

Lynch, F. (1998), 'Colour in prehistoric architecture', in A. Gibson and D.D.A. Simpson (eds), *Prehistoric Ritual and Religion*, Stroud: Sutton, 62–7.

Mallory, J.P. (1990), 'Trial excavations at Tievebulliagh, Co. Antrim', *Ulster Journal of Archaeology*, 53, 15–28.

Mandal, S. (1997), 'Striking the balance: the roles of petrography and geo-chemistry in stone axe studies in Ireland', *Archaeometry*, 39(2), 289–308.

Mandal, S., Cooney, G., Meighan, J. and Jamison, D.D. (1997), 'Using geo-chemistry to interpret porcellanite axe production in Ireland', *Journal of Archaeological Science*, 24, 757–63.

Meighan, I., Jamison, D.D., Logue, P.J.C., Mallory, J.P., Simpson, D.D.A., Rogers, G., Mandal, S. and Cooney, G. (1993), 'Trace element and isotopic provenancing of north Antrim porcellanites: Portrush, Tievebulliagh, Brockley (Rathlin Island)', *Ulster Journal of Archaeology*, 56, 25–30.

Mitchell, G.F. (1992), 'Notes on some non-local cobbles at the entrances to the passage-graves at Newgrange and Knowth, County Meath', *Journal of the Royal Society of Antiquaries of Ireland*, 122, 128–45.

O'Sullivan, A. (1990), 'Wood in archaeology', *Archaeology Ireland*, 12, 69–73.

O'Sullivan, M. (1996), 'A platform to the past – Knockroe passage tomb', *Archaeology Ireland*, 36, 11–13.

Patton, M. (1991a), 'Axes, men and women: symbolic dimensions of Neolithic exchange in Armorica (Northwest France)', in P. Garwood, D. Jennings, R. Skeates and J. Toms (eds), *Sacred and Profane*, Oxford: Oxford University Committee for Archaeology, OUCA Monograph 32, 65–79.

Patton, M. (1991b), 'An Early Neolithic axe factory at Le Pinacle, Jersey, Channel Islands', *Proceedings of the Prehistoric Society*, 57, 51–9.

Patton, M. (1993), *Statements in Stone: Monuments and Society in Neolithic Brittany*, London: Routledge.

Pétrequin, A-M., Pétrequin, P. and Cassen, S. (1998), 'Les longues lames polies des élites', *La Recherche*, 312, 70–5.

Pollard, T. (1996), 'Time and tide: Coastal environments, cosmology and ritual practice in early prehistoric Scotland', in T. Pollard and A. Morrison (eds), *The Early Prehistory of Scotland*, Edinburgh: Edinburgh University Press, 198–210.

Sheridan, A. (1986), 'Porcellanite artifacts: a new survey', *Ulster Journal of Archaeology*, 49, 19–32.

Sheridan, A. (1995), 'Irish Neolithic pottery: the story in 1995', in I. Kinnes and G. Varndell (eds), *Unbaked Urns of Rudely Shape*, Oxford: Oxbow Monograph 55, 3–22.

Sheridan, A., Cooney, G. and Grogan, E. (1992), 'Stone Axe Studies in Ireland', *Proceedings of the Prehistoric Society*, 58, 389–416.

Simpson, D.D.A. (1988), 'The stone maceheads of Ireland', *Journal of the Royal Society of Antiquaries of Ireland*, 118, 27–52.

Simpson, D.D.A. (1989), 'The stone maceheads of Ireland, part 2', *Journal of the Royal Society of Antiquaries of Ireland*, 119, 113–26.

Smith, A. (1998), 'White quartz pebbles', in T. Darvill, *Billown Neolithic Landscape Project, Isle of Man, Third Report: 1997*, Bournemouth and Douglas: Bournemouth University and Manx National Heritage, 19–23.

Taçon, P.S.C. (1991), 'The power of stone: Symbolic aspects of stone use and tool development in western Arnhem Land, Australia', *Antiquity*, 65, 192–207.

Taçon, P.S.C. (1999), 'All things bright and beautiful: the role and meaning of colour in human development', *Cambridge Archaeological Journal*, 9(1), 120–3.

Tilley, C. (1999), *Metaphor and Material Culture*, Oxford: Blackwell.

Whittle, A. (1995), 'Gifts from the earth: symbolic dimensions of the use and production of Neolithic flint and stone axes', *Archaeologia Polona*, 33, 247–59.

Woodman, P.C. (1992), 'Excavations at Mad Man's Window, Glenarm, Co. Antrim: problems of flint exploitation in east Antrim', *Proceedings of the Prehistoric Society*, 58, 77–106.

Woodman, P.C. and Scannell, M. (1993), 'A context for the Lough Gur lithics', in E. Shee Twohig and M. Ronayne (eds), *Past Perceptions: The Prehistoric Archaeology of Southwest Ireland*, Cork: Cork University Press, 25–34.

Woolley, P. (1989), 'The petrography of Langdale tuffs used for the manufacture of Neolithic artefacts', in P. Claris and J. Quatermaine 'The Neolithic quarries and axe factory sites of Great Langdale and Scafell Pike: A new field survey', *Proceedings of the Prehistoric Society*, 55, 1–25.

–5–

The Flashing Blade: Copper, Colour and Luminosity in North Italian Copper Age Society

Stephen Keates

As with colors, one cannot interpret a single metal any more than a single color without seeing it in its full context with other colors and materials. And as colors may have what seem to be almost contradictory significations but in fact turn out to be perfectly coherent alternative meanings, the same is undoubtedly true of metals. Investigation into color systems, in fact, may provide the most useful methodology for the study of the language of materials, because it has taught us to be more comfortable with ambiguity and to look at context rather than isolated phenomena. It has taught us, too, to go beyond perception. (Herbert 1984: 295)

Introduction

The study of metal artefacts in archaeology has been dominated by considerations of utility and typology, and the materiality of metal addressed largely through aspects of technological production (Budd and Taylor 1995). While these considerations were necessary in establishing a framework for the study of early metallurgy, ethnographic studies of metal artefacts and processes of metal production, consumption and display demonstrate potential avenues of research regarding the perceived colour qualities of metals and their significance in contexts in prehistoric societies.

In North Italian Copper Age society, copper artefacts, and particularly the so-called Remedello-style dagger, were highly potent signifiers for a range of ideological concepts including gender, status and cosmology. This can be explored via the physical remains of daggers deposited in the archaeological record as funerary equipment for adult males, such as at the flat grave inhumation cemetery at the eponymous site of Remedello Sotto near Brescia on the Po plain, and in iconographic terms in the many representations of copper weapons and other weapons, tools and ornaments which adorn the anthropomorphic figures in stone, termed statue stelae, which form part of ritual arenas in the Central Alps and the Lunigiana area.

Recent excavations undertaken at the site of Ossimo Superiore in the Valca-monica have suggested that images on stelae may have been highlighted in colour, due to the presence of naturally occurring pigments, such as red ochre and yellow limonite, found in association with the stelae. The juxtaposition of copper artefacts with solar images on stelae, such as those in the Valcamonica and at Sion in Switzerland, may suggest the creation of metaphorical associations linking copper artefacts with the sun in terms of the qualities of both colour and luminosity. I will argue that the luminous materiality of copper played a highly charged role in the creation of cosmologies, and in the development of the leitmotif of luminosity as a signifier of Otherworldly presences which was to have an enduring significance in European prehistory.

The north Italian Copper Age

Copper objects make a relatively early appearance in northern Italy, much earlier than the conventional chronology for its Copper Age suggests (3500–2300 cal. BC). Metal use is prevalent in the Late Neolithic from 4300–3500 cal. BC, and may even have occurred in the Middle Neolithic (Skeates 1993; Barfield 1996: 66).

Frustration with the discrepancies between the traditional chronological classification of a Copper Age and the appearance of copper artefacts in the archaeological record prompted Cazzella (1994: 12) to argue: 'the term Copper age can be of use if we forget about the copper itself '.

Despite this, the notion of a Copper Age has held ground from the point of view of schemes which attempted to argue the case for growing social complexity during the third millennium BC as a prelude to the emergence of chiefdoms in the Bronze and Iron ages. The evidence for social complexity has been marshalled by drawing upon Sherratt's notion of an economic Secondary Products Revolution (Sherratt 1981; 1983) sweeping through Europe during the third millennium, with a more highly developed and intensive agricultural 'package' coming into play, utilizing plough, animal traction and pastoralism and leading to greater status differentials (cf. De Marinis 1994a). Barfield (1986: 247) has noted that for northern Italy there is little evidence for strong social differentiation during this period.

While cereal agriculture and the herding of livestock had become common practices, in other respects, upland exploitation in northern Italy during the Copper Age must have retained a strong element of continuity. Patterns of seasonal movement in montane environments may have been 'scheduled' into social life in ways which were almost reminiscent of the seasonal movement of Mesolithic populations.

Groups of people were evidently moving from bases in valley floors in areas such as the Magra valley in Lunigiana, the Camonica, Adige and Aosta valleys

into the higher altitudes of the mountains to exploit the environment in a variety of ways. This is demonstrated by the periodic use of rock shelters, the presence of ritual sites with statues, and the increase in artefactual finds at higher altitudes during this period (De Marinis 1999). Judging from the evidence of the preponderance of wild animal teeth in necklaces presented as funerary offerings in the collective burials of the Pre-Alpine region, together with the numerous images of wild animals (particularly stags) on the Valcamonican stelae (Fossati 1994), hunting must have still had a significant prestige role in society.

During the more clement months of the year, bands of people were at high altitudes engaged in a number of activities, as suggested by the equipment of the famous Similaun Ice Man find from north-east Italy (Spindler 1994). Activities may have included pastoralism and hunting, the gathering of special plants, and the exploitation of stone and metal ore sources (Skeates 1993: 32). Given the existence of stelae sites at altitudes from 800 to 900 m, ceremonial activity involving encounters with ancestral spirits may have had a strongly seasonal flavour in common with that of many cultures who have calendrically defined 'Days of the Dead' (cf. Greenleigh and Greenleigh 1998), the dead being drawn into the ebb and flow of the world of the living.

The materiality of copper in the north Italian Copper age

Traditional accounts have emphasized copper's role as a scarce and valuable exchange object. However, visual properties such as colour and luminosity (as well as other forms of sensory apprehension such as tactile qualities, for example temperature, smoothness, sharpness, and so on) can play a role in our perception and aesthetic enjoyment of copper ore and copper artefacts.

Pearce (1998) has discussed the deliberate selection of arsenic-rich copper to produce halberds and daggers, in contrast to the purer copper (less than 1 per cent arsenic content) selected for flat axes. While he admits that functional considerations may play some part in this selection, with the need for axes to withstand percussive impact and daggers to retain their sharpness, he suggests that colour association may have also been a decisive factor. As Budd and Ottaway have noted (1991: 134) the addition of arsenic in copper alloys produces whitening, while pure copper has a yellower appearance, and Pearce suggests that this may reflect a distinction between cult and utilitarian artefacts.

A range of colours from red, pink, orange, yellow and white (as arsenic alloy) could be conjured up to describe copper, together with the green coloration of verdigris. The luminous property of the metal is enhanced by producing flat-surfaced objects which are polished to create a reflective surface, creating an aesthetically pleasing and dazzling effect, an effect which would certainly be apparent on axes, daggers and halberds.

The Remedello Dagger as 'An Object of Desire'

The Remedello dagger with its distinctive triangular copper blade with central rib and lunate-shaped pommel with rivets has achieved iconographic status within the archaeological literature as the artefact type par excellence of the North Italian Copper Age (Plate 5). Halberds from the same period can be interpreted as essentially a dagger-type blade hafted to an upright pole (Barfield 1969).

The Remedello dagger appears in two main contexts, both highly symbolically charged: as funerary equipment for adult males such as at the type site of Remedello Sotto in the second phase of the cemetery dated at 2900/2800–2500/2400 cal. BC (De Marinis, 1994b) and in the iconographic representations which appear on statue stelae. In this way it makes its presence felt across both collective and single burial traditions which co-exist in northern Italy at this time (Barfield 1986). Its iconic status is suggested by the appearance of metal dagger copies in both flint and bone, as at Spilaberto (Bagolini 1985).

Statue stelae are essentially monumental anthropomorphic images carved onto boulders or slabs. These have tended to turn up as isolated finds without context, but recent excavations have revealed that they form components of more complex 'ritual' arenas, which I have suggested played a significant role in the social construction of memory and the presencing of the ancestral dead as absent social actors among the living (Keates 2000). Stelae were erected in alignments in montane areas, often on terraces overlooking valleys as in the Lunigiana area and the Camonica and Adige valleys. They can be seen to form a series of stylistically coherent groupings which have internal iconographic and morphological congruency; however, several traits extend across these groups including the presence of copper artefacts and the Remedello-style dagger in particular.

A convincing case has been made that the dagger as iconographic image and as grave good appears to have symbolically been associated with the social construction of adult masculinity (Barfield 1986; Barfield and Chippindale 1997; Whitehouse 1992). On the Lunigiana stelae in particular, 'female' statues appear to be denoted by the presence of breasts and 'males' by the presence of the dagger motif. On these statues the dagger always appears below the waist horizontally placed, apparently functioning as phallic surrogate. The morphology of the blade with its straight edges and pointed end, together with the penetrative action required to use it, may have been conceptually linked to human penis morphology and the penetrative act of intercourse. This aspect is also embodied in the very morphology of statues with heads referencing both dagger pommels (on the *Filetto Malgrate* 'Gendarme's helmet' type), and phallus (on the *Pontevecchio* type). One might even venture that the whitening of the blade caused by the addition of arsenic may likewise have been seen as suggestive of the colour of semen. These aspects may have operated to link masculinity, potency and fecundity as principles

embodied by living clan members as well as the ancestral lineage. On other groups of statues the case has been made that both daggers and axes act as male signifiers, while double-spiral pendants may signify breasts and act as female signifiers.

Certain difficulties arise when considering statues such as that at Sion which has both double-spiral pendant and dagger displayed and those at Ossimo which have a whole palimpsest of overlapping images including both daggers and pendants. There may have been a looser association between gender and artefacts. One could suggest that these artefacts were polyvalent in nature, with meaning dependent on context. A dagger may have signified a number of different concepts which were loosely linked and were dependent on praxis: adult male, ancestral dead, the spirit world, lineage, clan, penetration, hunting, fighting, expeditions to acquire metal, the productive processes of metallurgy, and specialist knowledge, among other aspects of social life.

On the statues of the Adige valley (Pedrotti 1995), daggers are placed in rows along the upper half, suggestive of ribs; again the whitening of the alloyed metal caused by the addition of arsenic may be used to conceptually link the dagger with human bone, emphasizing the whitened bones of the transformed ancestors.

On the stelae of the Valcamonica region (Casini 1994) close association is made between copper objects and solar symbolism (Brunod 1998), which again appears to make reference to the materiality of the copper in terms of colour and luminosity. The whiteness of the arsenic alloy suggesting the fully ascendant sun or the yellow through to pink tones of pure copper perhaps linked to the colours of sunrise or sunset. On Style III A 1 stelae a solar image takes the place of the head, whereas on Style II A 2 stelae registers of linked-armed figures, perhaps suggesting the principle of lineage, descend from figures whose heads are surrounded by a solar halo (Figure 5.1). Further metaphorical play is made by the iconographically linking rayed solar motifs and the bent antlers of male deer, again perhaps providing connections between masculinity, virility, whiteness and luminosity. At Sion in Switzerland (Gallay and Chaix 1984) statues are erected in rows and then reused to construct burial cists placed on triangular platforms which echo the shape of the dagger blade. On stela 1 (Figure 5.2) the original head has been overcarved with that of a rayed sun perhaps representing the transformation of personhood upon the assumption of ancestral status.

At Ossimo Superiore, Valcamonica, a ritual site with stelae in situ at an altitude of 875 m, has been excavated (Fedele 1990; 1995; 1999). Here alignments of statues were erected facing eastwards across the valley (perhaps orientated toward the rising sun with solar motifs emphasizing this directionality). Statues were adorned with multiple representations of copper objects. Evidence has been discovered for the possible colouring of images on statues with natural pigments, such as yellow limonite and red ochre, discovered in association with the main alignment.

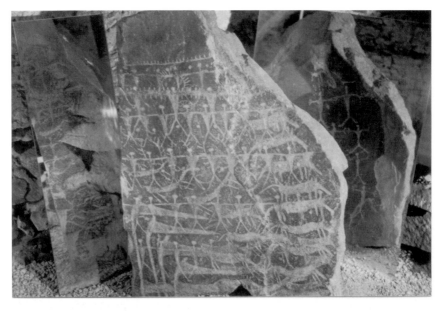

Figure 5.1 Style III A 2. (Cemmo 3 stela) With overcarved registers of linked anthropomorphs descending from figure surmounted by solar motif. Note halberds on bottom left. (Photo S. Keates).

Figure 5.2 Stela 1. from Sion Switzerland where the original head has been overcarved with a solar motif. (Photo. S. Keates).

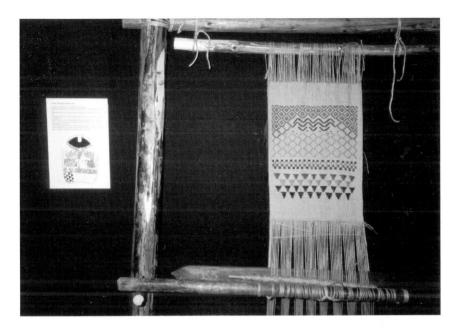

Figure 5.3 Example of what colour effects may have been created for Copper Age clothing. 1995 exhibition Riva del Garda. (Photo. S. Keates).

Stelae at Aosta and Sion are also represented with richly decorated clothing with strong geometric patterning in squares or diamond shapes which could represent vividly coloured garments (Figure 5.3) given the possible range of natural colouring materials available (Bazzanella and Mayr 1995).

Colour symbolism

The metaphorical use of colours in the creation of wider systems of symbolism, while occurring among all human societies, must be conceived of as a socially constructed and culturally relative phenomenon relating to historically contingent modes of thought and social practice:

> Meaning does not inhere in symbols, but must be invested in and interpreted from symbols by acting human beings. Interpretation is the product of a series of associations, convergences and condensations established through praxis. (Moore 1994: 74)

Drewal and Mason (1998) contrast Western aesthetics concerning colour with that of the Yoruba of West Africa. In Western terms colour is analysed in terms of light and pigment and is seen to consist of the properties of hue, value and intensity,

while the Yoruba have a far more complex polychromatic and multivalent colour classification scheme. In Yoruba thought:

1. Colour has polyvalent properties and is perceived of in terms of three chromatic groups which embody a cosmological scheme . . . in general terms, white is associated with the spirit world and the ancestral dead; red represents liminal situations fraught with danger; and black is associated with the transitory world of the living. Each group covers a whole range of colours and hues as well as colour values and intensities, as well as further layers of meaning.

2. This basic colour triad is also associated with notions of heat and coolness used to define human temperament and make moral judgements.

3. 'Colors define and reveal the nature, character, or personality . . . of things, persons, and divinities.' (ibid.: 21).

4. Colours provoke deep emotional responses:

> Colors are enculturated codes whose vibrations resonate meaningfully. Colors move those who experience them, for they connote specific attributes and modes of action. (ibid.: 18)

5. Colours reflect and reinforce social differences, for example, in terms of status, age and gender.

6. Colours play a role in the social construction of memory functioning as mnemonic devices.

7. The presence of certain colours make manifest and tangible Otherworldly entities such as ancestors, deities and spirits.

8. Colour expresses and facilitates the construction of cosmological ideas.

For the Yoruba, colour conceptually links several social domains activating certain highly charged emotional concepts in social arenas, particularly in ritualized and performative contexts but also in reference to all aspects of social practice. In Yoruba metaphysics colour symbolism ontologically permeates and structures social consciousness.

This is not to suggest that African colour categories remain constant in meaning across space and time. As Roberts notes (1996: 216–22), in south-eastern Zaire among Bantu-speaking peoples, while retaining the general notion of a cosmology sustained by colour distinctions involving the oppositional red-white-black

complex as a means of creating discrete metaphysical categories, people display subtle ambiguities of meaning in practice with colour categories blending into each other. Thus the perceived negative qualities of 'red' (destructive aggression), and 'black' (secrecy and suspicion), can act cathartically in certain contexts leading to a 'white' state of spiritual transformation. These abstract concepts are objectified by personification in myth and ritual incorporating historical and pseudo-historical figures as the embodiment of particular colour qualities. Certain types of animal may also be identified with colours (such as the 'black' buffalo) leading to further layers of cosmological elaboration.

These are details of apparently simple schemes of colour classification playing themselves out in complex and profound ways among different social groups who are constantly weaving new strands of metaphorical association into a rich and changing tapestry which encompasses material culture, social practice, belief and experience. The general schema, while retaining a certain congruency at the macro scale, is constantly transformed in the interpretation of the logic of its practice in differing spatio-temporal contexts. This is ultimately determined by the situational nature of social identity, and the polyvalent nature of material culture.

Copper as a medium of expression in African thought

It is from within this conceptual framework of colour symbolism that copper acquires its significance in African societies, as it is valued for its perceived properties of redness and luminosity as the 'red metal' (Herbert 1984). It not only has a utilitarian function, but is also instrumental in the structuring of social thought, action, and experience in the following terms:

1. By its incorporation into the 'white' (spiritual world), 'red' (liminal), 'black' (imperfect world of the living) cosmological classificatory scheme as a 'red' object associated with dangerous liminal states and the embodiment of power (cf. Turner 1967).

2. By its association with rites of passage:

> Red indicates the passage from this world to the other, as for example with the rising and setting of the sun. More abstractly it is identified with all passage in a social sense. (Janzen 1969)

3. By its association with attributes of power, heat, fertility and vitality . . . and its association to the colour of blood.

4. By its shiny reflective quality which is perceived to enhance the above attributes . . . it is:

kept highly polished . . . The implications of luminosity – both glare and of reflecting power – help to explain the frequent use of bright metal in the eyes of masks and statues: it dazzles, repels, looks beyond. (Herbert 1984: 280)

5. In eastern Gabon, copper is used on ancestor figures to suggest power, wealth, vitality and fertility and a mediating position between the dead and the living.

6. In myth a conceptual linkage is sustained with elemental natural forces which emanate or reflect light such as the sun or water. Thus, for the Dogon the sun's rays are termed 'water of copper' and in Kuba creation myth the primordial sister finds copper ornaments lying in the Kasai river.

7. It is a material which is gendered, although the nature of male–female association varies between social groups.

Presencing and embodiment

To understand the social role of African art, and indeed the art of most so-called 'traditional' societies, one needs to move away from Western notions of aesthetics grounded in Cartesian thought. We need to situate image creation and manipulation within specifically other modes of thought and social practice.

Whereas Western aesthetics are structured by notions of representation and beauty and art objects are designed for personal contemplation, African 'art' is designed to actively presence otherwise invisible spiritual forces which have to be activated in some way in the production of the image (Hackett 1996: 45–51). The application of colour plays a vital role in this process of embodiment. Once empowered, images serve to create an interface between human and spiritual domains in which energies can be exchanged. Given the dangerous nature of these energies, objects may only remain 'active' for prescribed periods of time after which the image becomes redundant, or may even be destroyed to discharge energies back to their point of origin. In contrast to the personal, contemplative experience invited by Western aesthetic images, African 'art' is a far more public and visceral affair in which the very materiality of objects invokes the presence of the dead and the spiritual world into the domain of the living.

Luminosity as a signifier of otherworldly presences

Morphy (1992) has explored the role of lumninosity as a signifier of ancestral presence in terms of what he calls an 'aesthetic of spiritual power' in his study of the paintings of the Yolngu, Arnhem Land, Australia. Yolngu paintings are

produced in ceremonial contexts on a variety of different surfaces, such as coffin lids, paper-board and bark, and as body painting.

The paintings consist of finely cross-hatched geometric designs which may be accompanied by more representational images of animals; it is this meticulously achieved cross-hatched effect executed in bright colours, which is designed to achieve a visual effect termed *bir'yun* or brilliance which is associated with the presence of ancestral power. It is this quality of brilliance which is central to the empowerment of the image during ritual performance. In concluding he presents his:

> hypothesis that 'bir'yun' is an effect that operates cross-culturally. Its impact may be modified by environmental factors, by individual and cultural experience of different visual systems; the way it is experienced may vary on an individual basis according to certain neurophysiological factors; but basically it is an effect which transcends particular cultural contexts. (ibid.: 202)

Saunders has also noted this aesthetic of brilliance at work in the pre-Columbian America where:

> indigenous Amerindians perceived their world as infused with a spiritual brilliance which manifested itself in natural phenomena – sun, moon, ice and rainbows: natural materials – minerals, feathers, pearls and shells, and artefacts made from such matter, as well as ceramics, textiles and metals. All, in their own way, and according to different cultural conventions, partook of an inner sacredness displayed as surface gleaming. (Saunders 1999: 245)

This has been further explored by Rivers (1999), who notes that luminous dress and adornment on living humans and anthropomorphic images is exploited across a whole range of societies in performative contexts, to construct social identity, create male–female metaphors, presence spiritual forces, and to magically protect the wearer against malevolent forces. The materiality of a wide variety of objects has been exploited to create these effects, including not only metals, but beads, sequins, silks, mirrors, feathers, seeds, shells, stones, beetle elytra, as well as bright vibrant colours in general.

The 'luminous and the numinous' in European prehistory

I want to take up some of the strands of association developed above and suggest that the associative links articulated in the North Italian Copper Age between material culture, monumentality, the tempos and contexts of social practice provide a framework of interpretation upon which the colour and material luminosity of copper can shed some light.

1. As regards luminous objects in luminous and numinous contexts, I have argued that the Remedello dagger and copper objects in general appear in contexts which emphasize the material qualities of copper, in terms not only of its colour, but also of its luminosity. Both in ritual arenas with solar imagery on stelae and as grave goods in the flat grave inhumation cemetery at Remedello, there is a strong association with the ancestral dead. Deposits of high-quality flint objects, and beads (also represented on stelae strung as necklaces) of various lustrous materials, seem to emphasize this associative link. In these terms luminosity as a material quality and numinosity as an ontological state (i.e. the experience of Otherworldly presences) seem to be metaphorically connected. The placing of daggers on the bodies of the dead, in concrete terms in burials, and iconographically on stelae may suggest that their bodies had metaphorically assumed the quality of luminescence on transformation to ancestral status.

2. With respect to relationship to celestial phenomena, solar imagery on stelae makes a close connection between the ancestral dead and the sun. This linkage is further emphasized by the orientation of stelae alignments toward the sunrise and possibly other celestial phenomena. A stela at Sion seems to convey the idea of the dead being transformed and incorporated into the luminosity of the sun upon the attainment of ancestorhood.

3. On the subject of material transformation and technological processing, perhaps the transformative processes required to render copper ore into a finished 'polished' artefact by the application of heat provided an analogous process to the spiritual transformation from deceased human to revered luminous ancestor through the application of solar heat and fecundity. When redeposited in the ground as at the Remedello cemetery, both human corpse and copper both undergo transformation processes. In the case of copper it may be perceived by its green verdigris colouring to have reverted to its natural condition, perhaps acting as a metaphor for the reassimilation of the deceased into the cosmological order from which they once emerged.

The processing of stelae at Ossimo seems to allude to the notion of the transformation of the individual deceased with distinctive characteristics, to that of an anonymous member of a collective group, an 'ancestor'. In the case of stela at Ossimo, however, in which individual details are flaked, or 'knapped' off (Figure 5.4), perhaps the metaphorical association is more closely linked to the technological processes involved in the creation of flint tools and weapons. These processes may allude to the processing of human remains, the flesh being removed to reveal the luminous bones beneath, transformed to relic status as potent signifiers of the attainment of ancestorhood. In this way analogous processes were seen at work in which materials were processed by reductive transformative

Figure 5.4 Stela 'core' at Ossimo which had been stripped of iconic detail with flake *débitage* used for repacking after its erection as a transformed aniconic image (Photo S. Keates).

technologies to produce polished final products worthy of veneration whose transformed status was signalled by changes in both colour and luminosity, and which at the end of their cycle of use were returned to their point of origin, the land.

4. As for cyclical manifestation, I have suggested that ritual activity at stelae sites may have had a seasonal/cyclical timing which would equate with the widely attested cultural practice in many cultures for calendar rituals pertaining to the dead, the so-called 'Days of the Dead'. At high-altitude sites this type of event, or series of events, must surely have been during the warmer times of the year, or at least before heavy snow fell.

In these terms the ancestral dead may have been encountered as part of a spatio-temporal cycle: a whole series of activities may have been linked to the seasonal exploitation of parts of the landscape including metal procurement. The seasonal scheduling of the acquisition of copper may have added a further layer of temporal association to the metal.

5. Next came matters experienced within the landscape: the ancestral dead were presenced and encountered within the landscape at a series of associative scales, both temporal and spatial, empowered by imagery invoking material luminosity. In these terms copper artefacts became enmeshed in a nexus of ideas and effectively became metaphors for Otherworldly presences, most obviously the ancestral dead, but also a host of other entities such as deified ancestors, deities and spirits in general, which likewise could be characterized associatively as:

i luminous
ii manifested in elemental natural forces which were cyclical and experienced as part of a spatio-temporal cycle of movement
iii accessible to the living through ritualized performance
iv encountered at specific times at specific places and whose immanence is heralded by significant changes in natural light phenomena
v constituting part of a cosmological and cosmographic scheme rooted in the ontological experience of the socialized landscape.

As such the ancestral dead were perhaps perceived as *shining figures in the landscape*, the materiality of copper artefacts providing one means not only to embody the incorporeal, but also to conceive the intangible.

In the foregoing I have outlined ways in which the materiality of objects became enmeshed with social practice at a variety of scales in the ontological construction of cosmology and cosmography. There is a danger of over-generalizing this framework, and we need to balance this with our understanding of local contexts. Despite this, I would venture to suggest that similar processes can be seen at work throughout the course of western European prehistory, which in different ways link the material quality of luminescence and lustre to the metaphysical experience of numinosity.

Flint has a lustre enhanced by its silica content and its emergence from the bright white chalklands as gleaming white nodules, and the polishing of stone axes must also surely have been designed to enhance this very quality in Neolithic ritualized contexts (see Cooney in Chapter 4 of this volume), while the whole passage grave phenomenon seems designed to capture light within monumental structure. In the later Bronze and Iron Ages a connection is established across Europe between shiny metal objects and their deposition in the reflective luminescent contexts of watery locations (Bradley 1990). In acknowledging this phenomenon we should surely reverse the old dictum and plead *Ex Occidente Lux*.

References

Bagolini, B. (1985), *Archeologia a Spilaberto*, Spilaberto.

Barfield, L.H. (1969), 'Two Italian halberds and the question of the earliest European halberds', *Origini*, 3, 67–83.

Barfield, L.H. (1986), 'Chalcolithic burial ritual in Northern Italy: problems of interpretation', *Dialoghi di Archeologia*, N.S. 2, 241–8.

Barfield, L.H. (1996), 'The Chalcolithic in Italy: considerations of metal typology and cultural interaction', in B. Bagolini and F. Lo Schiavo (eds), *Colloquium XIX Metallurgy: Origins and Technology, XIII International Congress of Prehistoric and Protohistoric Sciences Forli, Italia, 8–14 September 1996*, 65–74.

Barfield, L.H. and Chippindale, C. (1997), 'Meaning in the Later Prehistoric Rock-Engravings of Mont Bego, Alpes-Maritimes, France', *Proceedings of the Prehistoric Society*, 63, 103–28.

Bazzanella, M. and Mayr, A. (1995), 'L'uso del colore durante L'Età del Rame', in A. Pedrotti (ed.), *Le Statue Stele di Arco*, Trento: Museo Civico di Riva, 125–39.

Bradley, R. (1990), *The Passage of Arms: An Archaeological Analysis of Pre-historic Hoards and Votive Deposits*, Cambridge: Cambridge University Press.

Brunod, G. (1998), 'Les formes solaires des stèles chalcolithiques du Valcamon-ica', in *Actes du deuxième colloque international sur la statuaire mégalithique, Archéologie en Languedoc*, 22, 285–97.

Budd, P. and Ottaway, B. (1991), 'The properties of arsenical copper alloys: implications for the development of Eneolithic metallurgy', in P. Budd, A.M. Pollard and R. Scaife (eds), *Archaeological Sciences 1989: Proceedings of a Conference on the Application of Scientific Techniques to Archaeology, Bradford, September 1989*, Oxbow Monograph 9, Oxford: Oxbow, 132–42.

Budd, P. and Taylor, T. (1995), 'The faerie smith meets the bronze industry: magic versus science in the interpretation of prehistoric metal-making', *World Archaeology*, 27(1), 133–43.

Casini, S. (1994), *Le pietre degli dei. Menhir e stele dell'Eta del Ramein Valcamonica e Valtellina*, Nicolo: Civico Museo Archeologico e Centro culturale.

Cazzella, A. (1994), 'Dating the "Copper age" in the Italian peninsula and adjacent islands', *Journal of European Archaeology*, 2, 1–19.

De Marinis, R.C. (1994a), 'L'età del Rame in Europa: un'epoca di grandi trasformazioni', in S. Casini (ed.), *Le pietre degli dei*, Nicolo: Civico Museo Archeologico e Centro culturale, 21–30.

De Marinis, R.C. (1994b), 'La datazione dello stile III A', in S. Casini (ed.), *Le pietre degli dei*, Nicolo: Civico Museo Archeologico e Centro culturale, 69–87.

De Marinis, R.C. (1999), 'Chalcolithic Stele-Statues of the Alpine Region', in K. Demakopoulou and J. Mohen (eds), *Gods and Heroes of the European Bronze Age*, London: Thames and Hudson, 145–53.

Drewal, H.J. and Mason, J. (1998), 'Beads, body and soul: art and light in the Yoruba Universe', *African Arts*, Winter 1998, 18–27.

Fedele, F.G. (ed.) (1990), *L'altopiano di Ossimo-Borno nella preistoria. Ricerche 1988–90*, Capo di Ponte: Edizioni del Centro.

Fedele, F.G. (1995), *Ossimo 1. Il contesto rituale delle stele calcolitiche e notizie sugli scavi 1988–95*, Gianico: La Cittadina.

Fedele, F.G. (1999), 'Copper Age stelae and archaeological context: excavations at Ossimo, Val Camonica (Italian Central Alps)', in *NEWS 95: Proceedings, International Rock art Congress, North East West South 1995*, Turin.

Fossati, A. (1994), 'Gli animali nei massi incisi', in S. Casini (ed.), *Le pietre degli dei*, Nicolo: Civico Museo Archeologico e Centro culturale, 115–26.

Gallay, A. and Chaix, L. (1984), *Le site préhistorique du Petit Chasseur (Sion, Valais), 5–6, Le Dolmen M XI*, Lausanne: Cahiers d'Archéologie Romande.

Greenleigh, R.R. and Greenleigh, J. (1998), *The Days of the Dead. Mexico's Festival of Communion with the Departed*, San Francisco: Pomegranate.

Hackett, R. (1996), *Art and Religion in Africa*, London: Cassell.

Herbert, E. (1984), *Red Gold of Africa: Copper in Precolonial History and Culture*, Madison: University of Wisconsin Press.

Janzen, J. (1969), 'Introduction' to A. Fu-Kiau kia Bunseki-Lumanisa, *N-Kongo ye Nza Yakun'zungidila: Le mukongo et le monde qui l'entourait*, Kinshasa, 6–7.

Keates, S. (2000), 'The ancestralization of the landscape: monumentality, memory and the rock art of the Copper Age Val Camonica', in G. Nash (ed.), *World Perspectives in Rock Art and Landscape*, Oxford: BAR International Series.

Moore, H.L. (1994), *A Passion for Difference*, Cambridge: Polity.

Morphy, H. (1992), 'From Dull to Brilliant: The Aesthetics of Spiritual Power among the Yolgnu', in J. Coote, and A. Shelton (eds), *Anthropology, Art and Aesthetics*, Oxford: Clarendon.

Pearce, M. (1998), 'Reconstructing prehistoric metallurgical knowledge: the northern Italian Copper and Bronze Ages', *European Journal of Archaeology*, 1(1), 51–70.

Pedrotti, A. (1995), *Le statue stele di Arco. La statuaria antropomorfa nel III millennio a. C. abbigliamento fibru tessili e colore*, Trento: Museo Civico di Riva, Ufficio Beni Archeologici P.A.T.

Rivers, V.Z. (1999), *The Shining Cloth. Dress and Adornment that Glitters*, London: Thames and Hudson.

Roberts A. F. (1996), 'Peripheral Visions', in M.N. Roberts and A.F. Roberts (eds), *Memory: Luba Art and the Making of History*, Munich: Prestel, 211–44.

Roberts, M.N. and Roberts, A.F. (1996), *Memory: Luba Art and the Making of History*, Munich: Prestel.

Saunders, N.J. (1999), 'Biographies of brilliance: pearls, transformations of matter and being, *c.* AD 1492', *World Archaeology*, 31(2), 243–57.

Sherratt, A.G. (1981), 'Plough and pastoralism: aspects of the secondary products revolution', in I. Hodder, G. Isaac and F. Hammond (eds), *Pattern of the Past: Essays in Honour of David Clarke*, Cambridge: Cambridge University Press, 261–305.

Sherratt, A. (1983), 'The secondary exploitation of animals in the Old World', *World Archaeology*, 15(1), 90–104.

Skeates, R. (1993), 'Early metal-use in the central Mediterranean region', *Accordia Research Papers*, 4, 5–48.

Spindler, K. (1994), *The Man in the Ice*, London: Weidenfeld and Nicolson.

Turner, V. (1967), *The Forest of Symbols: Aspects of N'dembu Ritual*, Ithaca, NY: Cornell University Press.

Whitehouse, R.D. (1992), 'Tools the manmaker: the cultural construction of gender in Italian prehistory', *Accordia Research Papers*, 3, 41–53.

–6–

Munselling the Mound: The Use of Soil Colour as Metaphor in British Bronze Age Funerary Ritual

Mary Ann Owoc

Introduction

The interest in the colours of Bronze Age funerary practice that culminated in the contribution of this chapter, began from a detailed encounter with the constructional histories of a number of south-western British Bronze Age funerary/ritual sites. The term 'funerary/ritual sites' is used here to refer to the multiple examples of ritual architecture of the period, which generally include some combination of mounds/cairns, ditches, and rings/banks (Lynch 1970), and the features contained therein. While most scholars in the early twenty-first century appear willing to recognize that these sites are often structurally complex, a detailed investigation into this fundamental characteristic has been somewhat sidelined in contemporary interpretations of the period. Moreover, while some narratives of the Neolithic have included themes of landscape, cosmology and ritual, parallel work in earlier Bronze Age studies has been slower to emerge. Colour is relevant to both of these points since, first, the construction of these sites often involved the selective use of a number of coloured surface and subsurface materials and, second, the historic and ethnographic record has demonstrated that colour attribution and the symbolic construction of place and self has extensively involved symbolic constructions of colour and the ritual use of coloured materials (Barber 1999; Berlin and Kay 1969; Faris 1972; Gage 1999a; Turner 1967).

In what follows, colour and the extent to which it formed an important and meaningful component of south-western Bronze Age funerary architecture will be considered in light of some relevant observations concerning the 'construction' and use of colour ethnographically. It is suggested that colour was used by the builders of the monuments to delineate and highlight particular portions of funerary rituals and, moreover, that colour was part of a suite of symbolic attributes of the buried landscape that enabled particular interpretations of the funerary rituals to be made by the community of mourners.

A contextual classification of colour

While a large body of comparative data and analysis exists on colour perception, classification, terminology and their evolutionary development in both the historic and prehistoric periods (Berlin and Kay 1969; Kay et al. 1991), it has been noted that broad, all-encompassing, explanatory, cognitive models fall short when attempting to come to terms with the variety of nomenclatural and perceptual schemes for classifying and experiencing colour. Also neglected in these works is a comprehensive treatment of the historical circumstances within which agents come to give meaning and significance to colour (Gage 1999a; 1999b; Hewes 1992; MacLaury 1992; Saunders 1992; Stanlaw 1992). In particular Gage (1992a: 33, 110), has commented upon the 'fluidity' and 'instability' of colour perceptions which appear to contrast with assumed basic experiences of colour (black night, red blood and so on), while Casson (1992), MacLaury (1992), and Gage (1999a) have drawn attention toward the multidimensional aspect of colour, noting in some non-Western societies (and within Western society before the twelfth century) a recognition of colour *value*, or *brightness* at the expense of hue.

The critical focus of much of this work can be seen to revolve around an assertion that the practical *contexts* of colour naming and use must be considered within any attempt to classify colour ethnographically or prehistorically, since colour itself, and its recognition and/or delineation, is essentially an arbitrary category. Barth (1975: 173), in discussing the symbolic properties of the New Guinea Baktaman black, white, and red triad, noted that 'The *contrived* appearance of a feature in a context gives a much greater indication of significance than its prominent and inescapable presence . . . [since] symbols achieve their symbolic value or content through this contrivance, through the design and activity of persons, rather than by virtue of their natural qualities'.

Further, subjective impressions of colour (upon which classifications are built), though mediated by cognitive factors, are also likely to be significantly influenced by cultural circumstances. During Godlier's fieldwork among the Highland Baruya of New Guinea, for example, it emerged that subjects' identification of particular ritual pigments in a Munsell Book shown to them did not match the true colours of the pigments themselves when compared afterwards (Ollier et al. 1971). Instead of internalizing the actual colours of pigments used to create designs and to decorate material culture items, the Baruya perception of colour was idealized, and more influenced by the particular ritual or ceremonial *contexts* in which the colours were used or displayed.[1] This is of some importance since, like the example above, it serves to shift one's attention toward the meaningful, deliberate and contextual *construction* of colour, and away from its more superficial appearance or common-sense facticity.

Such processes of construction may be identified in the particular and varied ways in which humans use colour to express basic experiences. Following Taçon (1999), such expressions can be seen to involve the identification of change, the delineation of time, and the establishment of place and identity. Since all of these could be argued to be important in funerary rituals, and in the construction of funerary architecture, his remarks deserve further attention.

A selective ethnography of colour: time, identity, place and landscape

Taçon (1999: 122) notes that among human societies, colour plays an important role in the recording of change, in that new identities are 'given substance' and particular events are highlighted or defined through the deliberate use of colour and coloured materials. This can be exemplified by the frequent appearance and extensive use of colour during initiations and other ceremonial or meaning-laden ritual activities involving temporal change or definition of personhood in societies of the South Pacific, Africa, and the New World (Barth 1975; Faris 1972; Jones 1990; Turner 1967; 1969; Taçon 1991; Hosler 1995).

Among the south-eastern Nuba of Central Sudan for example, various clothing and pigment colours are used by women to signal the onset of socio-temporal events such as menstruation and menopause (Faris 1972). An even wider variety of pigment possibilities are associated with male initiation grades in the same society. Reds, oranges and grey-whites are used as background pigment after the first age grade is reached at 8, and a certain rich yellow may only be worn after the second age grade is achieved at 17. The wearing of deep black follows after two years, and as the male body matures, the decorative aspect of body painting declines.

Among the Baktaman of New Guinea, Barth (1975: 174–5) has also documented gender, kinship and initiation degree restrictions which govern the display of specific coloured pigments or items, citing both public and private uses of red, white, and black paint/pigments and feathers, and white shells, teeth and other ornaments.

In both these examples, it is important to emphasize that it is not merely the public or private display appearance of colour which creates its meaning and significance in these societies, but rather for both the Baktaman and the Nuba, it is the precise nature and intensity of the ritual practices involving the use and display of particular colours and coloured items which serve to simultaneously create and reinforce the symbolic significance and referents of these colours. The intimate relationship of colour and *place* is also noted by Taçon (1999: 121), since humans establish place from space in the landscape through action, oral tradition,

performance, material culture, and built form, and many of these activities involve the use or identification of colour. This may involve, as he notes, marking the landscape in colourful ways, though it may also involve the ascription of symbolic significance to certain, often coloured, features of the landscape. This phenomenological construction (Tilley 1994), however, should be seen to involve elements of both the surface and *subsurface* landscapes, and include the meaningful construction of a *variety* of buried soils, sediments and rocks.

Returning to the ethnographic examples cited earlier, among the Nuba (Faris 1972), the ochre and chalk body pigments referred to above are obtained from designated sites and collection points in the landscape which are traditionally associated with particular patriclans and gender groups.

For the Baruya, the significance and cultural construction of colour is also part of a wider subjective construction of the surface and subsurface landscapes. The Baruya have an extensive knowledge of the lithosphere, which they conceptualize and name through a three-fold division into over 30 names, which they divide into soils, hard rocks and limestone (Ollier et al. 1971). Within the soil subcategory, their nomenclature is basically built around colour and location, both of which are important for distinguishing particular ritual pigments and agricultural soils from one another. The collection points for these various items of material culture are varied. Some occur at considerable distance from residential compounds and at exceptional elevations, while others are associated with natural features of the landscape (such as streams), or occur in particular stratigraphic relationships to other soils. Some of these materials are further accorded significance in the local cosmology. *Kwonde,* the dominant limestone lithology in the region, is believed for example, to represent the bones of the original mythological inhabitants of the Baruya region.

Similar cosmological schemes involving stone or earthen materials which link (through colour or texture) the ornamental, the visible and the obvious with the powerful, the hidden and the sacred, have been documented elsewhere. The Zambian Ndembu's three sacred rivers of white, red and black, which are embodied by white Kaolin clay, red oxidized earth and black alluvial mud or charcoal, manifest a whole series of principles including purity and goodness, blood and power, and evil or death respectively (Turner 1967; 1969). These earthen symbols unify the disparate realms of the organic and the sacred, and tie intimately into communities' conceptualization of themselves.

In Eastern Arnhem Land, Australia, the everyday, the community and the sacred are linked via the buried landscape through a particular sort of white sparkling quartzite referred to as *djukurr*, used for projectile points and obtained from a sacred ancestral quarry (Jones 1990; Taçon 1991). The 'colour' of the quartzite can only be appreciated with some understanding of the cosmological scheme, which gives its visible and aesthetic qualities (brilliance and hardness) their real

significance. The shimmering quality of the stone is seen by the inhabitants as evidence that it is saturated with the essence of ancestral elements. Further, the stone is related via metaphor to the fat associated with the kidneys. The quarry where it is obtained is located within a ritually charged region associated with a Dreamtime myth cycle, related to gender relations and cited to justify male control over knowledge. This quarry, moreover, is located within the estate of a dominant patrilineal clan. Projectile points made from *djukrr* are therefore believed to have potency in hunting, not simply because of their sense of brilliance, or hard consistency, but rather because the stone itself 'bring[s] into play' (Turner 1967: 79) the organic, the power of the ancestors, formative events and creative forces of the dream-time, and the continuity of the patrilineage.

Interpreting the prehistoric colour aesthetic

Several points arise from the above remarks which have direct applicability to the assessment of colour in the funerary/ritual mounds of the Bronze Age South-west. First, colour is often intimately involved in the material celebration and communication of change, time and identity among communities or in relation to particular individuals. Second, the importance, definition and strength of colour should be seen primarily as emerging from its use, rather than as given natural qualities. Third, because colour is always located within broader schemes of perception, it is only through some understanding of these that the rationale behind the use of colour may be appreciated. Such schemes may be actualized, in part, during events where the symbolic referents of colours are enhanced and reproduced through their use in rituals of passage ceremonies. These ceremonies make use of the powers inherent within the colours for their successful completion and at the same time, define and reinforce their symbolic referents and the general cosmological structure of which they are a part. Fourth and finally, the ethnographic examples referred to above suggest that coloured elements of the surface and subsurface landscape may be intimately involved in the objectification of such cosmological structures, linking the social and the mundane with the moral and the sacred.

Frances Lynch's (1998) comments on colour in prehistory represent a point of departure for any interpretative work on the use of colour in British monuments, yet they also perhaps unintentionally hinder such a project. Lynch confines her discussion of monument colour and texture mainly to an appreciation of visual aesthetics, and seems rather to cast doubt upon the possibility of discovering the motivations behind the use of various building materials, or getting to grips with the meaningful content of this aesthetic sense. Similar sentiments are echoed by Gage (1999b) who ponders the difficulties of attributing meaning to colour, which – even when augmented by language – has multivocal qualities. Certainly, it may

never be possible to recover all the original meanings of prehistoric colours and coloured materials, and in any case, such a search is perhaps misguided (Barrett 1987). Nonetheless, a commitment to an interpretative archaeology demands some engagement with the logic which informs the particular schemes of perception that both condition the use of colour at these sites and were transformed by them. It is argued here that such an engagement should begin by focusing upon the contextual construction of colour *in practice*, through an attention to the actors'/builders' use of design elements, and how these elements were linked with other features during the rituals of passage at the sites.[2]

Additionally, when seeking to gain some understanding of the significance of these materials to local communities, it is perhaps not wise to entirely oppose choice and necessity in the matter of material selection (as in Lynch 1998). While necessity was obviously one factor which explains the use of local materials, and choice can be archaeologically isolated when non-local materials are used, it is important to stress that in the Neolithic and Bronze Ages, the buried landscape was most likely a phenomenological construction (as suggested above), so that necessity would always involve a meaningful choice. Some support for this may be found in the predominance of functionally unnecessary coloured and textured caps, mounds, buttresses and 'designed' turf strips in the Bronze Age sites in the region.[3]

Colour and Bronze Age south-western funerary/ritual monuments

The colour palate of the British South-west is richly endowed. This can be directly attributed to the complex geological composition of the region, which includes Devonian sandstones, shales, conglomerates and quartzes, the limestones, igneous and metamorphic rocks of the Lizard and granite uplands, the carboniferous sandstones, shales and limestones of northern Devon and east Somerset, and finally the chalks, sands, clays, shales, sandstones and marls of the Chalk, Greensand, Lias and New Red Sandstones in east Devon and Somerset. Consequently, the later Neolithic and Bronze Age monuments of the region display a variety of materials, including sparkling white quartz, gray slate, pink sand, pale flint, orange, yellow, grey, and red clays, and a variety of brown and black soils of various textures – all of which were derived from the local lithologies noted above and their overlying sediments and soils. A detailed overview of the Bronze Age monumental record of the South-west reveals a series of localized building traditions which made use of these varied physical elements of the landscape in what was a both knowledgeable and deliberate way (Owoc 2000a and 2000b). Before turning to particular examples, it is necessary to consider what general significance colour may have had in the rituals surrounding the construction of

theses sites, and in what ways colour might have related to other physical properties displayed by monumental components (Jones and Bradley 1999)

The deliberate use of colour by the builders of Bronze Age funerary/ritual sites as a device to draw attention to particular sites has been suggested by a number of commentators working in the period (e.g. Barrett 1994; Garwood 1991; Lynch 1993). Numerous examples of this phenomenon also exist in the South-west.[4] Just as interesting though, are the attempts, found at a number of south-western sites, to deliberately *mask* colour, either with the addition of a dark or dull brown, grey or black cap, or by the practice of leaving a site to 'weather' for a time, before further activities are commenced.[5] The masking layers and the weathering return a site to a more normal appearance, as infrequently seen and brightly coloured components of the buried landscape employed in construction either gradually or abruptly disappear. The use of colour, therefore, can be understood in particular cases as perhaps indicating a liminal period for the deceased or the community, during which the site is active, and the statuses of the deceased and of the mourners are in flux, particularly if an assumption is made (following from above) that these coloured materials are active signifiers which refer to or embody powerful cosmological principles and forces brought into play to affect or explain the transition represented at the sites.[6] I have suggested elsewhere (Owoc 2000b) that for some sites, a 'staged' mound construction involving a sequential series of both highly coloured and dull components relates to a temporal material demarcation of the responsibilities of the community of mourners to the deceased, and/or a symbolic rendering of the perceived state of the deceased and/or the community at various points during the rite of passage.

As Jones and Bradley (1999) and Lynch (1998) have suggested, the significance of colour in prehistory may be linked to other properties of materials, in particular texture. To this can be added other qualities. In one of the best examples of a deliberate barrow design strategy involving subsurface materials in the Southwest, at Crig-a-Mennis (Christie 1960), the use of sequential caps and new mounds to the site involved a difference not only in colour but also of texture, location, depth and consistency. Each mound layer becomes harder or lighter, or is found stratigraphically deeper, which seems to suggest that the mourners would have perceived their and the deceased's transitions according to some cosmological scheme involving hardening or whitening. The sequential site enlargement at Crig-a-Mennis was punctuated by two urn burials and a series of other activities on the mounds and the berm, so that as the form and appearance of the mound changed, specific actions marking the passage of the funerary rite for the dead and for the mourners were performed. This treatment of the colours of Bronze Age funerary practice is not complete without some illustration of the way in which particular components of the Bronze Age landscape were rendered meaningful in practice through site design, as argued above.

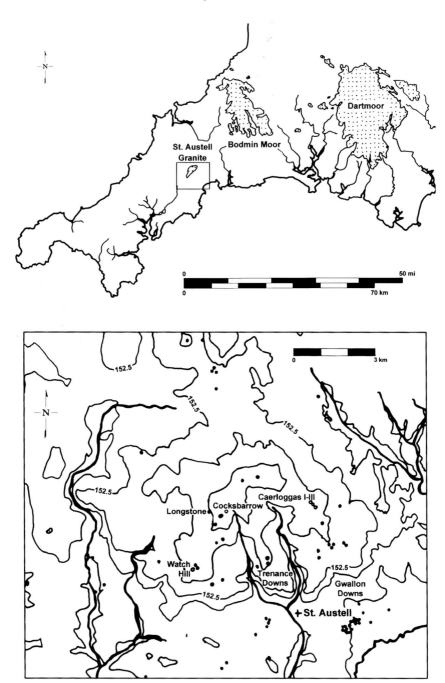

Figure 6.1 Barrows on the St Austell granite. A: Location of St. Austell granite in SW England B: Contours are at 60m intervals. Open circles indicate excavated sites.

The colour yellow on the St Austell granite

The later Neolithic and earlier Bronze Age sites of St Austell in central southern Cornwall are notable, though not unique, for their yellow clay mound caps or embellishments (Miles 1975; Miles and Miles 1971; Johns 1993) (Figure 6.1a,b). While the obvious visual impact of this coloured material during the construction of the sites is clear, the reasons for its use and significance are better interpreted if other activities of the builders, and the St Austell region as a whole, are considered. At the Early Bronze Age site of Caerloggas Downs III, before the mound was constructed, ritual participants laid branches on the ground surface in the south-east, and erected a standing stone in the north-west, near two solstial alignments: the midwinter sunrise (MWSR) and the midsummer sunset (MSSS) (Figure 6.2a). The concern with these two particular astronomical alignments is paralleled at Cocksbarrow, a nearby site of similar age, whose entrance gaps were located on these alignments. Further, movement within the monument itself was controlled to follow the path of the sun from one sunrise to the other sunset (Figure 6.2b).

Additionally, structural features and activities at three other sites on the granite (Caerloggas Downs I, Watch Hill and Trenance Downs) indicate that the portions of the funerary and ritual activities at the sites were built around the timing and/or recognition of the two other solstices. Thus, as a framing concept for the funerary rituals for this community, the significance of the sun, and moreover its movement through the sky, were of considerable importance and clearly linked in a meaningful physical way to the timeless seasonal cycles of birth, life and death for these communities. This frame of reference was further elaborated and objectified through the use of particular items of material culture at Caerloggas Downs III (branches and stone towards MWSR and MSSS positions respectively) and at Watch Hill, where the deposition of particular objects into a ditch followed related rules of alignment (Owoc 2000b). Although space does not permit the details of the larger logic of perception mobilized in the activities at this site to be addressed here (see Owoc 2000b), it can be noted that the specific physical properties of wood and stone, and their potential metaphorical links to flesh, bone, and corporeal and ancestral were no doubt brought into play to further frame a conceptualization of the ritual for the participants. It is within *this* meaningful context of practice that the use and significance of the yellow clay at Caerloggas Downs III and the other sites can be better appreciated. The yellow clay itself is actually yellow kaolinized granite, which is not available in the sites' immediate areas but was most likely obtained from nearby valley heads where it is exposed some 3 m below the surface. The desirability of this material is evidenced by its procurement for a number of sites both on and off the granite on the Gwallon Downs (Miles 1975).

Considering the particular astronomical alignments in these sites, and the system of material signification which linked them with individuals' funerary rites,

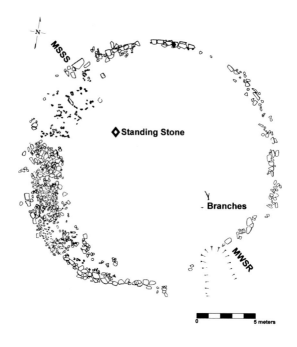

Figure 6.2a Caerloggas Downs III.

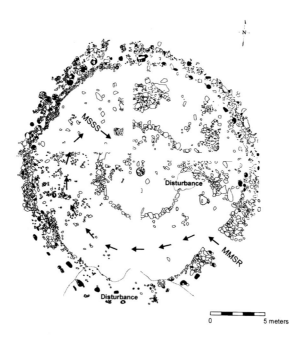

Figure 6.2b Cocksbarrow, early and later phases.

a metaphorical bond between the *yellow clay* and the *sun* appears to have been made during the construction rituals at the sites. Further support for this interpretation may be gained for the observation that the builders of Caerloggas Downs III placed this material in a position approximating the path of the sun from MWSR at the beginning of its seasonal cycle to MSSS at its end (Plate 6).[7] The yellow clay on the St Austell granite can therefore be understood as a dominant symbol mobilized during rites of passage to further create a link between the human cycle of life and death, and the timeless cycle of the dominant solar body. Like the sun, it has a dual existence both above and below the ground surface, so its deliberate selection and use within the funerary rituals most likely involved elements of both signification and power.

Conclusion

In closing, it is worthwhile to reflect on the fact that the funerary/ritual sites of the Bronze Age were public monuments. Most were physically formed by a small community who also stood and looked at them, and moved within them, around them and on top of them. No better locale existed to skillfully draw together a range of disparate symbolic significata for the purpose of accomplishing a meaningful and successful transition from life to death, and back again. The above discussion has suggested that the coloured elements of the natural landscape in the South-west were an important part of this suite of ritual symbols and, moreover, that their deliberate employment as design elements within these sites served both to meaningfully affect this transition and to simultaneously objectify and renew the tradition of knowledge within which these communities operated.

Notes

1 Gage's (1999a: 112) comments concerning the difficulties experienced by Berlin and Kay's informants while using the specialized modern view of colour displayed in the Munsell Colour designation system also have relevance to this example.
2 Work on the Bronze Age Clava Cairns, near Inverness (Jones and Bradley 1999; Lynch 1998), also seems to support this assertion.
3 In addition to the sites referred to below, several excellent south-western examples of this phenomenon, also involving deliberate colour and texture selections of stone/soil, can be found in Ashbee (1958), Christie (1960), Dudley (1964) and Pollard and Russell (1969).
4 Notable sites displaying final striking light caps can be found in Christie (1960), Dudley (1964), and Miles and Miles (1971).

5 Notable sites displaying these activities in the South-west can be found in Miles (1975), Pollard and Russell (1969), and Christie (1960).
6 Tilley's (1995) work on the power of stones in the south-western landscape is highly relevant to this discussion.
7 A yellow subsoil-sun metaphor was also created and reproduced at the Davidstow Moor cemetery in Cornwall (Christie 1988), where the construction of a number of yellow clay local subsoil rings and deliberate deposits (which invert the normal turf/subsoil relationship, expose the yellow subsoil below the surface, or draw attention to this material) bear deliberate material witness to the passage of the sun around the horizon, and to its appearance and disappearance above and below the horizon at particular locations around the circumference of a circular monument (Owoc 2000a and 2000b).

References

Ashbee, P. (1958), 'The excavation of Tregulland Barrow, Treneglos Parish, Cornwall', *The Antiquaries Journal*, 38, 174–93.
Barber, E.J.W. (1999), 'Colour in early cloth and clothing', *Cambridge Archaeological Journal*, 9(1), 117–20.
Barrett, J. (1987), 'Contextual archaeology', *Antiquity*, 61, 468–73.
Barrett, J. (1994), *Fragments from Antiquity: an Archaeology of Social Life in Britain, 2900–1200 BC*, Oxford: Blackwell.
Barth, F. (1975), *Ritual and Knowledge Among the Baktaman*, New Haven: Yale University Press.
Berlin, B. and Kay, P. (1969), *Basic Color Terms: Their Universality and Evolution*, Berkeley: University of California Press.
Casson, R. (1992), 'On brightness and color categories: additional data', *Current Anthropology*, 33(4), 395–97.
Christie, P. (1960), 'Crig-a-Mennis: A Bronze Age barrow at Liskey, Perranzabuloe, Cornwall', *Proceedings of the Prehistoric Society*, 33, 336–66.
Christie, P. (1988), 'A barrow cemetery on Davidstow Moor, Cornwall: Wartime excavations by C.K. Croft-Andrew', *Cornish Archaeology*, 27, 27–169.
Dudley, D. (1964), 'The excavation of the Carvinak barrow, Tregavethan, near Truro, Cornwall', *Journal of the Royal Institute of Cornwall*, 2(44), 414–51.
Faris, J. (1972), *Nuba Personal Art*, Toronto: University of Toronto Press.
Gage, J. (1999a), *Color and Meaning: Art, Science and Symbolism*, Berkeley: University of California Press.

Gage, J. (1999b), 'Did colours signify? Symbolism in the red', *Cambridge Archaeological Journal*, 9(1), 109–12.

Garwood, P. (1991), 'Ritual tradition and the reconstitution of society', in P. Garwood, D. Jennings, R. Skeates and J. Toms (eds), *Sacred and Profane*, Oxford University Committee for Archaeology Monograph 32, Oxford: Oxbow, 10–32.

Hewes, G.W. (1992), 'Comments', in 'From Brightness to hue: an explanatory model of color category evolution', *Current Anthropology*, 33(2), 137–86.

Hosler, D. (1995), 'Sound, color and meaning in the metallurgy of Ancient West Mexico', *World Archaeology*, 27(1), 100–15.

Johns, C. (1993), 'Littlejohns barrow, 168–169', in Recent Work, Cornwall Archaeological Unit, *Cornish Archaeology*, 32, 167–77.

Jones, A. and Bradley, R. (1999), 'The significance of colour in European archaeology', *Cambridge Archaeological Journal*, 9(1), 112–13.

Jones, R. (1990), 'Hunters of the dreaming: some ideational, economic and ecological parameters of the Australian Aboriginal productive system', in D.E. Yen and J.M.J. Mummery (eds), *Pacific Production Systems*, Canberra: Australian National University, 25–53.

Kay, P., Berlin, B. and Merrifield, W.R. (1991), 'Biocultural implications of systems of color naming', *Linguistic Anthropology*, 1, 12–25.

Lynch, F. (1970), 'Ring cairns and related monuments in Wales', *Scottish Archaeological Forum*, 4, 61–80.

Lynch, F. (1993), 'Excavations in the Brenig Valley, a Mesolithic and Bronze Age Landscape in North Wales', *Cambrian Archaeological Monograph* 5, Aberystwyth: Cambrian Archaeological Association and Cadw: Welsh Historic Monuments.

Lynch, F. (1998), 'Colour in prehistoric archaeology', in A. Gibson and D.D.A Simpson (eds), *Prehistoric Ritual and Religion*, Stroud: Sutton, 62–7.

MacLaury, R E. (1992), 'From brightness to hue: an explanatory model of color-category evolution', *Current Anthropology*, 33(2), 137–86.

Miles, H. (1975), 'Barrows on the St. Austell granite', *Cornish Archaeology*, 14, 5–81.

Miles, H. and Miles, T.J. (1971), 'Excavations on Longstone Downs, St. Stephen in Brannel and St. Mewan', *Cornish Archaeology*, 10, 5–28.

Ollier, C.D., Drover, D.P. and Godelier, M. (1971), 'Soil knowledge amongst the Baruya of Womenara, New Guinea', *Oceania*, 42(1), 33–41.

Owoc, M.A. (2000a), 'Symbols in Action: British Bronze Age Funerary Architecture and the Structuration of Society', Paper Presented at the 65th Annual Meeting of the Society for American Archaeology.

Owoc, M.A. (2000b), 'Aspects of Ceremonial Burial in the Bronze Age of South-West Britain', Sheffield: Unpublished PhD thesis, Department of Archaeology, University of Sheffield.

Owoc, M.A. (2000c), 'The Phenomenology of the buried landscape: soil as material culture in the Bronze Age of South-West Britain', in C. Cumberpatch and P. Blinkhorn (eds), *The Chiming of Cracked Bells*, Oxford: Oxbow.

Pollard, S.H.M. and Russell, P.M.G. (1969), 'Excavation of round barrow 248b, Upton Pyne, Exeter', *Proceedings of the Devon Archaeological Society*, 27, 49–78.

Saunders, B.A.C. (1992), 'Comments', in R.E. MacLaury, 'From brightness to hue: an explanatory model of color category evolution', *Current Anthropology*, 33(2), 137–86.

Stanlaw, J. (1992), 'Comments', in R.E. MacLaury, 'From brightness to hue: an explanatory model of color category evolution', *Current Anthropology*, 33(2), 137–86.

Taçon, P.S.C. (1991), 'The power of stone: symbolic aspects of stone use and tool development in western Arnhem Land, Australia', *Antiquity*, 65, 192–207.

Taçon, P.S.C. (1999), 'All things bright and beautiful: the role and meaning of colour in human development', *Cambridge Archaeological Journal*, 9(1), 120–23.

Tilley, C. (1994), *A Phenomenology of Landscape*, Oxford: Berg.

Tilley, C. (1995), 'Rocks as resources: landscapes and power', *Cornish Archaeology*, 34, 5–57.

Turner, V. (1967), *The Forest of Symbols: Aspects of Ndembu Ritual*, Ithaca, NY: Cornell University Press.

Turner, V. (1969), *The Ritual Process: Structure and Anti-Structure*, Ithaca, NY: Cornell University Press.

Making Monuments Out of Mountains: The Role of Colour and Texture in the Constitution of Meaning and Identity at Recumbent Stone Circles

Gavin MacGregor

Introduction

In the late twentieth century the potential significance of the deliberate use of colour in creating and sustaining meanings in the past began to be discussed by archaeologists (Gage et al. 1999). The incorporation of different-coloured stone in the architecture of prehistoric monuments has received particular attention (e.g. Bradley 2000a; MacGregor and Loney 1997; Lynch 1998; Jones 1999; see also Scarre in Chapter 12 of this volume). This chapter considers further the role of colour in the expression of meaning in prehistoric monuments through the example of the Recumbent Stone Circle tradition of Northeast Scotland.

The constitution of meaning

The majority of people are immersed in a world of colour. For this majority, experiences of colour and its potential significance are frequently paradoxical. In daily life colour is ubiquitous and permeates so many areas of social meaning that we are often oblivious to the presence and significance of colour. Thus in one respect colour provides a form of unconscious non-discursive structure to our daily life. At other times, in certain social contexts people explicitly evoke colours to generate and sustain particular meanings and it is often in these contexts that limited palates of colours are referred.

These two poles of experience of, and expression through, colour are transcended by the way that social meanings are constituted through material culture. Social meanings are not merely abstract concepts residing in the mind. Rather, a social meaning is the culmination of the nature and context of expression, the sensory perception of that expression and the internalization of that expression or

meaning. Consequently, the colours deployed in material culture have a range of physical, emotive and conceptual elements to their meaning. Thus meanings, in particular social meanings, are potent in relation to material culture, not because we think with them, but primarily because we feel with them. Such meanings are permeated with the history of the artefact or monument, the affordances of the materiality of their perception and the nature of internalization. The active and explicit use of material culture may result in the constant negotiation and reworking of related meanings. The nature of material culture and the meanings it is permeated with will form parameters to the nature of ontogenesis and the enculturation of individuals and social groups.

The recumbent stone circle tradition

Recumbent Stone Circles (hereafter RSCs) represent a distinct form of monument. They are characterized by a number of architectural traits (Burl 1974; 1976a), the most striking of which is the form created by the recumbent stone and accompanying flankers (Plate 7). The interior of an RSC was often the focus of other distinct architectural elements. These include such features as platforms behind the recumbent, two perpendicular stones running inwards from the point where the recumbent and flanker meet, ring-banks joining the orthostats, central kerbed ring-cairns and central cairns. Notably, RSCs have a limited geographical distribution within the North-east of Scotland (Figure 7.1). The majority of RSCs are close to or have a view to prominent peaks with a particular emphasis on the mountain of Bennachie.

A few RSCs have been excavated during the twentieth century. These include Garrol Wood (Coles 1905), Old Keig (Childe 1933, 1934) and Loanhead of Daviot (Kilbride-Jones 1935). The results of excavations at Berrybrae (Burl 1975; 1976b; 1977; 1978) and Strichen (Abramson 1980; Abramson and Hampsher-Monk 1981; Hampsher-Monk and Abramson 1982) remain to be fully published. The detail of the sequence and chronology of construction of the different elements is consequently poorly understood (MacGregor 1999).[1]

Previous studies of the use of these monuments have concentrated on the potential for significant astronomical alignments incorporated in the form and orientation of the recumbent flankers (e.g. Burl 1981). Such research has made a significant contribution to understanding how they may have been utilized at one particular occasion, i.e. observing the setting of the moon. However, these monuments have rarely been considered in terms of their relationship to a wider landscape setting or how people may have actually experienced them in the past (MacGregor 1999).

Lynch has highlighted the potential significance of the colour of stones utilized at RSCs (1998: 65–6). Lynch notes several examples of the potentially deliberate

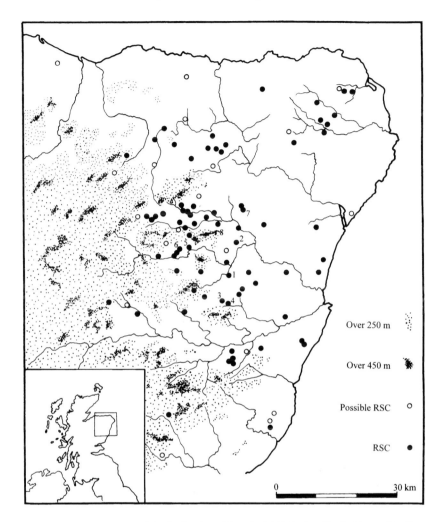

Figure 7.1 Location plan / RSC distribution (After Burl 1976); 1 = Castle Fraser; 2 = Easter Aquorthies; 3 = Midmar Kirk; 4 = Sunhoney; 5 = Cothiemuir; 6 = Old Keig; 7 = Loanhead of Daviot; 8 = Bennachie.

incorporation of patterns of colour, citing examples of RSC where the colour of the recumbent stone varies from those comprising the circle. The examples of the RSCs at Castle Fraser and Easter Aquorthies are highlighted for the use of alternating colours of stone. It is considered that the recumbent and flankers at Castle Fraser are of the same quartz-grained grey stone. Lynch recognized that although the eastern stones of the circle showed an alternating grey-red-grey pattern, the position of the other stones meant that a regular pattern could not have been maintained. In the case of Easter Aquorthies, Lynch notes that the recumbent

stone is a darker colour of grey than the colour of the adjacent recumbent stones, while the stones on the west of the circle are alternating grey and black; on the east they are alternating shades of pink. Lynch notes that the contrast in stone colours at Easter Aquorthies was particularly striking when all the grime and lichen covering them had been stripped while casts were being taken during the early 1980s. Finally, it is observed that at the site of Yonder Bognie all of the stones are of the same material and, without any justification, that this must be true for the majority of sites. Ultimately, however, Lynch concludes that:

> significant colour variation is not as consistently found as the gradation in stone height, the horizontality of the recumbent or its orientation, so, if it is a matter of symbolism, as distinct from architectural jeu d'esprit, it is not one that is essential to the religious function of the monument (Lynch 1998: 66)

Although it is important that Lynch stresses the potential significance of colour in prehistoric architecture, there are several problems with her approach to the study of colour in the architecture of RSCs. The conclusion quoted above indicates that Lynch is seeking coherent patterns in the present as an indication of significant meaning in the past. Although similar patterns of architectural expression between monuments are undoubtedly significant, it is not necessarily the only means of symbolic expression. The construction of small-scale monuments such as RSCs would undoubtedly have entailed a degree of individual choice in the construction and expression of meaning in architecture by the local communities that built them. Although wider traditions may have set certain broad parameters of monument construction, there was no prescription that the people who created them should build in a certain way, but they chose to do so within the terms of their own understanding as to what the act of monument building meant to them. It is therefore important to consider that subtle variation may have been as symbolically significant as the regular pattern of coloured stone that Lynch so clearly seeks in the case studies. Although colour may be potentially significant, we should not be obsessed with the visual experience of monuments. The choice of a particular stone may, in part, relate to its haptic qualities, for example texture or temperature. Thus, it is also important that the interrelationship between visual and haptic properties of monuments is explored.

Feeling the colour of monuments

I now wish to consider the potential significance of the interplay between colour and texture of the stones of a RSC through the examples of Castle Fraser, Easter Aquorthies, Midmar Kirk, Sunhoney, Cothiemuir, Loanhead of Daviot and Old Keig. In the main, these sites were chosen for being well preserved with the

Plate 1 Boulder 'Vulva', House 51, Lepenski Vir (after Srejovic and Babovic 1983).

Plate 2 Gold dish, grave 4, Varna cemetery (source: Georgiev 1988, Abb. 19).

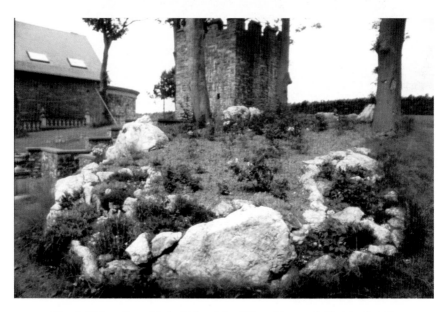

Plate 3 Billown Stone Circle, Malew, Isle of Man. (Photograph Timothy Darvill.
Copyright reserved).

Plate 4 Porphyritic andesite (porphyry) from Lambay, outcrop fragment and polished axe from the Eagle's Nest site.

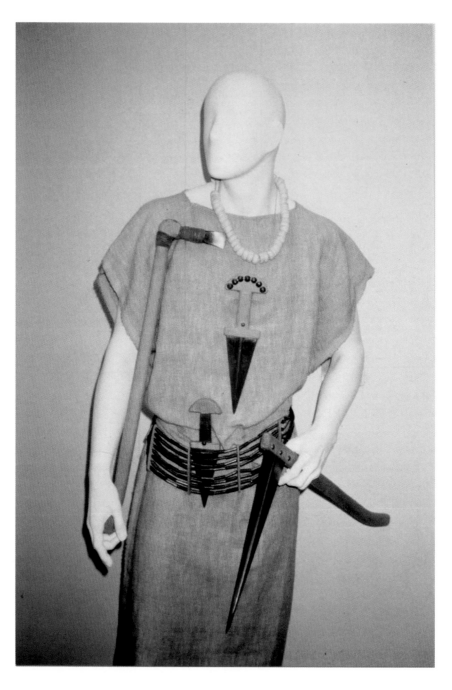

Plate 5 Copper Axe, daggers halberd and belt of rows of copper beads, reconstructed as represented on stelae. The classical Remedello style dagger is presented on the chest.
1995 exhibition Riva del Garda. (Photo. S. Keates).

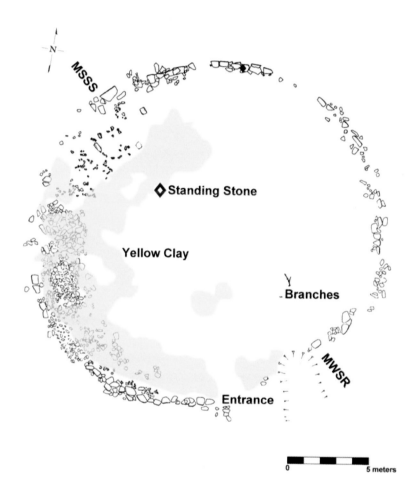

Plate 6 Caerloggas Downs III with final yellow clay embellishment.

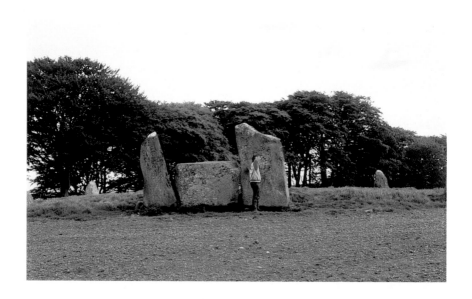

Plate 7 Photo of Castle Fraser RSC showing recumbent and flankers.

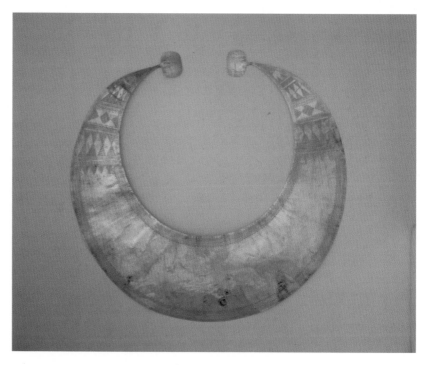

Plate 8 The gold lanula from Blessington, Co. Wicklow, Ireland. This clearly illustrates the lunate shape and the decorative treatment of the upper areas of these colourful Early Bronze Age neck adornments (Photo courtesy of the British Museum).

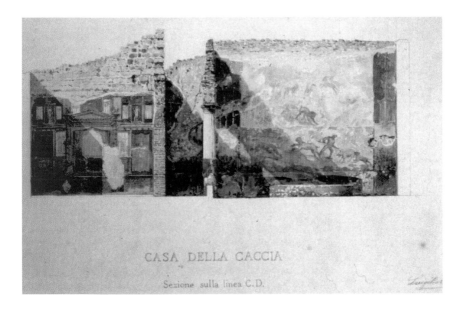

Plate 9 North/south transverse of inner west side of house, watercolour by L. Bazzani, 1899 (photo P.M. Allison).

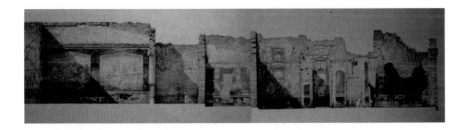

Plate 10 East/west transverse of inner southern part of house, watercolour by L. Bazzani, 1899 (photo P.M. Allison).

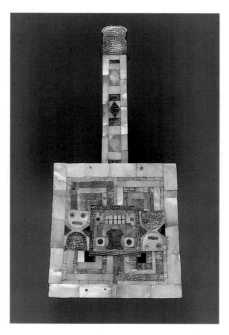

Plate 11 Multi-coloured, multimedia mirror/snuffing tray?, c. AD 650–800. This mosaic of shell and polished stone is surrounded by mother of pearl, with a central face in 'weeping' style of the Andean Huari culture. Reverse (not shown) is a reflective surface of pyrite inlay. (Photo courtesy of Dumbarton Oaks Research Library and Collections, Washington, D.C.)

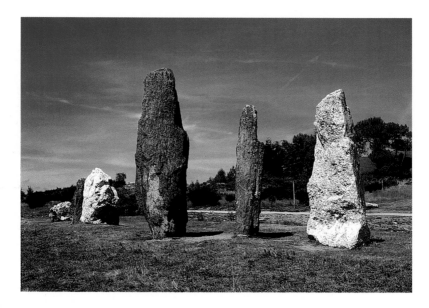

Plate 12 Central section of the 'file sud' alignment at Le Moulin. (Photo: Chris Scarre)

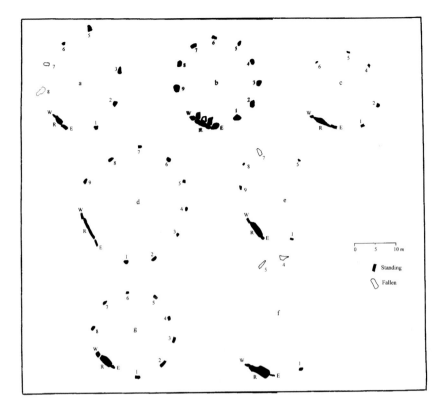

Figure 7.2 Ground plan showing main stones of RSCs subject to study; a = Castle Fraser (After Burl 1976); b = Easter Aquorthies (After Burl 1976); c = Midmar Kirk (After Burl 1976); d = Sunhoney (After Burl 1976); e = Cothiemuir (After Coles 1902); f = Old Keig (After Childe 1934); g = Loanhead of Daviot (After Lynch 1998).

majority of the stones being present at the site, but in several cases because of their close proximity to one another.

Castle Fraser

Only one of the stones comprising Castle Fraser RSC (Figure 7.2a) is missing. The texture of the stones forming the circle varies considerably, ranging from the coarse granite of two and three to the fine granite of stone seven. The stones of the circle are generally grey or pink-red granites (Plate7; Table 7.1). To describe a stone as a particular colour, however, often masks the variability of colour found throughout a stone. For example, let us consider stones one, two and eight which were described by Lynch as grey, paler red and grey in colour. From a distance

Table 7.1 The predominant colour and texture of stones at Castle Fraser

Stone	W	R	E	1	2	3	4	5	6	7	8
Colour	G	G	G	G/P	P	G	?	G	P	G	G/P
Texture	M	F	M	M-C	C	C	?	F-M	F-M	F	F-M

Key: W = west flanker; R = Recumbent stone; E = east flanker; G = grey; P = pink; W = white; F = fine; M = medium; C = Coarse; l = light; d = dark; v = very; Gl = glassy

stone one looks grey, but as you get closer the complexity of the colours of the stone becomes apparent. A series of veins of pink granite runs through the rock. The inward face of the stone is a light pink colour due to the cleaving of the rock along one of these veins. Although stone one is predominately grey in colour it is also pink. The ambiguity of this rock's colour is utilized during construction to present a pink stone to those inside the monument and a grey stone to those outside.

From a distance, stone two stands out from the other stones of the circle because of its intense pink-red colour. The coarse granite of which it is made is not, however, uniform in appearance. The inner face of the stone is markedly different through a highly polished surface that has a smooth glossy feel. In this case, the texture and brightness of the rock surface have been used to distinguish between the exterior and interior of the monument.

Stone number eight was described as grey in colour by Lynch. Indeed from a distance, grey is probably the best way to describe the colour of this stone. Once you come closer to it, however, the complexity of the composition of the stone is apparent. The surface is composed of regions of mottled white and black that merge into areas of grey and pink granite veins run irregularly across the stone. Unfortunately, it is impossible to assess whether the inside and outside of the monument was distinguished through different-coloured faces, since this stone has fallen at some time in the past.

We have concentrated on the three stones of the circle which display the most variation in texture and colour. Many of the other stones, however, also display quartz veins and other inclusions that may have influenced how the stones were arranged in an architecturally effective or symbolically meaningful fashion. A striking example of this is found with the flankers. The western flanker is a tall (*c.* 2.5 m high) stone of medium-grained grey granite, with some quartz veining. On the upper part of the stone is a flat oval surface, measuring 0.20 m × 0.30 m, of smooth white quartz. The stone has been positioned so that this feature points upward and outward. The taller (*c.* 2.9 m high) eastern flanker is of a similar quartz-veined grey granite. It is distinguished by a partial surface of flat white quartz. This surface is somewhat weathered and probably was at one time more

extensive. The stone was positioned so that the quartz surface faces toward the western flanker.

Notably, several features of the stones at Castle Fraser were utilized to distinguish the inside from the outside of the monument. Perhaps most striking was the choice of the western flanker, as it was positioned to orientate a white quartz disc up toward the sky; it pointed toward and provided a mirror to the celestial bodies.

Easter Aquorthies

Several points were highlighted by Lynch (1998) about the stones of Easter Aquorthies circle (Figure 7.2b). These included a degree of alternation on the west side between black and grey stones (Numbers six to nine), the alternation of shades of pink stone to the east, and the shared grey colour of the flankers and recumbent (Table 7.2). These observations are in broad terms correct, but the picture painted by Lynch is somewhat more complicated in reality. For example, upon examination stones six and eight (considered grey by Lynch) appear to be pink granite, and stones seven and nine (considered black by Lynch) are grey. Why should there be this difference in opinion about the colour of these stones? I shall return to answer this question below.

Table 7.2 The predominant colour and texture of stones at Easter Aquorthies

Stone	W	R	E	1	2	3	4	5	6	7	8	9
Colour	LG	dG	lG	P	P/W	P	P	P	P	G	P	G
Texture	F-M	M	F-M	C	Gl	C	F-M	vF	F	F	M	M

Key: W = west flanker; R = Recumbent stone; E = east flanker; G = grey; P = pink; W = white; F = fine; M = medium; C = Coarse; l = light; d = dark; v = very; Gl = glassy

Although I have described stone six as pink, it is of further note because of colour variation. In contrast to the main body of the stone, the upper 10 cm is of a grey granite. Stone two is, therefore, both pink and grey.

Let us now consider stone two. This stone is unusual for its striking appearance and waxy feel because of its composition of jasper. Although Lynch is broadly right to describe this stone as paler red, the variation in appearance and texture across the stone suggests that it may have been positioned to utilize this in a meaningful fashion. The lower part of the northern face of the stone is an intense red colour. In contrast, the face pointing toward the recumbent is a predominately milky white colour. Thus the stone was orientated to present the 'whitest' face

toward the stones of the recumbent and flanker and the face with the most intensely red colour is pointing away.

It was noted at Castle Fraser that the flankers had been positioned in such a fashion to employ quartz faces in an architecturally effective fashion. A variation on this theme can be witnessed at Easter Aquorthies. The east face of the west flanker has a highly polished surface to it. The recumbent stone is particularly striking as it has a series of short wiggly quartz veins running up and down it. This particular pattern of veins is not evident on any of the other stones comprising the circle.

Examining the texture of the stone indicates that the majority in the southern sphere are medium-textured and the majority in the northern part of the circle are fine in texture. It is difficult to be certain if this play on texture is deliberate. One pattern of texture which we may be confident is a deliberate architectural device is the choice of material for stones one to three. It is particularly significant that the stones on either side of stone two comprise of the coarsest granite within the circle. The unusual waxy quality of stone two is juxtaposed with the coarseness of the adjacent stones, all of which are in contrast to the fine- or medium-textured stones which form the rest of the circle. Therefore, the choice of material utilized emphasizes, in terms of their texture, the contrast between stone two and the others that form the circle. It is possible to suggest that the haptic quality of the stones was one of the reasons that determined their location in relation to one another in the circle.

Midmar Kirk

Midmar Kirk (Figure 7.2c) provides a striking contrast to the potential subtlety of architectural expression achieved at both Castle Fraser and Easter Aquorthies. Although three of the stones from the circle are missing, as the eight remaining stones are a pink granite it would seem likely that all the stones were originally produced from the same material (Table 7.3). There is only one apparent exception to the dominance of pink colour in the circle. That is seen on stone six, where the upper 0.40 m is a grey colour.

Table 7.3 The predominant colour and texture of stones at Midmar

Stone	W	R	E	1	2	3	4	5	6	7	8
Colour	P	P	P	P	P	?	P	P	P	?	?
Texture	M-C	M-C	M-C	M	M	?	M	M	M	?	?

Key: W = west flanker; R = Recumbent stone; E = east flanker; G = grey; P = pink; W = white; F = fine; M = medium; C = Coarse; l = light; d = dark; v = very; Gl = glassy

Although there would appear to be next to no variable use of colour in the architecture of Midmar, there are some notable differences in the texture of the stones employed. The stone used for the flankers and recumbent is coarser than that of the other stones of the circle. In striking contrast to the coarse texture of the recumbent flankers is the texture of the stone (number five) furthest from them. This stone has a much smoother surface than the surfaces of any of the other stones within the circle.

Sunhoney

This circle shows many similarities with Midmar, which is less than 2 km distant. In particular, as with Midmar the architecture of Sunhoney (Figure 7.2d) shows a limited use of variable colour in its architecture. All the stones, bar one, are composed of a medium-pink granite. The only exception is the recumbent stone, which is a fine grey granite (Table 7.4).

Table 7.4 The predominant colour and texture of stones at Sunhoney

Stone	W	R	E	1	2	3	4	5	6	7	8	9
Colour	P	G	P	P	P	P	P	P	P	P	P	P
Texture	M	F	M	M	M	M	M	M	M	M	M	M

Key: W = west flanker; R = Recumbent stone; E = east flanker; G = grey; P = pink; W = white; F = fine; M = medium; C = Coarse; l = light; d = dark; v = very; Gl = glassy

Cothiemuir

Although four of the stones of this circle are missing (see Figure 7.2e), there is sufficient remaining to demonstrate that there is considerably more variation in colour and texture than witnessed at Midmar and Sunhoney (Table 7.5). The

Table 7.5 The predominant colour and texture of stones at Cothiemuir

Stone	W	R	E	1	2	3	4	5	6	7	8	9
Colour	P	W/G	P	G	?	?	?	P	?	P	P	P
Texture	C	M	C	F	?	?	?	C	?	C	C	C

Key: W = west flanker; R = Recumbent stone; E = east flanker; G = grey; P = pink; W = white; F = fine; M = medium; C = Coarse; l = light; d = dark; v = very; Gl = glassy

Gavin MacGregor

majority of the stones are a coarse pink granite. The surviving exceptions are stone number one, which is a fine grey sedimentary rock, and the recumbent stone, which is a white-grey medium-textured conglomerate. The surface of stone one is pock-marked like a lunar landscape, probably through heavy weathering. The only other notable distinction in texture and colour present at the circle is found on the flankers. The lower part of the eastern face of the eastern flanker is a smooth red surface. A small patch of a similar surface that may originally have been more extensive is present on the eastern face of the western flanker.

Old Keig

Although few of the stones survive *in-situ* at Old Keig (Figure 7.2f), this circle was studied in order to provide a contrast with the nearby circle at Cothiemuir. The recumbent and flankers show variation in both colour and texture (Table 7.6). The recumbent is coarse pink sillimanite gneiss with large quartz inclusions. In contrast, the flankers are grey fine to medium granites.

Table 7.6 The predominant colour and texture of stones at Old Keig

Stone	W	R	E	1	2	3	4	5	6	7	8
Colour	G	P	G	G	?	?	?G	?P	?	?	?
Texture	F-M	C	M	M	?	?	?M	?M-C	?	?	?

Key: W = west flanker; R = Recumbent stone; E = east flanker; G = grey; P = pink; W = white; F = fine; M = medium; C = Coarse; l = light; d = dark; v = very; Gl = glassy

Loanhead of Daviot

The circle at Loanhead of Daviot is remarkably well preserved (Figure 7.2g). There is clear variation in both the colour and the texture of the stones, but unlike for the other circles this variation is largely confined to the stones of the circle and entirely absent from the recumbent and flankers (Table 7.7). The colour of the circle stones

Table 7.7 The predominant colour and texture of stones at Loanhead of Daviot

Stone	W	R	E	1	2	3	4	5	6	7	8
Colour	G	G	G	P	P	P/G	G	G	P	G	P
Texture	F	F	F	F	F	M	M-C	F-M	F-M	F-M	F-M

Key: W = west flanker; R = Recumbent stone; E = east flanker; G = grey; P = pink; W = white; F = fine; M = medium; C = Coarse; l = light; d = dark; v = very; Gl = glassy

varies in colour between grey and pink in a seemingly random fashion. The variability in the texture of stone is confined to a broad opposition involving fine stone to the south-west and relatively coarser stones to the north-east.

A myriad of textures and colours

Detailed study of the stones at RSCs has indicated that although the individual monuments share a basic architectural form, the way in which that form was interpreted is different at every circle through alternative choices of colour and texture of stones.

This variability within the constraints of architectural form is particularly evident when we compare the circles in close proximity: Sunhoney and Midmar (less than 2 km apart), and Cothiemuir and Old Keig (just over 2 km apart). The circles at Midmar and Sunhoney both utilize predominantly medium-pink granite. The presence of a dominant type of stone in the architecture may relate to a shared source of construction materials or may be because of particular locally based preferences or meanings. This choice of building material has not prevented major distinctions in the details of the expression of the basic architectural form. The recumbent at Sunhoney is grey granite that is heavily embellished with cup markings; in contrast, that at Midmar is composed of the same material as for the rest of the circle. At Midmar effort has been made to shape the flanking stones so the exterior face arches inward emphasizing the focus of the area within the flanker and recumbent. At Cothiemuir and Old Keig, there is a hint of subregional or local traditions within the constraints of the expression of architectural forms. Both show a use of grey and pink granite within the stones of the circle. There is a striking contrast between the choice of a stone for the flankers and recumbent at these sites. At Cothiemuir the recumbent is white-grey and the flankers pink; in contrast, at Old Keig the recumbent is pink and the flankers grey.

The complexity of the potential shared systems of meaning between the different sites is highlighted by the use of stones showing the same variation in colour in the same position in the circle. At both Easter Aquorthies and Midmar, stone number six is a pink granite with a striking upper band of grey granite. Perhaps this is coincidental but the choice of the same position, colour and composition of stone at the same point suggests this was deliberate mimicry.

Close study of these monuments also indicates that there is an apparent strong interrelationship between texture and colour in the stones chosen for the recumbent and flankers. In all but one of the cases, the pattern of variation of colour between the recumbent and flankers shows a corresponding pattern in terms of difference in texture of rock (Table 7.8). This raises the question of whether the choice of rock types was because of availability, colour or texture, or for an unknown reason

Table 7.8 Variation in colour and texture of recumbent and flankers

Site	Colour			Texture		
	W flanker	Recumbent	E flanker	W flanker	Recumbent	E flanker
Easter Aquorthies	Light grey	Dark grey	Light grey	Fine-medium	Medium	Fine-medium
Castle Fraser	Grey	Grey	Grey	Medium	Fine	Medium
Midmar Kirk	Pink	Pink	Pink	Medium-coarse	Medium-coarse	Medium-coarse
Sunhoney	Pink	Grey	Pink	Medium	Fine	Medium
Cothiemuir	Pink	White-grey	Pink	Coarse	Medium	Coarse
Loanhead of Daviot	Grey	Grey	Grey	Fine	Fine	Fine
Old Keig	Grey	Pink	Grey	Fine-medium	Coarse	Medium

relating to origin. Availability is difficult to gauge as the landscape was probably originally strewn with erratics and it is difficult to determine whether stones were quarried or collected among surface erratics. It is difficult to establish whether the choice of rock employed was because of colour or texture. We are probably best considering that people would have been aware of both the colour and the texture of the rock as they handled them during construction. Ultimately, the choice of position of particular stones would have been informed by knowledge of colour but, equally, by an intimate experience of texture.

The choice of position of different-textured stones within the circle has already been noted: in particular, the example of the juxtaposition of the two coarsest stones at Easter Aquorthies. Although the case studies indicate that there is not a shared pattern of texture distribution between all the circles, there is a degree of subregional variability. For example, the three circles located to the east of Bennachie (Easter Aquorthies, Loanhead of Daviott and Castle Fraser) all have the coarsest stones comprising the circle located to the east.

I now wish to return to the earlier question of why there should be this difference in opinion about the colour of these stones. One reason may relate to the intrinsic subjectiveness of colour experience. In the case of Easter Aquorthies we can anticipate that this difference in opinion is due to the fact that Lynch made observation when the stones were exposed after the taking of casts, a situation that

Lynch feels would parallel the situation when they were first quarried. Yet, it is not clear whether the majority of stones were quarried, presenting fresh faces, or erratics which would be weathered and covered in moss and lichen. Nor is it known whether the surface of the stones was regularly rejuvenated by scraping off moss and lichen, or indeed whether the surface was painted.

Explanations such as the degree of freshness of exposed surface or subjectivity may seem a satisfactory rationale for my differences in opinion with those of Lynch. However, I would suggest that there is another more important aspect about the colour of stones which makes colour an intrinsically unstable system of categorization. This is that the hue and brightness of colour constantly changes with observer, position and light conditions (see Jones and MacGregor's Introduction to this volume). In contrast, although occasional pieces of stone would shatter off through weathering and frost action, the texture of a stone is more stable than its colour. The texture of stone is, in human terms, timeless.

The study of the interplay between the colour and texture of stone has indicated that rock was more than simply a building material. The variations in the materiality of rock itself were a meaningful component of the architecture of the monuments. The subtlety of these meanings would only become manifest through the full range of experience of the sensory order.

Although there is considerable variation within the RSC tradition, the majority of monuments share the same basic architectural traits. Variations in expression of form is limited in the construction of RSCs across the region in which they are found. There is, however, considerably greater variation in the expression of colour and texture of stones used in these monuments. Why then should this be?

Mountains are truly monumental

It has already been noted that the majority of RSCs are relatively close to, or have a view of, the mountain of Bennachie. Bennachie is striking in part because of its high visibility in the region, which also affords extensive views, but also for its distinctive form (Figure 7.3). The distinctiveness of its form is from the series of prominent peaks on its top: Mithers Tap, Oxen Craig, Watch Craig, Brunt Wood Tap, and Hermit Seat.

When observed from a distance these peaks seem to be strung along the spine of Bennachie. Up on Bennachie, however, it becomes apparent that they are in fact widely spaced across the top of the mountain. The relative positions of the peaks means that when you walk across the top of Bennachie there are only a limited number of positions where they can all be seen.

At one point on the plateau of Bennachie there is a basin surrounded by four peaks; to the east Mithers Tap, to the south Brunt Wood Tap, to the west Watch

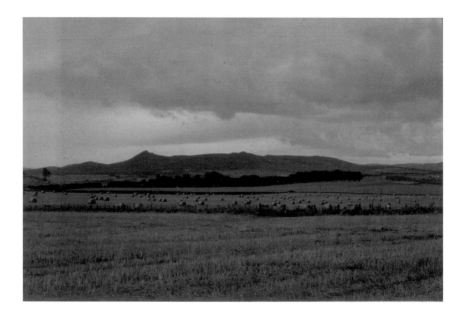

Figure 7.3 Bennachie

Craig and to the north Oxen Craig. Apart from a limited view to the north, this basin prevents views of the landscape below. The experience is of being enclosed by both land and sky. This is clearly a distinctive place on the mountain.

When you continue to walk within this natural amphitheatre toward the most prominent peak of Bennachie, Mithers Tap, the distinctive form of the Tor becomes apparent. The western side of Mithers Tap has a substantial cleft in the rock which when viewed from below has a geometric form to it (Figure 7.4). Together, Mithers Tap and the three other peaks viewed from within the basin form a topographic monument.

The architectural form of RSCs constitutes a regional tradition of building that was less frequently open to local interpretation and consequently variation in construction. I would suggest that this relates to the distinctiveness of Bennachie, forming a visible feature within the daily lives of many of the communities inhabiting the area in the past. The role of natural features in the structuring of past cosmologies was probably of great significance in prehistory (Tilley 1996; Bradley 2000c). I would thus argue that Bennachie is likely to have had consider-able importance within cosmologies during the third and second millennia BC in the region, and the nature of experience at the top of Bennachie provided the source of inspiration for the form of the RSC tradition. Construction of a particular form of monument was an explicit statement by local communities of wider shared-belief systems.

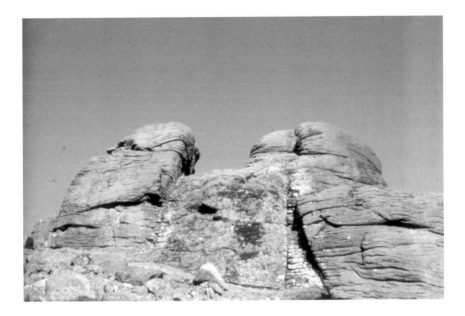

Figure 7.4 The Cleft in Mithers Tap

In the case of Bennachie, the basic form of the topographic feature was unambiguous. The potential variation in the colour and complexity of the individual peaks is considerable because of their large sizes. Thus rock, the substance of mountains, employed in the architecture of RSCs is not a neutral building material but is already loaded with meaning relating to these wider cosmologies. These meanings manifest themselves during the construction of monuments through the positioning of rocks in reference to particular character- istics such as colour and texture. The way in which these characteristics are deployed is variable from circle to circle, representing the expression of beliefs of local groups within the constraints of a more widely shared architectural tradition.

Conclusion

Study of the colour and texture of stones deployed at RSCs has indicated a considerable freedom in the expression of meanings relating to them. At some circles, the colours and textures of the stones were utilized to emphasize the experience of being inside or outside the monument. In the case of others, selection appears to emphasize certain zones or areas of the circle through marked juxta- positions of colour and texture. In other cases, it would appear that there was a deliberate decision to select predominantly the same colour and texture of stones.

It has been argued that such choices were available to small communities groups and represented a vehicle for the expression of meanings and identities. These meanings and identities were complex and potentially fluid within the expression of a wider shared identity that is manifest through the choice of morphology of monument form. It has been suggested that this choice relates to people's shared awareness of their landscape, and significant places within it, and the inter-relationship between cosmological principles and daily practices.

Material culture thus provided an arena where different levels of meaning were negotiated. The colours and textures significant to the daily lives of small communities may have been referred to through the choice of stones in the construction of RSCs. Those same stones provided a powerful statement of wider belief systems. Experience of aspects of the materiality of stones, including colour, texture and form, during the construction and use of these monuments would have provided a conduit for meanings between different levels of belief systems, from non-discursive daily practice to supporting explicit statements relating to people's place within wider cosmologies.

Acknowledgements

My thanks are extended to Richard Bradley for making us welcome at and providing information about his excavation at Tomnaverie; Kenny Brophy, Michael Donnelly and Paul Duffy for colourful discussions; Andy Jones for his exceptional patience and hard work.

Note

1 A programme of investigation of a number of RSCs, which should clarify many of these issues, has been instigated by Professor Richard Bradley (2000b).

References

Abramson, P. (1980), 'Strichen Parish, recumbent stone circle', *Discovery and Excavation Scotland* 9.

Abramson, P. and Hampshire-Monk, I. (1981), 'Strichen (Strichen p), recumbent stone circle', *Discovery and Excavation Scotland*, 12–13.

Bradley, R. (2000a), *The Good Stones: A New Investigation of the Clava Cairns*, Society of Antiquaries of Scotland Monograph Series No. 17; Edinburgh.

Bradley, R. (2000b), 'Tomnaverie recumbent stone circle: excavation and field survey, 2000', Unpublished Interim Report.

Bradley, R. (2000c), *An Archaeology of Natural Places*, London: Routledge.

Burl, H.A.W. (1974), 'The recumbent stone circles of North-East Scotland', *Proceedings of the Society of Antiquaries of Scotland*, 102, 56–81.

Burl, H.A.W. (1975), 'Buchan, recumbent stone circles', *Discovery and Excavation Scotland*, 7.

Burl, H.A.W. (1976a), *The Stone Circles of the British Isles*, London and New Haven: Yale University Press.

Burl, H.A.W. (1976b), 'Buchan, Berrybrae recumbent stone circle', *Discovery and Excavation Scotland*, 6.

Burl, H.A.W. (1977), 'Berrybrae, recumbent stone circle', *Discovery and Excavation Scotland*, 4–5.

Burl, H.A.W. (1978), 'Berrybrae, recumbent stone circle', *Discovery and Excavation Scotland*, 7–8.

Burl, H.A.W. (1981), 'By the light of the cinerary moon', in C.L.N. Ruggles and A.W.R. Whittle (eds), *Astronomy and Society in Britain During the Period 4000–1500* BC, Oxford: BAR British Series 88, 243–74.

Childe, V.G. (1933), 'Trial excavations at the Old Keig Stone Circle, Aberdeen-shire', *Proceedings of the Society of Antiquaries of Scotland*, 67, 37–53.

Childe, V.G. (1934) 'Final report on the excavation of the stone circle at Old Keig, Aberdeenshire', *Proceedings of the Society of Antiquaries of Scotland*, 68, 372–93.

Coles, F.R. (1905), 'Record of the excavation of two stone circles in Kincardine-shire- (1) in Garrol Wood, Durris; (2) in Glassel Wood, Banchory-Ternan; and (II.) Report on the stone circles of Aberdeenshire with measured plans and drawings; obtained under the Gunning Fellowship', *Proceedings of the Society of Antiquaries of Scotland*, 39, 190–218.

Gage, J., Jones, A., Bradley, R., Spence, K., Barber, E.J.W. and Taçon, P.S.C. (1999), 'What meaning had colour in early societies?', *Cambridge Archaeological Journal*, 9(1), 109–26

Hampshire-Monk, I. and Abramson, P. (1982), 'Strichen', *Current Archaeology*, 81, 16–19.

Jones, A. (1999), 'Local colour: megalithic architecture and colour symbolism in Neolithic Arran', *Oxford Journal of Archaeology*, 18(4), 339–50.

Kilbride-Jones, H.E. (1935), 'An account of the excavation of the stone circle at Loanhead of Daviot, and of the standing stones of Cullerlie, Echt, both in Aberdeenshire, on behalf of HM office of Works', *Proceedings of the Society of Antiquaries of Scotland*, 69, 168–223.

Lynch, F. (1998), 'Colour in prehistoric architecture', in A. Gibson and D.D.A Simpson (eds), *Prehistoric Ritual And Religion*, Stroud: Sutton, 62–7.

MacGregor, G. (1999), 'The Neolithic and Bronze Ages of Aberdeenshire; a study of materiality and historical phenomenology', Unpublished PhD Thesis, University of Glasgow.

MacGregor, G. and Loney, H. (1997), *Excavation at Kilcoy South, Chambered Cairn*, GUARD report 434.

Tilley, C. (1996), 'The power of rocks: topography and monument construction on Bodmin Moor', *World Archaeology*, 28, 161–76.

A Biography of Colour: Colour, Material Histories and Personhood in the Early Bronze Age of Britain and Ireland
Andrew Jones

Introduction

The mortuary archaeology of the Early Bronze Age of the British Isles is character-ized by the emergence of single-grave burials. At the same time we observe the emergence of the wide-scale usage of coloured substances such as amber, gold and jet. These substances are typically fashioned into items of dress, and are often found as components of grave assemblages. The presence of substances, such as gold or amber, in the single-grave burials of the period has been viewed as an indication of the high status of the individual interred (Eogan 1994; Piggott 1938). As such the assumed value of the substances and their context in single burials is mutually satisfying: value is conferred on the 'individual' by the association with exotic substances, and value is conferred on the substance since it is found in distinct and 'special' single graves.

Given the historical and contextual congruence of these two events, I believe that the relationship between colour and mortuary practices deserves closer examination. My aim is to write a 'biography of colour' which foregrounds the mode by which things – in this case coloured substances – are enrolled in the construction of particular ideas of personhood during the Early Bronze Age.

The body and the person in the Bronze Age

It is important to situate Early Bronze Age mortuary practices in relation to the preceding Neolithic period and Later Bronze Age. British Neolithic mortuary practices constitute a specific treatment of the body in which composite individuals are formed from regroupings of bones as part of larger communal deposits within chambered tombs or long barrows (Shanks and Tilley 1982; Thomas 1999; 2001). Irish Neolithic mortuary practices differed, as bodies were often cremated and deposited in discrete locations in chambered tombs and passage graves (Cooney 1992).

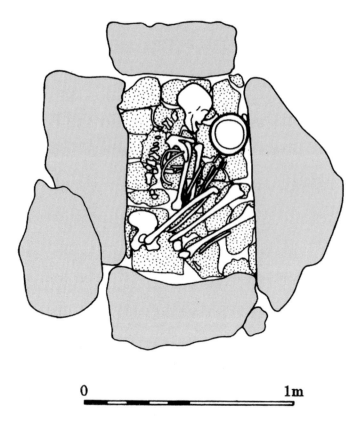

Figure 8.1 Cist burial from cemetery at Keenoge, Co. Meath, Ireland illustrating typical Early Bronze Age mortuary tradition (after Waddell 1998: 142).

During the Early Bronze Age the treatment of the body alters. In both Britain and Ireland by around 2200 BC we observe the emergence of single inhumations and cremations in well-defined graves, often placed beneath cairns or round barrows (see Figure 8.1). Arguably, this mortuary practice is different from previous Neolithic practices as it defines a new relationship between the living and the dead along with a definition of the body as a distinct entity. By the Later Bronze Age we observe few burials, and the body appears to have undergone a degree of fragmentation before burial (Brück 1995).

I want to focus on discussions of person and body in the Bronze Age. Julian Thomas (1991) draws our attention to the significance of the body in the beaker burials of the earliest phases of the Bronze Age. For Thomas the body is a canvas around which items of significance are arranged. While these objects only have symbolic significance inasmuch as they relate to the body, discussion of the

construction of the nature of body and personhood is absent from Thomas's account.

To overcome some of these problems, Last (1998) discusses the mode by which Early Bronze Age mortuary practice draws on

> the characteristics of the living body as an individual – age, gender and (probably) status – as much as those of the dead body as an artefact, e.g. orientation, posture. (ibid.: 44)

Following a discussion of the site of Barnack, Cambridgeshire, Last suggests that such an approach enables us to embody the complexities of lived experience rather than being forced into the idealist categories of an elite ideology (ibid.: 52). Similarly, Lucas (1996) emphasizes the *topology* of the body, its surface and orifices, in relation to the position of artefacts arranged with regard to the corpse.

In an attempt to surmount the problems associated with a reading of single burial as an instance of elite ideology, Treherne (1995) examines the aesthetics of the body in single burials. Although his discussion focuses largely on the Later Bronze Age, broader themes may be drawn from his account. He focuses especially upon the toilet articles, weapons and drinking equipment common to individual graves in Bronze Age Europe. Treherne stresses that the association of these items with the (male) body evokes an aesthetic of maleness, which is related to the institution of the male warrior. These items are significant because they are related to a particular lifestyle in which warfare, body ornamentation, the hunt, horses and the consumption of alcohol are expressions of self-identity and personhood. While he notes that this aesthetic ideal transforms over time, there is a sense in his account that 'the warrior' exists as a substantive category from the Chalcolithic to the Middle Ages.

The body has a curious status in these accounts of Bronze Age mortuary practices. Of interest here is the relationship between the body and the person. These discussions have a bearing on how we conceptualize the person in relation to the body. In some cases the discussion of the individual focuses on the body (Hodder 1999: 138–46; Meskell 1996), while other studies prefer instead to consider the performative conditions which enabled people to act (Fowler 2000; Thomas 1996; 1999). In these two instances the person is either constituted as a jural individual, distinct from other individuals, or the person is seen to be composed of relational transactions between and with other persons. The person is either a material entity signified by the boundaries of the body, or the person is a subject constituted through relationality. However, we need to be aware that the boundaries of the body need not stand canonically for the individual (Fowler 2000); equally we need to realize that the westernized individual is not an ideal type (Corin 1998). Importantly we need to be wary of figuring all persons in non-Western contexts as 'dividual'. LiPuma (1998) cogently argues that such a position

fetishes difference and results in the totalization of Western individuals and non-Western dividuals alike.

We need to retain notions of the integrity of the individual while analysing the constitution of the person through social relations:

> it would seem that *persons emerge precisely from that tension between dividual and individual aspects/relations*. And the terms and conditions of this tension, and thus the kind (or range) of persons that is produced, will vary historically. (LiPuma 1998: 57, original emphasis)

These issues are of critical importance for our discussion of prehistoric persons (see also Chapman 2000: 140–1; Last 1998). The treatment of the body is critical for our understanding of how persons are constituted in the Bronze Age (see Chapman 2000: chapters 2 and 5). However, as Strathern (1998) emphasizes, persons do not exist as static and substantive categories: personhood is emergent and continues to be substantiated through the maintenance and reiteration of social relations. If we are to comprehend the constitution of persons, we need to investigate not only how the corpse is treated but also how the *performance* of these mortuary rituals is in turn constitutive of the personhood of the mourners. Equally, we must not forget that subjects come into being not only through relations with other persons but also by relations between persons and things (Latour 1993). I wish to examine, then, how things are enrolled in the life projects of people.

Colour and technology in the Early Bronze Age

In the Early Bronze Age coloured substances are used to create a series of spectacular objects such as crescent-shaped gold *lanulae* (Plate 8) and spacer-plate necklaces of jet or amber. We also observe the production of jet and gold-covered buttons and lozenges and belt hooks of gold. If we are to understand how these artefacts are employed in the construction of the body, then I argue that we need to consider the technological and geographical context of these substances.

The Early Bronze Age is characterized by one major technological change: the advent of metalworking. The earliest (2500–2200 BC) and most abundant copper sources are in Southwest Ireland (O'Brien 1995). Other copper sources, of a later date (2000–1800 BC), include Cwmystwyth and Great Orme, Wales (Timberlake 1994), Alderly Edge, Cheshire (Gale 1990) and Mount Gabriel, Co. Cork (O'Brien 1994). The sources of copper are remotely located. Likewise, although sources of tin are located in Cornwall their precise location remains debatable (Sharpe 1992). Mining of copper ores utilized fire setting (O'Brien 1994), a process which involved the use of fire and water as mediums of extraction. Following extraction the ores

were smelted. Although there is considerable debate about the precise technology employed, in the broadest sense the process of smelting involved the transformation by fire of a stony substance – the ore – into a shiny substance: raw metal. The production of metal was a transformative process in which the qualities and colour of the substance was altered. The relationship between colour and metal ores is evinced in the early stages of prospection as ores are distinguished by specific vegetation species (Craddock 1995: 30).

The production of metal artefacts, from copper and bronze, brought into focus a number of properties of materials; in particular, materials may be altered through the action of other elements, especially fire and water. The application of these to metal ores transformed the physical state of the materials, making them fluid and malleable. These properties enabled substances to be combined in order to create composites or alloys. The change in state corresponded with a change in the colour and luminescence of the substance from a greenish ore to a yellow metal.

We should not view the working of copper/bronze and clay to have primacy over that of other substances. Rather, it is important to realize that many of the activities relating to the working of gold, jet and amber were associated, practically and metaphorically, with the technical processes relating to metalworking. This metaphorical association is given material form by the production of miniature halberds in amber in the Early Bronze Age of southern Britain (Beck and Shennan 1991).

As with copper and tin, the sources of other substances were associated with specific places in the landscape. Gold was obtained from alluvial deposits in Scotland, Wales and Cornwall. Drift deposits of gold are also found in the Wicklow Hills and more widely in eastern Ireland.

Jets and shales were similarly localized, with the major sources coming from Whitby, Yorkshire (Shepherd 1985), and from Kimmeridge, Dorset (Watts et al. 1997). The sources of amber are more diffuse. While all sources of amber are, geologically speaking, from the Baltic (Beck and Shennan 1991: 27), this material regularly washes up on the North Sea beaches of eastern England and Scotland, especially in regions such as East Anglia and Aberdeenshire (Beck and Shennan 1991: 17).

The production of objects from gold involved the application of fire in order to cast the metal, which was then beaten into sheet form. This sheet gold was then decorated with a fine point, with scoring or *repoussé* technique (Plate 8). Finally the gold was planished to produce a fine shimmering surface (Taylor 1980; Eogan 1994).

Jet is a carbon-rich fossil resin and its location within the rock strata of North Yorkshire is indicated by its association with other fossil remains, especially ammonites. Shales are carbon-rich sedimentary deposits, and the sources used in the Early Bronze Age were identified with phenomena such as fossils. After

procurement, jets and shales were shaped by abrasion and cutting, using sand, water and flint tools (Shepherd 1981). Once shaped they were drilled with a sharp point and decorated by incision. Finally they were polished. One of the most efficient means of polishing jet is by rubbing its surface with red ochre, a substance geologically related to jet. Amber is also a fossil resin, and once procured from the coast it was shaped using a process similar to that for jet and shale (Shepherd 1985).

Practically and metaphorically the working of substances involved a similar series of actions. Gold was panned from the water, cast using fire, beaten and planished, giving it a dazzling quality akin to that of rippled water. Jet was extracted from the earth and shaped using sand and water and polished with ochre – a fiery red substance – which altered its appearance from dull brown to shiny black. Amber was procured from the coast and shaped using sand and water, the primary constituents of the beach. It also was polished, transforming it from a dullish brown to a fiery and translucent red or orange. These technologies each involve the transformation of components of the earth and water through the action of other elements such as fire and water. In many ways we might think of fire, water and the action of polishing as a process of animation. In the cases of amber and jet, the life of the substances is signified by their remarkable ability to electrostatically attract materials. The bright colour revealed by polishing also invests these materials with their own agency.

This transformative technology is exemplified by the production of faience. Faience is unusual in that it is artificially manufactured using a combination of quartzite fused with lime as a core material with a powdered glaze which consists of, among other things, copper oxide. The production of this material employs elements from the earth (quartz and copper oxide) and fire. This process creates a dramatic colour change from white quartz and greenish copper oxide to the spectacular blue and green of the finished faience.

Through the production process colour, materiality and social relations were imbricated in the form of the artefact. I have noted that the locales from which coloured materials were procured suffused these objects with significance. However, there are other levels of significance enfolded within artefacts. The production of many objects was specialized. Joan Taylor (1980: 46) observed that the Bush Barrow lozenges and scabbard hook, the Clandon lozenge, the Manton discs, the Upton Lovell button covers and the discs and button covers from Wilsford G8 were all likely to be the product of a single master goldsmith. Moreover, she notes that such a craftsperson may have worked in more than one medium, producing the gold-bound amber discs in the Wilsford G8 barrow (ibid.: 46). The restrictive deployment of technical knowledge coupled with the trans-formative nature of the materials invest substances with significance.

The composite nature of the production of many coloured artefacts will have required not only skill in production but also the acquisition and accumulation of

numerous components. Objects such as jet or amber necklaces are composed of numerous components. Gold objects, such as *lanulae* or the spectacular gold 'cape' decorated with around 200–300 amber beads from Mold, Wales (Beck and Shennan 1991) will have required numerous separate nuggets and amber fragments for their completion. As a result of this gradual process of production, the act of creation will have been interwoven with a history of acquisition. From the outset the production of objects made from these substances was symbolic of cohesion. In some cases, coloured substances were employed in a piecemeal manner. This is true of jet and amber spacer plate necklaces that were composed of multiple components. To some extent this meant that the necklace need never be complete as an object and we observe a variance in the number of beads which make up these artefacts (Callander 1916). There are notable regional differences in the composition of necklaces. In Northern England, Scotland and Wales the jet necklaces predominate. In Southern England, especially in Wessex, necklaces are composed of beads of different substances, including amber, jet, faience, shale, chalk and shell. In discussing the variable composition of necklaces from Shrewton 5J and 5L, Barrett (1994: 121–2) suggests that variability relates to the antiquity of the necklaces, as remnants of earlier necklaces were reused in the production of composites.

That curation practices did occur is indicated through the analytical studies conducted by Sheridan and Davis (1998). They demonstrate that a number of the jet beads and spacer plates comprising the necklaces from Pen Y Bonc, Anglesey, Wales and Pitkennedy, Angus, Scotland had been replaced with 'inferior' materials such as cannel coal and shale. Signs of repair and secondary decoration on selected gold *lanulae* (Taylor 1980: plate 13) attest a similar process of curation. Artefacts of coloured substances therefore have complex biographies.

While curation practices suggest that the composition of artefacts is flexible over time, artefacts are also spatially extensive as the components that make up artefacts are exchanged over long distances. This is true of the jet artefacts from Wessex, since over half of the artefacts analysed from this region are composed of jet whose ultimate source lay in Whitby, Yorkshire (Pollard et al. 1981). For amber the relationship between source and distribution is more difficult to demonstrate. Given that the source of Baltic amber is concentrated on the coast of eastern England and that most amber artefacts are deposited in Wessex, exchange relationships appear to be directed in a unilinear fashion between East Anglia and Wessex (Beck and Shennan 1991: 133–42). Exchange of entire artefacts also occurs; for instance, we find examples of gold *lanulae* likely to have an original provenance in Ireland from Harlyn Bay, Cornwall and Auchentaggert, Dumfriesshire. Examples of jet necklaces from Rasharkin, Co. Antrim and Oldbridge, Co. Meath suggest periodic exchange relations across the Irish Sea. The amber spacer plate necklace and gold discs from the Knowes of Trotty, Orkney suggest wider

links, with either Aberdeenshire or southern England in the case of the amber and Ireland in the case of the gold (Eogan 1994: 28). *Lanulae* were also exchanged further afield, as attested by the hoard from Kerivoa, Brittany (Eogan 1994: 34).

It is important to note that each of the major substances discussed was used to create objects of a similar nature, such as crescentic *lanulae* of gold, crescent-shaped jet necklaces and crescent-shaped amber necklaces. The association between these objects is further emphasized by similar positioning and use of designs on the so-called 'Classical' *lanulae* (Taylor 1970; 1980) and jet necklaces (Craw 1929). The use of different substances for these necklaces is regionally distinct; gold *lanulae* are concentrated in Ireland, jet necklaces in northern Britain and amber necklaces in southern England. Similarly we find v-bored buttons of both jet and amber, while gold was used to cover similar buttons of shale. Beads of similar morphology are produced in jet, amber, faience and gold. We also find decorated plates of gold or jet and rare examples of handled cups in amber, shale and gold. The close relationship between colour and specific regions of Britain and Ireland meant that in the context of mediating exchange relations, colour was interwoven with place-related identity (see Cooney in Chapter 4 of this volume). While colour was important in this regard, the interchangeable nature of these materials suggests that colour itself was of less importance than the social relations mediated by and through coloured materials. Barrett (1994: 122) reasons that the circulation and subdivision of such artefacts among the living might also have been used metaphorically to speak of similar relations between the dead.

Colour, materiality and mortuary practices

Artefacts made of coloured substances have complex biographies. The use of substances from spatially distant sources and the deployment of these substances to create artefacts of a composite nature meant that many artefacts metaphorically spoke of temporally extensive relationships among the living.

The detachable and componential aspect of these artefacts allows distinct components to be removed or replaced, while the arrangement of beads on a thread allows for a material juxtaposition of each element. By virtue of their extensive histories of acquisition and the juxtaposition of each element, these artefacts embody strings of repetitive and interlocked memories. In Chapman's (2000: 17–43) terms, these artefacts offer the potential for enchained social relations. They are the locus for the expression and constitution of relational orders of personhood. How then were these practices related to the mortuary domain? To what extent was the life history of the artefact drawn on in mortuary practices?

In the beaker period of the earliest Bronze Age artefacts were commonly placed with the extended or crouched inhumation, usually in stone cists, pits or wooden tree-trunk coffins which were often beneath barrows or cairns, or in flat cemeteries.

The use of highly coloured substances was rare in this period. Notable exceptions to this are the burials from Kirkhaugh, Yorkshire and Radley, Oxfordshire, both male inhumations with gold basket earrings or hair ornaments (Eogan 1994). Decorated discs of gold – likely to have been sewn onto external clothing – are also found with beaker inhumations at Mere and Monkton Farleigh (Taylor 1980: 23). V-perforated buttons of jet are a more common addition to beaker burials, though not in great numbers.

The low-level deposition of coloured substances contrasts with the more spectacular use of colour in the later phases of the Early Bronze Age (2000–1500 BC). As with the earlier beaker period, many burials are of extended or crouched inhumations, although we also observe an increase in the practice of cremation. Cremations were often placed in pits or ceramic containers, either food vessels or collared urns.

It is important here to distinguish between objects which are removable from the body, such as necklaces, and components of clothing such as buttons (Sørensen 1997). Here I am concerned not so much with what is deposited as with the quantities and condition of objects deposited. For convenience's sake I will discuss northern and southern Britain separately.

In northern Britain, jet is the predominant coloured substance. There are notable patterns in the deposition of jet. If jet buttons were attached to clothing we would expect that only a few would be associated with each individual in the grave. This is largely the case, most burials (85 per cent) with buttons have 1 or 2 buttons deposited with the corpse. In a number of cases such as Hunmanby, Yorkshire, Harehope, Borders, Scotland and Grindlow, Derbyshire 20, 32 and 39 buttons respectively were deposited (Shepherd 1981; 1985), suggesting that buttons were associated with a quite different depositional practice. In the case of composite artefacts such as jet necklaces composed of numerous beads and spacer plates we should expect the opposite pattern. It is important to note that by virtue of the composite nature of these artefacts the numbers of beads are by no means fixed, as Callander (1916) observed in an early survey of such necklaces from Scotland. In many cases (48 per cent of total) we do find entire necklaces of multiple beads deposited in the grave. In a number of cases (31 per cent of total) we observe between 1 and 5 beads only placed into the grave. Interestingly, we also observe *parts* of necklaces being deposited (11 per cent of total). These practices of fragmentation pay closer examination. In a number of cases multiple pieces of the same component are deposited in the grave. At Hill of Roseisle in north-east Scotland, 64 spacer plates were deposited with an inhumation, at Greenhowe, Pluscarden, Scotland the end plates of a necklace were placed with an adult inhumation (Clarke et al. 1985; Shepherd 1985). Multiple fragments may also be incorporated in the grave as at Melfort, Argyll, Scotland (Clarke et al. 1985): the upper spacer plates and end pieces from at least two necklaces were placed in the

grave with an inhumation. In some cases, such as at Masterton, Fife, Scotland, a complete necklace is made up of components of at least two others (Shepherd 1985).

When recorded, most jet artefacts were deposited with inhumation burials (61 per cent), while relatively few (16 per cent) were deposited with cremations. Most of the burials with entire necklaces (46 per cent) were inhumations and necklaces are often recorded around the neck of the individual, while a number of deposits of single beads (17 per cent) were found with cremations. Similarly, most jet buttons (93 per cent) were deposited with inhumations, while only a few (7 per cent) were deposited with cremations.

Similar patterns of depositional practice occur in the south of Britain. Few burials contain 'pure' assemblages of coloured substances. We cannot know if distinct components are parts of previously 'pure' necklaces solely composed of amber. Contexts containing only amber beads comprise around 15 per cent of deposits, although common associations are amber and faience beads (22 per cent) or amber and shale or jet beads (36 per cent); the remainder are associated with low numbers of gold, shell, fossil or bone beads. As with the analysis of northern British material, we can examine whether whole or partial necklaces are deposited. In the south it would seem that an almost equal number of deposits contain entire necklaces of composite beads (53 per cent), or small deposits of only 1 to 5 beads (47 per cent). A similar pattern to that of northern Britain persists for the deposition of amber buttons, with the propensity of deposits only having 1or 2 buttons (64 per cent). In contrast to the finds in northern Britain, most of the deposits of both necklaces and buttons are associated with cremations (72 per cent).

In southern Britain we also see the dramatic use of gold in the so-called 'Golden barrows' of the Wessex series of graves. The use of gold ranges from the spectacular – with the gold lozenges and belt hook of the Bush barrow burial or the gold cones, plates and beads of Upton Lovell G2e – to the minimal, with the scraps of decorated gold associated with the Little Cressingham burial.

If we are to comprehend these practices we need to recall the material character of the artefacts deposited. As suggested above, the beads making up necklaces were entangled in diverse and extensive biographies; indeed, their biographical status and their context in mortuary deposits has led some commentators to describe them as heirlooms (Parker-Pearson 1999: 85–6). Just as the partible nature of necklaces provided the potential for establishing links between the living, so the deposition of fragments of complete necklaces, or of complete artefacts, enables social relations to be established between the living and the dead. The deposition of single beads, or of components of necklaces, had the effect of perpetuating relations between the living and the dead. The act of depositing single beads or necklace fragments therefore crystallizes the notion of 'keeping while giving' (Weiner 1992).

While relational socialities were established between corpse and mourner through the deposition of fragments of artefacts, what other kinds of relations are represented by the deposition of whole artefacts? If the construction of necklaces brings into relation the memory of numerous social relations then the deposition of a whole necklace – embodying a plenitude of memories – is a powerful act signalling closure and loss.

What of the deposition of multiple objects in the grave? The accumulation of objects also cements social relations through the principle of aggregation (Chapman 2000: 37–9). The act of fragmentation establishes relations between people, since distinct elements of the same object are held in common, and in a similar fashion the integration of multiple complete objects in the mortuary context brings each individual involved in the act of deposition into relation. The accumulation of objects surrounding the corpse, whether multiple jet buttons in northern Britain or multiple gold objects in southern Britain, is symbolic of social integration.

That the partible nature of these artefacts was crucial in mediating social relations is underlined by the contrasting situation in Ireland. While Irish gold *lanulae* appear to be decoratively and physically similar to jet and amber necklaces (Taylor 1980), because of the non-partible nature of *lanulae* they are not utilized to mediate social relations in the mortuary domain. Rather, *lanulae* are deposited intact and there is no empirical evidence to associate gold *lanulae* with the human body. Since most *lanulae* have been found as stray finds, often in watery places, the possibility remains that their deposition was votive in nature (Bradley 1990: 71). In fact the formal nature of some deposits, such as the example placed in a wooden box from Newtown, Co. Cavan, resonates with contemporary mortuary practices, suggesting these artefacts carried a biography of their own whose significance need not be expressed by deposition with the human body.

When we examine the relationship between body treatment and the deposition of coloured artefacts at the regional scale, differences in deposition occur. In northern Britain, whole necklaces are deposited most often with inhumations, while beads are deposited with cremations. In southern Britain, whole necklaces are more often deposited alongside cremation burials. The material discourse of partition and wholeness may relate to the treatment of the body in Early Bronze Age mortuary practices. Bodies are either placed whole in pits or cists as inhumations, or they are subject to fragmentation by fire elsewhere and placed in the ground as cremations in pits or pots. To some extent there is little difference in how the individual integrity of the corpse is represented since whether cremated or inhumed its surfaces remain integral and discrete due to the encirclement of the body by the pit, stone cist or ceramic container. At the macro-scale level of analysis there appears to be little relationship between the deposition of whole necklaces or their components and distinct types of mortuary practice, entire necklaces are found deposited with both cremation and inhumation burials. Strathern (1998)

notes that in order to propagate notions of externality and internality essential to the conceptualization of personhood, other differences are necessarily held in place. In this instance I argue that the bounded integrity of the body's surfaces and the boundaries of the grave are held in place while distinctions between the deceased and the living are mediated across this boundary.

Unlike the treatment of the body in the preceding Neolithic period, during the Early Bronze Age the body retains its integrity and is not circulated among the living. The integrity of the body in burial is crucial since, for the mourners, it objectifies the presence of the other and forms the ground from which relations of difference are established. There appears to be a tension between the partible nature of artefacts and the bounded integrity of the human body. I argue that notions of personhood lie in the space generated by the integrity of the individual corpse and the articulation of enchained or integrated relationships objectified through the deposition of artefacts typically worn on the body. While the deceased is represented as a bounded individual, the relationship between deceased and mourners is represented as relational through the deposition of significant artefacts.

Colour and personhood in the Early Bronze Age

During the Early Bronze Age the perception of colour is closely associated with the experience of transformation; indeed, we might say that colour embodies transformation. Over their lifetimes coloured objects are transformed as they are exchanged, disaggregated, reformed and accumulated.

At one level, then, colour is evocative of transformative physical changes and the transformation of social relations. How then are the transformative capacities of colour engendered? I argue that in the context of Early Bronze Age technologies colour acts as a form of material mnemonic or trap. The technical process of working coloured substances conforms more generally to what Alfred Gell (1992) describes as a 'technology of enchantment'. Through technique and knowledge, objects are invested with the ability to act as mediums of exchange and focuses for feelings of awe and wonderment.

In effect the luminous properties of coloured substances provide objects with the ability to act as vehicles for memory. Serematakis (1994: 11–12) argues that the sensory qualities of objects have the capability of eliciting perceptual and mnemonic recall. In this instance the colourful qualities of artefacts deposited in mortuary contexts enable memories to be recalled on their deposition. Coloured substances are generative of memory when deployed in the context of mortuary rituals. In material terms, objects composed of colourful substances are used to establish links between the dead and the living, but the means by which these links are generated is through the mnemonic capacities of coloured substances. Colour

here is a means of eliciting meaning, as it conjoins a series of domains such as the significance and identities related to the place of origin of materials, the significance of their material histories, and their relationship to the mortuary context. In effect colour acts as the means by which the personhood of the deceased continues to have an affective mnemonic presence in the world of the living beyond the temporal context of the mortuary site. In many ways the elicitory potential of these artefacts is enacted through their fragmentation and deposition, as the memories sedimented within them are literally prised apart in the mortuary context. In these terms the graveside, and the rituals of deposition surrounding the corpse, may be considered as generative of memory and personhood.

Rather than conceptualizing the presence of colourful substances as indicative of status and value, a preferable perspective would be to view them as the mediators of complex and entangled biographical encounters. The so-called 'rich graves' of the Early Bronze Age are therefore rich in terms of the complexity of the relationships they objectify, rather than in the intrinsic status of the deceased or of the objects placed with them.

Acknowledgements

I would like to thank Emma Read, Colin Shell and Marie-Louise Stig Sørensen for useful comments and discussion on certain points in this chapter.

Note

1 The data for the analysis of beads and necklaces in relation to mortuary practices was obtained from a number of sources: for amber Beck and Shennan (1991); for jet Callander (1916); Craw (1929); Pollard et al. (1981); Shepherd (1981) and (1985); Sheridan and Davis, (1998); Kinnes and Longworth (1985).

References

Barrett, J.C. (1994), *Fragments from Antiquity: An Archaeology of Social Life in Britain, 2900–1200* BC, Oxford: Blackwell.
Beck, C. and Shennan, S. (1991), *Amber in Prehistoric Britain*, Oxford: Oxbow.
Bell, C. (1992), *Ritual Theory, Ritual Practice*, Oxford: Clarendon.
Bradley, R. (1990), *The Passage of Arms: An Archaeological Analysis of Prehistoric Hoards and Votive Deposits*, Cambridge: Cambridge University Press.

Brück, J. (1995), 'A place for the dead: the role of human remains in the Late Bronze Age', *Proceedings of the Prehistoric Society*, 61, 245–77.

Callander, J.G. (1916), 'Notice of a jet necklace found in a cist in a Bronze Age cemetery, discovered on Burgie Lodge Farm, Morayshire with notes on Scottish Prehistoric Jet Ornaments', *Proceedings of the Society of Antiquaries of Scotland*, 33, 201–40.

Chapman, J. (2000), *Fragmentation in Archaeology*, London: Routledge.

Clarke, D.V., Foxon, A. and Cowie, T. (1985), *Symbols of Power in the Age of Stonehenge*, Edinburgh: HMSO.

Cooney, G. (1992), 'Body politics and grave messages: Irish Neolithic mortuary practices', in N. Sharples and A. Sheridan (eds), *Vessels for the Ancestors*, Edinburgh: Edinburgh University Press, 128–43.

Corin, E. (1998), 'Refiguring the person: the dynamics of affects and symbols in an African spirit possession cult', in M. Lambek and A. Strathern (eds), *Bodies and Persons: Comparative Perspectives from Africa and Melanesia*, Cambridge: Cambridge University Press, 80–103.

Craddock, P. (1995), *Early Metal Mining and Production*, Edinburgh: Edinburgh University Press.

Craw, H. (1929), 'On a jet necklace from a cist at Poltalloch, Argyll', *Proceedings of the Society of Antiquaries of Scotland*, 63, 154–89.

Csordas, T.J. (1994), 'Introduction: the body as representation and being-in-the-world', in T.J. Csordas (ed.), *Embodiment and Experience: The Existential Ground of Culture and Self*, Cambridge: Cambridge University Press, 1–27.

Eogan, G. (1994), *The Accomplished Art*, Oxford: Oxbow.

Fowler, C. (2000), 'The individual, the subject and archaeological interpretation: reading Luce Irigaray and Judith Butler', in C. Holtorf and H. Karlsson (eds), *Philosophy and Archaeological Practice*, Goteborg: Bricoleur Press, 107–33.

Gale, D. (1990), 'Prehistoric stone mining tools from Alderly Edge', in P. Crew and S. Crew (eds), *Early Mining in the British Isles*, Snowdonia, 47–8.

Gell, A. (1992), 'The technology of enchantment and the enchantment of technology', in J. Coote and A. Shelton (eds), *Anthropology, Art and Aesthetics*, Oxford: Clarendon, 40–67.

Hodder, I. (1999), *The Archaeological Process*, Oxford: Blackwell.

Kinnes, I.A. and I.H. Longworth (1985), *Catalogue of the Excavated Prehistoric and Romano-British Material in the Greenwell Collection*, London: British Museum Press.

Last, J. (1998), 'Books of life: biography and memory in a Bronze Age Barrow', *Oxford Journal of Archaeology*, 17(1), 43–53.

Latour, B. (1993), *We Have Never Been Modern*, Cambridge, Mass.: Harvard University Press.

LiPuma, E. (1998), 'Modernity and forms of personhood in Melanesia', in M. Lambek and A. Strathern (eds), *Bodies and Persons: Comparative Perspectives from Africa and Melanesia*, Cambridge: Cambridge University Press, 53–80.

Lucas, G. (1996), 'Of death and debt: A history of the body in Neolithic and Early Bronze Age Yorkshire', *Journal of European Archaeology*, 4, 99–118.

Meskell, L. (1996), 'The somatization of archaeology: institutions, discourses and corporeality', *Norwegian Archaeological Review*, 29(1), 1–16.

O'Brien, W. (1994), *The Mount Gabriel Project*, Department of Archaeology Galway Bronze Age studies volume 1. Galway: Galway University Press.

O'Brien, W. (1995), 'Ross Island and the origins of Irish-British metallurgy', in J. Waddell and E. Shee Twohig (eds), *Ireland in the Bronze Age: Proceedings of the Dublin Conference 1995*, Dublin: Stationery Office, 38–49.

Parker-Pearson, M. (1999), *The Archaeology of Death and Burial*, Stroud: Sutton.

Piggott, S. (1938), 'The Early Bronze Age in Wessex', *Proceedings of the Prehistoric Society*, 4, 52–106.

Pollard, A.M., Bussell, G.D. and Baird, D.C. (1981), 'The analytical investigation of Early Bronze Age jet and jet-like material from the Devizes museum', *Archaeometry*, 23(2), 139–167.

Serematakis, N. (1994), *The Senses Still*, Boulder, Colo.: Westview Press.

Shanks, M. and Tilley, C. (1982), 'Ideology, symbolic power and ritual communication: a reinterpretation of Neolithic mortuary practices', in I. Hodder (ed.), *Symbolic and Structural Archaeology*, Cambridge: Cambridge University Press, 129–54.

Sharpe, A. (1992), 'Footprints of former miners in the south-west', *Cornish Archaeology*, 31, 35–40.

Shepherd, I.A.G. (1981), 'Bronze Age jet working in Northern Britain', in J. Kenworthy (ed.), *Early technology in North Britain*, Scottish Archaeological Forum 11, Edinburgh: Edinburgh University Press.

Shepherd, I.A.G. (1985), 'Jet and amber', in D.V Clarke, A. Foxon and T. Cowie (eds), *Symbols of Power in the Age of Stonehenge*, Edinburgh: HMSO, 204–16.

Sheridan, A. and Davis, M. (1998), 'The Welsh "jet set" in prehistory: a case of keeping up with the Joneses?', in A. Gibson and D.D.A. Simpson (eds), *Prehistoric Ritual and Religion*, Stroud: Sutton, 148–63.

Sørensen, M.L.S. (1997), 'Reading dress: the construction of social categories and identities in Bronze Age Europe', *Journal of European Archaeology*, 5(1), 93–114.

Strathern, M. (1998), 'Social relations and the idea of externality', in C. Renfrew and C. Scarre (eds), *Cognition and Material Culture: The Archaeology of Symbolic Storage*, Cambridge: McDonald Institute Monographs, 135–47.

Taylor, J. (1970), 'Lanulae reconsidered', *Proceedings of the Prehistoric Society*, 36, 38–81.

Taylor, J. (1980), *Bronze Age Goldwork of the British Isles*, Cambridge: Cambridge University Press.

Thomas, J. (1991), 'Reading the body: beaker funerary practice in Britain', in P. Garwood, D. Jennings, R. Skeates and J. Toms (eds), *Sacred and Profane*, Oxbow Monograph series no. 32, Oxford: Oxbow, 33–43.

Thomas, J. (1996), *Time, Culture and Identity*, London: Routledge.

Thomas, J. (1999), *Understanding the Neolithic*, London: Routledge.

Thomas, J. (2001), 'Death, identity and the body in Neolithic Britain', *Journal of the Royal Anthropological Institute* (N.S), 6, 653–68.

Timberlake, S. (1994), 'Evidence for early mining in Wales', in T. Ford and L. Willies (eds), *Mining Before Powder*, Peak District Mines Historical Society Bulletin, 12(3), 133–43.

Treherne, P. (1995), 'The warriors beauty: the masculine body and self-identity in Bronze Age Europe', *Journal of European Archaeology*, 3(1), 105–44.

Waddell, J (1998), *The Prehistoric Archaeology of Ireland*, Galway: Galway University Press.

Watts, S., Pollard, A.M. and Wolff, G.A. (1997), 'Kimmeridge jet – a potential new source for British jet', *Archaeometry*, 39(1), 125–43.

Weiner, A. (1992), *Inalienable Possessions: The Paradox of Keeping while Giving*, Berkeley: University of California Press.

The Composition, Function and Significance of the Mineral Paints from the Kurgan Burial Mounds of the South Urals and North Kazakhstan

Alexander Tairov and *Anatoli Filippovich Bushmakin*

Introduction

One of the striking deposits found in the early nomads' burials of the South Urals and North Kazakhstan are caches of brightly coloured powder. The caches are placed into burial pits in fur or leather bags and sacks, in bone pipes and *gryphaea* shells. Occasionally powder is also spread over the bottom of the pits. A variety of colours occur but shades of red, blue, green, black and white prevail. As a rule these powders are attributed to paints. However, we feel that before a judgement about the purpose of this material can be made we need to undertake detailed research into its mineralogical composition. That is the subject of this chapter.

Here we shall present some of the results of mineralogical research into these powders. Research on these samples of powder was undertaken with the aid of several instrumental techniques. These include optical analysis and microchemical analysis as well as spectroscopy. From the results of this suite of analyses, while they are positive,we are unable to absolutely define the mineralogy of all components of the samples. Thus, for the material we describe below, only the fundamental components are diagnosed. Our aim is to define the easily determined major minerals and thereby determine the properties and function of the constituent powder.

Colour and context: an analysis of the case studies

Obruchevsky cemetery, Kizilsky district, Chelyabinsk region

Kurgan 2, central burial pit 1. This kurgan dates from between the second half of the sixth to the beginning of the fifth centuries BC (Gavriluk and Tairov 1993).

The burial mound was partly destroyed during the construction of a road. In both its destroyed and intact regions were found artefacts including weapons, horse harnesses, a mirror, an abrasive tile and two stone altars with three legs in the shape of lupine and ursine heads.

At the base of both of these altars traces of red paint were found. These traces were composed of hollow mineral formations with red powder inside. In this instance the mineral formation was composed of limonite. Inside it is covered with brick-red powdered haematite with a tinge of quartz and argillaceous minerals from the kaolinite group.

Kurgan 3, secondary burial pit 1. This site dates to between the fourth and second centuries BC (Gavriluk and Tairov 1993). At the bottom of the burial pit a male skeleton lay on its back with the skull towards the west-south-west. Pieces of chalk and bone were found in proximity to the skeleton. At its head a decayed grass 'pillow' was preserved. Under the burial was a complex stratigraphy with a stratum of dark soil at the bottom of the pit, which was followed by a stratum of yellow river sand. Onto these layers a mat composed of twigs was placed. Some yellow dye-stuff was sprinkled onto this mat.

Analysis of this substance indicates a uniform composition of pieces of material of around 8mm in diameter. The material is coloured a brownish-yellow. It is formed from the fine-grained accumulations of deep yellow natrojarosite with low levels of jarosite. There is also quartz, gypsum and argillaceous mineral (possibly kaolinite) as rounded grey-brown formations. From this we suggest that the sample is a mixture of substances found in their natural state.

Kurgan 3, central burial pit 2. This site dates to between the fourth and second centuries BC (Gavriluk and Tairov 1993). At the bottom of the rectangular burial pit the remains of a skeleton were found. The burial was lying on its back with its head towards the south-south-west, and its left leg was bent to the knee. The grave goods included a buckle-like iron object, an iron pendant and a whetstone made of quartz. In the grave-fill a secretion of deep wine-coloured material was found.

On first analysis the contents of the secretion appeared to represent a uniform powdery substance consisting of fractions of haematite, quartz and small amounts of argillaceous minerals of different shapes and sizes (up to 5 mm). More detailed inspection established that the haematite components are spherical. Among the sample, pieces of fused magnetite were also found. These observations suggest that the secretion was the product of pounding limonite. Therefore it is likely that this substance served as some form of paint.

Bolsheckaragansky Cemetery, Bredinsky district, Chelyabinsk region

Kurgan 18. This site dates to between the second and third centuries AD (Botalov 1993: 127). In the rectangular burial pit a female skeleton was found. The grave goods consisted of a bronze fibula, four spindle whorl, scissors, five pottery vessels, a mirror, a knife, a powder-case in the form of a small round-bottom vessel, a censer and a piece of chalk.

In the powder-case some grey-white substance was found. On analysis, it seemed to consist of finely laminated mica. More detailed analysis indicated the composition of the substance to be muscovite with a considerable amount of kaolinite and small quantities of bright-red grains of realgar. These grains were evenly distributed in the mixture. The principal component of the sample has a natural origin: fine-scaly muscovite mixed with kaolinite is typical of conditions of chemical weathering. However, realgar is an alien component to the mixture. The intentional addition of this substance to the muscovite mixture is therefore likely, although we cannot rule out accidental mixing.

The kurgan group at Mirny settlement, Bredinsky district, Chelyabinsk region

Kurgan 1. This site dates to the fifth century BC. The earthen loam soil of the mound was covered with stone. Under the mound a circular ditch with a diameter of 11 m and width of around 1 m was excavated. The burial pit was oriented east–west. At its base a male skeleton was found (Figure 9.1). The body lay in a supine position with the skull facing the west. To the left of the skull and to the north-west side of the pit lay an inverted altar of grey sandstone. Traces of red paint were preserved at the bottom of the altar. To the east of the altar a round bronze mirror lay in a leather case. In a case under the mirror a round flat clot of yellow crystalline substance was found. Near the mirror some fragments of *gryphaea* shell were found mixed with a mineral substance of a grey-yellow-brown colour. Along with these an iron knife and white oval pebble were found. In the region of the neck vertebrae of the skeleton some glass beads were found. Beads were also found scattered in the grave fill. In the south-west corner of the pit an undecorated hand-made vessel was standing upright. At the south side of the pit two dismembered ram carcasses were deposited.

The mineral substance found in association with the mirror is not homogeneous. The predominant component is gypsum in the form of grains of complex crystals and their accretions ('gypsum roses'). The second major component of the sample consists of a mixture of porous deep yellow pieces of natrojarosite and jarosite. There are also some fractions of eroded wood and quartz grains. This suggests that

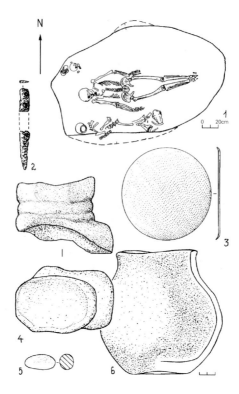

Figure 9.1 The kurgan group at Mirny settlement, kurgan 1. 1- the plan of the burial; 2-6 -the grave goods: 2 - a knife; 3 - a mirror; 4- an altar; 5 - a pebble; 6 - a vessel (2 - iron; 3- bronze; 4, 5 - stone; 6 -ceramic)

this substance has not been pounded and fractionated. Compositionally it is similar to the substance that covered the mat under the burial in pit 1, mound 3 of the Obruchevsky cemetery. While these materials are of natural origin their deposition in each of these contexts is significant.

The substance extracted from the case in association with the mirror also contained a mixture of an organic character with a great number of chitin covers of flies' chrysalises, also mixed with fragments of wood and fine wool. In the mixture there were also about ten small grains of realgar. Again the association of these substances in this context is not accidental.

Varnensky cemetery, Bredinsky district, Chelyabinsk region

Kurgan 2, principal burial 2. This site dates to between the seventh and sixth centuries BC (Botalov and Tairov 1996: 117–19). The grave goods consisted of two

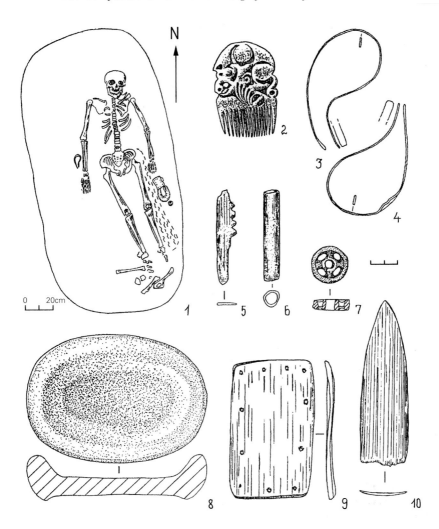

Figure 9.2 Varnensky cemetery, kurgan 2, burial 2. 1 - the plan of the burial; 2-10 - the grave goods: 2, 10 - combs; 3, 4 - a head-dressing; 5, 9 - plates; 6 - a pipe; 7 - a wheel-amulet; 8 - an altar (2, 5, 6, 9, 10 -bone; 3,4 - gold; 7 - bronze; 8 - stone)

gold head-dressings, two bone combs, two bone plates, a bronze wheel-amulet, a small stone oval altar and a bone pipe filled with deep blue powder corked up from both ends with wooden plugs (Figures 9.2, 9.3). The material from the pipe consists of ground charcoal and numerous grains of pounded aggregates of azurite and malachite. The principal component here is azurite. It is a deep blue mineral in a powdery condition and has properties which make it suited for use as a paint.

Figure 9.3 Varnensky cemetery, kurgan 2, burial 2. Arrangement of articles in the burial pit.

Nikolayevka II cemetery, Varnensky district, Chelyabinsk region

Kurgan 2, secondary burial 2. This site dates from the fifth century BC. The burial under consideration was dug into an earlier Bronze Age burial mound. The burial pit had an oval form and was oriented north-west–south-east. At the bottom of the pit a human skeleton lay in a supine position with its head to the west-north-west (Figure 9.4). On the jugular vertebrae under the lower jaw to the left of the skull a necklace of white paste beads was deposited. Between the pelvis and the right forearm a bronze mirror – in the form of a disk with a flat long handle – lay on its side. A bone pipe filled with grey-blue mineral powder was placed between the thigh-bone and the right hand. Above the right knee a flat stone altar was found.

The grey-blue powder from the pipe consists of white argillaceous minerals saturated with azurite, azurite crystals, malachite grains and transparent quartz. The minerals described are a pounded natural aggregate. Given this mixture of materials and the addition of rare substances such as malachite, the mixture must be considered as an artificial paint.

Yakovlevsky cemetery, Bashkortostan, Haybullinsky district

Kurgan 2, burial 1. This dates to the end of the sixth through to the fifth centuries BC (Fyodorov and Vasilyev 1998: 64–5, 72–3). The remains of a burial was excavated from a burial pit of a rectangular form. Artefacts include a flat stone tile of rectangular form, one oblong pebble and four rounded ones, a small round-bottomed toilet vessel, two flat-bottomed pots and a ceramic pipe.

In the north-west corner of the grave was found a rectangular stone altar. There are hollows on the upper and lower sides of the altar. The surface of the lower

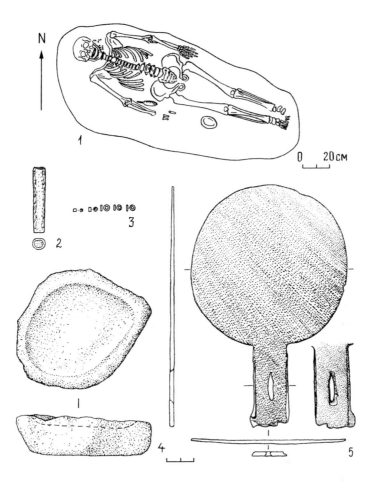

Figure 9.4 Nikolayevka II cemetery, kurgan 2, burial 2. 1 - the plan of the burial; 2-5 - the grave goods: 2 - a pipe; 3- beads; 4 - an altar; 5 - a mirror (2 -bone; 3 - paste; 4 -stone; 5 - bronze)

hollow is covered with a layer of a dark red paint, and the surface of the upper one has traces of percussion blows (Fyodorov and Vasilyev 1998: 65). Two *gryphaea* shells were found near the west wall of the pit. One of them contained a bright red powder while the other contained a bright green powder. Another two such shells were found in the grave fill of a later burial. Each of them also contained powder. In these cases the colour of the powders is either bright orange or bright blue.

The powder from each of these shells was obtained for analysis. We observed a degree of degradation of the colours relating to post-depositional conditions such as humidity. However, we were able to determine the mineralogical composition of the powders: the red powder is composed of fine grains of haematite, the blue

of fine-ground azurite with low levels of feldspar, The orange of grains of realgar and orpiment, and the grey-blue of a mixture of fine-ground azurite with a white argillaceous substance, a large quantity of realgar and low levels of orpiment.

Analysis of the small fragments obtained from the lower hollow of the altar indicated that the hollows were covered with a fine layer of ground haematite. This suggests that the altar may have served as a surface for pounding haematite for use as paint.

Yakovlevsky I, Bashkortostan, Haybullinsky district

Separated kurgan, secondary burial 3. This site dates to the middle of the fifth century BC (Fyodorov and Vasilyev, 1998: 69–70, 75). The skeleton of an adult, possibly a woman, was excavated from an oval burial pit at this site. The skeleton lay on its back with its skull towards the west. A bronze mirror was found on the right side of the skull and a stain from dark red pigment was found on the left-hand side in the north-west corner of the pit. A small flat-bottomed toilet vessel was excavated in association with this stain. Under the vessel was found a leather bag from which a wooden stick protruded. One side of the bag was covered with a large concentration of dark red powder. Besides the flat-bottomed ceramic vessel more than 20 glass beads, a rectangular whetstone and a ceramic spindle whorl were found surrounding the skeleton. To the right side of the skeleton, along the south wall of the pit, were deposited an iron knife accompanied by a great number of sheep bones arranged in discrete anatomical order.

Analysis of the powder from the base of the pit and within the bag indicates a mixture of fine-grained haematite with low levels of quartz, micaceous minerals (muscovite) and argillaceous mineral (kaolinite). Our assessment of this material suggests that, from the fine-grained nature of the mixture, the material was prepared by pounding.

Bekteniz cemetery, Sergeevsky district, North Kazakhstan region

Kurgan 1. This site dates from the mid-eighth to seventh centuries BC (Khabdulina 1987). A human skeleton was excavated from the central oval burial pit (Figure 9.5). The burial lay with its skull toward the north-west. Accompanying the skeleton were a bronze mirror in a leather bag, a stone oval altar and a bone pipe containing a grey-blue paint. Moreover, traces of the same paint were found on the altar (Khabdulina et al. 1980: 15–17). The bone pipe exhibits traces of polishing, suggesting repeated use. The pipe was sealed with a wooden plug at one end, and a curved wooden point had been placed in the pipe at the other end.

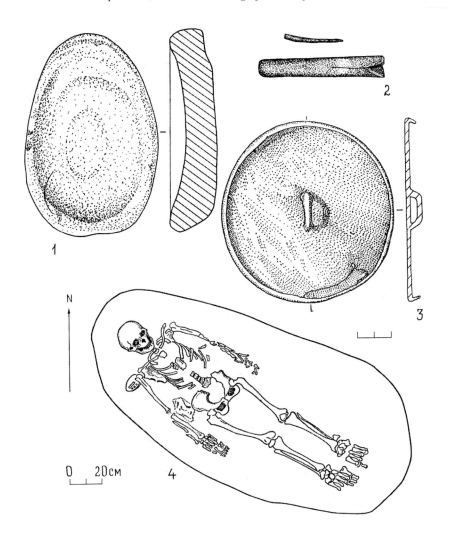

Figure 9.5 Bekteniz cemetery, kurgan 1. 1-3 - grave good: 1 - an altar; 2 - pipe and pointed stick; 3 - a mirror; 4 - a plan of the burial. (1- stone; 2 - bone and wood; 3- bronze)

Analysis of the powder found in the bone vessel indicates a mixture of crystal fragments with fine-grained aggregates of azurite, an argillaceous mineral from the kaolinite group, charcoal, a small quantity of grains of quartz and occasional grains of malachite. The initial raw material had been ground to an uneven powder. Another sample of the same overall composition was obtained from this burial, but it had been pounded more evenly. The preparation of these powders suggests their use as paints.

Grafskiye razvaliny cemetery, Sergeevsky district of North Kazakhstan region

Kurgan 2, the central burial. This site dates from the sixth to fifth centuries BC (Khabdulina 1994). The central burial lay in an oval burial pit on its back with its skull toward the north-east. On the bones and beneath them an organic black substance was deposited. Associated with the burial were two small vessels, a ceramic-ornamented spindle whorl and deposits of red and 'silver' paint found between the left hand and the pelvis of the individual (Zdanovich et al. 1980). One vessel lay on its side and a deep yellow paint was placed within it. As a result of the liquid nature of this substance, some of the paint had overflown from the vessel and hardened on its exterior in antiquity.

Analysis of the 'silver' paint suggests aggregates from foliated haematite. These natural formations of haematite could have been used for paint production: crushed haematite is a cherry-red colour when freshly ground. The 'yellow' pigment from the base of the pit is a compact formless mixture of acute-angled pieces of homogeneous fine-grained substance. The substance consists of goethite with low levels of an argillaceous mineral, quartz and mica (muscovite). This material was fine-grained in nature with coarser fragments of mica.

The paint from the intact vessel is homogeneous, consisting of fragments of a small-grained mineral aggregate surrounded by powder. This paint had been produced by grinding the natural mixture which consisted of an argillaceous mineral of the halloysite group (possibly metahalloysite) and dust-sized goethite that provided additional colour to the sample. It was produced by grinding material from the previous sample, the yellow paint from the base of the pit.

In the other vessel a fine grey-brown powder contained parts of acute-angled grains of transparent quartz and small quantities of fine-grained black magnetite. The principal mass of the mixture is composed of fine-grained feldspar (plagioclase). This substance was produced by a process of pounding.

The red paint is composed of irregular pieces of deep red fine-grained, homogeneous haematite. It had been produced by heating the yellow pigment from the base of the pit. Despite differences in colour, the composition and fractionation of the red paint and yellow paint is identical. Heat treatment of goethite produces haematite and alters the colour from deep yellow to deep red. So the same natural formations which consist of goethite are used as a raw material for preparing red and yellow paints, and the discovery of both red and yellow pigments suggests a degree of heat treatment as part of the preparation procedure.

Grafskiye razvaliny cemetery

Kurgan 7, secondary burial 3.　This site dates from the seventh to sixth centuries BC (Khabdulina 1994: 33). The burial pit was irregular oval in form and was orientated north-east to south-west. A small niche was cut into the south-west side into which the limb bones, vertebrae and shoulder-blades of a ram were inserted. A male skeleton was excavated from the base of the main pit. The burial was lying on its back with its skull toward the south-west. A bone spindle whorl and oval stone altar was discovered near the left arm of the buried. An ovate bone plate with apertures covered with paste beads lay beneath the altar. Again a bone pipe containing a bright-blue powder was associated with the burial. A bone point with a fretted haft had been placed in the pipe at one end while the other end was stoppered with a wooden plug. Analysis of that bright-blue powder indicated a mixture of fragments of different sizes. These consisted of small-grained agglo-merations of azurite mixed with an argillaceous substance with occasional grains of malachite. As with many of the other cases the azurite had been crushed and pounded.

Conclusions

The result of our examination of these mineral pigments are shown in Table 9.1. The data we have obtained indicates that the minerals taken from exposed weathering outcrops had been used to make pigments. The friable nature of this material meant it needed little treatment; however, it had occasionally undergone processes of pounding and crushing and occasionally heating as well as mixing with other substances. Our research indicates little evidence of the presence of a binding substance such as grease or oil. We can merely propose that water may have been used as an aid to binding and application.

Mineral pigments are widely documented archaeologically and ethnograph-ically. It is likely that the pigments were used for cosmetic purposes, for tattooing or body painting. It is difficult to determine a single purpose for one or another pigment or powder found in these burial contexts; we can only discuss their uses with a greater or lesser degree of confidence.

Cosmetically their applications are multiple. Likely uses include rouge, powder, shades and paint for eyelashes, eyebrows and hair. At a general level we know that a variety of colours were used for a number of purposes in antiquity. Malachite (a green copper ore) and galenite (dark-grey lead ore) have been widely used as cosmetic adornment of the eyes in Ancient Egypt. Both these materials are found as pieces of raw material located in small linen or leather bags, as stains on tiles and stones on which they had been pounded before use and as a ready preparation

Table 9.1 The phase composition of mineral powders from the South Urals and North Kazakhstan burial mounds

The place of a find	Date	The colour of a sample	The mineral composition of a sample		Comment
			principal	*minor*	
Obruchevsky cemetery, kurgan 2, burial pit 1	the second part of the sixth to the beginning of the fifth centuries BC	brick red	haematite	quartz, kaolinite-?	a natural material
Obruchevsky cemetery, kurgan 3, burial pit 1	the fourth to second centuries BC	brown-yellow	natrojarosite, jarosite	quartz, gypsum, kaolinite-?	a natural material
Obruchevsky cemetery, kurgan 3, burial pit 2	the fourth to second centuries BC	deep wine-coloured	haematite	quartz	a pounded annealed material
Bolsheckaragansky cemetery, burial mound 18	the second to third centuries AD	grey-white	muscovite, kaolinite	realgar	a natural material with an artificial tinge of realgar
Kurgan group at Mirny settlement, kurgan 1	the fifth centuries BC	grey-yellow-brown	natrojarosite, jarosite	gypsum	a natural material
Varnensky cemetery, kurgan 2, burial 2	the seventh to sixth centuries BC	black	charcoal, azurite	malachite	an artificial mixture of pounded components
Nikolayevka II cemetery, kurgan 2, burial 2	the fifth centuries BC	grey-blue	azurite, kaolinite-?	malachite, quartz	a pounded natural material
Yakovlevsky I separated kurgan, burial 3	the middle of the fifth century BC	deep red	Haematite	quartz, muscovite-?, kaolinite-?	a pounded natural fine-grained material, probably is annealed
Yakovlevsky cemetery, kurgan 2, burial 1	the late sixth to fifth centuries BC	deep red	haematite		a pounded by nature fine-grained material, seemingly is annealed. There are a lot of strange tinges including azurite and realgar

The place of a find	Date	The colour of a sample	The mineral composition of a sample		Comment
			principal	*minor*	
		dark blue	azurite	feldspar	a pounded natural material, a tinge of realgar
		bright orange	realgar, orpiment		a pounded natural material
		grey-blue with a green tint	azurite	a claylike mineral	a pounded natural material, a tinge of realgar and auripigment
Grafskiye razvaliny, kurgan 2	the sixth to fifth centuries BC	deep yellow	metahalloysite, goethite		
		grey-brown	feldspar (plagioclase)	quartz, magnetite	a pounded natural material
		silvery grey	fine-scales haematite		a natural formation
		deep yellow	goethite	quartz, muscovite-?, a claylike mineral	a natural fine-grained formation
		deep red	Haematite	quartz, muscovite-?, a claylike mineral	Naturally annealed fine-grained material
Grafskiye razvaliny, kurgan 7, burial 3	the seventh to sixth centuries BC	bright blue	azurite, a claylike mineral	malachite	an artificially pounded mineral
Bekteniz cemetery, kurgan 1	the eight to seventh centuries BC	grey blue	azurite, kaolinite-? charcoal	quartz, malachite components	an artificial mixture of pounded

(kohl). Powdered kohl is found most often in shells, in small vessels or in pipes made of hollow rush (Lucas 1958: 149–50; Kink 1976: 29, 62, 63). It is documented that Egyptian kohl had been exported to Khersones (Kadeev 1995: 101). The production of kohl consisted of mixing brown ochre (a mixture of limonite with argil), magnetic ferric oxide of a black colour and other minerals (Lucas 1958: 151, 154). Blue paint was also used for the adornment of the eyes in Judea (Dayagy-Mendels 1993: 28). In Egypt the blue paint obtained from azurite was also used in wall-painting (Lucas 1958: 519).

In the Early Iron Age in the region of the South Urals and North Kazakhstan, mineral powders may have been used as eye make-up. That mineral powders contain azurite, charcoal and kaolinite is indicated by our analyses. It should be emphasized that malachite outcrops are often found in the Urals and Kazakhstan, although azurite is found less often. Despite this, the compositions examined above indicate that malachite was not used as a principal component of the pigments. Charcoal, which gave the pigment a darker tone and a degree of brilliance, was found in association with an azurite powder and must have been added deliberately. The use of charcoal or soot for preparing kohl is also known from Egypt (Lucas 1958: 152, 153).

Some of the pigments from Obruchevsky cemetery, kurgan 2; kurgan 3, burial pit 2; Grafskiye razvaliny, kurgan 2; Yakovlevka, kurgan 2; Yakovlevsky I could have been used as rouge. In Ancient Egypt, pigments prepared of haematite or burnt limonite were used for such purposes. (Lucas 1958: 155–6, 526–8; Kink 1976: 62; Maksimova 1948: 49, 51).

The discovery of deep red realgar in the mirror case at Mirny, kurgan 1 and in the small cup made from *gryphaea* shell at Yakovlevka, kurgan 2 suggest that the pigment had served as a cosmetic preparation. The grey-white mixture of muscovite with kaolinite from burial mound 18 of Bolsheckaragansky burial ground could have been used as a powdered facial foundation. We observe the use of similar white paints in a number of contexts around the ancient world. In Hellenistic times white paint was prepared from chalk, gypsum or white argil, but the use of lead-based foundations has been documented (Maksimova 1948: 48–9). Despite its poisonous nature it was also used for whitening the skin of the face in Ancient Khersones (Kadeev 1995: 101).

Documentary evidence suggests the use of two different pigments for wall-paintings in the ancient world: yellow ochre and orpiment – a natural sulfide arsenic (Lucas 1958: 529). In Hellenistic times the principal yellow paint used in painting was ochre of different tints. The orpiment (yellow arsenic) was known but was not often used in painting (Maksimova 1948: 49). By analogy, the pounded natural mixture of argillaceous mineral (metahalloysite) with goethite found in burial mound 2 of Grafskiye razvaliny cemetery could been used as some form of yellow paint. The natural mixture that also came from the same burial

mound might similarly have been used as a brown paint. In ancient times pure ochre or a mixture of it with black pigment was often employed as a brown paint (Lucas 1958: 524; Maksimova 1948: 51).

If we are to consider the role of pigments in contexts closely associated with the human body we need to also consider the possible use of pigments as tattooing agents. An examination of the literature on tattooing suggests that for single-colour black tattoos soot, graphite or black argil was often used (Arutyunov and Shebenckov 1992: 194; Zibert 1955: 371; Ivanov 1954: 444, 477; Kocheshkov 1989: 34, 131; Lips 1954: 61; Miklukho-Maklay 1951: 273; Rudenko 1929: 15, 17; 1949, 149; Shternberg 1901: 678).

Our knowledge of tattooing in mortuary contexts comes from the contemporaneous contexts of the Pazyryk culture. The famous tattoos on the burials of the Pazyryk people were executed in coal or soot (Rudenko 1953: 140; Polosmak et al. 1997: 189). Mineral paints such as cinnabar had also been used for coloured tattoos (Rudenko 1949: 149; Shternberg 1901: 678). The using of an argil-based brown mineral paint is also typical of the Pazyryk people (Polosmak et al. 1997: 189). Tattooing was also more widespread with tattoos and body painting also a feature of the Sarmatae culture (Rudenko 1953: 138–40; Vasilyev 1998: 32).

We believe that we have evidence for accoutrements associated with tattooing. Examples include the wooden stick placed in the pigment-filled bone pipe from kurgan 1, Bekteniz cemetery and the fretted bone point in the pipe containing bright blue powder in burial pit 3, kurgan 7, Grafskiye razvaliny cemetery. Supporting evidence comes from Chetyre Mara cemetery (kurgan 5, burial 2) in Orenburg region where a twig with a pointed end was found placed within a leather bag containing white argil. Two further leather bags in association with the first were found lying on top of a bronze mirror. These contained yellow argil and a bone spoon with a figured handle. These lay on top of a bronze mirror; in addition, an iron awl and pieces of realgar were also found (Zasedateleva 1986: 21–5). However there is no *direct* evidence for tattoos; what is striking is that the instruments associated with the practice of tattooing are associated with the body on death. Ethnographically a variety of instruments are used for the application of tattoos. These include specialized instruments such as needle, awl, combs or fragments of shells, pike maxillae, fish bones or pointed bones of birds or animals.

In most contemporary cultural contexts tattoos were gendered, mainly being found on women. (Arutyunov and Shebenkov 1992: 194; Zibert 1955: 371; Ivanov 1954: 44–45, 443, 477; Kocheshkov 1989: 34, 131; Lips 1954: 61, 157; Lapunova 1979: 208; Miklukho-Maklay 1951: 273, 359–60; Rudenko 1929: 15–16; 1949, 149; Stingle 1978: 604; Shternberg 1901: 678). Many of the objects containing pigments found in female burials in this region also contain a complex set of accoutrements related to their preparation and application. These include mirrors, stone altars or plates, pebbles that served as grinding implements and instruments

such as needles and awls for piercing (Vasilyev 1998: 33). However, pigments are not only associated with the burial of women. A small leather bottle containing a black powdery substance and a pointed bone stick was found in a male burial from mound 4 of the Tre Mara group (Smirnov 1981: 83). Indeed the evidence for the embellishment of the male body is equally widespread, as L.S. Berg informs us when he notes that four different coloured pigments were deposited with a male Aleut (Lapunova 1979: 210).

In this context we need to consider the relationship between this practice and the mortuary context. The evidence in the burial pit for the grinding of pigment – and of implements for its application – suggests that bodily alterations of this kind were a means not simply of defining persons in life but also of redefining them on death. If we are to understand what this redefinition of identity relates to, we need to look closer at the provenance and selection of specific colours. We should start by noting that the colour of pigments used in this context is not accidental.

The location of pigments was either local or associated with those areas bordering the Urals. Notably, natrojarosite and jarosite are known in the zone of oxidation of a number of South Urals pyrite deposits (Yushkin et al. 1986: 115). Azurite and malachite are common products of weathered copper sulfides. Deposits of these kinds are widespread in the Urals and in Kazakhstan. In contrast, orpiment and realgar cannot be local because both in the Urals and in Kazakhstan minerals of this kind are found very occasionally and only as small fine-grained deposits (The minerals of the USSR 1940: 36; The minerals of the Kazakhstan 1989: 129, 140). However, realgar and orpiment are found in abundance in surface deposits in the Caucasus and in Transcaucasia (The minerals of the USSR 1940: 45). This may suggest that realgar and orpiment formed part of an exchange network between these regions. Support for this idea comes from another source: the analysis of copper objects.

The Caucasus and Transcaucasia regions have an abundance of arsenical copper sources. These sources are known to be superior in their properties to pure copper. Analysis of copper artefacts suggest that in the early Iron Age artefacts made of arsenic-rich alloys from this region were exchanged as far as the Altai region (Bartseva 1987: 71–3). Therefore it is likely that alongside the exchange of arsenical copper these regions could also have exchanged arsenical minerals such as orpiment and realgar to the South Urals and North Kazakhstan.

This is important for our argument since it means that within the burial context exotic materials from different locations were articulated together upon the body of the corpse. Evidence for the tattooing of the corpse therefore serves in mapping and articulating these widespread exchange relations. Colour therefore not only signifies the importance of particular distant places but also the nature of the exchange relations that connected these places. These relations are brought to bear through the medium of colour and its materialization on the corpse.

References

Arutyunov, S.A. and Shebenckov, A.G. (1992), *The Most Ancient People of Japan: The Fortunes of the Tribe of Ainu*, Moscow: Nauka.

Bartseva, T.B. (1987), *The Early Iron Age and the Middle Age of the Ural-Irtish Area*, Chelyabinsk: State University of Chelyabinsk.

Botalov, S.G. (1993), 'Bolsheckaragansky burial ground from the II–III centuries AD', in S.G Botalov (ed.), *The nomads of the Ural-Kazakhstan steppes*, Ekaterinburg: Russian Academy of Sciences.

Botalov, S.G. and Tairov, A.D. (1996), 'The monuments of the Early Iron Age in the environs of Varna village', in S.G Botalov and A.D Tairov (eds), *The Archaeology and Ethnography of the South Urals: The Works of the Arkaim Museum/archive*, Chelyabinsk: State University of Chelyabinsk.

Dayagi-Mendels, M. (1993), 'Cosmetics in the ancient world', *Ariel: The Magazine of Israeli Culture*, 16, 26–43.

Fyodorov, V.K. and Vasilyev, V.N. (1998), 'The Yakovlevsky burial mounds of the Early Iron Age in Bashkir Trans-Urals', *Ufimskij Archeological Herald, 1*, 10–15.

Gavriluck, A.G. and Tairov, A.D. (1993), 'The burial mounds near Obruchevo village in the South Trans-Urals region', S.G. Botalov (ed.), *The Nomads of the Urals-Kazakhstan steppes*, Ekaterinburg: Russian Academy of Sciences.

Handbook of Harmful chemical substance (1982), *Inorganic Combination of the V–VIII Groups*, Leningrad: Nuaka.

Ivanov, S.V. (1954), 'The fine arts of the peoples of Siberia from the nineteenth and early twentieth centuries', *The works of the Ethnography Institution of N.N. Miklukho-Maklay*, Moscow and Leningrad: Institute of Ethnology and Anthropology.

Kadeev, V.I. (1995), 'Perfumery and cosmetics in Ancient Khersones', *Kharkov History-archaeological Year Book*, Kharkov.

Khabdulina, M.K. (1987), 'The burial rite of the population of the Early Iron Age in North Kazakhstan (VIII–II centuries BC)', in T.B Bartseva (ed.), *The Early Iron Age and the Middle Ages of the Ural-Irtish area*, Chelyabinsk: State University of Chelyabinsk.

Khabdulina, M.K. (1994), *The Steppe Ishimye Basin in the Early Iron Age*, Almaty: XXI vek.

Khabdulina, M.K., Ivanova, N.O., Zdanovich, G.B. and Vinogradov, N.B. (1980), 'The Bekteniz cemetery in the North Kazakhstan region', *Field Archeological Researches of the Urals-Kazakhstan Archaeological Expedition 1980*, Chelsu: T. IV. Archives LAR.

Kink, H.A. (1976), *Art and Trade in Ancient Egypt and Neighbouring Countries*, Moscow: Nuaka.

Kocheshkov, N.V. (1989), *Ethnic Traditions in Decorative Art of the peoples of the Extreme North-East of the USSR (XVIII–XX centuries)*, Leningrad: Nuaka.

Kozhin, P.M. (1991), 'Body-paintings: The code of ethnographic conceptions and terminology', *Knowledge of the people: folk-lore and peoples art* 4, Moscow.

Lapunova, R.G. (1979), 'Traditional decorations of Aleut and ethnic-culture relations in the Pacific', in R.G. Lupunova (ed.), *The Ancient Cultures of Siberia and the Pacific*, Novosibirsk: Nuaka.

Lips, U. (1954), 'The genesis of things', in U. Lips (ed.), *From the History of the Culture of Humanity*, Moscow: Nuaka.

Lucas, A. (1958), *Materials and Handicraft Production in Ancient Egypt*, Moscow: Nuaka.

Maksimova, M.I. (1948), 'The source of raw materials and the primary processing of materials', in M.I. Maksimova (ed.), *Hellenistic Technology*, Moscow and Leningrad: Institute of Ethnology and Anthropology.

Miklukho-Maklay, N.N. (1951), *The Collected Works in 5 Volumes, Vol 3. Part 1 (Articles on Anthropology and Ethnology)*, Moscow and Leningrad: Institute of Ethnology and Anthropology.

Polosmak, N.V. (ed.) (1997), *Research on the material composition of the finds from the 'frozen' graves in the Mountain Altai (Ak-Alakh 3. Pazyryk Culture)*, Rossiyskaya arkheologiya, 1.

Rudenko, S.I. (1929), 'Graphic art of Ostyki and Voguli', in S.I. Rudenko (ed.), *Ethnographic materials*, Leningrad: Nuaka.

Rudenko, S.I. (1949), 'The tattoo of the Asian Eskimos', *Soviet Ethnography*, 1, Moscow: Nuaka.

Rudenko, S.I. (1953), *The Culture of the Population of the Mountain Altai Scythians*, Moscow-Leningrad: Institute of Ethnology and Anthropology.

Shternberg, L. (1901), *Tattooing*, in F.A. Brockgauze and I.A. Efron (eds), Moscow: Nuaka.

Smirnov, K.F. (1981), 'The rich burials and social life of the nomads of the Southern Trans-Urals region in the Scythian period', *The economy and social system of the tribes of the South Urals*, Ufa.

Stingle, M. (1978), *Over Unknown Micronesia*, Moscow: Nuaka.

The minerals of Kazakhstan (1989), Native elements, intermetallids, carbides, arsenids, antimonids, simple sulfides, Alma-Ata: Onyer.

The minerals of the USSR (1940), Sulfides, sulfosolt and similar combinations, Moscow: Nuaka.

Vasilyev, V.N. (1998), 'Sarmatian stone altars of the nomads of the South Urals', *Ufimskij Archeological Herald*, 1, 47–68.

Yushkin, N.P., Ivanov, O.K. and Popov, V.A. (1986), *An Introduction to the Topomineralogy of the Urals*, Moscow: Nuaka.

Zasedateleva, S.N. (1986), *Account of the Archaeological Expedition of Orsck Museum 1986*. Archives IA RAS, R-I, 11512.

Zdanovich, G.B., Habdulina, M.K. and Buhonin, A.A. (1980), The Grafskiye razvaliny cemetery in Sergeevskiy district of North-Kazakhstan region', *Field Archaeological Researches of the Urals-Kazakhstan Archaeological Expedition 1980*. Archives LAR Chelsu..

Zibert, E.V. (1955), *The Body Paintings of the Indians of the Kadubeo Tribe (Brazil)*, Museum of Anthropology and Ethnology, Vol. XVI. Moscow: Institute of Ethnology and Anthropology.

–10–

Colour and Light in a Pompeian House: Modern Impressions or Ancient Perceptions
Penelope M. Allison

Introduction

The Casa della Caccia Antica (Figure 10.1) is a Pompeian house whose well preserved Fourth-Style paintings, dating to AD 71–79, I have studied in detail (Allison and Sear forthcoming). This house offers a rare opportunity, even for Pompeii, where all the extant paintings can be shown to be the production of a single decorative concept, late in the life of the town. This chapter begins with an interpretative description of the impact that the colours used in these paintings have on modern visitors, in a hope to gain insights into their impact on ancient viewers. Then, a summary of the discussions of Vitruvius and Pliny the Elder on the various pigments in use in the early Roman empire is used to interpret the pigment choices made for the painted decoration of this house. The chapter's final section takes a more critical view on the potential significance of colour to the ancient viewers of Pompeian wall-painting.

Visiting the Casa Della Caccia Antica

If you were to enter the Casa della Caccia Antica (the House of the Ancient Hunt), from the Via della Fortuna running to the north of the forum in Pompeii, you would pass along a short corridor whose walls were covered in two different deep shades of red (Plate 9). Figures and other intricate details were picked out in yellow against this strong background (Bechi 1835; Rochette 1841: 37). To G. Bechi, writing when the house had only recently been excavated and the colours were still vibrant, this yellow imitated brilliantly shining gold.

If you were just passing down the Via della Fortuna and caught a glimpse of these paintings, you would very probably stop to get a better look. Those who did come inside the front hall, the so-called *atrium*, stepped onto a pavement made from lime mortar with fragments of terracotta tiles and black tufa stones that was hard but warm-coloured underfoot. Light in this front hall came from the central

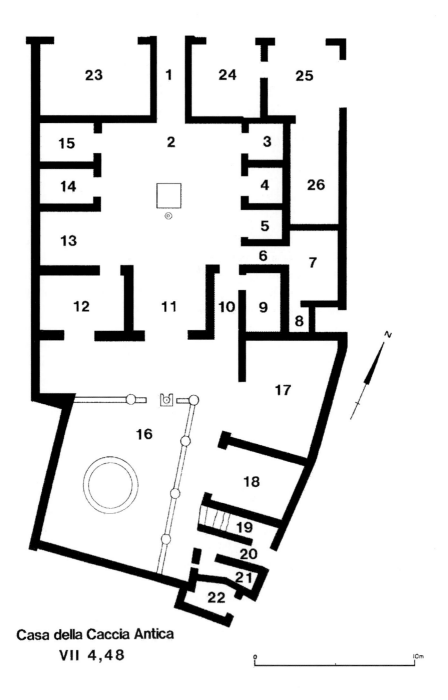

Casa della Caccia Antica
VII 4,48

0 10m

Figure 10.1 Plan of the Casa della Caccia Antica, Pompeii (by R. Apperley, adapted by P.M. Allison).

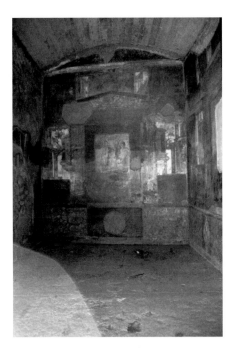

Figure 10.2 West wall of *tablinum* 11 (photo P.M. Allison).

opening in the sloping roof (the *compluvium*) that allowed rainwater to enter and collect in the central pool (the *impluvium*). The latter was furbished with white marble and a border of terracotta tiles. For much of the day the walls of this front hall would have been in shadow, making it difficult to take in all the details painted against their alternating fields of yellow and red. It seems unlikely that any of the frequent visitors, or the householders, would have been drawn to study these particular paintings in more detail. They may rather have been lured further into the house by the bright, light blue walls of the room on the opposite side of the front hall, the so-called *tablinum* (Plate 9 and Figure 10.2). In fact, the walls of this particular room were likely to have caught the visitor's eye from the entrance-way. The white mosaic pavement, the brightness of this room's predominantly blue and white walls and the light entering from the colonnaded garden beyond must have positively commanded the viewer into the house and then beyond the front hall to examine its intricate details. Like the front hall, the background blue colour of this room was much stronger than the figured and ornamental details applied to it. Only by closing the wooden doors across the north end of this room would it have been possible to exclude casual visitors from penetrating further into the house (see Vitruvius 6, 5, 1).

Even if the householders had closed this room off, they could not have closed off the other open-sided room, to the right of the front hall, the so-called *ala*. There is no evidence for doors on the west side of this room behind which to hide its bright yellow architectural facade from all who entered the front hall. The combination of yellow with white highlights and brown shadows, interspersed with white openings containing green and violet foliage, gives a three-dimensionality to the flat walls of this room. A clear sense of this would have been difficult in the limited natural light entering the central hole in the roof of the front hall. However, the early morning sun may have projected sharp beams of light onto this architectural extravaganza and encouraged early risers to take a closer look. Equally, lamplight in the evening would have created eerie shadows against the painted walls, mobilizing the architectural facade and especially the dark brown mythological figures painted against it.

If the doors of the *tablinum* had indeed been left open, one could have moved through this blue and white space into the colonnaded garden beyond. It is now rather difficult to fully appreciate the impact that this open area would have had when its vegetation had emanated a range of colour – certainly green but probably also a range of colourful flowering plants and bushes (see Varone 1990) – and when the walls beyond had exuded colourful and dramatic landscapes inside bright red borders. The confronting wall, to the south (Plate 10), was a mass of animals and humans in a strangely artificial landscape who were involved in killing each other – dark-coloured animals and dark-skinned men against the lighter greens, blues and browns of rectangular rocks and spindly bushes, punctuated by the deep red blood dripping from a wounded boar to the left, and of a bull being dragged down by a leopard on the right. While only vestiges of these figures remain today, the rich red of the blood still draws visitors' eyes.

The larger wall to the left of this garden was best viewed from the east side, from the large reception rooms which opened off the eastern colonnade (Plate 9). On this wall two large landscape paintings were set against blue-green backgrounds. The backgrounds of all the paintings in the garden were cool, light colours; the figures, the buildings, the trees and other landscape details seem to have been in more muted muddy browns, greens and pinkish tones – less pure and more earthy and natural than the stark colours seen in the more closed rooms.

It might seem surprising to the modern visitor that the walls of the ambulatories behind the actual colonnade were painted black. But the commissioners of these paintings were not alone in this choice of background for the lighter and airier parts of the house. Those in the Casa dei Vettii and the Casa degli Amorini Dorati had also chosen black for the ambulatories of the much larger and sculpture-laden gardens in these houses (Schefold 1962: figure 12.1; Peters 1977: plates 75–7; Seiler 1992: esp. figures 243–53, 281–90; for further examples: Allison 1992: esp. 244–5).

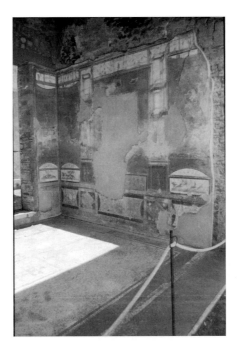

Figure 10.3 East wall of *exedra* 18 (photo P.M. Allison).

The first two rooms to the east of the garden area of the Casa della Caccia Antica, from which the west wall of this garden was best viewed, are likely to have been reception rooms. They are the largest covered spaces in this house and both had painted wall decoration. The remaining evidence for the decoration of the first, *triclinium* 17, indicates that it consisted of alternating red and yellow fields with architectural vistas between. Moving along the eastern ambulatory you might have been surprised to discover the next room, the so-called *exedra* 18, with its elaborate architectural scheme of red, black and yellow fields with solid-looking *aediculae*, or shrines, behind which light pink, grey and pale green colonnades vanished into white openings (Figure 10.3). Today the impact of this colour is distorted because parts of the yellow fields were burnt in the eruption and transformed into red, while areas of red which were similarly burnt are now black. The users of this room may have been as much overawed by the strong colouring and robust architectural forms of this scheme as by the relatively large figured panels of unusual mythological romances – Diana and Actaeon, Polyphemus and Galatea and Apollo and his male lover, Branchos – not to mention the large landscape paintings on the west wall of the garden, framed by the western doorway of this room. While the morning sun would have played with the architectural vistas in *ala* 13, the afternoon sun would have brought light into *exedra* 18, at the same time throwing the

landscapes in the garden into shadow. Only a very large number of lighted lamps would have produced more substantial illumination as the sunlight faded.

If you were expecting to find more colour in the final rooms in the south-east corner of the house you would be disappointed. The walls of these small service rooms and of the stairway to the upper floor were merely whitewashed. I can give you no information on the colour schemes of the upper floor, only that there had been an upper storey, and that, in the south-east corner at least, it had been colonnaded.

Use of colour in Roman Painting

Reinhardt Meyer-Graft (in Allison and Sear forthcoming) analysed the pigments used throughout the paintings of the Casa della Caccia Antica and found that the range was limited, in both backgrounds and the details. Both used fairly pure colours – red, yellow, blue, green, white and black. Selim Augusti (1967) analysed the remains of pigments, particularly those found in small terracotta pots in Pompeian shops and now held in the storerooms in the Naples Museum and in Pompeii. He identified most of them as the materials which were described by Vitruvius and Pliny (see also Conticello et al. 1992: 154–5).

In his specifications for the interior decoration of Roman houses, Vitruvius, writing before 27 BC, described the types of colours used, their properties and the methods of their production (7, 7–14). Pliny the Elder, writing in the first century AD, discussed the same pigments and gave indications of their relative costs (NH 35, esp. 31–51).

Vitruvius commenced with the natural colours (7, 7). He noted (7, 7, 1) that the ready availability of ochre (*ochra*) in Greece and Italy meant that yellow was frequently used in wall-paintings prior to his time of writing. Yellow appeared in all painted rooms in the Casa della Caccia Antica and was identified by Meyer-Graft as being from ochre. As a readily available material, yellow was probably the most economical colour to use; so much so, perhaps, that Pliny does not seem to have bothered to give a price for it. It was probably even more readily accessible than the reds, for which Pompeii wall-paintings are so well known. While this yellow may have imitated gold for Bechi, would it have also done so for the original occupants of this house who used it so freely? Golden yellow on deep red, as found in the entranceway to the Casa della Caccia Antica, had rich connotations in the medieval and post-medieval worlds but how did it affect people in the Roman period? It is perhaps not the colour which imitated gold but rather its use in certain circumstances. For example, the yellow of the architectural facade in *ala* 13, emphasized with its white highlights and brown shadows, may have imitated fantastic golden stage scenery, as was reputedly used by Marcus Scaurus

for his theatre in Rome (Pliny NH 36, 114). Flat yellow fields in the front hall, *triclinium* 12 and *triclinium* 17 probably utilized a cheaply available colour merely to bring lightness and brightness into these areas.

Red was also naturally and abundantly available (Vitruvius 7, 7, 2 and 5), particularly from red ochre (*rubrica*), from orpiment (*auripigmentum*) and from red arsenic (*sandaraca*). Sinopis, a type of red ochre predominantly from North Africa and Asia Minor, cost reputedly between eight *asses* and two *denarii* (i. e. twenty *asses*) a pound (Pliny NH 35, 32). Pliny costed *sandaraca* at six *denarii* a pound (NH 35, 38), although that from the Red Sea cost only five *asses* per pound but was not imported into Italy (Pliny NH 35, 39). A better substance, according to Vitruvius (7 12, 2), could be produced by roasting white lead and turning it into lead oxide. Still better, a more orangey red was produced from sulphide of mercury (*minium* or *cinnibaris*) but this needed considerable processing (Vitruvius 7, 8–9). This vermilion or cinnabar loses its brightness and becomes black when impure or used in open areas such as peristyles (Vitruvius 7, 9, 2–6). Pliny (NH 33, 118) costed it at seventy *sestertii* (i.e. 175 *asses*) per pound. Red pigment was used throughout the painted rooms the Casa della Caccia Antica, except in *ala* 13. It was mostly identified by Meyer-Graft as *rubrica* or red ochre, but a brighter red, which Meyer-Graft identified as *minium*, was used for certain details in *tablinum* 11 and *triclinium* 17. As with yellow, the widespread use of red in this house may have been as much dependant on its availability and cheapness as its desirability. Vitruvius stressed the special desirability of the brighter red colour of vermilion (*minium*). At the same time it was a very costly pigment. Extra expense was probably required to include even the smallest amount of it in these paintings.

Another naturally occurring material, a type of calcareous clay or mud (*paraetonium* and *melinum*), produces white (Vitruvius 7, 7, 3). According to Pliny (NH 35, 36), *paraetonium* cost fifty *denarii* for six pounds of the best quality while *melinum* cost only a *sestertius* (i.e. two and a half *asses*) for a pound. White could also be produced by combining lead with vinegar to produce white lead (*cerussa*) (Vitruvius 7, 12, 1). The white used in all the painted rooms in the Casa della Caccia Antica was identified by Meyer-Graft as *paraetonium creta*. Augusti (1967: 51–61) identified only one example of white pigment as *paraetonium*, finding predominantly a calcerous clay, which he identified as *melinum* or *selinusia*, and a siliceous clay, which he identified as *etretria* or *cimola*, all materials discussed by Vitruvius and Pliny. He found none of the artificial white (*cerussa*). Rooms with a white background, such as room 3 and *cubiculum* 14, probably employed the natural colour of the plaster. Similarly the white backgrounds of the architectural openings may have been the natural plaster surface. White pigment was probably used only for over-painted details, such as the highlights on figures and architectural details. If *paraetonium creta* was indeed the pigment used in this house, it was likely to have cost nearly five times as much as the common type of red (*rubrica*).

Green could be produced from naturally occurring green clay or chalk (*creta viridis*) (Vitruvius 7, 7, 4), which reputedly cost only one *sestertius* per pound (Pliny NH 35, 48), or by combining verdigris (*aeruca*) with vinegar in a similar manner to that for white lead (Vitruvius 7, 12, 1). A more brilliant but expensive green (Vitruvius 7, 14, 2) could be extracted from malachite (*chrysocolla*) (Vitruvius 7, 9, 6). Meyer-Graft identified the green used in the Casa della Caccia Antica as *creta viridis*, and therefore a cheap form of this colour. Even so, it was employed relatively sparingly but it may not have been cost that limited its use here. This colour seems to have been more expansively used in the earlier Third-Style paintings than in the Fourth Style and may not have been fashionable when this house was painted (for description and discussion on the four Pompeian Styles see Ling 1991).

According to Vitruvius (7, 11) the process for making blue (*caerulum*) originated in Alexandria in Egypt and involved mixing sand, soda and Cyprian copper, drying and burning it inside an earthernware jar in a furnace. This pigment is referred to as Egyptian blue (see Grave, forthcoming). The blue extracted from azurite or powdered lapis lazuli (*armenium*), or from indigo (*indicum*) (Vitruvius 7, 9, 6) was presumably a deeper colour. Azurite was originally imported from Armenium but it was later found in sand in the Spanish provinces which produced a lighter colour (Pliny NH 35, 47). Its price, therefore, reputedly dropped from 300 *sesterces* per pound to six *denarii* (Pliny NH 35, 47). Indigo came from India (Pliny NH 35, 46) and was apparently scarce (Vitruvius 7, 14, 2), costing twenty *denarii* per pound (Pliny NH 35, 46). Meyer-Graft identified the blue pigment used in the Casa della Caccia Antica – in *ala* 13, in *cubiculum* 14, in the garden paintings and in *exedra* 18, but most notably in *tablinum* 11 – as Egyptian blue (see also Grave forthcoming). Nearly all of Augusti's examples (1967: 62–70) were identified as Egyptian blue. The darker blue pigment used to colour the pool in the central garden area of the Casa della Caccia Antica (see Grave, forthcoming) could conceivably have been produced from azurite or indigo. The complex procedure needed to produce Egyptian blue and the considerable quantity required to decorate the *tablinum* highlights the significance of this decoration and of this room to the householders. Grave concluded that this was the preferred blue pigment for important pictorial wall decoration. Painting the *tablinum* such an alluring colour must have served to impress visitors to the house, not only with the expense incurred but with the choice of vibrant colour. Only by closing off this room could the householders perhaps have carried out more private activities with special guests in the reception rooms around the garden.

The production of black required considerable processing but with seemingly readily available materials (Vitruvius 7, 10). Resin was burnt in a vaulted chamber and then soot collected from the walls and mixed with size. Brushwood or pine chips, or the dregs of wine which were dried, burnt and ground with size, could

be used as alternatives to resin. The wine dregs reputedly produced a more pleasant black (see also Pliny NH 35, 42–3) but the most esteemed black paint (Pliny NH 35, 42) was produced from the wood of pitch pine. Vitruvius (7, 4, 4) stipulated that winter dining rooms should be painted with black (*atramentum*) panels and intervening strips of yellow (*silaceis* = ochre-like) and vermilion (*minium*), to avoid damage by the smoke from the fire or soot from lamps. Meyer-Graft identified black in *tablinum* 11, *triclinium* 12, the ambulatories and open area of the garden and *exedra* 18, calling it *atramentum*. Black may have been cheap to produce and to reapply. It may have been used in areas which might fade quickly, such as the ambulatories. However, it was obviously a desirable colour for this area that, to a modern mind, might have been cooler and more durable if left white or painted in a light colour. From Vitruvius' discussion there would also appear to have been a concern for the quality and intensity of the particular black used, a concern which is perhaps difficult to comprehend, for all except the absolute purist, in today's technicolour world. Interestingly, black dining rooms were more common in Third-Style decoration, which was contemporary with Vitruvius, rather than in the Fourth Style, such as the decoration of this house.

According to Vitruvius (7, 13) purple was the most prized colour obtained from crushing sea shells (*ostrum*), places such as Rhodes yielding the best colour. Purple could also be produced by roasting good quality yellow ochre to a bright heat and then quenching it with vinegar (Vitruvius 7, 11, 2) or by dying chalk with vegetal material such as madder (*rubia*) or hysginum (*hysginum*) (Vitruvius 7, 14, 1; Pliny NH 35, 44–6). Another method was to mix whortleberries (*vaccinium*) with milk (Vitruvius 7, 14, 2). According to Pliny (NH 35, 45) the cost of purple (*purpurissum*) varied from one to thirty *denarii* per pound, although he did not refer to the process of producing it from *ostrum*. Only in *ala* 13 in the Casa della Caccia Antica, in the violet used in the openings, did Meyer-Graft's analysis identify what he referred to as a real purple (*purpurissum*). He did not identify the substance from which it was made. The samples of violet pigment analysed by Augusti (1967: 73–6) were show to be an animal substance, and most to have been produced from Murex shell (*ostrum*). The more muted purply-black colours used in the hunt scene on the south wall of the garden of the Casa della Caccia Antica were probably produced by the mixing of other available colours while that in the *ala* may have been made by one of the techniques described by the ancient authors. The limited use of purple in this house perhaps testifies to the difficulty and expense of obtaining it. Like green, purple seems to have been more common in Third-Style paintings. While this may reflect changing economic status for painted decoration, equally this colour may not have been so fashionable in the latter part of the first century AD. Nevertheless, as with vermilion, there seems to have been a desire to include at least some of it in this house, and in one of the most elaborately painted rooms.

Pliny (NH 35, 30) distinguished between sombre and brilliant colours (see comparable concerns in Australian Aboriginal painting: Morphy 1989). In the latter group he placed vermilion (*minium*) and cinnabar (*cinnabaris*), rich blue (*armenium*), malachite (*chrysocolla*), indigo (*indicum*) and bright purple (*purpurissum*) which the patron (*dominus*) reputedly had to pay for. This assumes that other cheaper colours (whites, greens, yellows, reds and blacks) were covered in the decorating costs. Pliny (NH 35, 50) praised the famous Greek painters of the Classical and Hellenistic periods who had executed their remarkable works using only four colours – white (*melinum*), yellow (*ochra*), red (*sinopis*) and black (*atramentum*). He was disdainful of people in his day for their obsession with the value of the materials used to produce these colours rather than with the technical expertise of using the colours themselves. It would seem that whoever commissioned the paintings in the Casa della Caccia Antica felt a need to include even the smallest amount of these 'brilliant' and scarce colours but that the decorators had been fairly unadventurous in their uses of all the pigments. What is not obvious, however, is whether those who commissioned the work wanted to use these specific pigments because they had a aesthetic appreciation for the particular hues produced by them or because they were concerned to follow a fashion and demonstrate that they had the means to include such pigments in their decorative schemes.

Perceptions of colour in Pompeian domestic decoration

By analysing our own reactions when we enter the Casa della Caccia Antica and by understanding some of the concerns involved in producing the various pigments used in Roman wall-painting, can we really understand the impact and significance of the colour in these paintings for ancient occupants of and visitors to these spaces? Can we understand the psychological significance of colour for people in the Roman period?

This house is far from unique in Pompeii in its wall-paintings and use of colour. However, what is unique about these paintings is their relatively precise date and their proven contemporaneity. Some seventy coin impressions were found in the decoration of the north wall of the front hall which were made when the plaster was still wet. At least some of these coin impressions were made by a coin minted in either the third or fourth consulate of the emperor Vespasian (i.e. AD 71–72). Plaster analysis, painter-workshop analysis and iconographical analysis show that all the painted decoration in this house was contemporary with that in the front hall. Thus, this house was completely redecorated in the period AD 71–79 and is an example of a single decorative concept not more than eight years before the AD 79 eruption of Mt Vesuvius.

By the AD 70s, however, it would seem that practically every house in Pompeii was richly decorated with painted walls. The type of scheme witnessed in each

particular room type in the Casa della Caccia Antica is also found to be characteristic of these room types in other houses in Pompeii. For example, elaborate architectural decoration with stronger colours, as in *exedra* 18 and *ala* 13, was used in open rooms off courtyard areas; dark (often black) flat fields are found in the exposed ambulatories of peristyles, and large landscapes decorated open-air garden walls; passageways and entranceways had simple, fairly flat decoration, often red or black; long, narrow, closed rooms, such as *triclinium* 12, made use of reds and yellows, usually in alternating flat fields with limited architecture; and the smallest and most closed and private rooms, such as *cubiculum* 14 and room 3, had predominantly white backgrounds (for further discussion see Allison 1992). Less common in Pompeian houses were all blue rooms like *tablinum* 11, or largely monochrome architectural facades as in *ala* 13. Wallace-Hadrill (1994: 166–7) also noted that rooms with white backgrounds were the most common, then red and yellow; and that blue, green and black backgrounds were rare. However, he was observing decoration as preserved at the end of the twentieth century. Black backgrounds were used in open areas and corridors, which have been left uncovered by modern restorers, and which have therefore often completely faded.

Pompeians would have had a familiarity with intensely coloured walls which we generally do not. In public spaces Pompeii pictorial imagery seems to have been limited to verbal advertisements (e.g. produce for sale, rooms for rent and electoral notices). In contrast, even a relatively small house like the Casa della Caccia Antica was positively pulsating with vibrant primary colours often painted in enclosed and restricted spaces. But these houses were not art galleries. They were spaces in which a great range of people carried out their daily lives. Pompeians placed their furniture against these walls, sometimes obscuring their elaborate and intricate paintings. Many a modern scholar has stood in empty front halls of Roman period houses and described the living conditions by filling them with textual anecdotes, but paying scant attention to the plethora of domestic furniture and utensils that these spaces also housed (e.g. Wallace-Hadrill 1994: esp. 38–47; Clarke 1991: esp. 2–19). The front halls, ambulatories and *tablina* of Pompeian houses were frequently filled with cupboards, in turn filled with domestic utensils, and also with large weaving looms (see Allison forthcoming). The walls of reception rooms were often lined with dining couches, whose location may or may not have been accommodated for in the wall and floor decoration (Corlàita Scagliarini 1974–76; Barbet 1985: 57–8, 124–6). Chests filled with needs for the table might equally be kept in these rooms (e.g. room 11 in the Casa del Menandro: Allison forthcoming). The paintings, particularly those in the entranceway and open areas, probably had only a fleeting impact on those whose minds were on other household matters. At the same time, these houses provided a concentration of colour which was not so readily available in the world outside the domestic sphere. They brought natural colours into this sphere but in their choices and combinations they exaggerated them.

People of Pliny's acquaintance may have been obsessed with the rank and hue of pigments. Pompeians seem more concerned with the colour itself. Originally, if one can take the use of colour in Second- and Third-Style Pompeian painting as indicative, Pompeians seem to have paid considerably more attention to including the rarer blues, greens, purples and vermillion in their wall decoration. By the time the Casa della Caccia Antica received its final decoration the colours used seem to have been the cheapest available and the combinations among the most standard in Pompeii, with the exception of the blue in the *tablinum*. If particular colours, such as green or purple, held a special status, or psychological importance, this would seem to be less evident by the 70s AD.

Conclusions

It has frequently been noted that the use of particular colours and the complexity and richness of the schemes might be helpful in ascertaining the quality of the paintings in Pompeian houses (e.g. Allrogen-Bedel 1975: 228; Barbet 1985: 204–5; Ehrhardt 1988: 75). According to the latter criterion, the wall-paintings in the Casa della Caccia Antica seem of a quite high quality for this period. The numerous figured representations and the abundant employment of architectural motifs demonstrate that this decoration was detailed and that its execution was time-consuming, implying expenditure for the sake of display and prestige. According to the former criterion they seem to use a relatively standard repertoire of colour, those who commissioned the work only indulging themselves in the decoration of the *tablinum*, and discretely in the *ala*. The extensive use of Egyptian blue in the *tablinum* contrasts with its limited use in Pompeian Fourth-Style wall-painting, although its discovery in small pots in Pompeian houses (Conticello et al. 1992: 154–5 nos 16, 20–1) indicates that it was in use elsewhere, at least in small quantities (see also the *tablinum* in the Casa della Fontana Piccola – Fröhlich 1996: 29–31). During the last decade of the life of the city, at least one of the occupiers of this house was in a social, cultural and financial position to have the house completely redecorated. Essentially in only one room, but at the same time in the most prominent room, colour was employed to draw attention to this fact.

References

Allison, P.M. (1992), 'The relationship between wall-decoration and room type in Pompeian houses: a case study of the Casa della Caccia Antica', *Journal of Roman Archaeology*, 5, 235–49.

Allison, P.M. (forthcoming), *Pompeian Households: Analysis of the Material Culture*, Los Angeles: Cotsen Institute for Archaeology, UCLA.

Allison, P.M. and Sear, F.B. (forthcoming), *The Casa della Caccia Antica in Pompeii*, Häuser in Pompeji, 11, Munich: Hirmer.

Allrogen-Bedel, A. (1975), Zur 'Datierung der Wandmalereien in der Villa Imperiale in Pompeji', *Bulletin antieke Beschaving*, 50, 225–30.

Augusti, S. (1967), *I colori pompeiani*, Rome: De Luca.

Barbet, A. (1985), *La peinture murale romaine: les styles décoratifs pompéiens*, Paris: Picard.

Bechi, G. (1835), 'Relazione degli Scavi', *Real Museo Borbonico*, 12, 2–4.

Clarke, J.R. (1991), *The Houses of Roman Italy, 100 BC–AD 250: Ritual, Space and Decoration*, Los Angeles: University of California Press.

Conticello, B., Stazio, A. and Varone, A. (eds) (1990), *Rediscovering Pompeii: Exhibition by IBM-Italia*, Rome: L'Erma di Bretschneider.

Corlàita Scagliarini, D. (1974–76), 'Spazio e decorazione nella pittura pompeiana', *Palladio*, 24–26, 3–44.

Ehrhardt, W. (1988), *Casa dell'Orso*, Häuser in Pompeji 2, Munich: Hirmer.

Fröhlich, T. (1996), *Casa della Fontana Piccola*, Häuser in Pompeji 8, Munich: Hirmer.

Grave, P. (forthcoming), 'Plaster Analysis', in P.M. Allison and F.B. Sear, *The Casa della Caccia Antica in Pompeii*, Häuser in Pompeji 11, Munich, Hirmer.

Ling, R. (1991), *Roman Painting*, Cambridge: Cambridge University Press.

Morphy, H. (1989), 'From dull to brilliant: the aesthetics of spiritual power among the Yolngu', *Man*, (NS), 24(1), 21–39.

Peters, W.J.Th. (1977), 'La composizione delle parete dipinte nella Casa dei Vettii a Pompei', *Mededelingen van het Nederlands Instituut te Rome, Antiquity,* 39, 95–128.

Pliny the Elder, (1938–1984), *Naturalis Historiae*, vol. 9, books 33–35, Trans. H. Rackham, London, William Heineman and Cambridge, Mass.: Harvard University Press.

Rochette, D. (1841), *Lettre à M. du Salvandy sur l'état actuel des Fouilles de Pompéi et des Musées de Naples et Rome*, Paris.

Schefold, K. (1962), *Vegessenes Pompeji*. Bern and Munich: Francke.

Seiler, F. (1992), *Casa degli Amorini Dorati,* Häuser in Pompeji 5, Munich: Hirmer.

Varone, A. (1990), 'Attività della Soprintendenza', *Rivista di Studi Pompeiani*, 4, 202–4.

Vitruvius, (1934), *De Architectura*, Books 1–10, trans. F. Granger, London, William Heinemann and Cambridge, Mass.: Harvard University Press.

Wallace-Hadrill, A. (1994), *Houses and Society in Pompeii and Herculaneum*, Princeton: Princeton University Press.

The Colours of Light: Materiality and Chromatic Cultures of the Americas
Nicholas J. Saunders

Chromatic worlds

Throughout the Americas, indigenous valuations of light and colour were an integral part of multi-sensorial worldviews which saw metaphysical concepts manifested in a multiplicity of cultural attitudes to the natural world, spirituality, social identity, and conceptions of power. Here I explore the many aspects of shininess and colour in relation to a pan-Amerindian 'aesthetic of brilliance' (Saunders 1998a; 1999; 2001a).

In a book whose emphasis is on Europe, yet which also represents a significant step on new paths of interdisciplinary investigation, this chapter offers a way of exploring the complexities and intricacies of cultural attitudes to light and colour. The richness of America's ethnohistoric and ethnographic records allows us to conceptualize complex issues concerning the interpretation of brilliant and chromatic matter in the archaeological record. It can also serve as a comparative tool in the investigation of such concepts in ethnographic and archaeological contexts worldwide.

Aesthetic valuations and cosmological associations of light and colour are found throughout the world. In Africa, Asia, Europe, and the Pacific, indigenous notions of brilliance permeate natural philosophies and materialities. From an anthropological perspective, the sacred and spiritual dimensions of light and colour have been commented upon by Morphy (1989) for the aboriginal Australian Yolngu, Coote (1992: 252–3, 255) for the African Dinka and Nuer, Gell (1992: 45) for the Pacific Island Trobriand, and Bayley (1986: 291–2) for Indo-Persian culture. The relationship between light, colour, and art has also been discussed for the Western tradition by, among others, Gage (1995), Gombrich (1988: 30–52, 250–1), and Miller (1998; and see Rivers 1999).

Yet, while colour has received a variety of different treatments, archaeologists and anthropologists have so far not acknowledged data and insights into the physical nature and cultural implications of light. Publications by Hoffman (1998), Park (1997), Perkowitz (1996), and Zajonc (1993) are notable for their potential

in this respect, with Brill (1980) an early forerunner. These works indicate not simply that the kaleidoscopic relativity and hybridity of aesthetics in this matter are issues of historically contingent cultural forms, but also that they relate to the universal human reaction to light and light-reflecting objects. While in no way advocating neurological determinism in the cultural interpretation of light and colour, it is pertinent to note Perkowitz's (1996: 31–5) observation that human evolution has created distinctive responses to sunlight. The body's clock starts at dawn as light hits the retina, activating a neural pathway to the brain, stimulating the visual cortex, and affecting thought and perception. Forewarned is forearmed in the investigation of the cultural life of brilliance and colour.

The significance accorded to light and colour in the Americas appears deeply embedded in indigenous Amerindian worldviews, and can be traced through ethnohistoric and ethnographic records and, by analogy, suggested for the archaeological record (e.g. Helms 1993; 1995; 2000; Saunders 2001b).

Worldview, metaphysics, and matter

Throughout the Americas, the supernatural qualities of light are evident at every scale of activity, from the spiritual to the material, the personal to the social. Among the Akawaio of Guyana, the central concept of spirituality is *akwa* – which equates light and brilliance with life (Sullivan 1988: 423). Every person has a relationship with *akwa*, and depending on the nature of this association, an individual's supernatural condition is either *akwalu* (a spirit, i.e. 'a kind of light') or *akwalupö* (a ghost, i.e. 'without light') (ibid.). For the Mesoamerican Aztec similarly, the semantic dimensions of light are evident in a terminology of radiance embedded in the idioms and metaphors of language and moral philosophy.

An Aztec person's soul was conceived as hot and luminous (López Austin 1988: 204–6, 216). If a sick child's reflection was bright his soul was intact, if dark, it had escaped (ibid.: 216). The Aztec conceived semen as rain, and imagined it as a flock of brilliant blue cotingas (Gingerich 1977: 140). In both cases, the presence of light and colour was equated with life itself. Furthermore, the ethic of righteousness was seen as transforming the Aztec soul into an iridescent quetzal feather (ibid.: 324). 'Lighting the way', setting a moral example, was a metaphorical expression of the ethical significance of light in Aztec ideology (Burkhart 1988: 238).

More widely, light permeated Amerindian metaphysics, linking earth, sky, sea and atmospheric phenomena. Even time was associated with different kinds of light for the Mapuche of Chile, with each kind possessing different social, mythical, religious and moral correlates (Sullivan 1988: 157). While light was a force of earthly life infiltrating all things among the Aztec (López-Austin 1988:

204–5), for the Inca it was the creation of light which brought order into the world (Classen 1993: 38).

Rivers, lakes, and celestial phenomena were imbued with spirituality according to the sacredness of the light and colours characterizing them. Mountains and volcanoes, whose mineralogical constituents, snow-capped appearance and weather-generating capacities manifested light and colour, were regarded as the sacred dwelling places of supernaturals. For the Kogi of the Colombian Andes, snow-peaks were conceived as gleaming white crystals, prisms of light, and portals for the dead (Reichel-Dolmatoff 1981: 28). More transient were rainbows, rain, mist, and clouds, which nevertheless glowed with spirit essence and were highly, if differently, valued across the Americas (e.g. Garcilaso de la Vega 1987 [1609]: 183; Seler 1993a: 195; Stevens-Arroyo 1988: 190–1).

The symbolic landscapes, which constituted indigenous conceptions of heaven, were also characterized by brilliance and colour. The Aztec rain-god's paradise was conceived as:

> . . . a shimmering place filled with divine fire; [where] the light of the sun reflects from the petals of flowers and the iridescent feathers of birds; [and] human beings . . . are themselves flowers, birds, and shimmering gems. (Burkhart 1992: 89)

Similar ideas are found in Inca culture. At the Inca capital of Cuzco, the temple of the Sun God Inti was covered with gold, silver, and crystals (Garcilaso de la Vega 1987 [1609]: 179–84). In the adjacent garden, people, animals, plants and soil were modelled in gold and silver (Garcilaso de la Vega 1987 [1609]: 188, 318). Such structures represented a world of brilliance made physical (Helms 1981: 219–20).

Astronomically, light was imbued with cultural significance (and see Ruggles and Saunders 1993). At the Inca festival of the moon, the qualities of darkness were banished by warriors wielding slings of fire (Quilter unpublished). Every 52 years, the Aztec 'New Fire' ceremony saw the extinguishing of all 'old' light, and the sparking of a new fire in the chest of a sacrificial victim (Townsend 1993: 130–2). This 'new' light was then taken to rekindle the fires of the capital of Tenochtitlán, signifying the start of a new 52-year period.

Such positive evaluations of light were matched by attitudes towards its absence – notably during eclipses. In many Amerindian societies, such events were regarded as times of danger, threatening the cosmic order as well as individual life, and symbolizing disease, death, and catastrophe (e.g. Closs 1989: 390–4; Redfield and Villa Rojas 1962: 206–7). Unpredicted lights in the sky could also bring disaster. The Aztec believed comets could kill rulers and start wars (Köhler 1989: 289–90), and the Kogi saw meteors as mirroring dissonances on earth (Reichel-Dolmatoff 1981: 25).

These examples and many others (see Saunders 1998a, 1999) indicate that Amerindian conceptions of light were imbued with a variety of sacred, mythic, moral, and social values. The coherence of such generic attitudes toward light does not deny configurations of meaning which are culture-specific and manifested in a society's colour codes (e.g. Hamell 1986: 9–20; 1995: 47–8; Reichel-Dolmatoff 1978; and see Zajonc 1993: 14–15).

Shamanic visions

The importance of light and colour derives in large part from traditional non-Western world-views of indigenous Amerindian societies commonly, though misleadingly, referred to as shamanic. Shamanism offers a wealth of detail with which to explore notions of light and colour, as it concentrates such imagery and symbolism in well documented ethnographic accounts. An often uncritical reliance on shamanism as a catch-all category of explanation has replaced an earlier obsession with formalism, and has proved an equally effective straitjacket in the interpretation of prehistoric material culture, art and symbolism (see Saunders 1998b: 6; 2001c).

Easy recourse to altered-state imagery and vision quests has been a smoke-screen concealing misunderstandings of the complex relationships between different kinds of materiality, spirituality and natural phenomena, especially the conceptualization of brilliance and colour. In terms of light-related phenomena, the study of entoptics (Lewis-Williams 1997; Lewis-Williams and Dowson 1988) has promoted neurological determinism, in a way that degrades our ability to discern individual and cultural imagination and imperatives, by privileging a narrow class of phenomena, ignoring synaesthesia (Classen 1991; Houston and Taube 2000; Howes 1991), and distorting our understanding of shamanism. Images and designs which receive emphasis in art and myth regarded not so much the result of conscious and meaningful selection by a society as the autonomic consequence of altered states of consciousness (see Saunders 2001a; in prep. a).

What defines a shamanic world-view is not strict adherence to predetermined image-bearing stages of altered states of consciousness but the acknowledgement of a non-Western, indigenously coherent, concept of 'explanation and being' based on analogical symbolic reasoning. This fundamental characteristic of shamanism provides the explanatory framework and power to underwrite the diversity of world-views which differentially draw on, and assign meanings to, naturally occurring or induced altered-state images. Such a conceptual understanding of the world empowers priests and chiefs as well as shamans, and may well have been a feature of the power wielded by Maya kings, and Aztec and Inca emperors in pre-Columbian times.

Ethnographic data indicates that shamanic visions and the rituals and para-phernalia which articulate and reinforce them are characterized by bright light and brilliant colours. While every culture has its own classification of colours and associated symbolism, there appears a consensus that confrontations with the supernatural are visually stimulating events. These phenomena are not compart-mentalized, but are rooted in valuations of light and notions of mirror-image realms inhabited by luminous spirit-beings. For the arbiters of this world-view – whether shamans, priests, or divine rulers – it is no surprise that their visions, paraphernalia, and ritual knowledge are also conceived as being enveloped in shimmering light. The capacity of light, shadow, and colours to reveal and transform the appearance of an object, person, spirit, place, or phenomenon is symbolically acquired by those whose status is predicated on acknowledgement of their abilities as 'transformers' or 'shapers' of worlds.

The brilliant and multi-coloured nature of shamanic visions can be addressed from the perspective of 'seeing' and perceiving, as shamans observe and under-stand more than ordinary people (e.g. Butt-Colson 1977: 63; Hugh-Jones 1979: 33, 283; Wilbert 1987: 163). Seeing in visions is widely regarded as seeing the essence rather than the surface of things in the same way that an object's shiny or coloured surface reveals the sacred glow within (see Saunders 1998a: 226–30). Shamanic visions characteristically feature bright multicoloured light (e.g. Kensinger 1995: 221; and see Descola 1996: 207) and supernaturals themselves appear as luminous beings (e.g. Furst 1976: 46, 131; Goldman 1979: 210; Taussig 1987: 322–3). Among the Warao of coastal Venezuela, there exists a category of 'light shamans' (Wilbert 1987: 160–1). For the Warao also, reality and metaphys-icality coalesce in the colours of cosmic serpents which themselves are modelled on brightly coloured natural prototypes such as the red or golden-brown rainbow boa (*Epicrates cenchris*) with its striking metallic sheen and strongly iridescent body (Wilbert 1997: 318). In a Warao shaman's trance:

> . . . the shapes, colors, and motions of natural reptiles converge with the dynamic and chromatic forms of hallucination, evoking a nearly universal serpent symbolism that unlocks the gates of intuitive reality. (ibid.)

The Warao data informs us of a so far under-documented aspect of shamanism – and the world-view-materiality interface more widely – i.e., the synaesthetic dimensions of visions and the multisensorial nature of a world-view defined by analogical symbolic reasoning. As Wilbert (1997: 327) observes, tobacco-induced visions encompass auditory as well as visual hallucinations. Tactile sensations also feature inasmuch as shamanic initiates touch the body and head scales of serpents to attain enlightenment (ibid.).

Across the Americas, and arguably throughout the world, brilliant visions equate with spiritual enlightenment. Whether concerned with the symbolic

dimensions of colourful atmospheric phenomena, the colours and hues of metals, the chromatic resonances of minerals, plants and animals, or glowing ritual knowledge and oratory – and whether induced by tobacco, hallucinogens, and/or music and abstinence – the recurring image is of the shiny nature of divine knowledge. This sometimes takes a dramatic form, albeit founded on experience of the natural world – such as shamans of the Brazilian Araweté, who smoke tobacco to become translucent enough to experience visions (Viveiros de Castro 1992: 219). The Araweté judge the light-giving qualities of tobacco so strong that it causes the skin of initiate shamans to shine and give off shocks like those of the electric eel (ibid.: 220).

This illustrates that, despite cultural differences, the significance attached to the brilliance of light and colour appears remarkably consistent throughout the Americas. Any investigation of these qualities in archaeological cultures in the Americas requires an acknowledgement of the complex associations between world-view, spirituality and materiality available in ethnographic accounts.

Materiality of luminosity

It is possible – though unlikely, given the bridging nature of ethnohistoric evidence supporting ethnographic data – that the embeddedness of attitudes toward luminosity in shamanic visions and natural philosophy did not affect the valuations of material culture. It is equally possible that a quality of inextricability between materiality, brilliance and colour is accorded with indigenous world-views. In such a transformational universe, brilliant objects could have been conceived as earthbound material manifestations of light, and of the social relationships and spiritual qualities which light embodied (Saunders 1998a: 230). This view, together with the many brilliant objects found in graves, fits well with the wider point that individuals' social being is determined by their relationship to objects that represent them (Hoskins 1998: 195).

The brilliance and colours of matter

The production of shiny and coloured material culture objectified a society's valuations of these qualities which themselves were mediated by the sacred nature of the technologies used to make them. Technological processes are social and cultural choices whose practical consequences are valued, legitimated by and operate within the spheres of mythology, religion and ideology. In Amerindian world-views, making such objects was an act of transformative creation. Harnessing the social and mythical significances of light, colour, and matter, and shaping them into solid forms via technological choices whose efficacy stemmed from a

synergy of myth, ritual knowledge and individual technical skill (Saunders 1999: 246). In other words, indigenous notions of the supernatural qualities of light and colour as embodiments of cosmological energy were materialized in objects and validated in their myriad forms by artistic and ritual display (see Houston and Taube 2000 for a Mesoamerican case study).

Throughout the Americas, different minerals were made into what are generically called 'mirrors' (Plate 11). In Mesoamerica, mirrors were made from polished iron-ore among the Olmec (Carlson 1981), various mosaics of pyrites and jade for the Maya (e.g. Kidder et al. 1946: 126–31) and Teotihuacan (e.g. Taube 1992). In South America, they were made from anthracite and jet (e.g. Burger 1995: 91, 121, 169; Quilter 1991: 404–13), and pyrites and shell (e.g. Boone 1996: 181–6), and in North America from slate and mica (e.g. Ford 1969: 75–6). This variation of raw materials, and the different 'reflections' thus produced, argues against their use as 'vanity mirrors'. Yet all share the quality of luminosity, suggesting a common use as divinatory tools (see Saunders 1988: 1–10).

In Mesoamerica, in the sixteenth-century *Florentine Codex*, Sahagún (Book 11: 223, 229–30) refers to the translucence, preciousness, iridescence and light-giving qualities of different minerals – some of which were items of elite Aztec tribute (Berdan 1992: 310–12). Greenstones were especially valued as their colour connoted fertility. Sahagún (Book 11: 221–2) illustrates how colour and materiality fused in Aztec symbolic thought as greenstones were believed to signal their presence at dawn by emitting smoke, and to impart greenness to the flora in their vicinity. The complexity and inextricability of such imagery for the Aztec is indicated also by the placing of a greenstone in the mouth of a deceased emperor (López Austin 1988: 326–7), and by the glyphic combination of a greenstone in a stream of water which signified 'precious water' – a metaphor for sacrificial human blood (Seler 1993b: 277).

Such complex ascriptions of meaning, which blur the boundaries between cultural matter and natural philosophy, can be seen among the Colombian Muisca. Here, pregnant women offered (artefactual) gold/copper figurines and (naturally occurring) emeralds to their Rainbow deity to ensure successful childbirth (Falchetti 2001). This act mixed together two different kinds of shiny matter, human fertility, spiritual belief, and a god whose referent was an iridescent natural phenomenon produced by sunlight and moisture in the air.

Similarly informative is the attitude of the Amazonian Desana for whom the hexagonal shape of crystals replicates cosmic order and is associated with concepts of energy and transformation – the crystal itself regarded as concentrated semen (Reichel-Dolmatoff 1975: 102; 1981: 23). Shells and pearls also possessed white shiny qualities which perhaps were enhanced by being found beneath the reflective surface of water – a recognized boundary between the physical and spirit worlds (Hamell 1998: 258, 281; Roe 1998: 193–4). There is abundant evidence which

attests the widespread ritual importance of shells as offerings (e.g. Murra 1975: 257), and of being made into prized jewellery in South America (e.g. Arriaga 1968: 45; Whitehead 1988: 54–5). In North America, wampum (cylindrical shell beads) signified light and spiritual well-being (Hamell 1986; 1995). Pearls also were highly regarded for their light-giving and spiritual qualities (Saunders 1999: 247–9).

Artefacts also served as conveyors of spiritual brilliance. Burnished, slipped and painted pottery items, whose clays and temper themselves might have sparkling inclusions (Arnold 1993: 113), could dazzle with their shininess (Medina 1934: 201). Polished and glazed pottery had a wide distribution throughout Mesoamerica, Central America, and South America (Helms 1993: 240). Polished black wood in the Caribbean (Helms 1986), and shimmering featherwork in lowland Amazonia (Howard 1991) and Mesoamerica (Yturbide 1993), are all conveyors of the sacred values and positive cultural valuations of light embodied as shimmering matter.

Ethnographically derived insights are invaluable interpretative tools when supported by the chronological bridge of ethnohistory (Saunders, in prep. b). An indication that ethnographic detail can throw interpretative light on the arch-aeological record comes from prehistoric Oaxaca in southern Mexico. Around 1150 BC, at the site of San José Mogote, evidence suggests that shell, jade, magnetite and mica signified high status in this early ranked society (Marcus and Flannery 1996: 93, 101–3). Each of these materials was still highly regarded some two and a half thousand years later in Aztec society where, in addition to jade, mica was believed to be excreted by the moon, to symbolize cosmic forces and to be possessed of soft and buoyant light (Sahagún Book 11: 235).

Technologies, enchantment and matter

Artefacts are invested with qualities abstracted from the cultural appraisal of the natural world. Ethnohistoric and ethnographic data indicate that brilliance and colour represent the accumulation of creative powers. Shiny and multicoloured objects, as embodiments of these powers, can be viewed as the ultimate symbols of power and influence. In this sense, it is possible to suggest a variety of meanings for the myriad archaeological objects displaying shininess and colour and which appear in association with elites, in life and in death. As Geertz (1973: 90) has observed:

> Religious symbols formulate a basic congruence between a particular style of life and a specific (if most often implicit) metaphysics, and in so doing sustain each with the borrowed authority of the other.

When viewed as manifestations of sacred power, the making of bright and coloured objects is revealed as being spiritual talent as well as technological process. Technological know-how is enveloped in ritual knowledge which itself enables elites to arbitrate with supernatural powers by selecting and mixing the cosmic energies embodied in raw materials. What might, from a Western perspective, be viewed as the secular use of such objects is assessed by Pfaffenberger (1992: 505) who notes that

> . . . a design constituency creates, appropriates, or modifies a technological production process, artifact, user activity, or system in such a way that some of its technical features embody a political aim – that is, an intention to alter the allocation of power, prestige, or wealth.

Shiny objects can be seen as definitive statements of social prestige, centrally located in the symbolic representation of political power and elite status (e.g. Blanton et al. 1993: 220–2). Dazzling costumes, jewellery, body paint, and glowing knowledge and oratory are 'real time' statements of political power, not simply visually stimulating esoteric events (Figure 11.1). This may be because the

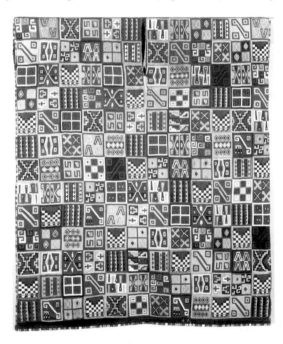

Figure 11.1 A brightly coloured high-status Inca tunic. A tapestry-weave garment of cotton and wool, its checkerboard of colourful motifs encode information on the wearer's ethnic identity, and possibly also includes political and cosmological information. (Photo courtesy of Dumbarton Oaks Research Library and Collections, Washington, D.C.)

individuals concerned are seen to control, wear and manipulate cosmic energy from whence political power flows. It is for these reasons that Amerindian shamans, chiefs and rulers employed brilliance and colour in their elite displays and even acquired epithets and names which referred to their own luminous qualities. One example among others is the case of Bohechio, a Taíno chief on the Caribbean island of Hispaniola. Bohechio held the title *Tureywa Hobin* which meant either 'Shiny as Sky-Brass', or 'king as dazzling and heavenly as guanín' (Whitehead 1997: 88; and see Saunders 2001b), an indication of the ways in which elite status and political power were entangled with notions of the cosmic powers of light.

The implications of a holistic world-view is evident in the invention and uptake of metallurgy within the Americas. When metalworking first appears it may have possessed a significance beyond modern definitions of economical and technological efficiency. By comparison with existing technologies of wood, bone and stone, metallurgy is a time-consuming and technologically complex process whose advantages over existing technologies were possibly related to spirituality, ritual and display. In the Americas, indigenous valuations of naturally occurring metals and their alloys may have derived from established ideas concerning brilliance – of which they were the most technologically sophisticated conveyors. Archaeology has tended to see such materials from a Western perspective, itself a product of the base-metal technological nature of Western civilization, and the facility with which modern science can analyse 'primitive' metallurgical traditions (Saunders 1998a: 225).

Early metalwork might usefully be regarded not for the practical/secular qualities which it sometimes acquired, but for the context into which it was originally received – i.e., *a pre-existing, age-old, symbolic, analogical, and multi-sensory world of phenomenological experience* (see Saunders 2001b). The role of brilliance and colour in this meeting of world-view and technology can still be glimpsed in traditional societies beyond the Americas. In the Cameroon Grassfields, for example, iron-making is associated with the processes of pregnancy and childbirth (Rowlands and Warnier 1993: 524), and the technology is seen to recapitulate ideas about natural reproduction in a mythological and cosmological context and re-establish the link between magic, fertility and technology (ibid.: 512–13).

In the Americas, metals were regarded as sensorial stimulants (Figure 11.2) used for decoration and adornment, and to symbolize status and power by visually expressing elite connections to immanent powers (e.g. Reichel-Dolmatoff 1981: 22–3). Among the Desana, the true importance of metal adornments lay in their symbolic associations of colour, shape and odour, and their ability to modify colourful hallucinogenic visions (ibid.; and see Hosler 1994: 235, 241–3). The Desana associate ear-pendants with male virility, and relate their odour to sex and fertility (Reichel-Dolmatoff 1981: 22). In the Island Caribbean, the copper-gold

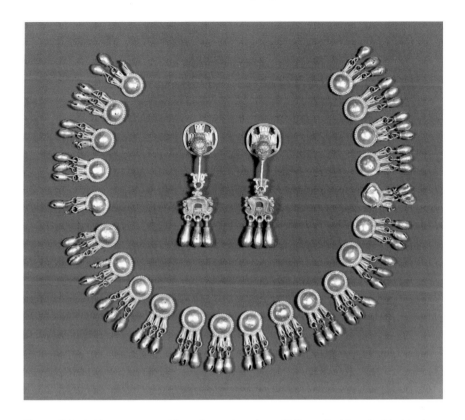

Figure 11.2 Multi-sensory cast-gold necklace and earrings of Mixteca-Puebla style, Mexico. Apart from the shimmer, each of the twenty-two gold disks, and both ear pendants, has three bells attached, adding sound to colour and brilliance. (Photo courtesy of Dumbarton Oaks Research Library and Collections, Washington, D.C.)

alloy *guanín* was valued not just for its brilliance but also for its smell (e.g. Falchetti 2001; Whitehead 1997: 78).

Lechtman (1993: 269) has observed that the popularity among pre-Columbian metalsmiths of copper-gold alloy was due to the indigenous preference for its colour over that of pure gold (and see Sauer 1971: 60; Stevens-Arroyo 1988: 67–9). The most insightful ethnographic comment on the relationship between metals, colours and light relates to the Colombian Kogi who expose their gold and gilded copper ornaments to the rays of the sun, whose power is then transmitted to priests and participants during rituals (Reichel-Dolmatoff 1981: 26). Here we observe Miller's (1987: 99) point that materiality acts as a bridge between mental and physical worlds. While metalworking techniques were specialized technologies, they were not immune to established metaphysical principles which governed a society's relationships with cosmological forces (and see Saunders 2001b).

Conclusions

It is clear that the search for the meanings of brilliance and colour in archaeology must acknowledge the metaphysical dimensions of these qualities in the ethno-historic and ethnographic records of traditional societies. Many archaeological cultures do not have such potential 'continuities' amenable to (a geographically focused application of) the 'Direct Historical Approach' (Steward 1942). An awareness of the variety of ways in which geographically and chronologically distant cultures have conceptualized light and colour can still inform our inter-pretive strategies, and allow us to refine our engagement with the materialities of brilliance and colour in archaeological research.

Whatever significances prehistoric peoples ascribed to the iridescence of the natural and artefactual worlds, it seems likely that they had more in common with a world-view predicated on analogical symbolic reasoning than on 'ideas of the world' and 'theories of being' which have arisen in the last five hundred years of Western civilization. This is hardly a novel conclusion, but perhaps not a bad starting point as archaeology begins to address the cultural implications of the fact that virtually all earthly life is phototropic.

References

Arnold, D.E. (1993), *Ecology and Ceramic Production in an Andean Community*, Cambridge: Cambridge University Press.

Arriaga, Fr P.J. de (1968), *The Extirpation of Idolatry in Peru*, Lexington: University of Kentucky Press.

Bayley, C.A. (1986), 'The origins of Swadeshi (Home Industry): Cloth and Indian Society, 1700–1930', in A. Appadurai (ed.), *The Social Life of Things*, Cambridge: Cambridge University Press, 285-322.

Berdan, F.F. (1992), 'Economic dimensions of precious metals, stones, and feathers: the Aztec state society', *Estudios de Cultura Nahuatl*, 22, 291–323.

Blanton, R.E., Kowalewski, S.A., Feinman, G.M. and Finsten, L.M. (1993), *Ancient Mesoamerica*, Cambridge: Cambridge University Press.

Boone, E.H. (1996), *Andean Art at Dumbarton Oaks*, Vol. 1. Washington, D.C.: Dumbarton Oaks.

Brill, T.B. (1980), *Light: Its Interaction with Art and Antiquities*, New York: Plenum Press.

Burger, R.L. (1995), *Chavin and the Origins of Andean Civilization*, London: Thames and Hudson.

Burkhart, L.M. (1988), 'The Solar Christ in Nahuatl Doctrinal Texts of Early Colonial Mexico', *Ethnohistory*, 53(3), 234–56.

Burkhart, L.M. (1992), 'Flowery heaven: the aesthetic of paradise in Nahuatl devotional literature', *Res: Anthropology and Aesthetics*, 21, 89–109.

Butt-Colson, A. (1977), 'The Akawaio Shaman', in E.B. Basso (ed.), *Carib-Speaking Indians: Culture, Society and Language*, Tucson: Anthropological Papers of The University of Arizona, 28, 43–65.

Carlson, J.B. (1981), 'Olmec concave iron-ore mirrors: the aesthetics of a lithic technology and the Lord of the Mirror', in E.P. Benson (ed.), *The Olmec and Their Neighbours*, Washington D.C.: Dumbarton Oaks, 117–48.

Classen, C. (1991), 'Creation by light/creation by sound: a sensory analysis of two South American cosmologies', in D. Howes (ed.), *The Varieties of Sensory Experience: A Source Book in the Anthropology of the Senses,* Toronto: University of Toronto Press, 239–55.

Classen, C. (1993), *Inca Cosmology and the Human Body*, Salt Lake City: University of Utah Press.

Closs, M.P. (1989), 'Cognitive aspects of Maya eclipse theory', in A.F. Aveni (ed.), *World Archaeoastronomy*, Cambridge: Cambridge University Press, 389–415.

Coote, J. (1992), '"Marvels of Everyday Vision": The Anthropology of Aesthetics and the Cattle-Keeping Nilotes', in J. Coote and A. Shelton (eds), *Anthropology, Art and Aesthetics*, Oxford: Clarendon, 245–74.

Descola, P. (1996), *The Spears of Twilight: Life and Death in the Amazon Jungle*, New York: The New Press.

Falchetti, A.M. (2001), 'The seed of life: The symbolic power of gold-copper alloys and metallurgical transformations', in, J. Quilter and J.W. Hoopes (eds), *Gold and Power: In Ancient Costa Rica, Panama, and Colombia*, Washington D.C.: Dumbarton Oaks.

Ford, J.A. (1969), *A Comparison of Formative Cultures in the Americas*: *Diffusion or the Psychic Unity of Man*, Smithsonian Contributions to Anthropology 11, Washington D.C.: Smithsonian Institution Press.

Furst, P.T. (1976), *Hallucinogens and Culture*, San Francisco: Chandler and Sharp.

Gage, J. (1995), *Colour and Culture: Practice and Meaning from Antiquity to Abstraction*, London: Thames and Hudson.

Garcilaso de la Vega (1987 [1609]), *Royal Commentaries of the Incas and General History of Peru*, Austin: University of Texas Press.

Geertz, C. (1973), *The Interpretation of Cultures*, New York: Harper-Colophon.

Gell, A. (1992), 'The technology of enchantment and the enchantment of technology', in J. Coote and A. Shelton (eds), *Anthropology, Art and Aesthetics*, Oxford: Clarendon Press, 40–67.

Gingerich, W.P. (1977), 'From dream to memory: a psycho-historical introduction to Nahuatl myth and moral philosophy', Ph.D Dissertation, University of Connecticut, Ann Arbor: University Microfilms.

Goldman, I. (1979), *The Cubeo: Indians of the Northwest Amazon*, Urbana: University of Illinois Press.

Gombrich, E.H. (1988), *Art and Illusion: A Study in the Psychology of Pictorial Representation*, Oxford: Phaidon Press.

Hamell, G.R. (1986), 'Wampum among the Northern Iroquois: A proposed semantics of color, ritual, and material culture', Preliminary revised draft of a paper prepared for the 1986 Shell Bead Conference, Rochester Museum and Science Center.

Hamell, G.R. (1995), 'Wampum: white, bright and light things are good to think', in A. van Dongen (ed.), *One Man's Trash Is Another Man's Treasure*, Rotterdam: Museum Boymans-van Beuningen, 41–51.

Hamell, G.R. (1998), 'Long-Tail: the panther in Huron-Wyandot and Seneca myth, ritual, and material culture', in N.J. Saunders (ed.), *Icons of Power: Feline Symbolism in the Americas*, London: Routledge, 258–91.

Helms, M.W. (1981), 'Precious metals and politics: style and ideology in the Intermediate Area and Peru', *Journal of Latin American Lore*, 7(2), 215–38.

Helms, M.W. (1986), 'Art styles and interaction spheres in Central America and the Caribbean: polished black wood in the Greater Antilles', *Journal of Latin American Lore*, 12(1), 25–43.

Helms, M.W. (1993), 'Cosmological chromatics: color-related symbolism in the ceramic art of Ancient Panama', in M.M. Graham (ed.), *Reinterpreting Prehistory of Central America*, Niwot: University Press of Colorado, 209–52.

Helms, M.W. (1995), *Creations of the Rainbow Serpent: Polychrome Ceramic Designs from Ancient Panama*, Albuquerque: University of New Mexico Press.

Helms, M.W. (2000), *The Curassow's Crest: Myths and Symbols in the Ceramics of Ancient Panama*, Gainesville: University Press of Florida.

Hoffman, D.D. (1998), *Visual Intelligence: How we create what we see*, New York: W.W. Norton and Co.

Hoskins, J. (1998), *Biographical Objects: How Things Tell the Stories of People's Lives*, London: Routledge.

Hosler, D. (1994), *The Sounds and Colors of Power: The Sacred Metallurgical Technology of Ancient West Mexico*, Cambridge, Mass.: MIT Press.

Houston, S. and K. Taube (2000), 'An archaeology of the senses: perception and cultural expression in Ancient America', *Cambridge Archaeological Journal*, 10(2), 261–94.

Howard, C.V. (1991), 'Feathers as ornaments among the Waiwai: fragments of the heavens', in R.E. Reina and K.M. Kensinger (eds), *The Gift of Birds: Feather-work of Native South American Peoples*, Philadelphia: University Museum of Archaeology and Anthropology, University of Pennsylvania, 50–69.

Howes, D. (1991), 'Introduction: "To Summon All the Senses"', in D. Howes (ed.), *The Varieties of Sensory Experience*, Toronto: University of Toronto Press, 3–21.

Hugh-Jones, S. (1979), *The Palm and the Pleiades*, Cambridge: Cambridge University Press.

Kensinger, K.M. (1995), *How Real People Ought to Be*, Prospect Heights, Ill: Waveland Press.

Kidder, A.V., Jennings, J.D. and Shook, E.M. (1946), *Excavations at Kaminaljuyu, Guatemala*, London: Pennsylvania State University Press.

Köhler, U. (1989), 'Comets and falling stars in the perception of Mesoamerican Indians', in A.F. Aveni (ed.), *World Archaeoastronomy*, Cambridge: Cambridge University Press, 289–99.

Lechtman, H. (1993), 'Technologies of power: the Andean case', in J.S. Henderson and P.J. Netherly (eds), *Configurations of Power,* Ithaca: Cornell University Press, 244–80.

Lewis-Williams, J.D. (1997), 'Harnessing the brain: vision and Shamanism in Upper Paleolithic Western Europe', in M.W. Conkey, O. Soffer, D. Stratmann and N.G. Jablonski (eds), *Beyond Art: Pleistocene Image and Symbol*, San Francisco: Memoirs of the California Academy of Sciences 23, 321–42.

Lewis-Williams, J.D. and Dowson, T.A. (1988), 'Signs of all times: entoptic phenomena in Upper Palaeolithic art', *Current Anthropology*, 29, 201–45.

López Austin, A. (1988), *The Human Body and Ideology: Concepts of the Ancient Nahuas*, Salt Lake City: University of Utah Press.

Marcus, J. and K.V. Flannery (1996), *Zapotec Civilization: How Urban Society Evolved in Mexico's Oaxaca Valley*, London: Thames and Hudson.

Medina, J.T. (1934), *The Discovery of the Amazon According to the Account of Friar Gaspar de Carvajal and Other Documents*, New York: American Geographical Society.

Miller, D.M. (1987), *Material Culture and Mass Consumption*, Oxford: Blackwell.

Miller, J. (1998), *On Reflection*, London: National Gallery Publications.

Morphy, H. (1989), 'From dull to brilliant: the aesthetics of spiritual power among the Yolngu', *Man*, 24(1), 21–40.

Murra, J.V. (1975), *Formaciones económicas y políticas del mundo andino*, Lima: Instituto de estudios Peruanos.

Park, D. (1997), *The Fire within the Eye: A Historical Essay on the Nature and Meaning of Light*, Princeton: Princeton University Press.

Perkowitz, S. (1996), *Empire of Light: A History of Discovery in Science and Art*, New York: Henry Holt and Company, Inc.

Pfaffenberger, B. (1992), 'The social anthropology of Technology', *Annual Review of Anthropology*, 491–516.

Quilter, J. (1991), 'Late Preceramic Peru', *Journal of World Prehistory*, 5(4), 387–438.

Quilter, J. (unpublished), 'The Native American Mythic Tradition: An Essay on Mythology, Space, and Time in Ancient America', Unpublished mss.

Redfield, R. and Villa Rojas, A. (1962), *Chan Kom: A Maya Village*, Chicago: University of Chicago Press.

Reichel-Dolmatoff, G. (1975), *The Shaman and the Jaguar*, Philadelphia: Temple University Press.

Reichel-Dolmatoff, G. (1978), 'Desana animal categories, food restrictions, and the concept of color energies', *Journal of Latin American Lore*, 4(2), 243–91.

Reichel-Dolmatoff, G. (1981), 'Things of beauty replete with meaning: metals and crystals in Colombian Indian cosmology', in *Sweat of the Sun, Tears of the Moon: Gold and Emerald Treasures in Colombia*, Los Angeles: Natural History Museum of Los Angeles, 17–33.

Rivers, V.Z. (1999), *The Shining Cloth: Dress and Ornament that Glitters*, London: Thames and Hudson.

Roe, P.G. (1998), 'Paragon or peril? The jaguar in Amazonian Indian society', in N.J. Saunders (ed.), *Icons of Power: Feline Symbolism in the Americas*, London: Routledge, 171–202.

Rowlands, M. and Warnier, J-P. (1993), 'The magical production of iron in the Cameroon Grassfields', in T. Shaw, P. Sinclair, B. Andah and A. Okpoko (eds), *The Archaeology of Africa*, London: Routledge, 512–50.

Ruggles, C.L.N. and Saunders, N.J. (1993), 'The study of cultural astronomy', in C.L.N. Ruggles and N.J. Saunders (eds), *Astronomies and Cultures*, Niwot: University Press of Colorado, 1–31.

Sahagún, B. de (1950–78), *Florentine Codex: General History of the Things of New Spain*, 13 vols, trans. and eds A.J.O. Anderson and C.E. Dibble, Santa Fé: The School of American Research and the University of Utah.

Sauer, C.O. (1971), *Sixteenth Century North America: The Land and the People as seen by the Europeans*, Berkeley: University of California Press.

Saunders, N.J. (1988), '*Chatoyer*: Anthropological reflections on archaeological mirrors', in N.J. Saunders and O. de Montmollin (eds), *Recent Studies in Pre-Columbian Archaeology*, Oxford: British Archaeological Reports International Series 421, 1–40.

Saunders, N.J. (1998a), 'Stealers of light, traders in brilliance: Amerindian metaphysics in the mirror of conquest', *RES: Anthropology and Aesthetics*, 33(1), 225–52.

Saunders, N.J. (1998b), 'Introduction: Icons of power', in N.J. Saunders (ed.), *Icons of Power: Feline symbolism in the Americas*, London: Routledge, 1–11.

Saunders, N.J. (1999), 'Biographies of brilliance: pearls, transformations of matter and being, *c.* AD 1492', *World Archaeology*, 31(2), 243–57.

Saunders, N.J. (2001a), 'El "Estetico de Brillo": Chamanismo, poder, y el arte de analogia', in A.M. Llamazares y C. Sarasola (eds), *El languaje de los dioses: arte, chamanismo y cosmovisión indígena de Sudamérica*, Buenos Aires: Fundación Desde América.

Saunders, N.J. (2001b), '"Catching the light": technologies of power and enchantment in Pre-Columbian goldworking', in J. Quilter and J.W. Hoopes (eds), *Gold and Power: In Ancient Costa Rica, Panama, and Colombia*, Washington D.C.: Dumbarton Oaks.

Saunders, N.J. (2001c), 'Pre-Columbian Shamanism', in D. Carrasco (ed.), *Oxford Encyclopedia of Mesoamerican Cultures*, Oxford: Oxford University Press.

Saunders, N.J. (in prep. a), *When Colours Sing and Sounds are Seen: Shamanism, Synaesthesia, and Worldview*, mss in preparation.

Saunders, N.J. (in prep. b), *Shimmering Worlds: Symbols of Brilliance and Colour in the Americas*, mss in preparation.

Seler, E. (1993a), 'The Huichol Indians of the State of Jalisco in Mexico', in J.E.S. Thompson and F.B. Richardson (eds), *Eduard Seler, Collected Works In Mesoamerican Linguistics and Archaeology*, IV, Culver City, CA: Labyrinthos, 179–97.

Seler, E. (1993b), 'The wall sculptures in the Temple of the Pulque God at Tepotztlan', in J.E.S. Thompson and F.B. Richardson (eds), *Eduard Seler, Collected Works In Mesoamerican Linguistics and Archaeology*, IV, Culver City, CA: Labyrinthos, 266–80.

Stevens-Arroyo, A.M. (1988), *Cave of the Jaqua: The Mythological World of the Tainos*, Albuquerque: University of New Mexico Press.

Steward, J.H. (1942), 'The direct historical approach to archaeology', *American Antiquity*, 7(4), 337–43.

Sullivan, L.E. (1988), *Icanchu's Drum*, London: Macmillan.

Taube, K. (1992), 'The iconography of mirrors at Teotihuacan', in J.C. Berlo (ed.), *Art, Ideology, and the City of Teotihuacan*, Washington, D.C.: Dumbarton Oaks, 169–204.

Taussig, M.T. (1987), *Shamanism, Colonialism, and the Wild Man: A Study in Terror and Healing*, Chicago: University of Chicago Press.

Townsend, R.F. (1993), *The Aztecs*, London: Thames and Hudson.

Viveiros de Castro, E. (1992), *From the Enemy's Point of View: Humanity and Divinity in an Amazonian Society*, Chicago: University of Chicago Press.

Whitehead, N.L. (1988), *Lords of the Tiger Spirit: A History of the Caribs in Colonial Venezuela and Guyana 1498–1820*, Dordrecht: Foris Publications.

Whitehead, N.L. (1997), 'The Discoverie as ethnological text', in Sir Walter Ralegh, *The Discoverie of the Large, Rich and Bewtiful Empyre of Guiana*, transcribed, annotated and introduced by N.L. Whitehead, Manchester: Manchester University Press, 60–116.

Wilbert, J. (1987), *Tobacco and Shamanism in South America*, New Haven: Yale University Press.

Wilbert, J. (1997), 'Illuminative serpents: tobacco hallucinations of the Warao', *Journal of Latin American Lore*, 20(2), 317–32.

Yturbide, T.C. (1993), *El Arte Plumaria en México*, México, D.F: Fomento Cultural Banamex, D.F.

Zajonc, A. (1993), *Catching the Light: The Entwined History of Light and Mind*, London: Bantam Press.

–12–

Epilogue: Colour and Materiality in Prehistoric Society

Chris Scarre

Colour is one of the neglected dimensions of prehistoric archaeology, a distinction it shares with more difficult areas such as music or language. Whereas music may be represented only through the remains of musical instruments (Buisson 1990; Holmes 1986), or the acoustic properties of particular spaces (Lawson et al. 1998; Watson and Keating 1999), and languages perhaps not at all (though see Renfrew 2000 for an attempt to resolve some aspects of this question), colour does survive in the remains of artefacts and structures created by early societies. Paul Taçon (1999) has drawn attention to the importance of colour in human cognitive evolution, though it receives little or no comment in some other standard works on this subject (e.g. Noble and Davidson 1996; Mithen 1996). The study of colour in the Upper Palaeolithic decorated caves of France and Spain has focused more on the identification and preparation of the pigments than on the symbolism and meaning of colours themselves, though attempts have been made to associate individual colours with particular contexts, specific signs or images, or particular chronological periods (Bahn and Vertut 1997: 169). In fact, the range of colours represented in this cave art is very limited, and is mainly restricted to blacks, reds, and yellows or browns, with occasional use of white (ibid.: 115).

The restricted palette of colours is typical of many human contexts, both pre-historic and ethnographic. It raises questions about symbolism and cognition which relate to those discussed by Berlin and Kay in their seminal work *Basic Color Terms* (1969). It was in this context that the *Cambridge Archaeological Journal* invited a number of contributions on the subject of colour symbolism. The resulting group of short papers (Gage et al. 1999), drawing upon diverse cultural contexts though selective, did provide elements of a response to the question as to whether the regularities in colour perception suggested by Berlin and Kay find support from archaeological material. They also went beyond that and identified ways in which colour symbolism might be approached in archaeological research. The intention in these contributions was to stay clear of issues concerning the meaning of *applied* colours (used in wall paintings or painted rock art) and instead concentrate on the *innate* colours of natural materials, and above all stone artefacts

and building stones, where comparisons between a wide range of cultural contexts could more readily be made.

Art historian John Gage highlighted the primary difficulty facing the attempt to construct a prehistory of colour symbolism. If we cannot identify meaning outside a linguistic context, how could we possibly attribute meaning to colours in societies where no records of colours have survived? (Gage 1999: 110). Put this way, the question gives primacy to linguistic function in the classification of colours. We may note, for example, that the Egyptians had abstract colour terms only for black, white, red and green, whereas artefacts indicate that they used several reds, several blues, yellow, brown, grey and pink as well (Baines 1985). The complexity of the issue is indicated by the presence of Egyptian terms for pigments of yellow and blue, even though they had no abstract term for either of these colours. Gage concludes:

> Where it is clear that a culture which is not concerned to label the distinctions which it clearly perceives . . ., modern scholars must respect this reluctance and seek to reconstitute the attitudes which lie behind it. (Gage 1999: 112)

If we are to understand the nature and development of human colour symbolism, we must explore beyond the chronological and cultural limits set by the survival of linguistic evidence. The study by Baines points the way in proposing that not only the possession of colour terms by a particular society but the use of colours themselves may follow a significant and discernible pattern. Here the emphasis switches from linguistics to materiality. Thus a case can be made for red as one of the earliest and most widely recognized colours, a primacy which may be a product of cognitive classification, but could also derive from its frequent association with blood. The colour of blood has arguably been symbolized by the use of red materials since the Middle Palaeolithic, and constitutes the oldest evidence for human colour-symbolism. Two lumps of ochre were discovered in Bed II of site BK at Olduvai Gorge (Hay 1976: 185), though whether this indicates perceptive colour categorization at such an early period remains open to question (Wreschner 1980: 632; Butzer 1980: 635). Colour vision is present in all known primates, and may have arisen as an evolutionary adaptation in an early primate ancestor switching from a nocturnal to a diurnal habit (Stephenson 1972). At Lion Cavern in southern Africa, red ochre mines were exploited from at least the MSA 2b period (110,000–75,000 bp) (Knight et al. 1995). Pieces of red and yellow ochre and ground haematite have been found in the lowest layers at the Malakunanja II and Nauwalabila I rock shelters in northern Australia, dated to *c.* 60,000 bp. The Nauwalabila material included a large piece of high-quality haematite with ground facets and striations indicating use as a red pigment (Flood 1996: 10).

Red ochre was also applied to human burials, suggesting that the symbolism of colour had been extended from 'blood' to indicate 'life'. Red ochre is found on

Neanderthal skeletons at Le Moustier and La Chapelle-aux-Saints, though it was not a universal feature of Neanderthal burial practice (Wreschner 1980). Ochre finds are more common with early burials of anatomically modern humans; the material may have been scattered over the body after it was laid in the grave. In the triple burial at Dolni Vestonice, red ochre had been placed on the heads of the two men and over the pelvis and thighs of the woman (Klima 1987). In Mesolithic graves of the Iron Gates region of Southeast Europe red ochre may have played an apotropaic role, sprinkled over pregnant women at Vlasac and powerless infants at Vlasac and Lepenski Vir (Boriç in Chapter 1 of this volume). The fact that the red ochre was located in the groin area of the adult females again suggests a metaphorical association with blood.

The symbolic link between ochre and blood was employed by Knight and colleagues to develop a model for the emergence of language (Knight et al. 1995). They argued that as a body paint red ochre was used by females to manipulate menstrual signals in order to secure meat from males; these deceptive signs of menstruation being in their hypothesis the origin of symbolic culture. It is important to recognize, however, that the symbolic meanings attached to the colour red in ethnographic contexts are much more variable than would be indicated by this association with blood or life. In New South Wales, red was symbolic of aggression (Gage 1999); in Western society, it has become the symbol for danger or interdiction in road signs or control lights used on railways and highways. To the Ndembu, 'Red things . . . act for both good and bad', and red is associated both with power and with (sexual) impotence (Turner 1967: 70–1). Among the Yolngu of Arnhem Land, blood is a source of ritual power, but this quality is shared by brightly coloured substances and red ochre that produces a naturally burnished finish (Morphy 1992: 196).

The widespread symbolic importance of red does indeed make it exceptional. One reason for this may be the unstable appearance of many natural phenomena, such as the changes in the sun from rising to setting. Such instability may in itself have inhibited the development of symbolic colour associations (Gage 1999: 111). Examples of the ambiguity of natural phenomena include the colour of water or the sea (which we typically consider blue; though note that warships are camou-flaged in grey), or similarly the sky, and even fire, where flames may be yellow (rather than the red usually associated with fire), and can sometimes be blue or even green depending on the substance involved. It is no doubt the power of the human body as a source of symbol and metaphor, rather than practical consider-ations, that lead to bodily fluids, notably blood and semen, being the primary referents for colour symbolism.

The discrepancy between the range of colours perceived by all human beings and the restricted number of colour terms present in many languages provides an unusual insight into processes of categorization and symbolization. As Jones and

Bradley remark: 'Although [colour perception] may have been seen in the same ways, its categorization would always have been culturally specific' (Jones and Bradley 1999). The full significance of such categorization may only be clear when the colour terms employed by that society are known. Material culture, however, reveals the range and deployment of coloured materials and provides an alternative approach. The symbolic associations of colours can only be known when written sources are available. We could not know that the Egyptian use of travertine, drawing on its natural qualities of light coloration and partial translucency, held an association with purity, nor could we postulate that the general use of white stone for tombs and temples may incorporate the same symbolic values (Spence 1999: 116). Yet the patterning of white stones around the entrances to Irish passage graves, and the structured placement of red sandstone slabs and pieces of quartz at Balnuaran of Clava (the former illuminated by the setting sun, the latter by the rising sun at midsummer) cannot be dismissed as pure chance. It is clear that coloured stones were carefully selected for monument construction because of their particular qualities (Jones and Bradley 1999; Spence 1999). In the Egyptian case, written testimony provides evidence that these colours had symbolic associations; and we may suppose that the same was true for the coloured stone used in prehistoric Europe. The case is all the more persuasive in that the colours used in west European Neolithic monuments (as in ancient Egypt: 'Textual sources . . . associate only three terms with the colour of building stone: black, white and red': Spence 1999: 115) were the primary triad of red, white and black. The same three colours form the palette employed in the painted decoration in Iberian megalithic tombs, where designs in red, or in red and black, were applied to a white-painted background (Shee-Twohig 1981: 32–5).

The prominence of the triad red, black and white invites direct comparison with the colour classification of the Yoruba of Nigeria (Drewal and Mason 1998; Keates in Chapter 5 of this volume) and the Ndembu of north-west Zambia (Turner 1967). Turner notes that the Ndembu possess primary terms only for the colours white, red and black, and that in a symbolic sense they perceive these as

> rivers of power flowing from a common source in God or permeating the whole world of sensory phenomena with their specific qualities. (Turner 1967: 68)

Turner finds a number of cross-cultural parallels for the primary or ritual significance of these three colours, and interprets these regularities in terms of basic bodily experiences. Not only do the three colours stand for basic human experiences of the body (associated with the gratification of libido, hunger, aggressive and excretory drives, and with fear, anxiety, and submissiveness), they also provide a kind of primordial classification of reality (Turner 1967: 89–90).

Turner's work provides a framework for archaeologists seeking to understand prehistoric colour usage in that it takes us beyond the linguistic into the use of coloured materials in rituals. This may lead us to question the validity of the 'stages' of Berlin and Kay's neo-evolutionary scheme. An alternative model postulates that colour terms used by a particular society will derive from the salience of specific colours (in the form of coloured materials, or colours present in the natural environment). Thus in Chapman's study of the Durankulak and Varna cemeteries, he envisages societies in which the perception of colours would be derived from local environmental features or from cultural materials, including imports. The resulting analysis illustrates that over the course of time, the number of colours present in the graves increases as imported materials become more common: new materials create new possibilities for colour perception and naming (see Chapman in Chapter 2 of this volume).

It is still the case that the evidence from the Durankulak and Varna cemeteries indicates a progressive broadening over time of the range of coloured materials in use. This is not to deny the obvious reality that many colours – notably those on textiles – have been lost. But it nonetheless parallels the colour-term sequence proposed by Berlin and Kay in suggesting a sequence of change, from few colours to many, which may relate to increasing complexity in the social or cultural environment. Again, it must be emphasized that we are dealing with symbolic importance or salience, not perception: what appears to be documented is the attribution of special meaning to a widening range of colours. A classic example is the sequence presented by Baines (1985) in his study of colour use in Egyptian dynastic art. The Old Kingdom colour palette (equivalent to Berlin and Kay's stage V) expands to a partial stage VII mode by the New Kingdom, while the Egyptian language remains at stage IIIa. Cooney also observes that among Irish polished stone axes, it is the colours black, white, yellow, blue and green that are most prominent, these (with the notable omission of red) corresponding once again to the most commonly occurring basic colour terms in Berlin and Kay scheme (Cooney in Chapter 4 of this volume).

The conclusion to be drawn from these studies is that material culture may well follow a sequence of palette-accretion without direct impact on the linguistic terms used by those societies. We might go further, and question whether the linguistic terms need be of particular concern in this context. The evidence does suggest that among the range of colours, black, white and red have a special and perhaps universal significance for human societies, and that this significance may be of considerable antiquity. This is a conclusion which may be reached without any reference to Berlin and Kay's scheme. We should perhaps decouple the sequence derived from linguistic terminology and consider instead the development of particular colour symbolisms as they are represented in the material remains of individual early societies. Such an enterprise emphasizes materiality over linguistics

and leads us to consider the encounter with colour in terms of bodily and sensory experience. The task facing the archaeologist may hence be characterized as understanding the contextual significance of particular colours in their material manifestation.

Colour in megalithic architecture

Nowhere is the question of colour perception more tantalizing than in the case of stone selection in prehistoric monuments. It is well known that the pillars and slabs employed to construct stone monuments in western Europe during the Neolithic and Early Bronze Age were frequently brought from a distance. Black, white and red appear in many cases to be the primary categories: black and white in the facade of Newgrange (O'Kelly 1982); red and white at Knockroe in Co. Kilkenny (O'Sullivan 1996); red and white in the chambered tombs of Arran (Jones 1999). At Balnuaran of Clava, the cairns are built of red and white materials, with black used in the corbelling at the rear of the chambers (Trevarthen 2000). Lynch has noted how in the recumbent stone circles of Northeast Scotland, the recumbent stones are of a differently coloured stone from that in the rest of the circle (Lynch 1998, 65). MacGregor (Chapter 7 of this volume) takes this further and notes the symmetrical composition of flankers and recumbent, the flankers normally matching each other in colour and texture, and contrasting with the recumbent which is of a different material. The precise description of colours may vary from viewer to viewer, but Lynch and MacGregor agree in assigning a prominent role in these recumbent stone circles to whites and reds (or pinks), alongside greys which may represent the darker pole of a white/black dichotomy.

Similar contrasts are present in monuments in adjacent regions of Europe. Lynch notes the alternation of schist and quartz in the kerb of the elongated monument of Jardin aux Moines in central Brittany; the schist, which Lynch and Briard describe as red, is the local bedrock; the quartz blocks were taken from exposures some 3–4 kms distant (Lynch 1998: 64; Briard 1989: 45). The dating evidence presented by Briard is ambivalent (1989: 51–2; see also Briard et al. 1995: 47) but Lynch attributes this alternation of coloured stone to a reworking of the monument in the Late Neolithic (third millennium BC). It is more likely that the Jardin aux Moines belongs within the category of *tertres tumulaires* dating to the earliest phase of the Breton Neolithic (fifth millennium BC). This would link it with the structured use of quartz and schist in the *tertre tumulaire* of La Croix-Saint-Pierre at Saint-Just, where the schist slabs are ranged along the northern flank and the quartz along the southern flank of the mound, though here the colour of the schist may more accurately be described as blue or blue-grey ('schiste bleue': Giot et al. 1995: 39). The north-south symbolism is mirrored in the patterning of

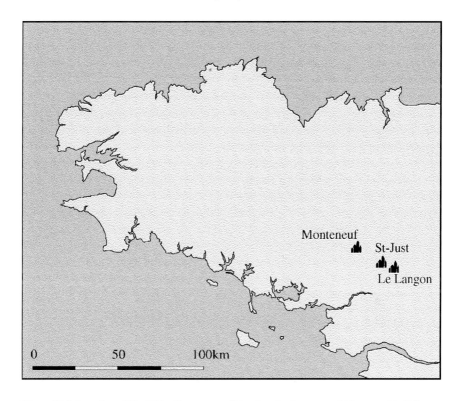

Figure 12.1 Location of Neolithic alignments at Saint-Just, Le Langon and Monteneuf in Brittany.

material found within the mound make-up at La Croix-Saint-Pierre, potsherds being conspicuously restricted to the area north of the mid-line (Giot and L'Helgouach 1955; Briard et al. 1995: 39; Scarre 2001). Once again, the schist is local but the quartz has been brought from a distance.

A case for colour symbolism can be made for three contrasting stone settings in central Brittany, to the southwest of Rennes (Figure 12.1). The three sites in question – Le Langon, Saint-Just and Monteneuf – employ schist and quartz in a series of stone rows consisting of menhirs up to 5 metres tall. The alignments at Le Langon consist of 37 stones arranged in six rows, climbing the slope above the River Vilaine toward the remains of an oval setting or cromlech. The lines of stones lead away from the river in a manner suggestive of a processional way, and are of glistening white quartz (Giot et al. 1998: 543; Bézier 1883). The source of the material lies within the quartz seams, which cut through the local schist bedrock. To obtain blocks of sufficient magnitude, it may have been necessary to transport material over a distance of several kilometres.

Some 30 kilometres northwest of Le Langon, on the high ground beside the old road from Rennes to Vannes, stand the Monteneuf alignments. These consist

of single lines of stones which meet or cross at an angle; what the visitor sees today is largely the result of re-erection following recent excavations; only three stones were standing before those investigations began (Lecerf 1999). All the menhirs save one are in 'schiste pourpré', a blue-grey schist locally available; the exception is menhir Dg, in 'grès blanchâtre' (whitish sandstone). The origin of the schist is confirmed by the discovery within the confines of the site of an extraction area, where a large schist block appears to have been abandoned in course of its detachment from the bedrock.

The employment of local material of matt blue-grey colour gives the alignments of Monteneuf a muted character, which is in strong contrast to the glistening quartz rows of Le Langon. The Monteneuf settings express a different aesthetic, which binds the monument to the local bedrock through a continuity of material. It is instructive to note the difficulty faced during recent excavations of distinguishing fallen menhirs from simple erratics. As the excavator of Monteneuf remarks,

> In some cases the impossibility of distinguishing between erratic blocks and menhirs places difficulties in the way of reconstructing a precise image of the whole complex. (Lecerf 1999: 19)

The criteria used to identify the fallen menhirs included the presence of cup marks on one stone, the alignment of the stones, the orientation of their geological grain, the fact that some appear to have been broken up after they had fallen, or in other cases had left a broken stump within their stone hole. In terms of colour and material, the effect had been to blend the monoliths with the local geology. Such contrasts as were intended were achieved by the size, shape and alignment of the stones, rather than through their colour or material.

If Le Langon uses quartz to contrast with the local geology, and Monteneuf uses schist to blend with it, then the third site, the alignments of Saint-Just, employ both materials so as to set up internal contrasts within the stone rows. The alignments of Le Moulin, at the eastern end of the upland known as La Grée de Cojoux, comprise three single rows of blocks: the 'file nord' and 'file ouest' with fifteen and five blocks respectively, all of quartz; and the 'file sud' consisting of ten schist menhirs and three of quartz (Figure 12.2). The 'file sud' includes a number of stone-sockets from which the uprights have been removed or disappeared, two of these contain the stumps of broken menhirs, one of schist and one of quartz, bringing the totals to eleven and four respectively (Le Roux et al. 1989). A related group of post-holes forming a pentagon centred on a hearth were found between menhirs 4 and 5 and have been interpreted as a (roofed) timber structure; in one reconstruction, several of the empty sockets in this section of the alignment are shown furnished with timber posts (Le Roux 1979), but the presence of menhir stumps in two other sockets urges caution.

Le Moulin alignments (Saint-Just): southern stone row

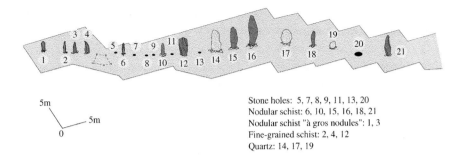

5m

5m

0

Stone holes: 5, 7, 8, 9, 11, 13, 20
Nodular schist: 6, 10, 15, 16, 18, 21
Nodular schist "à gros nodules": 1, 3
Fine-grained schist: 2, 4, 12
Quartz: 14, 17, 19

Figure 12.2 Isometric view of the 'file sud' alignment at Le Moulin, Saint-Just (Brittany) illustrating the arrangement of schists and quartz. (Based on Le Roux 1979, and Le Roux et al. 1989.)

Stratigraphic information enabled the excavators to determine that the alignment was not a single-phase structure but that the three large quartz menhirs had been erected first. This was followed by the construction of a low cairn or platform around the foot of these menhirs which sealed a series of hearths radiocarbon-dated to the fifth millennium BC. There may have been a timber palisade along the midline of this structure. The erection of the other menhirs followed, their bases secured within the body of the cairn rather than in sockets cut into the bedrock beneath (Le Roux et al. 1989). This final phase includes schist menhirs 15, 16, 18 and 21, but the quartz menhir 14 is also described as resting against the cairn (Le Roux et al. 1989: 18). Whether the quartz preceded the schist menhirs, or whether both quartz and schist were involved at each stage, it is difficult to be sure. The result is the same: the striking and intentional combination of elements contrasting in colour, shape and texture (Plate 12).

The most salient impression at Le Moulin is the contrast between the bright white quartz and the dull schist, but among the schist there is variation in colour and texture. Cleavage patterns have left prominent yellow-orange patches on the faces of some of the schist menhirs. Others vary in colour between a lightish grey-blue and a dark blue-black; it is the dark colour of menhir 16, as well as its size, which makes it the most prominent element of the row. There are also differences in texture between the nodular schist and the finer-grained 'schiste homogène'. There is no clear pattern in the arrangement of the different materials and textures within the row as a whole; the careful alternation at the eastern extremity between 'schistes à gros nodules', with a texture resembling fossilized coral (menhirs 1 and 4), and the darker and more regular 'schiste homogène' (menhirs 2 and 3) (Le Roux et al. 1989: 17) suggests awareness of the qualities of these materials among the builders of the alignment.

The significance of the schist and quartz must be set against the context of local geology. Quartz veins run through the Grée de Cojoux. One vein cuts across the northern file of the Le Moulin alignments. Others are visible in the cliff face overlooking the Etang du Val at the western end of the Grée. (The quartz blocks for the monuments were brought to the Grée from sources of material 3–4 kms to the south and south-west: Briard et al. 1995: 10.) The juxtapositioning of the two materials is revealed in the outcrop toward which the western file of the Le Moulin alignments appears to be aligned: an outcrop half of schist (east) and half of quartz (west). The special significance of quartz in other cultural contexts has been discussed elsewhere (Darvill in Chapter 3 of this volume; Scarre 2001; Taçon 1991). The builders of the Le Moulin alignments, and of other monuments on the Grée de Cojoux in which schist and quartz were combined, may have been taking up the colours of the land and seeking to release or tap into the special powers or qualities associated with the whiteness and brilliance of the quartz.

This analysis argues for a colour symbolism derived from the natural landscape. The schists vary in colour and hue from light to dark, and from grey to blue-grey or even yellow. What unites them is the dullness or matt quality of their appearance: it is this which distinguishes them most from the quartz. Thus what we may have at Saint-Just is an opposition framed not so much in terms of particular colours but in terms of brightness – bright quartz contrasting with dull schist – coupled with texture, if the gnarled forms of Le Moulin 'file sud' are significant. Brilliance is associated in ethnographic contexts, for example in Yolngu art of Arnhem Land (Australia), as having an association with ancestral power (Morphy 1992: 189). Keates (Chapter 5 of this volume) has discussed the quality of luminosity, and its connection with the spirit world, in his study of the copper daggers represented on North Italian statue-menhirs. Brilliance was also associated with spirituality and power in many pre-Columban Amerindian societies (Saunders, Chapter 11 of this volume). At Le Moulin, alongside brightness we must also include the shapes of the stones, the jagged and often pointed forms of the schist contrasting with the more rounded contours of the quartz blocks. In material objects, colour is always only one of several salient qualities, alongside notably shape and texture.

Conclusion

The seminal works of Berlin and Kay (1969) and Victor Turner (1967) suggest different approaches to the significance of colour, the former relying on linguistics, the latter on symbolic meanings which both are polysemic in nature and incorporate the use of material symbols. The Berlin and Kay study has led to the proposal that the ordering of colour terms is physiologically driven, and may relate to the

order in which the ability to discriminate colours was gained by the primates (Stephenson 1972: 381). Social scientists have been wary about claims which attribute colour perception to physiological universals, on the grounds that they pay little attention to specific contexts of colour term use (Bolton 1978; Saunders 1995; Wierzbicka 1990). In the study of Egyptian colour use, Baines contrasts the development of linguistic terms with the chronology of applied colour in Egyptian art (Baines 1985). These publications essentially frame the question which archaeologists must seek to comprehend.

A further aspect of colour significance lies in colour change; the firing of a pot or the casting of a copper dagger involved striking transformations in the colour of the original materials. Similar transformations accompanied the working of amber and jet (Jones in Chapter 8 of this volume). At Neolithic sites in southern Sweden, the burning of flint axes appears to have been designed to turn them from black or grey to white, with the temperature of burning carefully controlled in order to achieve this (Larsson 2000). Owoc (Chapter 6 in this volume) has discussed the more subtle colour changes induced by weathering, where materials dug from the buried landscape may at first appear brightly coloured before weathering dulls them and blends them into their surroundings.

One feature common to almost all studies of colour symbolism and its development is the importance of the colour triad red, black and white. These are the colours prominent in Ndembu ritual (Turner 1967), and in the Palaeolithic cave art and megalithic architecture of Western Europe. A cultural-evolutionary perspective might interpret this as a primordial contrast between dark and light, to which the colour red is added by reason of its association with blood and life. However, this overlooks the fact that dark and light are *shades* rather than *hues*. Berlin and Kay observe that in the small number of languages where basic colour terms exist only for black and white, these are terms for colours or hues:

> Stage I in the evolution of lexical color categories is represented by just two terms: *black* plus most dark hues, and *white* plus most white hues. (Berlin and Kay 1969: 17)

Several studies support this crucial distinction between shade and hue. Casson has observed that in Old English, spoken *c.* AD 600–1150, the predominant sense of colour was in terms of brightness; only in Middle English (*c.* AD 1150–1500) did hue become salient (Casson 1997: 224). Berlin and Kay have modified their original scheme, observing that the two-term colour systems do not divide colours into dark and light shades regardless of hue, but into white plus 'warm' colours versus black plus 'cool' colours. The oppositions in such two-term systems are not always focused in white and black but may sometimes lie in red or yellow versus green or blue (Kay et al. 1997, 21). Jameson and D'Andrade suggest alternatively that the most fruitful way to explain the developmental order of colour names is in terms of those successive partitions of colour space that are most informative:

> If one has only two color terms, the most informative system is one that places the referents of the terms at the maximum distance from each other. A dark/cool versus light/warm division of the color space accomplishes exactly this. Once the light/warm versus dark/cool division has been made, the region of color space that is most distant from the regions specified by these two terms is red. (Jameson and D'Andrade 1997: 312)

The danger of these approaches lies in the encouragement of process of abstraction. Linguistic colour terms may not refer to a single Western-type colour but may have a range of colour associations derived from multiple facets of meaning. In seeking to recognize the significance of colour symbolism in colour terms familiar to the modern Western observer, there is a tendency to divorce the quality of colour from the other qualities of the material to which it pertains. It is tempting to recognize the contrast between white quartz and red schist in monuments such as the Jardin aux Moines in terms of the triad white, black and red. Consideration of other Neolithic monuments in the same region of Brittany cautions against such a conclusion, for the schist there is of a different colour, more properly described as blue or blue-grey. Since the schist is the predominant local material, and the quartz frequently transported from a distance, it may be more appropriate to consider the schist as the recessive background against which the striking quartz blocks were deployed and displayed.

We may extend this argument further. To interpret the significance of the jadeite axes of Alpine origin and the variscite beads from Catalonia found in the Neolithic burial chambers of southern Brittany in terms of their colour alone would fail to recognize the full materiality of the artefacts concerned. The central chamber beneath the Tumulus de Saint-Michel near Carnac held no fewer than 136 beads of jasper and variscite, 9 variscite pendants and 36 polished stone axes, 11 of them of jadeite (Le Rouzic 1932). The variscite is a distinctive blue-green stone, a colour shared by some of the jadeite axes. Other Breton jadeite axes are of darker coloration. It is not only colour but the tactile qualities of the material and the size of the axes themselves – up to 50 cms and more in length – which mark them out as of significance. Colour, texture, translucence and working properties may have played a part in the attribution of value to these exotic imported materials.

Colour may not have been the most salient characteristic of particular materials or artefacts. Colour may have been not only a quality in itself but a marker of origin enabling distinction to be drawn between exotic products and those from local sources (Bradley 2000; Cooney in Chapter 4 of this volume). Colour is only one of the properties of the bluestones at Stonehenge, and the group includes five stones which are dark olive-green rather than blue in colour (Atkinson 1956: 35). We may perhaps question whether the colour of the bluestone stones held particular significance, or whether their primary importance derived from their place of origin on the Preseli mountain of south-west Wales, 'the cloud-capped

crest of the sacred mountain far to the west' (Atkinson 1956: 175). The arrangement of the various bluestones within the final design of Stonehenge implies an awareness of their specific geological source within the Preseli region, and to this recognition colour, along with texture and shape, would have provided vital clues (Bradley 2000: 92–6). Similarly on Arran, the colour of stone selected for use in the tombs provided evidence for their origin in different parts of the island (Jones 1999).

In seeking to develop an archaeology of perception and the senses (Houston and Taube 2000), one must ensure that the significance of colour and coloured objects be contextually grounded within a world experienced equally through texture, sound and smell.

References

Atkinson, R.J.C. (1956), *Stonehenge*, London: Hamish Hamilton

Bahn, P.G. and Vertut, J. (1997), *Journey through the Ice Age*, London: Weidenfeld & Nicolson.

Baines, J. (1985), 'Color terminology and color classification: ancient Egyptian color terminology and polychromy', *American Anthropologist*, 87, 282–97.

Berlin, B. and Kay, P. (1969), *Basic Color Terms: Their Universality and Evolution*, Berkeley: University of California Press.

Bézier, P. (1883), *Inventaire des Monuments Mégalithiques du Département d'Ille-et-Vilaine*, Rennes.

Bolton, R. (1978), 'Black, white, and red all over: the riddle of colour term salience', *Ethnology*, 17, 287–311.

Bradley, R. (2000), *An Archaeology of Natural Places*, London: Routledge.

Briard, J. (1989), *Mégalithes de Haute Bretagne: Les monuments de la forêt de Brocéliande et du Ploërmelais: structures, mobilier et environnement*. Paris: Documents d'Archéologie Française

Briard, J., Gautier, M. and Leroux, G. (1995), *Les Mégalithes et les Tumulus de Saint-Just, Ille-et-Vilaine*, Paris: Comité des Travaux Historiques et Scientifiques.

Buisson, D. (1990), 'Les flûtes paléolithiques d'Isturitz (Pyrénées-Atlantiques)', *Bulletin de la Société Préhistorique Française*, 87, 420–33

Butzer, K.W. (1980), 'Comment on E.E. Wreschner "Red ochre and human evolution: a case for discussion"', *Current Anthropology*, 21, 635.

Casson, R.W. (1997), 'Color shift: evolution of English color terms from brightness to hue', in C.L. Hardin and L. Maffi (eds), *Color Categories in Thought and Language*, Cambridge: Cambridge University Press, 224–39

Drewal, H.J. and Mason, J. (1998), 'Beads, body and soul. Art and light in the Yoruba universe', *African Arts*, 1998, 18–27.

Flood, J. (1996), 'Culture in early Aboriginal Australia', *Cambridge Archaeological Journal*, 6, 3–36

Gage, J. (1999), 'Did colours signify? Symbolism in the red', *Cambridge Archaeological Journal*, 9, 110–12

Gage, J., Jones, A., Bradley, R., Spence, K., Barber, E.J.W. and Taçon, P.S.C. (1999), 'What meaning had colour in early societies?', *Cambridge Archaeological Journal*, 9, 109–26

Giot, P-R. and L'Helgouach, J. (1955), 'Le tertre tumulaire de la Croix-Saint-Pierre en Saint-Just (Ille-et-Vilaine). (Fouilles de 1953–1954)', *Annales de Bretagne*, 62, 282–92

Giot, P-R., Briard, J. and Onnée, Y. (1995), 'Le tertre tumulaire de la Croix Saint Pierre et les tertres longs néolithiques armoricains', in J. Briard, M. Gautier and G. Leroux (eds), *Les Mégalithes et les Tumulus de Saint-Just, Ille-et-Vilaine*, Paris: Comité des Travaux Historiques et Scientifiques, 39–47.

Giot, P-R., Monnier, J-L. and L'Helgouach, J. (1998), *Préhistoire de la Bretagne*, (2nd edn) Rennes: Ouest-France

Hay, R.L. (1976), *Geology of the Olduvai Gorge*, Berkeley: University of California Press.

Holmes, P. (1986), 'The Scandinavian bronze lurs', in C.S. Lund (ed.), *Second Conference of the International Council for Traditional Music Study Group on Music Archaeology, 2: The Bronze Lurs*, Stockholm: Royal Swedish Academy of Music, 51–125.

Houston, S. and Taube, K. (2000), 'An archaeology of the senses: perception and cultural expression in ancient Mesoamerica', *Cambridge Archaeological Journal*, 10, 261–94.

Jameson, K. and D'Andrade, R.G. (1997), 'It's not really red, green, yellow, blue: an inquiry into perceptual color space', in C.L. Hardin and L. Maffi (eds), *Color Categories in Thought and Language*, Cambridge: Cambridge University Press, 295–319.

Jones, A. (1999), 'Local colour: megalithic architecture and colour symbolism in Neolithic Arran', *Oxford Journal of Archaeology*, 18, 339–50.

Jones, A. and Bradley, R. (1999), 'The significance of colour in European archaeology', *Cambridge Archaeological Journal*, 9, 112–14.

Kay, P., Berlin, B., Maffi, L. and Merrifield, W. (1997), 'Color naming across languages', in C.L. Hardin and L. Maffi (eds), *Color Categories in Thought and Language*, Cambridge: Cambridge University Press, 21-56.

Klima, B. (1987), 'Une triple sépulture du Pavlovien à Dolni Vestonice, Tchécoslovakie', *L'Anthropologie*, 91, 329–34.

Knight, C., Power, C., and Watts, I. (1995), 'The human symbolic revolution: a Darwinian account', *Cambridge Archaeological Journal*, 5, 75–114.

Larsson, L. (2000), 'The passage of axes: fire transformation of flint objects in the Neolithic of southern Sweden', *Antiquity*, 74, 602–10.

Lawson, G., Scarre, C., Cross, I. and Hills, C. (1998), 'Mounds, megaliths, music and mind: some thoughts on the acoustical properties and purposes of archaeological spaces', *Archaeological Review from Cambridge*, 15, 111–34.

Lecerf, Y. (1999), *Les Pierres Droites: Réflexions autour des menhirs*, Document Archéologique de l'Ouest, Rennes: Association pour la Diffusion des Recherches archéologiques dans l'Ouest de la France.

Le Roux, C-T. (1979), 'Circonscription de la Bretagne', *Gallia Préhistoire*, 22.

Le Roux, C-T., Lecerf, Y. and Gautier, M. (1989), 'Les mégalithes de Saint-Just (Ille-et-Vilaine) et la fouille des alignements du Moulin de Cojoux', *Revue Archéologique de l'Ouest*, 6, 5–29.

Le Rouzic, Z. (1932), *Carnac: Fouilles faites dans la région: Tumulus du Mont Saint-Michel 1900–1906*, Vannes.

Lynch, F. (1998), 'Colour in prehistoric architecture', in A. Gibson and D.D.A. Simpson (eds), *Prehistoric Ritual and Religion*, Stroud: Sutton, 62–7.

Mithen, S. (1996), *The Prehistory of the Mind: A Search for the Origins of Art, Religion and Science*, London: Thames and Hudson.

Morphy, H. (1992), 'From dull to brilliant: the aesthetics of spiritual power among the Yolngu', in J. Coote and A. Shelton (eds), *Anthropology, Art and Aesthetics*, Oxford: Clarendon, 181–208.

Noble, W. and Davidson, I. (1996), *Human Evolution, Language and Mind: A Psychological and Archaeological Inquiry*, Cambridge: Cambridge University Press.

O'Kelly, M.J. (1982), *Newgrange: Archaeology, Art and Legend*, London: Thames and Hudson.

O'Sullivan, M. (1996), 'A platform to the past – Knockroe passage tomb', *Archaeology Ireland*, 2, 11–13.

Renfrew, C. (2000), 'At the edge of knowability: towards a prehistory of languages', *Cambridge Archaeological Journal*, 10, 7–34.

Saunders, B.A.C. (1995), 'Disinterring *Basic Color Terms*: a study in the mystique of cognitivism', *History of the Human Sciences*, 8, 19–38.

Scarre, C. (2001), 'A place of special meaning: Interpreting prehistoric monuments in the landscape', in B. David and M. Wilson (eds), *Inscribed Landscapes: Archaeological and Anthropological Approaches to Place Making*, Honolulu: University of Hawaii Press.

Shee-Twohig, E. (1981), *The Megalithic Art of Western Europe*, Oxford: Clarendon.

Spence, K. (1999), 'Red, white and black: colour in building stone in ancient Egypt', *Cambridge Archaeological Journal*, 9, 114–17.

Stephenson, P.H. (1972), 'The evolution of colour vision in the primates', *Journal of Human Evolution*, 2, 379–86.

Taçon, P.S.C. (1991), 'The power of stone: symbolic aspects of stone use and tool development in western Arnhem Land, Australia', *Antiquity*, 65, 192–207.

Taçon, P.S.C. (1999), 'All things bright and beautiful: the role and meaning of colour in human evolution', *Cambridge Archaeological Journal*, 9, 120–3.

Trevarthen, D. (2000), 'Illuminating the monuments: observation and speculation on the structure and function of the cairns at Balnuaran of Clava', *Cambridge Archaeological Journal*, 10, 295–315.

Turner, V. (1967), *The Forest of Symbols: Aspects of Ndembu Ritual*, Ithaca: Cornell University Press.

Watson, A. and Keating, D. (1999), 'Architecture and sound: an acoustic analysis of megalithic monuments in prehistoric Britain', *Antiquity*, 73, 325–36.

Wierzbicka, A. (1990), 'The meaning of color terms: semantics, culture, and cognition', *Cognitive Linguistics*, 1, 99–150.

Wreschner, E.E. (1980), 'Red ochre and human evolution: a case for discussion', *Current Anthropology*, 21, 631–44.

Index

Index